WHOREPHOBIA

WHOREPHOBIA

Strippers on Art, Work, and Life

Edited by Lizzie Borden

SEVEN STORIES PRESS
NEW YORK • OAKLAND

Seven Stories Press
140 Watts Street
New York, NY 10013
www.sevenstories.com

College professors and high school and middle school teachers may order free examination copies of Seven Stories Press titles. Visit https://www.sevenstories.com/pg/resources-academics or email academics@sevenstories.com.

Library of Congress Cataloging-in-Publication Data

Names: Borden, Lizzie, 1958- editor.
Title: Whorephobia : strippers on art, work, and life / edited by Lizzie Borden.
Description: New York : Seven Stories Press, [2022] | Includes bibliographical references.
Identifiers: LCCN 2022009342 | ISBN 9781644212271 (trade paperback) | ISBN 9781644212288 (ebook)
Subjects: LCSH: Sex-oriented businesses--United States. | Stripteasers--United States--Case studies. | Prostitution--United States. | Sex--United States.
Classification: LCC HQ144 .W5438 2022 | DDC 306.70973--dc23/eng/20220404
LC record available at https://lccn.loc.gov/2022009342

Printed in the United States of America.

9 8 7 6 5 4 3 2 1

CONTENTS

PREFACE

Lizzie Borden

I n the late 1970s and early '80s in downtown New York, my friends and I hung out in funky bar/strip clubs like the Baby Doll and the Pussycat Lounge to watch our friend Cookie Mueller go-go dance. Cookie, the inimitable John Waters actress and writer, supported herself and her son largely on Social Security checks, an occasional film part, and columns for downtown magazines. Go-go dancing was just one more piece of the jigsaw puzzle of her survival.

I was a filmmaker at the time. Downtown—meaning anything below Twenty-Third Street—was where those of us seeking to escape traditional, often middle-class backgrounds came to make art. We were the first gentrifiers of raw, industrial loft spaces that had once housed turn-of-the-century sweatshops. In this scene, sex was everywhere: We saw nude performances by dancers and theater performers in galleries and art spaces. We took the subway to Times Square to sneak into "tip-and-touch" places. We'd seen all of Fellini, and we revered Sam Fuller's film *The Naked Kiss*. We scoffed at Vegas showgirls with their perfect, android's bodies. But despite the ubiquity of sex in the city's artistic and commercial life at the time, I'd always been mystified by what went on in the strip clubs that seemed to populate every street, male bastions advertised by neon signs. Who

were the strippers who worked in them? What were they expected to do? And what made them want to do it?

So, I was in awe of Cookie and the other downtown writers, painters, and musicians who performed at the clubs in their thrift-store costumes, platform shoes, layers of eyelashes, and tons of glitter, alongside plenty of working-class dancers from the outer boroughs. They were as far from Vegas showgirls or Fellini vixens as one could imagine. The ironic casualness with which they vamped to popular songs in their underwear, using a pole only to keep their balance, changed my concept of who strippers could be.

Their comfort eased my own leap into a world of paid sex.

I'd been working on a film for several years by then, editing eight hours a day and shooting whenever I had a few hundred dollars. At some point, I learned that a few of my closest artist friends worked for a madam in a small brothel. My best friend dared me to do it with her; she told me it could be a way to afford to keep my film going. This kind of working was like Cookie's go-going—nothing like the media stereotypes of street-based hookers or high-class call girls. Whatever our job, and whoever the client, we were riffraff, wearing what we could glean from our closets in order to meet the madam's requirements. ("Dress as if you've just had lunch with your in-laws and are on your way to meet your boyfriend.") We were solving our own jigsaw puzzles so we could make our art.

My way of justifying working at the brothel was to tell myself it was part of what I considered my "real work" of writing and directing, so I always went to work armed with a tape recorder. After a few months, I had enough material for a script—and had received a grant for the film I'd been working on—and I quit the brothel. My friends eventually

quit, too; we were privileged by our middle-class position to leave when we wished. Among us was a shared secret.

What we didn't share was the bravado of the go-go girls, onstage for everyone to see. On the street, when we encountered one another after years of being out of contact, we'd exchange cautious looks coded with reminders of our decades-long agreement: we wouldn't out one another about the brothel. Our camaraderie shrank under the suspicious pressure to deny the past, a pressure I now understand to be the result of our internalized societal whorephobia.

That term, *whorephobia*—which, back then, had yet to be coined—describes this shame perfectly.

<center>✳ ✳ ✳</center>

My feature film *Working Girls*, about a day in the life of a group of women working in a brothel, was released in 1986. My cover story—except to the sex workers I befriended—was that my film was about "a friend."

As part of the promotional campaign, I had the opportunity to meet even more incredibly dynamic women who worked in the sex industry when my producers and I assembled several panels featuring sex workers and activists for discussions after screenings. In San Francisco, I met Margo St. James, a founder of the group COYOTE (Call Out Your Old Tired Ethics), who advocated for the decriminalization of prostitution; Carol Leigh, the poet/writer/activist who coined the term *sex worker*; strippers from the pre-unionized female-centric strip club the Lusty Lady; and Susie Bright, cofounder and editor of the first woman-produced sex magazine, *On Our Backs*. In Los Angeles, I spoke with ex-cop turned sex worker and activist Norma Jean Almodovar, author of the bestselling book *Cop to Call Girl*. In New

York, I had the pleasure of interviewing writer and spokes-woman for PONY (Prostitutes Of New York) Tracy Quan; porn actor and educator Veronica Vera; pioneering porn film director Candida Royalle; and porn provocateur and artist Annie Sprinkle, whose cutting-edge performances included inserting a speculum to allow audience members to view her cervix. Later, I visited professional dominatrix ("prodomme") Terence Sellers's leather-walled dungeon.

All these encounters opened my eyes to the variety of jobs included in the world of sex work and the differing interests, desires, and needs of those who performed them. For example, escort Tracy Quan would never want to per-form on a stage, but some strippers I knew might cross the line into seeing a regular client privately. Activist and self-proclaimed "whore" Carol Leigh was out and loud, but prodomme Terence Sellers operated in ultra-coded secrecy. Even so, we were all united against the exclusionary politics of radical feminist antiporn activists like Andrea Dworkin and Catharine MacKinnon, both early SWERFs, or "sex worker–exclusionary radical feminists," who argued that sex work was inherently degrading and oppressive. We all supported the decriminalization of sex work.

While political organizing by sex workers was active and passionate before the advent of social media, much of it was localized. In San Francisco, unrelenting activism around the Lusty Lady resulted in its becoming the first strip club to be unionized. In New York City, organizing took place through zines, in the back pages of weeklies, and on Al Goldstein's cable show, *Midnight Blue*. Tracy Quan has written about how it shook things up for her when she became involved with PONY, stuffing envelopes at Annie Sprinkle's apartment.

After I moved to Los Angeles in 2001, I met Jill Morley,

who had come to LA to pitch a TV series based on stories she had written about her experiences go-go dancing in New York and New Jersey during the late eighties and early nineties. She also had a few stories by sister go-go dancers Debi Kelly Van Cleave, Susan Walsh, Terese Pampellonne, and Elissa Wald; and one by Cookie. The experiences relayed in these few stories could not have been more different. Debi Kelly Van Cleave and Terese Pampellonne both met their husbands in go-go clubs. But while Debi, a young, self-educated single mother, liked her customers and gained confidence onstage, Terese, a professional modern dancer, held the men in the go-go bars in disdain, refusing to give lap dances. Jill, more upbeat, used dancing as material for plays but hid her coke habit. Elissa Wald's memoir evokes a Times Square club and its denizens with affection; Susan Walsh, a part-time reporter for the *Village Voice*, despised dancing; her dark stories grapple with existential questions. Susan disappeared in 1996 and is presumed murdered, her vanishing still under investigation. Cookie Mueller, too, died prematurely, in 1989, of HIV/AIDS.

These stories revealed their authors' erotic imaginations, fears, desires. Dancing colored much of what they did, thought, and felt inside and outside the club. I asked Jill if I could publish the stories, and they became the foundation for this anthology.

At first, I wanted the book to remain within the time frame of the 1980s and '90s in New York and New Jersey. It was an exciting time, before New York City mayor Rudolph Giuliani erased the character of Times Square by closing porn theaters and peep shows. Susan Walsh—and, as I discovered later, Kathy Acker—performed in live sex shows there. Downtown, artists like Joan Jonas, Carolee Schneemann, Hannah Wilke, Ana Mendieta, and Karen

Finley used their own naked bodies in controversial, sexual works. Annie Sprinkle ruptured the boundaries between art and porn when she performed on downtown stages. I discovered later that writer Chris Kraus (*I Love Dick* and *After Kathy Acker*) also stripped during this time, as did the late novelist and slam poet Maggie Estep and the iconic ex-stripper/burlesque performer Jo Weldon.

Yet, strangely, I couldn't find enough stories about stripping in this milieu to fill an entire anthology, although there were many about burlesque. Several writers did both. But burlesque is entirely theatrical, while stripping is transactional, creating gray areas often difficult to negotiate. Stripping itself wasn't a uniform experience—sometimes dancers worked behind a barrier, as in peep shows; sometimes contact with customers led to full-service sex work. I considered adding stories about other kinds of sex work, but these jobs likewise seemed too different from stripping. Being a domme or an escort—operating one-on-one rather than in a group—can be very isolating, as can the more recent work of camming and "sugar dating"—young people seeking arrangements with older "patrons." By contrast, every story I read about stripping involved, at least in part, relationships with other dancers in the club. I thought of a remark from Tracy Quan about how political organizing changed her view of her work:

> *I met people who worked in peep shows, in different kinds of brothels and dance clubs, on the street, in the domme sector. There were phone sex workers at our meets. I also had the chance to meet guys who sell sex. I loved having contact with people outside my scene and I developed this feeling that we're like a nation, with provinces and constituencies, but still a nation of sex workers.*

<center>* * *</center>

Despite the challenge of finding them, I decided to stick to stripping stories only for this book.

When I met Jill Morley at the turn of the millennium, except for Lily Burana's landmark 2001 memoir *Strip City*, a recounting of Burana's affectionate farewell to stripping, published writing about stripping consisted mostly of memoirs primarily intended to be, as Jo Weldon has described them, "redemptive narratives." But there soon appeared a new kind of writing about stripping, in the form of stripper blogs. Many blogs seemed to be journals and/or advice columns, "dos and don'ts" for wannabe strippers; some discussed the best song sets to play for dancing, or the best stage lighting, or how to handle bad customers. The responses to these posts from fellow strippers revealed an immense desire for communication and community, and as the internet expanded, more such sites appeared. Distinct voices began to emerge, credited to intriguing names like #Sassylapdancer, Mounting&Counting, #survivetheclub, and DiaryOfAnAngryStripper. Tits and Sass, a website that published writings by workers from every branch of the sex industry, became a lively forum.

One of the most influential strippers who became prominent in this period was Jacq Frances, aka Jacq the Stripper, who was also a writer, stand-up comedian, and cartoonist. (She is now retired from stripping.) I met Jacq after she published her first book, *The Beaver Show*. She became a star with the publication of her second book, *Striptastic!*, a collection of cartoons about stripping, which she wrote and drew after interviewing hundreds of other strippers. From this work, she created her business brand and began to conduct workshops around the country, selling stripper

"merch" that led to her apparel line, Strippers Forever. Now she is developing a TV series.

Lindsay Byron (aka Lux ATL), based in Atlanta, stopped dancing in 2016 and now likewise conducts empowerment workshops and retreats for women.

Overseas, Sassy Penny, now a lawyer, was one of the founding members of the East London Strippers Collective, which created fund-raising events in which strippers modeled for life-drawing classes.

Antonia Crane, who authored the introduction to this book, has been stripping and writing about stripping for more than two decades. While her stories explore, among other things, aging and disappointment in relationships, she uses her powerful voice in print and social media to rally strippers in her organization, Strippers United (formerly Soldiers of Pole). Formed after the 2018 passage of FOSTA-SESTA—legislation ostensibly designed to stop sex trafficking but that, in fact, deprives sex workers of means of advertising on the internet through sites like Backpage and Craigslist, thereby forcing many onto the streets and subjecting them to arrest by the FBI—Strippers United protests against wage theft and other problems affecting sex workers and rallies for the decriminalization of the profession. Crane rages at marches and strikes, but her writing is laced with self-deprecating humor, wonder, and tenderness.

For the Incredible, Edible Akynos, founder of the Black Sex Workers Collective in New York City, the pull toward activism was fueled by the pervasive racism in strip clubs. While she ultimately quit stripping because of anti-Black hiring and firing practices, her lush writing lays bare the soul of a romantic with a sly sense of humor and great empathy for her clients.

AM Davies's activism has been similarly unflagging, although she was recently forced to stop dancing due to an unthinkable accident, which she recounts here in her devastating piece.

Like Akynos, Selena the Stripper, a Black and Latine nonbinary sex worker, stripper, podcaster, and writer who is now president of Strippers United, seeks to empower sex workers of all races and genders through political organizing.

Meanwhile, Kayla Tange performs an Asian identity in the clubs, but she reclaims her power by creating performance artworks that purposely confound the audience with their own stereotypes.

All their stories reveal the seeming contradictions that can coexist in this line of work. Although New York stripper, burlesque dancer, and activist Essence Revealed chronicles depression in her essay for this collection—a condition likewise caused by the degradations of anti-Blackness in the business—she's equally honest about the perks of the job and the skills it has taught her, which she now uses to conduct online empowerment workshops.

While some strip clubs are notoriously dangerous, turning a blind eye to harassment and even rape, Reese Piper, who is on the autism spectrum, finds strip clubs safer for her than many other places because of their strict rules governing interaction between customers and dancers.

＊ ＊ ＊

Social media connections now provide a support system for strippers that wasn't feasible a mere fifteen years ago. Many strippers now know one another online, if not always in real life, and support one another through lonely nights

in clubs with no customers, fights with mean girls, family problems, romantic problems, legal problems, and the economic, safety, and health issues they have all confronted throughout the Covid-19 pandemic. In this book, I've tried to convey some of this sense of community by having some of the dancers interview each other. Jill Morley interviews Jacq Frances, Lindsay Byron, and Jo Weldon. Antonia Crane chose to be interviewed by Dr. Vanessa Carlisle, a scholar and professional domme. Chris Kraus was interviewed by Alison J Carr, a British academic and performance artist; Carr also interviews Sassy Penny, with whom she has worked in London. This is more than a village: it is a bustling, global community.

At the same time that it has brought them together, the internet has also made sex workers of all kinds more visible to the general public—not just their professional personas but also their personal lives. Yet, whether sex workers are being lauded by observers who claim to support them while declining to fight for their rights or being condemned by those who vilify all sex work, the habitual othering of sex workers persists, allowing those who have never done the job to maintain an imagined boundary between themselves and these ostensibly enigmatic, problematic figures. After Akynos addressed Antonia's writing class at UCLA, Antonia asked about her goals for the Black Sex Workers Collective. Akynos invoked Jacq Frances:

> *Jacq has campaigns where she makes fun of the straitlaced job versus the stripper that's changing the conversation on how we look at work, at sex workers. And we want to do something like that, where we're making comparisons to the Hollywood casting couch, to what sex workers might go through in a strip club,*

because I feel like the conversation of what sex work is and who we really are needs to shift. A lot of conversation about sex workers makes me uneasy because I feel like we're talking about us as as if we're aliens. I just don't want to hear a conversation like, "Let's find out who sex workers are." I want to ignore that and just talk about us like we're regular, because we are regular. So instead of, "Let's sit down with the sex workers and find out what their life is like," it's like, "I'm right in the grocery store line with you, boo; you just need to stop it."

For some writers in this collection, stripping was an early aspiration. For Jo Weldon, it was a romantic ideal inspired by performers she admired in movies. For Susan McMullen, it was a joyful escape from the Canadian provinces with her best friend, Lindalee Tracey, of *Not a Love Story*. Jodi Sh. Doff ran away from a middle-class Long Island home with the intention of finding a pimp in Times Square; Akynos grew up near *Playboy*'s New York City office yearning to be a porn centerfold. But for many other contributors, including the go-go dancers whose stories originally inspired this book, stripping was and continues to be their only viable economic option for supporting other pursuits. One reason is the widespread stagnation of educational and job opportunities, especially for writers and artists, in the decades since Cookie Mueller danced. Like her, dancers today piece together their lives, stripping to augment teaching jobs and acting gigs and freelance work and grad school stipends while raising kids and caring for elders and trying to change the world. Postpandemic, their employment prospects have only worsened.

Whereas most of the contributors to this anthology who worked in the seventies or eighties danced for only

a few years before moving on, these days, stripping is a lifestyle choice and a career for many. Some strippers now have over twenty or thirty years in the business. But although the empowerment narratives that have emerged in tandem with strippers' increased visibility and their work's longevity—embodied in performances by pop artists like Cardi B, music videos, "twerking" in thousands of self-posted videos on social media, films like *Hustlers* and *Zola*, TV series like *P-Valley*, and the popular embrace of pole dancing as a sport—may suggest acceptance, strippers today still face overwhelming stigma and whorephobia, in addition to other challenges. The stigma reaches back in time—two writers who danced briefly in the eighties and whose writing had been in this collection for years dropped out of this project because they were concerned about the negative impact it could have on their current careers. And labor conditions for dancers working today are worse than ever. Activists are trying to change media portrayals of their work and, along with these, the actual working conditions in clubs. When she is interviewed for TV, Antonia Crane demands that a sex worker be present on the production team, a request that frequently raises eyebrows. She and others have also called for hiring sex workers for meaningful paying jobs, as opposed to sometimes decorative "consultant" credits, on TV shows and films that portray sex worker characters. Crane is acutely aware of the darker realities behind the empowerment narratives. As she remarks in her interview with Dr. Vanessa Carlisle:

I find myself hungry for a less celebratory experience. Where's the melancholy stripper who's a woman of color, who's queer, who gets turned away from her strip club because they have too many Black girls? Show me

the story of the melancholic Black stripper. Show me the human, sad issues.

Much has been written about strippers and sex workers by civilians, including feminist academics who, despite never having walked in their platform stilettos, feel entitled to argue for or against social and political programs that could have devastating effects on the lives of the sex workers they're writing about. Watching strippers from the sidelines, I, like many observers, have been dazzled by their extraordinary confidence, enamored of their brave nakedness and sense of play. I wish I could catch it and internalize it by proxy.

For want of such an ability, I have instead gathered together the essays that make up this anthology. These stories, by strippers themselves, are glimpses into their lives of camaraderie and celebration, joy, pride, despair, frustration, self-doubt, and fear—lives that are complicated, contradictory, and bold.

STRIPPER ARCHIVE

Antonia Crane

> "You live through that little piece of time that is
> yours, but that piece of time is not only your own life,
> it is the summing-up of all the other lives that are
> simultaneous with yours. It is, in other words, History,
> and what you are is an expression of History."
>
> —ROBERT PENN WARREN

I stripped in nude clubs before I could legally drink. It was the early nineties, in San Francisco, and my friends were unkept, chain-smoking queer punks who wore beat-to-shit ripped slips that looked like they were stolen from some grandma's dumpster. I wasn't *chic* grunge like Courtney Love, who stripped on Hollywood Boulevard at Jumbo's Clown room back then. I was broke. I was undone. I worked at a used clothing store on Haight Street for minimum wage, which, in 1992, was $4.25 an hour. I spent my lunch break selling T-shirts I found in trash piles on put-out night, hoping to make enough for a burrito next door. If I lucked out, I scored a burrito *and* bus fare. When I couldn't afford bus fare, I walked straight to the Century, a grubby

nude club where drugs were plentiful and twenty-dollar bills were rare.

Some of the strippers at the Century gave grand performances, with boas and whips and choreographed moves like in *Fame*. I merely darted to the dressing room before my stage set to put on something I could take off. The dressing room was down many narrow steps and through a low door, a smoker's basement with a dirt floor that we called "the Crypt." Luscious, Micky, Destiny, and I ashed our cigarettes on loose planks of wood. I was addicted to meth, but heroin was big then. My coworkers slid in the dark theater from lap to lap, or nodded off, or went to law school.

The Century was where I fell for stripping. Stripping is a hard, taxing job. It entails waiting, hustling, and negotiating personal physical boundaries in a place where strangers assume access to your body. As an art form, stripping is joyful, magical, and adrenaline-inducing. But it was also emotionally and politically confusing. Stripping contained that tension for me and has held me in its grip for twenty-nine years.

On the one hand, stripping was a public-facing revolt against demure femininity and heterosexual norms. Monetizing straight desire and performing as patriarchy's plaything was fun and lucrative; lap dancing was fast money earned in the dark. At the time, feminist performance artists like Karen Finley, Laurie Anderson, Diamanda Galás, and Lydia Lunch challenged second-wave feminist ideals by performing desire and rage as a poetic disruption. They used their bodies as a site of protest against sexual shame, misogyny, and homophobia.

Stripping felt powerful back then, but not every second was an empowering feminist orgy. The job was not something I advertised to my friends or family. Deeply

puritanical ideas about sex and class informed our cultural lives and affected dancers' feminist visions of ourselves as deviants, artists, or societal failures. Among my peers, my life as a queer stripper was considered sleazy, even if it was rebellious. Dykes I dated were skeptical or downright disapproving of the sex industry, and they let me know it. Deep down, they believed the patriarchal party line that sex work was intrinsically wrong, even if they refused to admit it. One of my girlfriends threatened to break up with me if I continued full-contact lap dancing; she preferred my tenure in the live peep show behind glass at the Lusty Lady. She followed through with that promise eventually—but not before I joined a group of startlingly intelligent live nude girls who began unionizing the Lusty Lady in 1996 and eventually became the Exotic Dancers' Alliance.

Stripping is a working-class grind.

Over the next decade, my customers became regulars, which turned me into a professional stripper who had the audacity to keep a schedule. I stripped on holidays, on weekends, and during sports events. I squirreled away cash in envelopes under my bed. My lust for financial security and love for travel led to many road strips on the search for gold mines; I stripped in Las Vegas, Hawaii, and New Orleans with only the tips and tricks of other stripper friends to guide me. This was five years before Facebook and nine years before the creation of the iPhone, which granted every sex worker the ability to screen a client in the palm of their hand.

I learned everything I know about where and how to strip by talking to seasoned strippers I befriended on the job. Strippers know where to find the money clubs and which shifts are the best ones there. They know how the fees and fines work and which managers to avoid. They

know which clients to talk to and who is a time waster. I highly recommend talking to veterans in person, at work, about what they've learned. They are a part of my history, just as I am a part of yours.

Not only did we not text back then, but we also communicated without apps, websites, email, or the terminology strippers now use to accurately discuss the complexity of client relationships that progress outside the strip club. The fact was that I simply trusted certain clients to take me shopping or out to dinner. I indulged some of my clients in their fantasy that I was their girlfriend, their human vacation. And I charged as much as I could while maintaining a straight face.

When I moved to Los Angeles in 2004, I searched the vast whorescape that is the San Fernando Valley and Hollywood for a strip club to call my home—to no avail. Clubs in Los Angeles County were miserable, empty places with no use for a chubby, tattooed thirty-four-year-old with a women's studies degree from Mills College. I did strip briefly at Cheetahs, Pleasures, Knockouts, and Nicholas, but the hustle baffled me; Los Angeles clients were cheap, unreliable, and awful. Unlike in San Francisco or New Orleans, where strippers are culturally relevant VIPs, Los Angeles treats non-famous strippers like the least favorite gum grabbed on the way out of the gas station. Perhaps this is due to the cultural prevalence of the porn industry that dominates the field here, rendering strippers an afterthought.

That same year, my mother was diagnosed with aggressive bile duct cancer. I was panicked and stressed, untethered by her illness. I constantly drove back and forth from LA to where my mother was hospitalized in my hometown. I switched from stripping to other types of sex work that required less of me, timewise and commitment-wise,

where I could snatch as much cash as possible and still answer my phone in case my mother called.

Stripping outside the club entailed risks that were hard to anticipate, like depending on strangers to pay when they say they will and having no security whatsoever from violence. One night I stripped as "Ginger" at a *Gilligan's Island*–themed fortieth birthday party. Shit-faced party guests grabbed my friend, a petite, impeccable "Maryanne," and threw her in the pool, despite her frantic, screaming pleas that she couldn't swim. I jumped in the pool after her, carried her out fully clothed, and scolded the organizer. I told them the least they could do was pay for her lost contact lenses and vintage clothing. A woman wrote me a check, and we left. But what if my friend had drowned? I had assumed the gig would be an easy one-off. No one knew where I was that night.

The next day, the check was canceled.

❋ ❋ ❋

In 2007, at the age of sixty-two, my mother died. That same week, I attended my first class in an MFA program she had encouraged me to apply to before her illness. "Get that degree," she said. I was heartbroken, and I was alone, but I got my MFA.

Around this time, the club in Pasadena where I stripped shut down. I was out of options and broke as fuck. My friend Kara told me about her lucrative "massage" hustle. She showed me how to put up photos and ads on sites like Backpage and Eros and—lickety-split—I was a hand job whore. At first, we mostly saw her regulars, like CJ, a chipper guy in his sixties. He'd eat her pussy while I jerked him off, and he always said the same shit: "What exemplary

customer service." Eventually, he gave Kara trichomoniasis. I had to convince her to get tested, which was not easy, because she believed she was in a constant state of orgasm—sex cult stuff she said she learned from OneTaste, an orgasmic meditation retreat up in San Raphael. It was also not easy to tell my ex, whom I was still fucking, that we had been exposed to trich. Soon after that incident, I saw CJ at Trader Joe's piling lunch meat into a shopping cart. "Hey, CJ," I said, before I could catch myself or think twice.

Kara had faith in her ability to stack cash safely. I did not, but I didn't care. Blind faith, dumb luck, good timing, and magical thinking are markers of the sex trade. Similar to gamblers or stand-up comics, sometimes we lucked out. Sometimes we were on fire, sometimes we tanked. Unlike gamblers or stand-up comics, though, sometimes we got arrested. Sometimes we got STIs from our coworkers. Sometimes we got robbed or thrown in a pool. Sometimes we went missing. Sometimes we were murdered.

Class shame and whorephobia are rampant in our culture. Institutions, banks, and media platforms are denied to sex workers as punishment for trying to survive late capitalism in resourceful, clever ways. Sex workers and strippers themselves are not immune to whorephobia, in the same way that Black folks are not immune to anti-Black racism. I want to communicate the specific ethos of the deeply abusive landscape of strip clubs in order to unlearn it and to stop it.

Some commonalities in every strip club that I've witnessed and/or have experienced directly: the business model of theft, wage theft, specifically; tip stealing; the acute lack of safety from violence inside the club; racism; anti-trans antagonism; whorephobia; anti-worker hostility; extortion; coercion; the negligence of any bookkeeping by

employers; sexual assault; blame casting; misclassification; drugging of workers, unfair termination; racist hiring and firing policies; and harassment. Nothing bristles against whorephobia and class shame like a bunch of fierce strippers unionizing a strip club and then becoming a union collective. The tide changed in 1996, but the labor war has dragged on since we won that battle.

I haven't stripped inside a club since 2020; I've stepped away due to Covid-19 and the fact that I'm in a PhD program for literature that fills my time and pays me to show up. Clients and friends sometimes ask if I've retired, as if I long to quit the one job that has supported my life for nearly thirty years.

I miss stripping. Not just pole tricks and sliding from lap to lap, but being good at a thing and getting paid well to do it. Watching dancers twirl and fly on the pole like muscular ribbons. Ripping on clients and talking shit. Making money hand over fist, mid-shift. Counting dances and money under my breath while strippers pull customers from their chairs with a yank. Locking eyes with other dancers while they grind and guessing how long they will last on certain laps. I miss the grubby red theater chairs with gum residue, the zigzag carpet. I don't miss the migraines, the wage theft, or the tired two-hour drive home.

Since April 30, 2018, I've been trying to organize strippers, sex workers, and allies from California to New Zealand to fight for safer and more humane working conditions. I will continue to fight for this cause because I answer to my community. My coworkers over the past twenty-nine years are a collection of intersectional, dynamic people, and my life is better for knowing them and their stories.

I was still in high school when my friend and mentor Lizzie Borden premiered *Working Girls*, a fictional film that

shows the complex relational field sex workers navigate while also exploring class differences and queer relationships within the industry. When I met Lizzie, in 2015, she mentioned an anthology of memoir pieces she was collecting that centered on strippers. I was delighted that she chose strippers as the group to focus on, because strippers are usually depicted as mere background, as invalids awaiting rescue, or as sociopaths. I think the best stories and films are ones where strippers/sex workers try to do right by one another, which has not happened much since *Pretty Woman*.

The essays and interviews Lizzie Borden has curated and collected here were written with a burning desire to share honestly about the landscape of stripping, the camaraderie and artfulness, without delighting in our demise; to celebrate our small and large triumphs, our rage, our sadness, our hope, and our love for stripping. We are living in the truth of our shared experiences together as strippers. We share that truth, and so we share our stories here. When we share our stories, we build our collective archive. When we share our collective history, we articulate our presence. And when we articulate and assert our presence, we can attempt to change our lives for the better and change the future we create. This is my history, which is part of yours. This is our history.

GO-GOING—NEW YORK & NEW JERSEY, 1978-79

Cookie Mueller

In the beginning I just couldn't bring myself to do floor work. Bumping and grinding while lying on the floor looked completely ludicrous to me.

I would have made more tips if I had; the girls who did floor work always had stacks of one-dollar bills in their G-strings. They wore the money like a tiny green fringe tutu flapping around their hips.

Those girls brought their own personal floor mats onstage with them for their half-hour sets. They'd just unroll their fake fur bathroom rugs on the stage floor and lie down and start undulating.

It seemed so inane ... convulsing there on a dirty Dynel shag pad on a "stage," which was usually nothing but a flimsy fly-by-night platform the size of a dinner table, while stone-faced male loners sat in a circle around it, clutching their overpriced drinks, watching intently this twitching female flesh parcel.

No, that wasn't for me. I just danced. On two feet.

I had decided to topless go-go dance when I first moved to New York from Provincetown. It wasn't something I especially wanted on my résumé, but I had been casting around, looking for work ... something to pay the bills

while I was making a start at designing clothes, searching film parts, and writing. I was down to thirty-seven dollars. That kind of money doesn't go far in New York, especially when you have a kid.

I'd tried waitressing when I was sixteen and found out fast it wasn't my calling in life. I always screwed up. People were always bitching about the missing side orders. I spilled everything, had a lot of walk-outs. It's a horrible job, demanding, demeaning. I started hating people. I wound up throwing food.

I'd worked in offices when I was eighteen, and that always turned into a fiasco; anyway, the pay was so low and it took all day, five days a week. I needed some kind of job that didn't have such long hours and paid really well.

A go-go friend suggested dancing. She gave me her agent's name. I got the job.

The agent was straight out of a cheesy '50s gangster B-movie, second-generation Italian, the good-looking-twenty-years-ago type, flare-collared polyester Nik-Nik shirt, pasta belly, lots of big rings on the pinkies.

He sat in a greasy office filled with cigar smoke, pictures of broads on the walls, the telephone ringing.

Every Monday the place was packed with girls getting the next week's bookings and picking up their checks. He called everybody sweetheart or honey. He was close: all the girls had phony names like Jujubee, ChiChi, CoCo, Sugarplum, Dumpling, BonBon, Sweetie Pie.

Most topless bars in the city had eight-hour work shifts, noon to eight or eight to four a.m. The bars in New Jersey had five-hour shifts.

I liked working in Jersey more, where topless was against the law; the dancers had to wear a little something on top. That eliminated my stretch marks and sag problem that

came with the pregnancy and breast-feeding package. It was less sleazy in Jersey; the bars were local hangouts for regulars; the customers didn't feel like they were getting ripped off, because drinks were cheap. Dancers made more money in Jersey anyway, and there, no one would ever recognize me from John Waters movies, not that they did in Manhattan go-go bars, but I always had this horror. People in Jersey didn't go to those kinds of movies.

Actually, it wasn't a horrible job, when I thought about it. I was just there exercising and getting paid for it. I was never in better shape: tight buns, strong legs, flat stomach. Working in Jersey, I began to wonder why every woman didn't want to go-go.

But then, every time I worked in a bar in Manhattan, I discovered why all over again.

Manhattan go-go bars are really sleazy. The owners sometimes want you to go in the back rooms to do hand jobs on the creeps. They made customers buy outrageously priced little bottles of champagne; some managers demanded that you "flash" (show your puss) when they knew you could get busted for that.

Of course, right over on the next block a guy could walk into a strip joint and get a bird's-eye view deep into the internal structure of a vagina for a dollar; in fact, he could stick his nose right in if he wanted, but in topless places, because they served liquor, nothing like this was supposed to go on.

I was working the day shift at the Pretty Purple Pussy Cat, doing my half an hour on, half an hour off. I was working the same half hour as Taffy, on stages facing each other. The other two girls, Marshmallow and Lollipop, went on after us. With those names, the place could have been a candy store.

Taffy was wallowing on her bathroom rug, with all the customers at her stage, ogling. She had piles of bills tucked in everywhere, mostly ones, but when somebody wanted her to flash, she'd do it for a five.

I was on the other stage, knocking myself out doing flips, splits, high kicks, triple spot turns, with nobody watching me, thinking that somebody with respect for a real dancer would soon toss me some fifty-dollar bills. Nobody did.

I watched Taffy. She was lying there pumping her hips and looking right into the eyes of the men. She was turning them on, obviously.

I was exhausted. I'd been up since seven thirty getting Max to school; then I had this early interview at Macy's to show some buyer a couple of silk blouses I'd designed. After that, I'd gone for a cold reading for some low-budget independent cable TV movie.

All I wanted to do was lie down.

When the half hour was over, I put my little mini-dress over the pink sequined G-string and got off the stage. In Manhattan the dancers are required to hustle drinks from the customers . . . or at least try. Nobody was buying drinks for me, but Taffy called me over to sit next to her and a customer.

"Buy her a drink," Taffy told the guy, and he ordered me a vodka soda.

Taffy pulled her chair next to mine. "Sweetheart, I've been watching you bust your ass over there, and you ought to give it a rest, girl. You ain't making no tips. Look here," she looked down at her G-string, "I got a mess of money here," she flipped through the bills hanging on her hips, "and I got more in my pockets here." She put her hands in her mini-dress pockets and pulled out handfuls of ones and fives, even a lot of tens and twenties. "And I didn't make this working too hard."

"For some reason," I told her, "I just can't bring myself to lie down up there. It looks so stupid . . . I mean, you don't look stupid, the idea is so stupid."

"I know just what you mean," she said. "I used to feel the same way when I started working these bars, but you get over it." She lit a cigarette and put her Revlon Cherries in the Snow lips to my ear. "Look," she whispered, "these guys just want to look at something they can fantasize about. They like to feel horny; it makes them happy."

"I think I'd feel like an asshole," I said.

"Oh shit, forget it. You want to make money or not? Just try it next set. Lie there and look right into their eyes. Remember to do that part, otherwise it doesn't work. You have to make it personal."

The next set, I took my scarf onstage with me and I laid it on the floor. Nobody would want to lie on the slimy platform without something under them.

Feeling dumb, I got on the scarf and put my head back and looked at the ceiling while I did some sort of cold Jane Fonda–type floor workouts. There was a customer sitting there in front of me, but he didn't look very interested.

"That ain't it," Taffy yelled to me from across the room. She pointed at her eyes.

So, I made myself look into this guy's eyes. It worked immediately. He started peeling off the ones and handing them to me. This made me start putting some sex into the workout. I undulated all over the place, just like an eel in heat.

Other customers started moving over to my stage, looking for something hot, I guess. They loved it hot. By the end of the set, I had twenty or thirty dollars, and it was so easy on the heel bunions and the toe corns, so relaxing for the calf muscles. Wow! What a job!

"I should'nta told you nothin'," Taffy said. "You took all my paying customers."

So, I had graduated. Every working day, I'd dance the first half of the set, and when I got tired, I'd just lie down and stare into eyes and pump the hips, do leg lifts, things like that.

I worked this job for a year or so, two or three days a week, saved some money. I worked in Jersey mostly, taking the Path train to Newark and then taking a cab. There weren't too many problems except for having too much to drink during the day. It would be an ideal job for an alcoholic, I often thought.

One day, I was working in a Manhattan bar where sometimes the owner would try to act like a pimp. I hated working there, but it was the only place the agent had left on a Wednesday, since I forgot to see him on Monday, booking day.

I was doing floor work in front of a customer, and he was handing me dollars. He asked me to sit and drink with him when I came off the stage. So, I did.

He was a young guy from Brooklyn, a blond meathead who wasn't unlike all the other meatheads who hung around go-go bars every day. He was buying vodkas, and he was getting drunk, and I was getting drunk. He was telling me his life, his astrological sign, the standard rap.

"Ya read about dem tree peoples killed in Brooklyn yesterday?" he asked. "Was inna *Post* and da *News*. Sawr it onna tube too, late-night news."

"Yeah, I saw it. Terrible," I said. I had seen it. Pretty grisly it was, too. Torsos in green garbage bags, with treasure hunt notes leading to the heads, which were in black garbage bags.

"I did dat," he said, and smiled. "I killed dem. Cut 'em up. Waddn't too easy eitha."

I turned and looked at him very closely. He was proudly smiling, but he looked really serious, although he didn't look like a killer, except maybe for his eyes ... but then, I don't know if I'd ever looked in the eyes of a killer before.

"You didn't do that." I laughed.

"Oh yeah, I did. It kinda bodda me a lill, but dey was assholes. Ya don know. When dey died der was no human lives lost. Dey was animals. Deserved it. Fugging animals." He looked into his sixth vodka and drained it.

When he started to cry, I half-believed his story.

What could I say? Could I say something like "Oh, don't feel so bad. Tomorrow's another day. Forget all about these heads and bodies. You're just depressed." That wasn't really appropriate under the circumstances.

"Ya know, I have dis gun, heer, in ma coat." He looked around to see if anybody was watching, then withdrew it quickly and showed it to me.

I was beginning to believe him.

"I have dis index finga too, from one-a dem animal." He pulled out a plastic Ziploc bag with a human finger in it. The blood was caked around the stump. He put it away fast.

I think I just sat there staring at his pocket for a while.

"Well ..." I just didn't know what to say. What could I say? What would be the right thing to say when something like this happens? Maybe I could say, "Oh. Isn't that interesting looking!"

I thought that maybe I should say something to the bouncer though, but this guy would figure it out if I told him I was going to the bathroom and, instead, started whispering to the tough guy in the corner. He might go on some wild shooting spree. No, I couldn't say anything. I just drank the rest of my vodka and tried not to stare at him aghast.

The other dancer, Pepper, got off the stage, and it was my turn.

"I need to talk ta ya sommoor," he said. "Comon back afta. I'll be real pissed if ya don't."

I certainly didn't want to piss him off.

"Don't worry, I'll be right here in front of you, and I'll sit with you again after my set," I said, and he smiled.

If I hadn't been slightly drunk, I think I might not have been able to dance, maybe not even able to undulate on the floor. Considering the circumstances, I was very nonchalant, but I decided not to do any floor work in front of him now. I didn't want to get this guy aroused or anything. I just stepped around on the stage while he smiled at me.

Pepper started to sit down with him to ask him for the drink.

"Gedda fug outta heer." He pushed her away. Then he felt bad. "Hey, look, girlie, I'm sorry, ba I'm savin' my dough fa dis chick heer." He pointed to me. "I like er."

Great. Just great, I thought.

While I was dancing and trying to smile at him, thinking about garbage bags and heads, a bunch of men came in the bar talking to each other. One of the guys stopped to look at me, and he handed me a fifty-dollar bill.

"Come have a drink with me after your set," he said and winked. Then he walked to the end of the bar and sat down with his buddies. They were all talking to the owner and looking at the girls, nodding and laughing.

The gesture wasn't unusual, but the fifty was.

I loved the fifty, but the killer didn't.

"Ya ain't gonna sit wit im. Are ya?"

"No. Never."

"Yall havta give im bak dat fifty." He looked over at the guys.

"Yeah," I said. "I was going to do that anyway."

Then the bar owner, one of those Grade-D bad eggs, walked over to me and whispered in my ear: "This group of guys back there are friends of mine. They want to party with you, Venus, and Fever. In the back room. Go there after the set. They got lots of money. We can both make a little."

He walked off before I could tell him I wasn't interested. First of all, I didn't go to back rooms, and then of course there was this angry young man sitting here . . .

He was getting angrier by the minute. He'd heard what the owner asked me to do, so he kept looking at the guy who gave me the fifty. He clenched his fists, ground his teeth, bit his lip. His face was getting all red. There was going to be trouble.

What could I do? Getting shot or beheaded wasn't the way I had planned to go out. I didn't have many options: (1) I could sit the rest of the evening with the killer, but at closing time, he'd probably follow me home; (2) I could maybe call the police, but the killer might see me at the phone, get paranoid, and shoot me; (3) I could go to the bathroom and climb out the window, if only the bathroom had a window; and (4) I could quit the job and walk out while the killer was in the bathroom, but he looked like he had a good bladder.

"Hey, ya name again?" the Brooklyn Butcher yelled up at me over the music.

I told him.

"Dat ain't ya reel name." He sneered. "Tell me ya reel name."

"That is my real name."

"It ain't," he barked.

"Okay," I said. "You're right. My real name is Charlene Moore." Any name would do. The kid swallowed his next vodka and started on another one, then another. His eyes

were very green, and the whites were very red after those twelve vodkas.

"I'm gonna tell dat fugging asshole bak dere dat ya sittin wit me afta ya dance." He got up and stumbled to the back of the room. I froze.

When he got there, he started poking his finger at this fifty-dollar guy. The guy stood there taking all this abuse, and then he just hit the kid killer in the face, really hard. The kid butcher fell on the floor, and his gun fell out of his pocket and slid across the carpet and disappeared under a huge, stationary space heater radiator thing.

He saw it when it slid, and they saw it, and everybody pounced on the space heater and started wailing in pain because the heater was so hot.

Then the kid just scrambled for the door and left the bar, fast.

The bouncer and the owner let him run. They all started bending around the heater, but they couldn't find the gun because, first of all, the bar was so dark and the heater was so wide and hot.

Finally, somebody got a broom and pushed it out.

I got off the stage and walked up to them while they were all huddled around the gun. I told them all about the kid, the whole story. Nobody believed me.

The owner took the gun and disappeared into his office; the rest of the guys just started drinking again; the girls started dancing again, so I went back to the stage.

All the party boys forgot about their party even before I finished my set. They left, all fired up, talking about how "they were going to find that little motherfucker."

I made a phone call to the police. I described the kid, told them everything he told me about himself. They weren't too interested until I told them about the finger. I didn't

mention the bar or the gun, I just said I met this kid in some restaurant. I told them my name was Charlene Moore. They thanked me and hung up.

That was the last day I worked as a go-go dancer; I never wanted to see any of those sleazy joints again. I didn't want to writhe on another floor in my life. I didn't want to be forced to talk to any more creepy dummies in dark, smelly dives; I was perfectly capable of finding creepy dummies on my own time. I didn't want to be in the same room with murderers or birdbrains or desperate people anymore.

After all, I'd made my first fifty-dollar bill that day. Not a bad way to finish up.

When I got home, I hung up my pink sequined G-string, and there it hangs to this day, gathering dust. It still sparkles just a little when the sun hits it.

INTERVIEW WITH LINDA YABLONSKY
ABOUT COOKIE MUELLER

Linda Yablonsky is the author of *The Story of Junk: A Novel*, as well as an art critic and journalist for more than twenty-five years; her byline has appeared in the *New York Times*, *Bloomberg News*, *Artforum*, and *W*, among many other publications. As a MacDowell fellow in 2019, she worked on a book about Jeff Koons for publication by Henry Holt and Company. The character Honey in *The Story of Junk* is based on Cookie Mueller, a close friend.

Honey was another would-be writer and sometime actress, mother to an eight-year-old named Mike. She knew Jayne Mansfield's life story by heart and never went anywhere without eyeliner. She worried about

her looks, which only fascinated me; a toss of White Minx–tinted hair over blue-flame eyes that winked at the world; whore-pink painted lips under a Teutonic nose that snubbed it.

LIZZIE BORDEN: Honey Cook, from your novel, *The Story of Junk*, is an undisguised portrait of Cookie Mueller. When did you first meet her?

LINDA YABLONSKY: I first saw Cookie in 1973, at a party after the premiere of John Waters's film *Pink Flamingo*, but we didn't become friends until 1976 or '77, after she moved from Provincetown to New York with her son, Max, and her partner, Sharon Niesp, a blues singer who also acted in John Waters's films. Our apartments were nearby, and we saw each other often.

LB: At what point did Cookie go-go dance?

LY: About the same time she moved to New York. She was subsidized by government payments from SSI [Supplemental Security Income], but it just covered the rent. She took a couple of dance classes a week, and one of the women there introduced her to go-go. She worked at the Metro, the Baby Doll Lounge in what became Tribeca, and a couple of other places. There wasn't any shame in it, and as she says in her story—and her character says in my novel—it was great exercise.

LB: Why was Cookie getting SSI?

LY: Cookie was unemployable. She could never hold down a regular job. One of her stories is about having a nervous

breakdown when she was in San Francisco. Cookie had a unique aesthetic. She decorated her apartment the same way she did herself up, with no money at all. She was always having big parties. Her apartment was very small, yet there was always room for hundreds of people.

LB: How much did Cookie's son, Max, know about her life?

LY: Cookie didn't think anything should be hidden from Max. I'm not sure if Max knew about Cookie's go-go dancing, but being a mom didn't interfere with Cookie's public persona. She cut quite a figure going down the street in her mules, with that hair, wearing monkey fur jackets, lots of makeup. Cookie would put her makeup on before she went to sleep, so when she woke up, she was ready to go. She got up, made Max breakfast, and took him to school.

LB: When did Cookie get sick?

LY: Everyone was taking drugs and drinking a lot in those days. Cookie was dealing coke and doing heroin. Then AIDS came along. The first deaths were in 1982. Cookie and her husband, Vittorio [Scarpati], both died of AIDS in 1989, within weeks of each other.

LB: Was Cookie as open about AIDS as she was about dancing and everything else?

LY: She didn't want anyone to know for a long time at first, because of Max. She was afraid to cause some stigma at his school. And she was treated really badly at the hospitals when she first got sick. At St. Vincent's, they treated

her like shit because they assumed she was a prostitute and deserved to get AIDS. Then she started going to Beth Israel, and her doctor turned out to be a guy we'd known from the John Waters days in the seventies. He was very sympathetic to AIDS patients and even managed to put Cookie and Vittorio in the same room. They used to have parties there. Vittorio never made it out of the hospital. Cookie did. She never stopped dressing the way she did, putting on her eye makeup. When she died, I took her hand, which was still warm, but there was no life in her. It was strange. The absence of breath made her seem small. She was at peace, though, and looked it. Just gone.

STRIPPER DISINTEGRATION

Kathy Acker

EDITOR'S NOTE: Kathy Acker never finished this piece for publication. The manuscript was found in her archive at New York University, dated March 1973, its unnumbered pages seemingly out of order. It's unclear if pages are missing, or if pages from a different typescript got mixed in. This text was distilled from a manuscript of more than sixty pages with many repetitions. The punctuation is unchanged, but extra spaces have occasionally been added for clarity. "Stripper Disintegration" was written shortly after *Politics* (1972), Acker's first published work, which seamlessly intercuts stories from the strippers she was working with in New York City with her own story. "Stripper Disintegration" was written in San Diego as she continued to work as a stripper and similarly mixes up other strippers' narratives with her own; it includes dream material, acid trips, comments from the audience, and other found texts without indications of their source. The jazz pieces it mentions were the music to which Acker stripped, and material about the war in Vietnam and the Nixon presidency contribute to the sense of a world falling apart. "Target" and "Kathy Kat" were names Acker used as a stripper.

I make war for the sake of war 1973 aesthetic bluh dia-
monds. I awake only at night who do I want to sleep with
last two days love Peter he's going to leave me I treat him
like shit (bluh) he beats me we fuck I come five times I have
to get rid of the cats allergy don't think about that but how
interesting are you I have a new relation to nonexistent
readers hatred Peter's cock swings around he buys a
long black wig down to his waist to go in drag leather-out

again it's night

this is it baby for you for me for Peter why'm I doing this too
late the stars fall into our hands I'm in New York in a sleazy
nightclub Charlie Hayden Ornette Coleman etc. play they're
my accompaniment we're at the Met huge white stage high
above the people I don't want to go on I miss dancing right
next to the audience I go outside see the black guys that I
show at the club hey Target let's get this place real so we can
play move chairs on floor clear space in middle of people I
tell the guys backstage we can fuck the stage everyone digs
me I'm walking down the street with Wanda I live with her
we're returning from the market high on acid some Mex-
ican guy's beating up a girl it's a Sunday night cold rainy a
woman's chasing us old she takes tiny little steps her eyes are
white huge she throws a knife at us we race up the street the
end of the world dance to Ornette Mingus Liberation Music
Orchestra five joints two beers forget codeine it's none of
your business when I turn 21 I'm going to work at the bars
none of this theater shit

I'm going to make myself a fortune they like cute flirty girls
I'll just wiggle my butt a little wiggle wiggle [s]o I can get the

money this is how you do it lick Willy's neck I can't bring the codeine because of supposed bust can't bear being this tired do you care about sex no can't think of anything else to talk about dreams Ornette Coleman Carla Bley a tall red-haired woman jeans laugh I dream all night the end of the world wake up to remember dream back to before end give Bree and Ben donuts why don't you like me actually I don't care a double life I'm in a house among dark green leaves leave Peter for Alfred Hitchcock Alfred believes a man and a woman in true love are one person

a dead brown kitten gray feathers the head is joined to the body by a red string in the middle of the feathers a vertical streak of red a few gray feathers lie on the carpet the body dangles the feathers part two oval red shapes CRUNCH more of the oval red shapes show the children sniff step on a small grey foot the red globes hang outside a few feathers some bones only one red globe remains and a tiny red dot some of the smell is gone as I flip out begin to remember I can feel dancing-robot ride in car when you die only the consciousness goes to eat sandwich salad or take along hungry while dancing I'm anxious back to nine years ago scared about what not that time myself watch time fear of being late Yvonne tries to stick a knife through my back misses slashes my arm as I twist back her arm no one helps me (I'm naked) I manage to drag her over to Willy tell Willy to call Peter Morgan comes into the dressing room I'm trying to improvise a tourniquet why'd she knife you I've never done anything to her call in other women for proof I don't speak to her why don't you help me blood drips over the arm to floor instead of trying to find out how I'm supposedly guilty what does it matter who I fuck if I don't do it here you're a lousy homosexual I fuck 10 foot alliga-

tors you're just scared what are you you're hating yourself through me I wouldn't work for you again can't get on schedule get knifed the whole night snore

we got to get some money I'm going to start doing it tape Marianna In Los Angeles there's an all-woman rodeo this friend of Carol Becker's coming here Thursday who's a whore I'm going to the bars with her she might not talk I tell women's lib's people I'm a stripper Bluuu Rich is dating this girl who's Harlan Ellison's mistress he went away for a week I don't fuck anymore she gets $200 a week to rub his back he's impotent I could do the same all these Picassos we'd be invincible do I think Peter's a child or a man if his mother stays in Los Angeles he's a man she comes down here to hold his hand hello Kathy here's Peter all her friends stop by to give him presents what do you get mixed up in these fucking scenes for (stick to women) guilt hello who are you I'm dying along with Laos my body's placing itself on a black stone a band of violets around my cunt no I don't mind stripping what the fuck am I doing here education rich parents be ready to do anything anywhere I hitch up and down 101 two laborers who are broke no one tries to rape me one guy raises greyhounds blow all my money I'm sick and broke

nightmare I write my parents with hope future money evil capitulation I can't keep on stripping for the rest of my life most turn twenty-five five kids three ex-husbands live on Welfare whine all the time at thirty are huge hit their kids across the mouth are junky-whores I'll interview them they're really smart I've got to get out of here my head spins I can't think a huge black vulture walks in the door the world is perishing three thousand Martians land on Empire State six thousand near poison army base

work as a stripper the walls close in no I can do whatever I want this night everything is chaos I get off the bus fish is ready Melvin calls 12:00 scratch Pickle Paul's nipple we eat donuts leave go to the bank because we don't have any checks printing shop optometrists get my glasses adjusted straight shits refuse to help me shine fuck Bree buy headband wigs don't look good I want a white wig hair down to my ass you can go in drag half the people are in drag aren't get back in the green car Rich Norma Warren call I eat corn chips donuts play recorder turn on heat turn heat down Kotex I live on an island there are many levels of houses the bottom is sand water laps I'm at an orgy I climb from level to level by a hanging ladder a stupid woman Corinne is in the university I want the easy money I have all A's super recommendations I work as janitor everything is chaos all I think about is sex off the job the excitement is necessary when I'm horny I begin to worry about myself and dislike myself Americans are sex-crazy (no knowledge) I dream sleep with specific women there's going to be a gay dance shun knowledge in the morning Pickle Paul sleeps . . . the machinegun all available rifles join in make way for the morning light! at 2:40 jazz and rock an orgy begins she comes to me grabs my breasts uh-huh I reach for her she turns to talk to someone else I'm two hours on a bed with her she doesn't want my passion kiss plah! Like we're half asleep! I made you all wet she puts on her clothes walks away nowadays I kick those shits (Barnetts) out of my house I'm spaced out

war and drugs

STRIPPER'S CHAOS DIRGE

body not here who cares what the fuck they want! one finger

two fingers move ankle to cunt San Diego enters my body
the Navy blows up! Indict Nixon for blowing up three arse-
nals one tank ten ships the sailors flee enter the pink car
we drive through Los Angeles Oregon here's the pink car
they're all dead let's see your license I could take you to jail it's
not my fault it's not my fault where are the cats now I feel
powerless I'm not able to control myself murderer pervert
what do you do I go to school what year graduate student do
you plan to continue sick of the whole system I like what I'm
doing what do you do I dream I'm a good-for-nothing shows
go over badly tonight I don't have any hair I'm not a real
female give me a double dildo I dance slow slower Bree kisses
Ginger I kiss Bree and Kathy Kat Cybil takes my phone
number bunch of drivel diary turd but still the truth I need
a good luck charm ward off evil demons stomach aches from
codeine I pass out on stage end up in some guy's lap they
don't rape women down here only girls this is pig paradise
you can't get a screw if you try in retaliation Peter cries I
won't give you my car I don't give a fuck if you lay out in the
grass all night arrested twice don't bother me I'm perfect I
want my cats I tell Kim Ginger's going to move in to the new
house I can fuck her I'm going to fuck her Ginger thinks I'm
serious I don't go after women that way I wouldn't pass up
the opportunity this is a bust I'm frightened take off your
clothes bend over face to the ground where's our take this
gun goes off you'd better do what I say now you'll learn I can
do anything I want the narration of the ghosts is dying
america death blow up everything each building San Diego
diamond death gas and light building three block cop com-
plex the whole of everything

fuck all audiences you readers hearers snuffle snotasses hate
you I do what I want to strange writhing shit get that lousy

jazz off the stage do you want her do you want her to come sit on you[r] head piss over your green cocks no fuck off do you want smear it your asses what other shit can I do two years graduate school fits you for this replica of Rockefeller beep-beep I'm going to dance to nothing but jazz Elliot Crap-cart bee-eep—schliepeel-li-loo ignores everyone when I start managing here everyone laughs at me you got to keep repeating it fuck you I have diamonds in my cunt my cunt's going to poison you take your arms wrap your intestines into a straitjacket set fire to your hair stick knives into your blood vessels red white blue spurts this is more exciting than New York every hippy is like us hippies a woman has long hair various colors doesn't do anything gross or strange loves teases men have them do things for her. I'm in drag I'm a creature from the third planet Jigoplex everything (hell) 10 9 8 7 6 5 4 3 2 1 0 past 0 it's Jigoplex or LSD I'm completely evil the worse smell in the world EVIL pour coke over his head Harris is dead I didn't kill him I have to get rid of his body or the police will think I killed him we cut off his head and arms we have to hide the blood we bury him in an underground stream of air he lies face down in the snow no one will ever find him hey you want to be in *Penthouse* I'm getting my rocks off you can only meet this slick creep if I say so you don't have to fuck to get into they only want untrained chicks I almost get in at 5:00 in the morning Marsha Ginger Bree Joyce the phone rings O.K. I don't know I'm their pawn stars shoot out of rotting corpses diamonds swirl round my body I have a million jobs do them all effortlessly perfectly I have tons of money I dance write whenever I want destroy

the wanderers in chaos meet evil
smoke one joint two joints I'm riding to another place
 vomit in

the bathroom only time left to write have to write down
dreams

death I'm making love with a woman my age we hold each
other's hand thighs next to thigh my mouth touches her
mouth long brown hair I get into my pink car I don't know
how to drive I'm on a two-lane road a highway ahead two
roads run into one the road turns sharp to the right I head
into the bushes I have to swerve around the cars ahead of
me to my left swerve around the car on my right I made the
sharp turn my doors keep opening I drive past Cardiff up
a narrow gravel road to a College old stone buildings in
the midst of green woods hills dip up down I'm on a bicycle
I'm leaving school on the stone road I don't know how to
bicycle my sister's with me knit a pink and brown sweater
the car keeps becoming a bicycle it's already night there's no
more day we've been paddling for hours past Cardiff finally
we reach New York just past midnight everyone I know is
furious at me we drove 500 miles I didn't know we could
do it brown brick buildings I'm pacifying my mother
and father diamonds cover our naked bodies we dance nine
shows drop down dead you better be alive tomorrow O
Ronny please I'm soo tired I can't work tomorrow I'll fuck you
tell you you're God I like to first ski then ball third read fourth
dance I'm going to vomit the sun comes out sneaks into the
center of my head energy! Robin's vomit is yellow you're a
whore and a slut I might dance nude on the stage I'm not
in your category vomit get your shit together hi momma
bitch grab for each other tear clothes skin to bits yellow hair
over the floor I live in another world I get you a bead neck-
lace tiny red and green dot ankh ring for good luck I lie on
the floor dead San Diego pukes over me the dancers leave
their hair as shrouds romantic elegy by stripper

kill a cop for fun

A SHORT NARRATION OF WAR AND DRUGS

this is a narration ha ha the end of the world the end of the
world after after the after who after all the world is you I do
an after suck my ass Peter gets home Pam hasn't called
cop car disappears what do you dream about read mastur-
bate the desert appears bodies stretch out upon if we enter
the cubical giant city huge blocks move apart at the center
don't you understand you're on acid the blocks tumble
over each other constant change as we leave the city a
gorge valley climb up rocks tiny ledges impossible passes
red purple birds skwawk craw the world ends begins
three times I get it all together I'm coming down I live
among humans I'm in myself can't get out people press
upon each other cause each other to change I'm meshed
up with every being only emotions matter fuck the trip I'm
too fucked up to tell if I'm really sick get to sleep I'll see
Pam tomorrow allowed go cruising this is garbage I'm
too tired Ben makes it with every dame he caresses Joyce in
front of my face he expects me to not make him feel guilty
sleep with whatever woman he brings home I'm supposed
to be getting interested in sleeping with women I'm too
sensitive shouldn't plague him with my problems men like
young girls I study my pictures when I was 17 through 21
learn how to model my face I look as young as possible I
look younger now than I did when I was 20 I'm lucky I have
oily skin this job keeps my body in shape I'm too old to learn
to love women I'd have to make too many changes piss in
the toilet I don't want to work in this place too sleazy there's
no less repulsive place to dance I should be working (5)

more days a week you figure it all out all I want is to make love to you

we're the ghosts of Solana Beach we come to you from Grecian depths of insanity from the hollows of Africa voodoo exotic means eastern anything means shit moreover I don't know more have no job we're interested in being rich because there's absolutely no possibility we'll ever be anything but bums we wouldn't know how to be materialistic Lenin wakes up says he's around goes back to sleep drunk let me talk to Peter let me talk to Peter I'm not paid to be your fucking toady we (the ghosts) take out our knives Pam sleeps with me! I can be nauseously sentimental! erase the ghosts are peeing everything's fucked do they read the books I tell them the plots and meanings do they give a shit no 9:30 tonight I don't want to talk to you I'm depressed you want attention I don't want to apologize what the hell I'm trapped here take out Sun Ra album leave twenty disastrous years go by O dear our first fight will our true marriage survive the only thing which comes through is fuck the political part O I wanted to warn you girls I know more than anyone there's going to be a bust I took acid Monday then Friday Saturday Saturday was wonderful I saw yellow trees everywhere was yellow mist endless water against the sky incredibly mellow emotions aren't that important how fast can I alienate you that assumes I have friends I might as well write as much as possible black poets find the golden spirit I can't think of any stories to put down I'm scared to sleep with a woman I fall in love with two straight women I make out with them they refuse to sleep with me one year I want to sleep with a woman straightforward feeling I fall in love with a gay woman am I gay or straight I made out with her not now sleeping with her mad mood

MY CHILDHOOD
for Warren:

I'm a frigid bitch who hates to work aren't you glad you live with me I'm glad I live with anyone (my mother) how's the weather I'm moving to San Francisco how's the weather are you dying of a heart attack I love you how's the weather I'm the night-time secretary I stuff the ghosts dead teachers into the trumpets of angels bodies shoot out all over the U.S. it's Vietnam retaliating the phone freaks install cancer into all the computers we send out bombs against the Vietnamese nothing explodes the end of the war anything can work through memory strangers walk into my office I don't see them because I'm blind through the windows I see Peter David (Antin) make love mmmm I'm going to become Secretary of Music I'll give anyone who says it's magic wings they have to make love to me provide snakes for my pet bats I'm always sick I have arthritis rheumatism the three times I've been closest to death I haven't been scared of dying if I die I won't know about it that's strange Peter's talking to the car tell the car he'll give her (him) a bath don't worry I go to an all male Catholic military school after gym class I'm in the shower seven older boys enter the shower they rape me I'm prejudiced against fags I hand out posters pro free love a priest calls me my two friends into his office when my first friend comes out she looks shocked a black car passes by the priest tells me physical love is forbidden he gets hornier and hornier he can't control himself he puts his hand on my shoulder why are you for free love Peter doesn't sleep with men at this moment rips my shirt apart I run out of his office I get freaked out thinking about this these stories explain my childhood I can't stay madly in love for more than a week I want to see Pam the angels hover above my childhood freak

How long's my cock 10 inches 12 inches 1 can make any woman expand they don't want to fuck me their cunt muscles get tight infections they never want to fuck again homosexuals are sick the problem with women is they're not straightforward my cunt's silver and gold 1 feel terrific gook's flowing out of my nose a white ambulance passes us on the road Peter's lying on the bed he lifts his head hand scratches beard 1 realize he's not dead the nurse adjusts his head still 1 can't tell if the headlights 1 see are real imaginary keep driving hamburger men zoom out in front of my eyes Peter gets some peyote even though I'm the most famous artist in America the UCSD art department refuses to hire me because I'm a teacher's wife I'm more famous than the teachers are 1 teach for more years don't get near her she's a viper 1 write them a horrendous letter denounce Nixon they're all Nixon Harold the fuck sends out subterranean letters to all the deans of the school my husband's insane because I'm pushing myself try to get a job 1 refuse to use their mimeo machine 1 don't want anything to do with anyone 1 adore Peter but 1 go crazy about women 1 don't like repressing myself then going nuts follow some woman madly around everyone stares at me women are cunts they ought to get fucked as much as possible their main function is fuck they get confused get away from realizing their identity let's see your cuntie let's see your titties I'm not really sexist I'm scared to death 1 understand your real nature 1 know what you want either you're sick you hate me you should see a psychiatrist 1 love you more than 1 love anyone else 1 never love anyone until 1 love you I'm going to kill myself, Ann

I live in a house with a company of murderers. I flee from the house into the black a gang of men chase after me to rape murder me we race down a wide paved street hear their footsteps pirates one hatchet hits me I turn doesn't go through my skin next hatchet glances through my leg two more hatchets I barely bleed one pirate takes out short gun shoots bam bam bam I die

INTERVIEW WITH MATIAS VIEGENER
ABOUT KATHY ACKER

Matias Viegener is a writer, artist, and critic who teaches at CalArts. He's the author of *2500 Random Things About Me Too* and *The Assassination of Kathy Acker* and the editor of *I'm Very into You*; he recently received a Creative Capital Award. He also serves as Kathy Acker's literary executor.

LIZZIE BORDEN: A couple of other writers in this anthology performed in Times Square sex shows, but I think Kathy did it before anybody else.

MATIAS VIEGENER: Kathy worked as a stripper from 1970 to about 1974. She would tell people in conversation, but the main way she incorporated it was in her writing. Most of her work is autobiographical but often kind of layered—not veiled, but she's not interested in telling you it's all about her. She didn't see that as useful or desirable. Stripping was important to Kathy because having grown up in an upper-middle-class, conventional, bourgeois family, it was an escape. Stripping opened her eyes to gender dissymmetry, the asymmetrical relationship between women and men [. . .] until then [they] were mostly seen as being in symmetry with each other.

The impact stripping had on Kathy is hard to overestimate. A lot of what interested her was just the women's conversations. They talked about their unhappy relationships as much as about work, so it was a kind of lab about gender problematics and about bodies and how women felt about their bodies.

LB: Did Kathy have any sense of this world beforehand?

MV: She came of age in New York in the 1960s and started having sex when she was sixteen or so, in part to escape her family. It should also be said that Kathy needed the money. She had a BA and two years of grad school, but her family did not support her, thinking she was best off married. Rent may have been cheaper in the seventies, but the jobs were just as shitty. Stripping paid the rent and gave her time to write.

I think a lot of the attraction of stripping was stuff Kathy already understood intuitively, but she didn't have the evidence. In her family she witnessed the difficult, unhappy marriage of her parents. She describes her mother as demanding and seductive. And her stepfather—he wasn't her real father—wasn't present. What she got from stripping was really a set of narratives, but more importantly, a dynamic, a set of dynamics, because there's a complicated power relationship at stake. In one sense the stripper has no power, and in the other, she has power because she's the desired object. I think that complicated political power relationship is exactly what clicked in her mind, and it changed her writing forever. Everything that was repressed in her family was played out onstage and later delivered in stories offstage.

LB: Did Kathy gain confidence in her body by stripping? Later, she always seemed to be at ease in her body.

MV: She was always happy in her body, comfortable, and she liked her body. After Kathy had a mastectomy for her breast cancer, she went to a psychic, and the psychic yelled at her because she let the surgeon amputate an essential part of her femininity. Kathy said, "This is bullshit. First of all, I never liked my breasts, and I don't really miss them." I don't think it meant she disliked them, but that they were not the parts of her body she valued most highly. For Kathy, it would have been a toss-up between her brain and, in her words, her cunt—maybe depending on when you asked her.

LB: Do you think Kathy was in any way an exhibitionist?

MV: There was an evolution. Kathy always said she was essentially shy but had figured out strategies around it. Her first job stripping was in simulated sex shows with her boyfriend in New York, Lenny Neufeld, which might have eased her entry. Friends who saw them said they were clever but not flat-out comedy; the focus was on sex. After she broke up with Lenny, she moved in with Peter Gordon in San Diego and stripped in several clubs. Kathy would summarize important books to the bored men as she took off her clothes and had sex with the other strippers; Mel Freilicher recalls her stripping to Ornette Coleman's "[Song for] Che" and explaining to the clientele why Che Guevara was an important figure.

As far as performance goes or being an exhibitionist, I think that Kathy was a ham in a certain way but also very reserved. There was a sense that what she performed in the world wasn't necessarily her true self. It was just this

external thing that she gave the world that was based on herself, but she never confused the two.

LB: Not that it's a contradiction, but Kathy also seems to have been an incredible romantic.

MV: Yes. She wanted the mysticism and intensity of romantic love. And she was critical of it the way we all are. It's a trap. It's a cultural idea that can interfere with human relationships as much as facilitate them. She also wanted the power of eroticism, and sometimes the erotic could become romantic, and vice versa.

LB: There's a certain eroticism in her writing, too, the question of whether she's going to be feeling anything. Is she getting off on any of the things she's doing onstage, or is it just performance?

MV: Right, which is a classic sex work question. How much of your real desire and inner life are you going to externalize for work?

LB: Do you see Kathy as some kind of performance artist?

MV: A lot of people call her a performance artist, which I don't really agree with because, to me, a performance artist is doing something framed to stand alone in the world. For Kathy, her written text was primary. Kathy's "performances" had a much more amorphous shape. There were at least two kinds of performativity in her work. One is a performativity that we can recognize, usually on the stage where you don't necessarily become a character, but you're not necessarily yourself. You are clearly doing something

based on the consciousness of the circumstances of the performance—you're on a stage in front of an audience of hundreds or dozens or one. The other performativity, in some ways more important, is the performance within the text, a performative writing. All narratives generate a set of expectations: Kathy's objective was to disrupt and interrupt and explode those expectations and then stop and continue.

LB: In "Stripper Disintegration," it feels as if there are constant explosions, almost as if she's caught in a night or series of nights that never end; the stories don't feel as if they have a beginning or an end.

MV: That's generally true of Kathy's narratives. It's her sense of how life works, which is that beginnings and endings are artificial constructions that we all assume are natural, but everything is a flow or a set of ongoing transformations that really never end.

LB: So many girls and women idolized her. Was she aware she was held up as—or was she—some kind of feminist icon?

MV: She had her problems with the feminism of the seventies and eighties, which she saw as being reductive and prescriptive. Feminism in the nineties changed, and suddenly Kathy felt very in tune with it.

LB: Within "Stripper Disintegration" there are unfiltered moments of sexism, racism, and homophobia. Those weren't her beliefs.

MV: All of those would have been things she heard while she was writing "Stripper Disintegration," perhaps comments from the audience or the media or just the programmed language of oppression. Kathy's texts are polyphonic, but not in a way that you could detect who is speaking and when. She always said she didn't want to have a voice or a style, an "I" in the text, and though the through line of her work is autobiographical, it's important not to mistake what's in the text for Kathy herself. Her politics were absolutely aligned against sexism, racism, and homophobia.

LB: One last question: Why does Kathy use "disintegration" in the title?

MV: I don't think the strippers (or stripping itself) are disintegrating here. Clearly the world she describes is chaotic, the period of rage against Richard Nixon, the Vietnam War, and the intolerable sexism, racism, and homophobia she witnesses. But the real disintegration is the text itself, the sentences piled on top of each other, the breakneck language and disorientation of events. At this point Kathy Acker is remaking herself as a writer, inventing new modalities and narrative forms for herself. Two months after "Stripper Disintegration," she starts to work on *The Childlike Life of the Black Tarantula*, her first mature work, which leads her to the readership she always longed for. Perhaps the stripping fueled her radical dismantling and reinvention of narrative itself, and in that sense "disintegration" would not have had a negative spin.

TAKE YOUR PASSION AND MAKE IT HAPPEN

Jo Weldon

I had always wanted to be a stripper—not a dancer, not a showgirl, not a movie star, but a stripper. I loved sassy, smart, shameless Gypsy Rose Lee, and I loved the dramatic teasers at the beginning of the 1966 film *The Silencers*, in which three consummately skilled performers introduce the titles: a terrifying brunette who literally tears her clothes off; an icy bouffant blonde, fully nude and strategically juggling a boa; and Cyd Charisse, who devastated just by moving her eyes to the left and to the right. Each of them was powerfully individual, yet all shared a silkily sensual confidence that I, though full of earnest and awkward commitment to the form, possessed in no abundance.

I managed to spot burlesque stars everywhere—party girls who were glamorous, but not as perfectly put together as the ladies of the silver screen. They seemed a little messy, a little less perfectly groomed. They seemed to have written themselves, with their gimmicks and taglines, to have created glamour from adversity, given that they were obviously not senators' daughters, to have created roles for themselves to play instead of auditioning for roles created by someone else.

Of course, in one way or another, we are all fulfilling

some roles, and the wild woman is one of them. But of all the roles available to me, this one seemed to have the most opportunity for anarchy and self-invention.

I started working it out early on. When I was thirteen, I talked a friend into stripping out of our matching nylon jumpsuits, creating our own eccentric routines to "Afternoon Delight." It was clear to me that it was a performance of some sexual meaning, but not of an actual sexual act. I was too young to need either money or sex, but I was excited by the idea of having both of them, and I was more than ready, as soon as I moved out of my parents' house, to go wherever the money and the sex could be had. I figured strippers were in that place. I had a dream.

I was in Atlanta when I turned eighteen (1980) and had driven by the Classy Cat, on Piedmont Road, more times than I could count. Tattletales (well known later for being the hangout of Mötley Crüe in the "Girls Girls Girls" video, though it seemed I ran into Mötley Crüe in almost every strip joint) was just a few blocks down the street. Its sign's elegant Picasso-ish line drawing of a woman's lower torso suggested pretensions to something more savory than seedy—but I didn't want class, which was why I was drawn to the Classy Cat. I wanted camp, and I wanted sleaze, and, young as I was, I knew that anything that described itself as classy was bound to be sleazy. Also, I was a Leo born in the Year of the Tiger, and anything about cats felt as if it belonged to me. It was destiny.

One early afternoon, I made the plunge, boldly going where only my imagination had gone before. I drove my beat-up boat of a 1972 Impala into the parking lot, which was discreetly set down a slope behind the club. As I walked to the door—its wood scarred by what I was later told was a chainsaw wielded by the husband of one of the dancers—

my heart pattered with anticipation. What degenerates would I encounter? How much money would I make? Would they fit me for costumes? Would I have to dance? (I couldn't dance.)

I walked in feeling acutely self-conscious, but as my eyes adjusted to the rank, smoky atmosphere, I knew I was finally home. It was dark, mostly red, with sultry Top 40 songs playing from the jukebox. Most of the light came from behind the bar, from below the Plexiglas floors of the stages, and from the cigarette and video game machines along the wall. The space smelled like liquor and hairspray and ravaged carpet. A few men were scattered about, managing to look both furtive and supremely confident. A pear-shaped stripper with long, luxuriant black hair and a calm, almost dazed expression shifted her weight from foot to foot, swaying almost absentmindedly yet sensually. She wore a short, strapless red lace–trimmed spandex dress with a pointy hem that kept creeping up over her ample behind. Her gentle tugs to bring it back in place were the sexiest move she made. She had a weird, lopsided dirty green flower on the side of her leg, which I slowly realized, as my eyes adjusted to the low light, was a wad of money.

I was the happiest I had ever been in my short life.

Behind the bar, a mild-mannered man of about thirty was rubbing a glass with a towel, staring off into space. I walked up to him, sure I was in the right place, but not sure how to qualify to stay there.

"Hi," I said. "I'm Cheryl"—not my real name; I had gotten it from one of Riff Randell's brunette sidekicks in *Rock N Roll High School*, to whom I bore a remarkable resemblance—"I'm looking for a job."

He turned his mild eyes to me and, with all the world-

liness of a chivalrous and deceitful southern gentleman, understood me completely. "Have you ever worked in a titty bar before?" he drawled sweetly, knowing the answer.

Titty bar! Oh my god. What an awesome word.

"No," I said, "but I've always wanted to."

"You've always wanted to," he said, amused. "Can you dance?"

"I've got some moves," I said, although I realized my Gypsy Rose Lee–inspired slow-zipper striptease and my sinuous glove peel might not suit this place.

"Let me see your ID." The drinking age—and therefore the age of entry into titty bars—was eighteen. I showed him my driver's license. I was visibly drunk in the photograph. (It was the 1980s. What can I say?)

He sent me into the dressing room to talk to Endora, the housemother, who was the most fabulous old bitch I had ever met. (She was probably about the age I am now while writing this, by the way.) She had red hair in a beehive, just like one of Matt Helms's girlfriends, and nails and eyes like daggers. I was enraptured. I knew immediately she had been a star, swilling champagne and sucking celebrity cock in limos and being showered with minks and diamonds. My hero. God, how she hated me on sight.

She lent me a used costume that was for sale and charged me five dollars to borrow it—given that, as she made very clear, she'd have to wash it afterward. There was a G-string, a thong, and a little dress not unlike the one the other woman had been wearing, plus a pair of elbow-length gauntlets, all in a faded purple-on-green floral print. I wore a purple sequined garter on my leg. I loved it. I was never going to give it up, no matter what happened.

"Your shoes are horrible," she let me know. "Men hate brown shoes."

"Thank you," I breathed, overcome with gratitude for this insight into the minds of men.

"You'll do three songs. First one, keep your clothes on. Second, the dress and the thong, till you're in your G-string. When the last song starts, walk around the edge of the stage and show them you're ready to take off the G-string, and see if you get more tips. You can't take them in your hand, only in the garter."

I pranced out onto the stage at the end of the bar. I was onstage! I was under the lights! And above the lights! And the music was playing, and men were looking at me!

The bartender, who was also the emcee, got on the mic and, suddenly sounding more like radio deejay than a southern purveyor of fine liquor, said, "This is Cheryl, guys! She's never danced before. Give her a little encouragement, and let's see if we can get her out of those clothes!"

After a lifetime of dreaming about being paid to get naked, I couldn't imagine what they could have done to keep me in those clothes.

The only song I remember from that set was "She's So Cold," by the Rolling Stones. Every man and stripper in the place—there were only men and strippers—tipped me on every song, and at the end of the set, I had $34. At the time, the minimum hourly wage was $5.15. I multiplied frantically. Thirty-four dollars in ten minutes! Three dollars and forty cents a minute! I was gonna be rich!

"That's fine," said the bartender/boss after my set. Endora sneered.

I gave Endora $10 of the $34, so I could keep the costume, and got a schedule. I would be working the day shift four days a week. (At the time, I didn't know this meant I wasn't looking so promising onstage.) I could start the next day,

although I would have to go by the sheriff's office to get a work permit before I arrived.

And just like that, I was no longer dreaming it. I was being it.

INTERVIEW WITH JO WELDON BY JILL MORLEY

JILL MORLEY: How did you become one of the faces of the burlesque Mount Rushmore?

JO WELDON: Am I?

JM: Yes.

JW: Just by being an early adopter, I guess, because I had a little bit of a background in academic presentation. When I started out in burlesque, I wasn't performing. I was doing photographs and trying to promote it, let people know about it. Because of that, people saw me as an educator. And I had one of the first websites dedicated to burlesque and something like a blog before there were blogs.

JM: What do you consider your role in the burlesque community now?

JW: Before, I thought of myself as someone promoting burlesque and also connecting the generations of twentieth-century burlesque—what we call the legends at the Burlesque Hall of Fame—to newer performers. That was my main role. And now, because there are so many other teachers, I feel like my role is to be more of a worker among workers and be part of the body of people who are giving people permission to engage with their bodies in this way.

JM: What advice would you give to a young woman who wants to try to become a stripper?

JW: Weigh the pros and cons, but understand that a lot of people on social media are presenting marketing. I'm glad I did it. I know people who have regrets, but for me, it was like, *I need to get out and have sex, drugs and rock and roll and I don't care if it kills me, because this is what I want. I'm fine with all the repercussions.* But some people aren't. I guess the best advice would be to consider what you want. Know what works for you. The most important thing is be aware that strip joints are incredibly different from each other. And if one strip joint doesn't fit you, there's another one a few blocks away that will.

JM: I would say use it until it starts to use you. I don't recommend strip joint stripping for everybody, because of the ego-emotional roller-coaster ride.

JW: And you're gonna need support. You're gonna need people that love you. But there will be times when it is the most fun anybody could ever have.

JM: Let's talk about the bond strippers have. We've known each other at least twenty years. And we know Lily [Burana]. I know strippers and women and sex workers who have been thought to be catty and jealous of each other, but I haven't seen that, especially with those of us who've taken it and transformed it into an art of some kind. Why do you think that is?

JW: I think we're bonded by—and I don't mean this in a negative way—but there's a little bit of an "us" and "them,"

people who do and people who don't. We've crossed that line. So, there's a whole world out there of people who would never. We are women who would. And we are women who know that we can do this and be our full selves, whole, with our integrity, with our dignity, and completely able to engage in intimacy and relate to each other. And I think of people who have never done it—it's something they just don't know. Because there's not only an "us" and "them" between everybody else in the world who's not involved, but we have an "us" and "them" with the customers, we have an "us" and "them" with management. We have an "us" and "them" with the occasional mean girls. You know, you can go on all day, like, "I'm not a stripper, I'm a dancer"—you're the only one doing that, and we all see you. We see you. We're not fooled, but we love you anyway. It just creates a sisterhood of knowing how much you can do things that people perceive as wrong for one reason or another, damaging, and never be defined by it. And it ends up defining you because of that sisterhood. It's not a bad way to be defined.

JM: And there are these girls coming up, like Jacq Frances [aka Jacq the Stripper]. I love watching them bring it out into the open and translating it in their own art as well. It makes me feel close to them. They're like, *I'm out about it and I'm gonna write about it, I'm gonna educate you and I'm gonna entertain you with it. But outside the strip club and outside of you objectifying me, I'm going to show you what's inside me.*

JW: I feel like some of the past work—not all of it, but some past work, couldn't get published unless there was an element of regret or poignancy; that was the endgame. Right? For the publisher, you have to be redeemed, you

have to have regret, the sadness has to be the point of the story. And Jacq is like, *No, that's not my story. I'm gonna tell it myself. I don't have a gatekeeper. I don't have an editor. I've got social media.* I also feel like as people in adult entertainment—we get to look at each other and admire each other for being hot and sexy and appreciate that. And I think young women now maybe do it a little more than in my generation. And celebrate each other's appeal and beauty and sex appeal. Before, beauty was a consensus; now beauty is an acknowledgment: *I could love you. I'm loved.* And I think, as sex workers, knowing each other, we know each other as lovable. Which is something we're told: *You can't be fixed. You'll never be loved. You'll never love.* That's not true.

JM: In your story, you write about why you wanted to become a stripper. Was it about the glamour?

JW: It was the idea of my sexuality being not only whatever it is inherently, but also something I could play with. I love the idea of it as a site of play and entertainment. This is serious business, to be sure, but it's playful. And I love the idea of sexuality as something for entertainment, both for the viewer and for the person expressing it. It's something I saw in performers like Cyd Charisse, and Eartha Kitt—I always saw [Kitt] as this incredible free spirit, open about sexuality and absolutely shameless. The absence of shame was absolutely the pinnacle of achievement for me in a world where everybody tries to control you by shaming you.

JM: Were your parents both born-again Christians?

JW: My mom was. My dad was a hedonist, and over time, I had to look at it and take the elements that could work,

because the goal of most Christianity is service. I'm not interested in the whole "Don't go to hell" aspect—that's superstition to me, even though I struggle with it—but how can you be of service? Then there's the hedonistic part: How can I enjoy life to the fullest and respect other people's boundaries? So, first, what are my boundaries? Then, the much longer and more painful process: What are everybody else's? But their boundaries don't extend to their right for me to not exist and not be seen. If your boundary is that you don't even want to know that I exist, that you don't want to hear about my kind of presentation or sexuality, that's not right. I've had to talk to legislators about adult entertainment legislation, and this comes up lot of times: "We don't want you to be seen, we don't want our business to be next to you." And, "Our property values are decreasing." And I'm: "You don't have a constitutional right to maintain your property values at my expense. That's not in the Constitution." I was always really clear on that. Your desire to not look at me until you want to use me is not okay. Whether you want to use me to engage my services, or use me nonconsensually to make yourself look moral by contrast, it is not okay. If you want to engage me, you've got to respect me. And if you don't respect me, I don't respect your point of view, because everybody's human.

JM: Is that why you became an activist?

JW: I just saw so many people suffering under that stigma; it broke my heart. And it wasn't that I never felt it, but there were people who believed it one hundred percent, who felt they were ruined, who internalized that stigma and felt hopeless. I'm like, *You're only twenty-two years old! You haven't ended up anywhere, you're in motion and just believe*

whatever people say about you. That's why I'm so grateful for social media sex work activism. I was like, *How can I put it out there that sex workers don't need to be ashamed?* Because I was never for one minute ashamed of engaging in sex work. Not for a second.

JM: I don't think I was, either, for a different reason—because I was considered kind of homely, the jock or the mousey girl. I wanted to tell people, "Look, guys. I can do this with all these amazing ladies." The joke was on them. Stripping helped me see myself differently and did a lot of good things for me.

JW: I remember there being some very horrible nights, but I got more than I lost out of it. I have trouble sometimes when girls who have never worked in a strip club ask me about the pros and cons. I want to show them how it feels when you walk up to someone and you either verbally or tacitly ask for a dance or a tip or whatever, and they look you up and down and say no. I almost can't handle showing them what it was like, because it would hurt them so much. I swear to god—it's tolerable, but it is not pleasant, and the pain does accumulate.

JM: I would tell myself, *They just don't have any money*; otherwise, I'd be crushed. You have to tell yourself these stories, so that you're just, *Okay, I'll just find someone else.*

JW: The story I would tell myself is that guy came in here not for the purpose of experiencing pleasure, but for the purpose of making a woman he thinks is pretty feel bad. And they weren't all doing that—some of them are "You're not my type." And watching the nicer guys try to negotiate

saying no is always interesting: "Oh, not right now"; "Come back later"; "Dance for my friend." But I think part of the fantasy that advertising sells us is that if you're beautiful enough, nobody will ever cheat on you, you'll never experience rejection, and you'll be secure. And that's not true. And when you let go of the idea that there's this safe zone, it's so relaxing. Like, *I'm gonna go in there tonight, and a lot of people are going to say no to me.* There would be nights when I couldn't handle it. I would be like, *I have to leave, just too many people said no to me, and I'm in pain and I gotta go.* But if you walk in going, *I know people are going to say no to me,* "no" isn't devastating.

JM: And drinking alcohol to make it easier.

JW: I drank to make it easier, and then, when I quit drinking, it was much easier because you have that window of confidence with alcohol, but it's a window. I had much more access to that window when I had to manufacture confidence in my system without alcohol. There's that "happy hooker" thing a lot of people think you're saying when you say, "Oh, I got these good things out of it, and it was cool," and I'm like, "Oh, no, it's not an easy job."

GO-GO GIRLS

Susan McMullen

The hormones arrived like a Trans Am pulling up fast, tires bruising the curb—then I was gone. Nothing to be done about it... the car had arrived, and I was getting in. It was the early seventies, and I'd watched the sixties unfold with all their shocking imagery, and I wanted to be a part of it. My parents, far younger than I am now, surely remembering their own wildness, could not do a thing about it.

She and I were born at either ends of May. We met in grade eight, and it started in the usual way: smoking and drinking our parents' whiskey in the basement after school. By high school, we barely went at all, preferring to hitchhike while we sang our anthem, "Me and Bobby McGee"—"Freedom's just another word for nothing left to lose"—a thousand times while we waited for someone to stop by the side of the road, pick us up, and deliver us downtown to the Tap Room, where they would gladly serve us beer; or somewhere we could shoplift a pair of new boots that would soon be marked by the winter's salt, a soft blue shadow for our eyes. It was Canada, life was a lark, and we were testing the waters, preparing ourselves to swim oceans far wider than we knew and live lives we could not imagine. She, smart and fiery and much tougher than me; me, feisty and up for anything. Both of us lean, her with the dizzying body

of a teen goddess, with full, perfect breasts and mine small and made for the seventies. Our town could not hold us. Once we got a taste of our freedom, she left home young, jumped the trains, and headed out west by herself.

When I was asked as a young child what I wanted to do when I grew up, I would reply, "Go to California," and at sixteen, I kept my word. I headed south and wandered around with nothing. Hitchhiking, following and practicing what I learned from the music I listened to. From Gram Parsons's "Grievous Angel" ("Out with the truckers and the kickers and the cowboy angels") to those of my guru Joni Mitchell ("I'm a wild seed again / Let the wind carry me").

After a couple of years, I landed back home, got a taxi license, and drove a cab for a while. She was back, too, working in a massage parlor, drinking Southern Comfort, collecting the bottles and arranging them along the wainscoting of her apartment, creating an arty tableau that Janis Joplin would have appreciated. I hit the road again, and she moved to a bigger town and started stripping, became well known, the "Gypsy Rose Lee of Canada," and traveled to bigger and bigger audiences. I don't remember her having any other female friends—she preferred the company of men, in whom she had an audience captured by her intelligence, her wiles wasted on no one. In those days, strippers performed a couple of shows a night, in costumes, no pole, just a not-so-innocent teenager pretending to be Little Red Riding Hood, slowly revealing her perfect body, and falling to her knees, in towns all over Eastern Canada. I was her sidekick.

And then there were go-go girls, those who danced for tips in between the stripper's sets, choosing three songs from the jukebox and dancing in regular underwear and heels, then serving the customers in such. There were go-go-only establishments, smaller bars that had a girl or two to

amuse the customers. It all happened so fast. A tiny club on a main street downtown, a painted sign announcing go-go dancers and nickel beers. You think you'd remember something like that, the first time you took your clothes off and danced in your underwear for a room full of strangers, but all I remember is soft blue light and cigarette smoke. I was a pretty girl, and liked to dance, but I wasn't a sexy girl. The men wanted something, but I had not yet learned to open up that part of me, that space that begins behind the eye, that makes them believe there's room for them and that they're wanted there.

So, I became a topless go-go dancer at nineteen. I moved farther and farther out of town for a while, to places where they were grateful for any girl . . . a biker town on the South Shore of the St. Lawrence, where another friend and I landed, and no doubt would have been raped, had it not been for her speaking French and for Rosie, the only nonbiker guy in town who was friends with the leader of the gang and who responded to our cries for help out the window. I got booked in small towns on Lake Ontario. In one, I was the first go-go girl in an establishment that had strippers the week before. I was accompanied by a belly dancer. She was older, exotic at thirty, had an elaborate routine with swords, and drove a Volkswagen. She was lovely in her belled costumes, and accomplished, the swords balancing on her head as she twirled. They had never seen anything like it, and probably would rather not have, but they liked her more than they liked me. It was customary to house the girls in rooms above the establishment—which, in retrospect, does not seem like a great idea, but in many of these places, there were no towns or hotels, nowhere else to stay. Those summer nights, tomatoes were thrown through my windows, hitting the curtains and making sounds like

small bombs exploding. They wanted their strippers back, with their legs akimbo and their forward moves. The belly dancer was married and having an affair with Bob. He had come to see her, and she was planning to break it off with him. I told her I thought he was cute, and she said I could have him, and I did, and then I had his children, but I'm getting ahead of myself.

I headed to Toronto with the belly dancer in her VW bug and landed a job at the "Lancaster Club," a gentleman's club...go-go only. I guess because they were gentlemen, they could appreciate my more refined sense of rhythm, and because I was such a clean dancer, I was put up whenever the cops frequented, and because it was such a "respectable establishment," the cops came often, just to hang. It was a cavernous place and often full at night, and even in the day, when businessmen, dressed in suits and ties, chose to conduct their meetings there—because who doesn't like to conduct a little business when you have a young topless waitress serving you, a girl who at some point will get up and dance.

The stage was a boxing ring, four steps up and twelve across. The deejay would play my three-song set: David Bowie, "Golden Years"; Marvin Gaye, "What's Going On"; and Stevie Wonder, "Isn't She Lovely." I'd let the music move through me while my feet kept the beat. The more you could feel the music inside you, the easier for the men to imagine they were there, too, and they would come to you, reach beyond the maroon velvet ropes to lay money at your feet. It was quite a juxtaposition from the places where I had been, and I made real bucks.

There were always girls that had one foot in Toronto and one in Montreal, which was the Canadian way of saying they did spreads, letting those who would imagine what lay on the other side of the double layer of fabric. But those

were sad girls mainly, often junkies, and they did so mostly because they had a hard time standing. I once saw a stripper in Montreal whose whole act consisted of her lying on the stage, pulling her legs over her head, and putting on a pair of sunglasses with one of the arms up her vagina and the other up her ass. Maybe it was just the drugs, more likely some dark thing that haunts and disfigures, but Montreal was a dark, criminal town in the seventies, and one I imagine you could quite easily lose yourself in.

So, I was dancing in Toronto, making more money than most nineteen-year-olds did in 1977, having found a place that appreciated and treated me well. We were booked for two-week stints, and I booked a few consecutively. I was young and having fun, cocaine was king, and with my tips, there was always plenty accompanying me. One night, I decided to buy some quantity and got ripped off for a lot of money. It was a long night, and when all my options for scoring as intended vanished, I ended up at Bob's. When I had first met him, he was headed out of town and had given me the key to his place, in case I needed somewhere to stay. I never did until that morning, when I just wanted to sleep off a lousy night. It was weeks later, and as I arrived at his door, he was just getting back from his trip. We had sex, and I got pregnant.

I danced a little while longer, in smaller clubs after leaving the Lancaster. The last one was tiny and on the border between Ontario and Quebec. There, I was asked if I would take everything off and dance for the men if they locked the door. It was a late-fall afternoon, the light was low, and the wind had stripped the leaves from the trees. There were only a few patrons, dressed in plaid and camouflage, stopping in for a beer before heading home to their families. I danced for those men with nothing on and thought nothing of it.

She stopped stripping and had her way with life, always such a bright light. She made documentary films, wrote books, and was always an activist for social justice. I, fighting nausea, finally gave way to the change and headed out west by myself, giving birth to twin daughters in June. She and I lost touch along the way, only needing each other then, knowing it was a good, brave thing to sail toward that wide-open abyss, propelling us beyond unseen borders that otherwise would have hemmed in our lives. One would think that danger would manifest in our lives, but I like to think bravery is rewarded, and we did go on to live remarkable lives for two girls from the East End.

<p align="center">* * *</p>

I heard she died. Another friend read in the newspaper that she'd been ill for some time. She was forty-nine when she passed. I hadn't thought of her in a long time. When I reflect on those years, they don't feel good or bad, just one way one girl finds her way to fame and the other one gets where she's going. Funny what you do remember in the end . . . sharp blue eyes, a tongue that could spark lightning, all those songs. The battle cries of our youth echoing in the end.

INTERVIEW WITH SUSAN MCMULLEN

LIZZIE BORDEN: Lindalee Tracey became famous in Canada because of the 1981 antiporn documentary *Not a Love Story: A Film About Pornography*, in which Lindalee denounces porn, but she later said she was forced to by the filmmakers. It became a scandal. Why don't you mention her by name in your story?

SUSAN MCMULLEN: Lindalee was my friend. Her stripping name was "Fonda Peters." By the time I'd written this story, she had already died. If she'd been alive, I certainly would have given her a heads-up.

LB: When did you begin to write?

SM: I always wanted to write songs. My life has always been strongly influenced by music, and at some point, when I sat down to write lyrics, they came out as short stories instead. My stories tend to be about the length of a three-minute song.

LB: When did you want to become a writer?

SM: All my life I've been asked, "Are you a writer?" I've always liked the idea, but maybe because of my lack of education, I've never felt like I've had a right to be one. My father was a poor Irish immigrant's son, left on his own to raise himself, as my mother essentially was. And when it came to me, I was left alone, too. My parents were decent, generous, churchgoing people, but education wasn't something that was important to them. It wasn't just me: College wasn't important to many of us then. We were out doing our thing, growing up. Even some people I know in Canada who are extremely successful now didn't go to college or even finish high school.

LB: Did you ever study writing?

SM: In the mid-nineties, I started to write and took classes at UCLA. Over a few years I amassed some interested parties and was asked to contribute a piece to *Another City*, an anthology of LA writers, by City Lights. That was the first piece I got published.

LB: Why didn't you continue?

SM: I became ill. It's been many years now, and I've had other things to do. I've always been into alternative healing arts, so I studied a bunch of different modalities.

LB: Your mother was Indigenous. Did she spend her childhood on a reserve?

SM: She had a difficult upbringing. She was taken off the reserve and was raised in the Canadian government's Indian Residential Schools. They were always bad places, where the Church did its best to erase any so-called Indian proclivities in a child. In light of the recent news and uncovering of mass unmarked graves at the schools and the histories that survivors tell, it's a miracle she lived through it. I was able to piece her story together through talking to relatives and through pictures I found, but she never spoke of it. Along with the obscured heritage, there was a lot of psychological damage from her time in the residential schools. She had no positive parental role models, so it was difficult for her to be a loving mother. But she was strong, very bright, and did not suffer fools. It's funny; in a way, she was a little like Linda.

LB: What First Nation was she from?

SM: She thought she was Swampy Cree, from Hudson Bay. I think more likely she was Chippewa/Ojibwe from southern Ontario, based on genetic testing.

LB: What was it like growing up Indigenous?

SM: Honestly, it was kind of exotic, and I thought it was cool. Once, a girl in grade school called me a "dirty Indian," and I smashed her head against a brick wall. My mother would pick and choose when to be "Indian," but mostly we were just like everyone else. The Indigenous percentage of the population in Canada is much higher than here, so you see Indigenous people all the time.

LB: Many of the women in this anthology stripped because they were insecure about their bodies. Were you?

SM: I wasn't like that. I was very confident. My mother may never have said, "Oh, you're really smart"—I never heard that in my life—but I was always "pretty." I never felt sexy. It wasn't until I started dancing that I started looking at myself like that. I was also a hippie in the seventies, and I spent most of my time with little clothes on. I had a fine body. Not a sexy body, but I didn't have any insecurities. I was lean, I was fit, I had no complex about it. All us girls had great bodies. We were all fabulous.

LB: What role did drugs play?

SM: There was weed and acid, but that was more in high school. Then cocaine in the seventies . . . a lot of cocaine. Most of my boyfriends were cocaine dealers. They were fun times. People were respectful, for the most part, chill, probably nicer than now . . . and it was Canada.

LB: There seemed to be fluid lines back then, between stripping, burlesque, and go-go.

SM: Strippers in those days did two or three shows a night.

SUSAN MCMULLEN

They wore costumes, had music and danced, and then got offstage. They weren't out on the floor interacting with customers. They went back onstage for their next show, and probably the clientele changed over. You would buy a ticket, see the show, then leave—very burlesque. The go-go girls held down the fort in between.

LB: Why did you stop?

SM: I got pregnant. I was ready for something new.

LB: In your story, you describe stripping as "just one way a girl . . . gets where she's going." Are there things you learned from your experience stripping that helped you later in your life, or that changed the way you related to the world?

SM: When I look back, I was so innocent and wild, but rather spectral. I don't think there was that much to me. I was rebelling against things I didn't even know. I objectified myself, becoming the "pretty girl" that men wanted to dance for them, and it gave me a sense of power, which was new to me. Do I wish I'd had more self-esteem? Certainly! Is [stripping] something I'd like to see my daughters do? Certainly not. But life leads us, and for a girl like me, wild by nature, I had to follow.

BAD DAY AT THE HAIR SALON

Maggie Estep

I was an unemployed receptionist with dyed orange dread-
locks sprouting out of my skull. I needed a job, but first, I
needed a haircut.

So I head for a beauty salon.

A gorgeous Puerto Rican girl in tight white spandex and
a push-up bra sits me down and starts chopping my hair:

"Girlfriend," she says, "what the hell you got growing
outta your head there, what is that, hair implants? Yuck,
you want me to touch that shit, whadya got in there, *sand-
wiches?*"

I just go: "I'm sorry."

She starts snipping.

My foul little dreadlocks are flying around all over the
place, but I'm not looking in the mirror, I just don't want to
know.

"So what's your name anyway?" she asks.

"Uh, Maggie."

"Well. My name is Suzy."

"Yeah?"

"Yeah, it ain't just Suzy S-U-Z-Y, I spell it S-U-Z-E-E, the
extra 'e' is for extra Suzee."

I nod emphatically.

Suzee tells me when she's not busy chopping hair, she

works as an exotic dancer to support her boyfriend, named Rocco. Suzee loves Rocco, she loves him so much she's got her eyes closed as she describes him:

> *6 foot 2, 193 pounds and, girl, his arms so big and long they wrap around me twice like I'm a little Suzee sandwich.*

Little Suzee Sandwich is rapt, she blindly snips and clips and snips and clips.

I look in the mirror: "Holy shit, I'm bald."

"Holy shit, baby, you're bald," Suzee says, finally opening her eyes.

All I've got left are little post-nuke clumps of orange fuzz. I'll never get a job now.

But Suzee waves her finger in my face: "Don't you worry, baby, I'm gonna help get you a job at the dancing club."

"What?"

"Baby, let me tell you, the boys are gonna like a bald go-go dancer."

She whips out some clippers, shaves my head smooth, and assures me I will love getting naked for a living.

None of this sounds like my idea of a good time, but I'm broke, and I'm bald.

I go home and get my best panties. Suzee lends me some five-inch heels and gives me seven shots of Jack Daniels to relax me.

8 p.m. that night I take the stage.
I'm bald,
I'm drunk,
and by god,
I'm naked.

HOLY SHIT I'M NAKED IN A ROOM FULL OF STRANGERS. I DON'T KNOW THESE PEOPLE. THIS *REALLY* SUCKS.

A few guys risk getting their hands bitten off sticking dollars in my garter belt. My disheveled pubic hairs stand at full attention, ready to poke the guys' eyes out if they get too close.

Then I notice a bald guy in the audience, I've got a new empathy for bald people, maybe it works both ways, maybe this guy will stick ten bucks in my garter.

I saunter over.

The bald guy looks down into his beer, he'd much rather look at that than at my pubic mound, which has now formed into one vicious spike so it looks like I've got a *unicorn* in my crotch.

I stand there weaving through the air.

The strobe light is illuminating my pubic unicorn.

My head starts spinning, my knees wobble, I go down on all fours and vomit in the poor bald guy's lap.

The strip club manager comes running over:

"You're drunk, you can't dance, and you're fired."

A few days later I ran into Suzee. She got fired for getting me a job there in the first place. She promptly dragged me to a wig store on 14th Street, bought me a brown wig, and got us both telemarketing jobs on Wall Street.

And I never went to a beauty salon again.

INTERVIEW WITH JOHN RAUCHENBERGER ABOUT MAGGIE ESTEP

Musician John Rauchenberger, one half of the group August Wells, was a close friend of and sometime artistic

collaborator with Maggie Estep until her death. He is now the executor of her estate.

LIZZIE BORDEN: When I first spoke to you, you were in such a state of grief. Do you still feel that way?

JOHN RAUCHENBERGER: Maggie's still here in so many ways. It's obviously not the same type of grief that you have at the beginning, where you go through all the stages and all that. I remember the biggest part was, even after a long time, you would just be walking down the street and you get the feeling when you think you lost your wallet or something. You get this shock of just remembering. That kind of thing has subsided, but her presence is still really here. I take care of mail that comes for her here. I take care of her estate. When I search my email for something, quite often the search will return Maggie's emails. Quite often it's about some dog she wants to adopt or wants me to adopt or together we wanted to adopt; or a house; or some piece of property; or some joke.

LB: Did you became the executor of Maggie's estate after she passed or beforehand?

JR: Oddly enough, Maggie wrote a will two years before that, when she was having hip surgery. She decided that me and Jenny Meyer would be the coexecutors of the estate.

LB: Did Maggie have any fear when she went into hip surgery?

JR: No. She had this thing about her, this kind of organization—and then she wrote [the will] in a way that sounded so much like her, too.

LB: Although she was famous, in her blog she makes everyone feel they could be close to her. People who never knew her were like, "Oh my god, why didn't she live? We could have been best friends."

JR: She actually was my best friend. It's interesting, the word *famous*—whatever kind of celebrity Maggie had, I don't think she ever acknowledged it in any way, shape, or form. She was just such a down-to-earth, regular person who was really a great friend and really cool to hang out with.

LB: She could seem tough and confrontational in performance.

JR: There was—definitely is—a different feeling in social settings from attitudes put forth in her performance. She was not that way in groups with people. She was usually very friendly and open. She had a magnetism that drew people, and she got very into things. She would get so into something or into somebody, like some new person she met or some new thing she started doing or some new place she started living, that she would want everyone to move there or start doing this thing or know this person. Me and Jenny were joking that when Maggie moved to Hudson, she was telling everybody how great it was, and she wanted everyone to move there. Now she's kind of moved on into the next cool thing, like the next realm—she's gonna be telling us how great it is and that we should come there.

LB: In the meantime, she is still so alive through the words and photos she posted. Was she always taking pictures?

JR: Once the whole iPhone thing started to happen. Before that, she was a photographer of sorts and definitely loved pursuing that. But it was really more of that instantaneous, journalistic pictures of the moment, and now there was a forum for it. I never really got into Facebook until Maggie started doing it. Then I would look every day, to look at Maggie's post. They were always so clever and funny and witty, along with the pictures.

LB: When did you first meet her?

JR: In 1999, 2000. Then I remember googling her. I read *Soft Maniacs* first, and I called her up and said, "Oh my god. I'm so happy. I love that book." She was worried that I wasn't going to like it. I love all her books.

LB: Were any of them going to be adapted for film or TV?

JR: Wren Arthur and Steve Buscemi have a film company, and for years they wanted to make either a series or a movie from Maggie's Hex series—*Gargantuan* and *Flamethrower*, the Ruby Murphy character. A lot of the books take place at the horse stables in Brooklyn, at the Federation of Black Cowboys. This was something she really wanted to happen. A little over a year ago, I got a call from Maggie's agent, and they optioned the book and then re-optioned it again this year. Steve was at Maggie's memorial and read a letter Maggie wrote to him and then a piece about Lou Reed Maggie has on her blog, "Lou Reed Died." It was heartbreaking how you could just replace a lot of the words and the feelings with "Maggie"—and she had written it.

LB: When did Maggie write?

JR: She was very organized. She wrote in the late morning and worked through until the late afternoon, every day, always at the same time—late morning through later afternoon.

LB: Then she got her real estate license. It's interesting, because writer Chris Kraus—also in this anthology—did real estate. Was Maggie really doing it toward the end or just starting?

JR: She was starting. Like anything she does, she got it in her head. She was struggling to make a living. When we lived here together, we used to go upstate and always look at places and torture some real estate guy. Anyway, she got the idea of doing real estate, so she went to school for it up in Albany. She was a little worried about the math test, then took it and passed and got a job with a pretty big real estate company. The last time I was up there, she was doing her time in the office on a gray Sunday in January. We're just sitting there with the dogs, Spike and Mickey, when these people walked in—this big blonde and some weird gangster guy. They were like, "We want to sell our house." They were such characters. It was such a Maggie thing. They were talking about how the house used to be owned by this famous gangster in the forties. Maggie took the name and stuff. When they left, we were both just like, "Whoa, did that just happen?" It was the strangest thing. But she now had a listing.

LB: Maybe real estate would have given her more material for her blog. She was so funny and accessible. Women felt they could be her best friend.

JR: She was a powerful woman and especially a big inspiration to college girls.

LB: Did she ever talk about stripping?

JR: No, but as she wrote in her blog, "I always used to figure if I got really broke, I could be a stripper again, but at this point I wouldn't be getting top dollar."

TRICK

Chris Kraus

I n the late seventies and early eighties, I worked in the topless hustle bars owned by "the Jewish Mafia." The clubs thrived for a while, and then closed at the dawn of the AIDS epidemic, when the New York City Department of Health shut down most of the bars and all the gay baths.

I can't really separate the clubs from my sense of that time in my life and that of the city. There was a feeling that the club world would always be there and would go on, but then it ended abruptly. What stopped it, for me, wasn't AIDS—I got out before that—but the installation of a large restaurant exhaust system outside one of the two windows in my small East Village tenement. Prior to that, the apartment, backing onto an airshaft, had been kind of a refuge for me. Through the tiny crack between buildings, I observed the changing of weather and the seasons. How quickly we adapt to our prisons. A slab of vertical sky, one or two trees, nesting sparrows.

I started my dancing career at the Adam and Eve on the Upper East Side, but I soon settled into working three nights a week at the Wild West Topless Bar on West Thirty-Third Street, one of its down-market sisters. Located on a seedy block near Penn Station, across from a church and two doors from a trade union office, the Wild West was equally lucra-

tive but much less competitive. It had an old neon sign with a pair of average-size tits and a lasso. The Wild West was one of four or five places owned by Sy, Hy, and three other guys who made up "the Jewish Mafia." Old, bald, in cheap white button-down shirts with their bellies hanging down over their belts, the owners looked almost identical. Rotating between clubs to collect cash and check over the books, they otherwise kept a low profile. At the Wild West, Ray Mazzone was in charge of us girls. He was about thirty-two, lived in Queens, and said he was married; he spent about fourteen hours a day at the club. Ray was the one who hired and fired, figured our pay at the end of the night, and made it his business to know who was strung out, who was just chipping, whose boyfriend was beating her up, and who was giving out "action" in the back rooms. He kept a chart ranking our bottle sales by the night, week, and month. Ray was everybody's best friend. The girls told him everything.

At that time in New York, there were still old-school burlesque clubs featuring big-name professional strippers with managers. There were "bottomless" bars that offered "hot lunch," where customers put fifty bucks on the table to get a faceful of cunt. But the Wild West didn't offer these things. The Wild West was all about hustle. While dancers were paid twelve dollars an hour to show up and dance alternate sets, the real money was made selling bottles of ersatz champagne.

The hustle began on the long T-shaped table that served as a stage. Whenever someone gave you more than a $1 tip, you gave him all your attention and tried to sell him a split. One split equaled $35, which equaled fifteen minutes of conversation on a banquette, which you used to push the next drink. It was a dream of eternal postponement. For $150, a guy could buy us a magnum, served in a curtained back

room. These dates lasted about half an hour. Given this framework, giving out "action"—any sexual contact that would result in a customer having an orgasm—was, though not completely forbidden, discouraged and obliquely punished. Because once a guy spent, he'd stop spending. Patiently, night after night, Ray taught us the ground rules for romance and dating. Don't put out. Don't act like a hooker. Because once you do, the hustle is over. And he was right. Because while a guy might offer you a big tip for a blowjob, he might not deliver. And then, where would you turn? Better to keep the guy hoping, buying champagne . . .

Girls who gave action were whores. They were not in control of the game. A "good" girl could keep a customer entranced out on the floor over three or four splits and then get him to celebrate the budding romance in the back room with a magnum. A really good girl could keep the guy ordering magnums until the club closed at four or his American Express credit line was exhausted—whichever came first. "You're artists," Ray told us. "You're showgirls."

In a way, he was right. A thin vestige of glamour surrounded the hustle—faint echoes of silvery black-and-white films, good girls gone astray in the big city, the Great Depression. "Would you buy me a drink? Then I won't have to dance the next set." Waitresses in fishnet stockings and cigarette trays uncorked the bottles of ersatz champagne with a flourish while Ray ran the guy's Amex. "Would you care to order another round for the lady?" When one of us hooked a promising mark, Ray got on the phone to some primitive gray-market hacker to find out how much the guy had on his line. Sometimes he got the good news that the card had no ceiling. Ray transmitted this news to the girl via the waitress, and so long as the customer stayed, that girl was Ray's special princess. Ray, at these times, was like

Daddy. The system worked well because it was so close to routine heterosexual life. The toxicity of the club lay not in its demeaning of our "femininity," but in the putrid, despicable sense of all human nature it revealed or engendered.

* * *

I liked coming home from the bar in a cab around four in the morning. I'd get into bed, sometimes still in my clothes, and read myself to sleep. Cabs lined up outside the club when our shift ended, and I rode downtown in the deep quiet. Once, I was in a cab, and the driver pulled out a knife and told me to give him a blowjob. But that was only one time. In bed, I read Joyce, Merleau-Ponty, Djuna Barnes, all the Greek plays, and Colette. If I could fall asleep before dawn, I could wake up at ten or eleven not as "Sally West," my club name, but as myself, with the mysterious addition of two or three hundred dollars' cash on the dresser.

You make me feel like dancing / I wanna dance the night away.

But the days between shifts passed by in a daze. Within this pile of cash, there were usually thirty or forty dollar bills creased in a vertical fold. These were the tips that customers inserted into my G-string (or, more often, lace nylon panties; the dress code in the clubs at that time was not very exacting). It was an era of humanist generalism, before specialization ruled. No one had silicone implants. Any tits—so long as they were attached to a person who could cajole men to buy outrageously priced fake champagne—would do. Likewise, the definition of "dancing" was loose. "Dancing" consisted of jiggling around on the stage to let the men know you were available for a "date" in the back room. I remember using these bills at the delis and

drugstores and restaurants in the East Village, wondering each time if the (usually female) cashier knew from the vertical fold how I'd acquired the bill. The folded-up bills were every whore's signifier. Any girl who'd ever danced knew.

It was 1978, and then it was 1981. My life could have gone on like that for a very long time, but when the exhaust fan was installed three feet from my bed outside the window, I could no longer come home late and sleep undisturbed into the morning. The prep cooks turned on the fan when they came in at eight, and it roared. The sound scared the sparrows, who stopped eating the seeds on the fire escape. I could no longer pretend my room was a monastery. The fast swirl of capital was putting an end to this dreamtime all over Lower Manhattan. Vacant one-bedroom apartments were now renting for $1,400 a month. The hardware store on the corner turned into a paella restaurant. Karpaty, the Polish shoe store downstairs, was replaced by Bandito, the first in a rapid succession of high-concept pig troughs that did business there.

Within months, the street was alive with ambition. With their short skirts and high heels, the Bandito waitresses looked more convincing as sluts than I'd ever looked in the clubs. Everyone was going somewhere. This extreme movement forced you to look at yourself, where you were. Time was no longer so aboriginal. In this new environment, we who just wanted to sleep looked like pale maggots under a freshly turned rock, abruptly exposed to the sun.

* * *

A typical night at the Wild West found Maritza onstage, doing her floor work. At forty-five, this Dominican grandmother was well past her prime as a dancer, but that didn't

stop her from grinding her cunt near a customer's face with a smile. She wore rhinestone pasties, G-strings, a marabou boa—the only girl in the club with real costumes. As a professional, she was stiff competition for the rest of us junkies, aspiring writers and artists, and rock-and-roll whores. "Look at Maritza!" Ray would say when one of us stepped out of line or was suspected of giving out action.

Maritza knew how to turn on the charm. She was often the night's top-ranked bottle seller. No one knew much else about her. She confided in no one. While the rest of us bitched and complained and swapped the most intimate confidences, Maritza dealt only with Ray. (Though, no matter how close to each other we were in the club, these friendships stopped as soon as we walked out the door. In "real life," us art girls crossed rooms to avoid saying hello at parties or openings.)

Gabrielle, waitressing on her "working holiday" from Australia, walked briskly around pushing drinks. Tall, athletic, with long chestnut hair, she wore her fishnets and leotard like a school uniform. No one could figure out why she was here. She had no drug habit, abusive boyfriend, or illusions about being an artist. For reasons we never knew, she had chosen to share our place in hell.

Brandy was a stupid slut from the boroughs who liked to walk over and jiggle her tits in a customer's face just as you were closing the deal on a split. This served her well, because despite her limited conversational skills, Brandy sold lots of bottles. Mary, a pretty blonde woman, had two kids and an unemployed coal miner husband. She caught the bus in from Allentown two nights a week and slept on a girlfriend's couch. Lorraine was everyone's negative role model, the girl in the ratty pink slip you don't want to end up as. She had track marks all over her arms and cigarette

burns on her legs. Susan (now a lawyer in Silicon Valley) had her own band.

The night shift began around seven p.m. The day girls—mostly bridge-and-tunnel types who saw this as a regular job—changed and went home. Costumes were more or less optional. Girls danced alternate "sets" (six jukebox songs), and the rule was that whatever you wore over your underwear had to come off by the end of the first song. Your tits had to be bare by the end of the third; then you used songs four through six to hustle splits and do floor work.

Selling splits didn't excuse you from dancing, but you were let off the next set if you were in the back room on a magnum. Until eight or nine, the clients were straggling New Jersey commuters, guys who just wanted to see some bare tits on their way home from work and who had no intention of draining their wallets by getting into the game. Best case, they'd be good for a split. They already knew you'd use the fifteen minutes to try to sell them a bottle, so this rarely worked. Often, you'd just give up and let them tell you their problems. *Listening* was a lower-grade failure than giving out action, but they were in the same class because you'd lost control of the game.

The real hustle began later on, around nine or ten, when our real customers, the ones from Manhattan, arrived. These men were professional gamblers just back from Las Vegas, solitary stockbrokers in three-piece blue suits, advertising executives, foreign businessmen, frat boys, and furtive lawyers. Literal sex was not what they came to the club for. As Ray liked to point out, they could get blown in Times Square for less than the price of a split. They were legitimate hustlers in their own right, and I guess they got off seeing the hustle reduced to a girl's desperate bid to protect her own piece of pussy.

Keeping these guys in the back room ordering magnums was vastly more difficult than jerking them off. For a hand job, you just closed your eyes and took out a Kleenex. But to keep a guy ordering, you had to dig deep into yourself to sustain the con. My worst moment of shame came in the back room one night when I'd run out of banter. I didn't know how to talk to the guy. Unlike most of the others, he was not intelligent. Exhausted, I let him put his cock in my pussy. He left without tipping. Two nights later, I had to pay Ray back my share of the bottle because the guy had called Amex and disputed the charge.

Lawyers were my special niche. They had the best sense of irony. Sitting there in my thrift store jacket and boa with my legs spread, I was a study in cubism: lips mouthing well-bred, earnest truisms about postcolonial theory, hand guiding their hand up under my skirt. It was, on a deep level, hilarious. And at these times, my pussy often got wet.

* * *

These are some of the songs we played on the jukebox:
"Bad Girls"
"The Tide Is High"
"Heart of Glass"
"Shame"
"Ring My Bell"
"Super Freak"
"Heaven Knows"

* * *

I didn't have a regular boyfriend during the years I worked at the club. Outside the club, I rarely had sex. For a while,

a man who called himself John came in at ten p.m. once a week, bought me a magnum, and tipped me seventy-five dollars. On our first night together, during the very first split, John said, "*I have a hobby.*" His hobby was cunnilingus. John knelt on the floor, and I lay on the couch, lifted my long lace-tiered skirt, and pretended I was pretending to come.

During the day, I worked for trade unions doing theater with old people. My life at that time had become completely improbable. But at times like these, I believed. Like everyone else who worked in the clubs, I was always trying to leave. Girls saved, quit to travel in Europe or start their own business, and then came back broke three months later.

A few months after the exhaust fan went up outside my window, a friend got me a job teaching college. English Comp., Greek and Roman Literature. I didn't have any degrees, told them my records were "lost in a fire" at a university ten thousand miles away in New Zealand. I taught under a false name, with a false Social Security number, so I could collect unemployment from the trade union under my actual name at the same time. Meanwhile, the college itself was defrauding the state and federal government by enrolling dead and fictitious low-income students and collecting tuition grant reimbursement. The scam came straight out of Gogol's *Dead Souls*, one of the books we were teaching.

Two years later, the whole thing got busted.

INTERVIEW WITH CHRIS KRAUS BY ALLIE CARR

Alison J Carr is an artist and writer who holds a PhD from Sheffield Hallam University. Her book, *Viewing Pleasure and Being a Showgirl: How Do I Look?*, was published by

Routledge in 2018. She is a lecturer at the University of Huddersfield.

ALLIE CARR: How did you prepare for that kind of experience—dancing in a titty bar?

CHRIS KRAUS: Like any shit job, you try and let it take as little out of your life as possible. I tried to keep living my life until half an hour before work. Then I'd throw my clothes in the bag, get a cab uptown, and be "Sally West" for seven or eight hours, two or three or four nights a week. The rest of the time, I tried not think about it, except for buying the costumes. In those days, they were not very elaborate; it was all thrift store stuff: a ratty blue feather boa, a little 1940s fitted jacket I'd wear with a pair of spike heels. You had to wear makeup and heels, but beyond that, it was not very exacting. The students I met in LA when I arrived in the mid-nineties who were lap dancing had to be *so* into it. It was much more professionalized. I could never have done that. *Art students* getting silicone shots to better compete? I mean, shit.

AC: So, you never felt that you did things to your body like waxing or shaving that you wouldn't have done ordinarily?

CK: No, you didn't have to do those things. I don't think I even waxed. All you had to do was get up in some nylon underwear or a G-string and a feather boa and shake around and sell drinks.

AC: Did you have dance training or enjoy dancing in nightclubs?

CK: Like anyone studying theater, I'd taken some dance. But, really, you could do anything—jiggle around, do an interpretive modern dance—so long as your top was off by the end of the second song. By the start of the fourth, you had to be on the floor. It didn't look anything like what you see in the clubs now. There were no poles—just a table where you'd get up and jiggle around. It was a hustle—getting an empathic line into the guy and figuring out how to play him best. What is he looking for? How can you make him spend?

AC: Is there any part of that that you enjoyed?

CK: Well, I liked to do it well. Doing it "well," of course, just means making more money. The more bottles you sell, the more tips you get. I did get a certain kick, as a nascent writer, in being able to get this verbal dance going with some of the men. I was good at that. About a third of the women were art girls, and everyone had their own thing going on. Some were rock musicians; one was a choreographer—her thing was much more physical. Mine was more verbal.

AC: Why were there were so many kinds of artsy people in the scene?

CK: Because it paid very well. You could just walk in, get hired, and make three hundred dollars a night, which was a lot of money at that time. Three hundred dollars equaled about three weeks of rent. The reason I needed so much money was that I was starting to produce my own plays. That was expensive, and I didn't have any other means of support.

AC: Did your experiences change your attitude toward your body?

CK: It took me years to cultivate a relationship to my body *after* doing that work, because I became so detached from the sexuality I had to project in the club. I wrote a little about it in *Aliens & Anorexia*, dressing in camouflage gear and being completely asexual whenever I wasn't in the club. I didn't have a boyfriend for most of the time I was doing that work.

AC: Was that your way of recuperating from overexposure?

CK: It was confusing. Because if what went on in the club was "sexuality," it had nothing to do with me. Going out to CBGB at night, I'd see these girls stuffed into these bustiers with their tits hanging out and wonder, *Why would you do that if you're not getting paid?* It was years before I could reclaim any femme quality, or sexuality, in my persona.

AC: Looking back, was there anything interesting about the interactional element—talking to the clientele as a stripper?

CK: In my case, it was more conceptual, not sex talk at all—more like engaging people through stories or digressive conversations about ideas. I guess I was practicing to be a writer. I was reading all the female Japanese court writers at the time, *Tales of Genji*. Or *Scheherazade*, where the story itself becomes a form of seduction. I had my niche. I did really well with lawyers. I did well with a certain kind of hustler, people who were cynical and had a strong sense

of irony. The clientele were a particular type of person. Anyone who just wanted to get off could walk four blocks over to the piers and do it for twenty bucks. There was plenty of vastly cheaper actual sex to be had. Like gambling, the hustle bars played into somebody's hubris and masochistic streak at the same time. It's complex, a way of losing yourself. Like in a casino, there were no clocks in the club. Time would just disappear.

AC: So, you must have learned something about men?

CK: For someone who already had a fairly jaded and misanthropic view, the work in the clubs certainly reinforced it.

AC: So, you went with your misanthropy?

CK: It was reinforced. No matter how intimate things felt during the con, there was always the moment when the customer would wake up and abruptly leave. A curtain dropped; the connection was broken. They had a strong instinct for when they'd had enough. At that moment, the tables turned, and it became clear they'd been using you like a drug. So, that was a toxic double helix, enacted over and over again. The girls were not nice to each other, and the management was abhorrent. I mean, everyone was just out for themselves. It was, like, a perfect microcosm of real life.

AC: Were there any silver linings to this cloud?

CK: I don't know that I regret doing it. I would have preferred to have independent money and not have to do that, but given that I did not, and it seemed imperative at the

time to produce those plays, it was a way of pursuing my work. When I see younger women doing it now, I don't see a happy outcome. I don't want to be the person who says, "Don't do that," but given how professionalized it's all become, I don't see any way for the woman to win. It just takes you down this very dark street. The risk is that it takes over. You always begin by seeing it as a means to an end, but gradually it becomes the content you're working with.

AC: Were you conscious of gathering ideas for future writing about it at the time, compared to the women you were dancing with?

CK: I don't know. But because I was kind of *whoring* my charm, my relation to it got kind of messed up, or maybe clarified.

AC: Did it take you while to get back into being "charming" for yourself?

CK: Any kind of charm got channeled into my writing. This is not the same kind of charm you exercise to teach or give a reading. Charm as seduction is something else. It's a tool, a mask . . . a mask that I used a great deal in writing *I Love Dick*. That book was a kind of performance . . . and the idea of the mask was very important. I remembered it from studying acting. The mask isn't fake—it's more an aware-ness, a slight exaggeration or a push of certain gestures or tendencies you observe in yourself.

AC: Do you think about theater school and stripping, your kind of work, as being something very similar, because they were happening at the same time?

CK: Yes. The work in the clubs is a kind of performance, but you're always in an abject position because you need to go home with three hundred dollars, and if you don't, you've wasted the night. Performance and writing have other objectives than money. It boils down to a class-based thing. If you need money, you will always be in an abject position of need. In Colette, all the old whores play the stock market or buy real estate. In *Cheri*, the narrator spends afternoons with the other courtesan retirees discussing their stocks.

AC: It's interesting that you use the words *abject* and *glamour*.

CK: I'm writing something about Simone Weil right now. Among other things, she worked on a Renault factory assembly line for a year and a half, work that she—as a philosopher, klutz, and sickly, underweight person—was extremely unsuited to. But she believed the leadership of the Communist Party, of which she was a part, had become very estranged from the physical experience of what it is to do routine factory work. She needed to have that experience in her own body before she could "represent" anyone in that situation. And it was completely abject. Deadening. Any work you do purely out of financial, survival need is probably going to put you in an abject position. It's the same for someone competing for tenure. So, my goal became to be independent. And I did that.

AC: Was the abject something that was revealed to your customers, or was that something that this kind of mask that you've mentioned prevented them from seeing?

CK: Oh, no, they ate it up; that's what they're there for. The debasement that they're witnessing is part of the kick.

AC: So, you didn't feel that you were creating an impenetrable body—you didn't feel that you were becoming a hard body to them, but you were a soft body.

CK: I never had that kind of commitment or conviction to the physical mask. I know what you're talking about, and I think people who have to do the pole dance thing, who have to do a much more professional version of it, that's probably how they cope. But I wasn't nearly halfway down that road of professionalism, where it became that. It was pure dilettantism.

AC: Do you think that saved you psychologically in the long run, that lack of commitment to it?

CK: No, I mean nobody wins, right? Nobody wins. The damage for me was this estrangement from myself, going through these porno-calisthenic moves while my head's someplace else. A cubist mind-body split. It's not a desirable thing. I don't really think there's any way to beat it. It became important to me to make my own money after that, and not to be dependent on others.

AC: How did you manage it?

CK: After arriving in LA, I saw a chance to make my own money, and that seemed better for me than the tenure track line. I bought apartment buildings that give me some rental income, and that allows me to decide when to teach and for whom. I'd be in a very different position now as a writer if

I didn't have that income. I always felt strongly about the singularity of my work and knew it wouldn't be easily fundable. This is awkward, maybe, to disclose, but I think it's important: especially in the United States, people are led to believe that there's something wrong with their work if it doesn't result in financial security when, in fact, many of the most prominent artists and writers have relied upon outside support for at least the first part of their careers.

It's almost impossible to create a body of work and do all the professional networking things that go with an art career if you have to work thirty or forty hours a week at something else. So, in a way, working in the titty bars at that moment in New York in that dilettantish way was almost like the GI Bill! After World War Two, the GI Bill enabled anyone who'd served to go back to school for free. For the first time, working-class people had access to four or five years of free time during their youth. A lot of amazing artists and writers who might otherwise not have appeared developed their work thanks to the GI Bill. Poets like Ted Berrigan, Ron Padgett—all those people who came from lower-middle-class families in the Midwest had that leisure given to them. And it was a great thing. So, that's the upside; I couldn't have afforded it otherwise, I guess. The titty bars did provide a certain amount of free time to young women who couldn't have afforded it.

ROBBIE'S MARDI GRAS

Jodi Sh. Doff

The ad read, "BARMAID NEEDED—NO EXPERI-ENCE NECESSARY." If there was anything I had plenty of in 1975, it was no experience. Every once in a while, I'd show up at a local topless bar with Michael for a few drinks or to shoot pool. Michael and Debbie had been together since the night we'd all dropped acid, but Debbie was too much of a nice girl to go to a strip club. I'd go any-where I thought people would buy me drinks, or anywhere I thought men were looking for women. I'd found both at the Raven's Nest, but drinking at the Nest hadn't prepared me for the hallelujah chorus that was Robbie's Mardi Gras.

The double glass doors of Robbie's opened into a per-fect storm of mirrors, colored lights, blasting disco music, and then more mirrors. I stared, mouth open, taking it all in until I felt someone staring back at me. I looked up into his face, soft and leathery like an old catcher's mitt; it was a face that could've launched a thousand gangster movies. He said his name was Ralphie. I told him mine.

"'T'sa boy's name," he said, with a snort I took for a laugh. "Dja mother wanna boy and get stuck wichoo?" One side of his face moved, just the one side. Ralphie snorted again, like a bulldog when he's happy or excited or about to bite you, and half his face smiled at me. I stood, still speechless,

mesmerized by his face and the huge glittering palace that swelled behind him. "We'll come up with sumpin' better later. Dancer or barmaid?"

"Barmaid?" I hadn't expected a multiple-choice test. I hadn't expected anyone would look at me and think I was sexy enough that being onstage could even be an option. I don't know what I'd expected.

He raised one eyebrow. "Can ya mix drinks?" the right side of his face asked me. I shook my head no. "Can ya open a bottla beer, liddle goil?" He bent down to look me in the face, as if I were either the town idiot or a small child. I felt like both at that moment, but opening beer bottles—there was something I had plenty of experience with. I nodded yes. "Good," he said, standing back up. "Now, can ya close your mout 'n folly me?"

I closed my mout 'n follied.

I'd arrived. Times Square was the center of the world; the doorway to a three-ring circus at a human freakshow, and Robbie's Mardi Gras was center ring. At a time when every other business in Times Square was a peep show, a porn theater, a go-go bar, dirty book and video store, or one of those second-floor joints that advertised "Nude Models for the Casual Photographer," Robbie's was the largest topless bar in New York City. I stood behind one of fifteen cash registers horseshoed around three stages. I was all the way in the back of the bar, but I was there. Sequins, feathers, balloons, and streamers swirled around bottles of gemstone-colored liquids; mirrors caught neon and threw it back in dizzying patterns. Outside, the air was thick with automotive exhaust, the sweat of panhandlers and chain snatchers, cheap cologne and vomit. Inside, the air was cool and conditioned, infused with cigarette smoke, the glittering sweat of beautiful women wearing little more than cheap per-

fume, and the intoxicating smell that happens when there are dozens of open bottles of every liquor you can imagine. The speed rack staples: vodka, gin, tequila, scotch, bourbon, rye whiskey. The rest of the rainbow: sambuca, anisette, ouzo, grappa; Galliano, Pernod, Rémy, Hennessy, Martell, Courvoisier, Drambuie; crème de menthe, crème de cacao, crème de cassis, crème de café; the twins peach and peppermint schnapps; Grand Marnier, amaretto, Frangelico, Kahlúa, Tia Maria; Campari, Cointreau, Curaçao. There was red wine, white wine, champagne. And coolers filled with brown bottles of ice-cold beer.

Outside, Broadway blared, traffic stalled and honked; everyone was rushing somewhere more important than where they'd just been. Inside, I stood center ring, and as long as I didn't mind working in a skimpy leotard, I smiled and charged high prices for short drinks. I had a job—a job where not only were my drinks free, but where the more I drank, the more money I made. In my first afternoon, I would make eighty-five dollars, cash money, more than I had earned in a week at my file clerk law firm office job. I never wanted to leave.

In my brief career in the corporate business world, the rules were frequently unspoken and confusing. In the half-naked-lady business, the rules were clear. Girls were paid cash money to be sexually attractive, but not available, to men who were willing (or who could be coerced) to spend more cash money on exorbitantly priced drinks.

Life is easier when you know what's expected of you. Robbie's expected me to be sexy, so I was. My parents never expected me to work in a strip club, so I lied. I told them I worked in a restaurant in Manhattan. I took the train in from Long Island each day, changed into a leotard, layered the makeup on, made my money, took the Long Island

Railroad back home, and slept. Fred had more time alone with Elayne, I had my freedom, and because I was expected to be self-supporting, and now I was, they felt they were doing a good job as parents. It was three cherries on the slot machine. It was seven on the first roll.

* * *

I'm three when I learn to shoot craps.

"Don't you take the kid's money," my mother yells from the kitchen.

"If the kid's gonna learn to gamble, the kid's gonna learn to lose."

I'm three when I learn don't risk anything you're not willing to lose. It's one of my earliest memories. My father takes my three pennies when I lose, a week's allowance. But it's his way of teaching me to count, his way of giving me an edge. *One plus three is four, two plus two is four* the hard way. *One plus one is snake eyes. One and six? Craps. You lose.*

I'm three when I learn to play blackjack. I can add up to twenty-one like nobody's business by the time I start first grade. Fred teaches the boy cousins about dealing from the bottom of the deck, spotting marked cards, palming dice and switching the loaded pair in or out of the game. I never learn enough to really be in the game, but I start school knowing when to hold, how to bluff, how to spot a tell.

* * *

The ladies of Robbie's Mardi Gras were a spectacular range of what a woman could be. They were Little Annie Fannys and biker bitches and divas and Jewish-American princesses, West Indian, Brazilian, and all-American. Like

walking along the beach collecting sea glass—they were both different and somehow the same, each one beautiful in a way that set her apart from all the other beautiful things there.

Raven was pushing the hard edge of thirty: bony, tattooed, and black-leathered. She took me under her wing and turned me into an honest-to-goodness go-go bar barmaid. I learned the basics: how to mix scotch and soda, Manhattans, and whiskey sours; how to pour a beer; how to use a shot glass to short-shot the cheapskates, overpour the tippers, and never get caught doing either; how to "drink" without getting drunk. She turned me into a polyglot, as long as no one expected anything more complicated than *salud*, *skoal*, *prost*, *l'chaim*, *kanpai*, and *chin-chin*. *La propina no está incluida*. At the end of each shift, Raven folded the wad of bills from her tip cup into her pocket and straddled the bitch seat of her boyfriend's Harley, and they rode away down Broadway. I wanted to be Raven.

The women were a virtual Crayola 64-pack of sensuality; the men a package of No. 2 Ticonderoga pencils badly in need of sharpening. They were working stiffs on a lunch hour, drinking lunch and maybe their rent money. Sometimes they showed up at lunch and forgot to go back to work, or came after work and forgot to go home. They were unremarkable men in white short-sleeve shirts and two-dollar ties with nothing interesting to say outside of "Can I buy you a drink?"

* * *

My father was full of swash and buckle, a charming liar with a hypnotic gaze and an encyclopedic knowledge of useless trivia and small-time cons. He wore black jeans

and a green felt fedora. He was nothing like the Unremark-able Men in the Mardi Gras, nothing like the clean-shaven, cigarette-smoking, buttoned-down fathers around our neighborhood. Fred and his life before my mother were a tough act to beat, but I was finally in the same league as him, beginning a life that would give me my own collection of entertaining stories. I was even a step above. I could have had a bumper sticker made: "My Topless Bar Can Beat Up Your Burlesque House." I was sure he'd secretly be proud of me if he knew where I worked. The inside of Fred would be proud, anyway. The outside of Fred would be angry, because where I worked would have made my mother cry.

I had cash, but the short-sleeve shirts and two-dollar ties weren't exactly pushing one another out of the way to wave dollar bills in my face. I had a body that appealed to Black men, Puerto Rican men, and old Italian men—I had small breasts, a small waist, and an ass you could hang on to in a storm. Even without the attention of the two-dollar ties, though, there was rarely an empty barstool in front of me. My section and Raven's were almost exclusively Black. These men were not the Coloreds of the National Association for the Advancement of Colored People, nor the Negroes of the National Negro Congress, nor even the Blacks of the Black Panther Party or the Black Power movement. Raven and I had pimps.

Pimps were not like regular men. They had more in common with the go-go bar owners and managers than they did with the men drinking next to them. The Times Square bosses were usually men (and usually Mobbed-up men) who solicited customers for strippers and/or live

sex shows in return for a share of the earnings. In other words, like the pimps, the bosses were also panderers and procurers. The difference was really one of semantics. And legality.

Every day on Forty Deuce pimps turned out wearing new displays of feathered hats, polyester suits, and matching shoes of crocodile or alligator (crocogators) in cool orange sherbet, lime Jell-O, grape jelly. A smart pimp doesn't drink much; he prefers to remain clear-headed and in charge. If they drank at all, they wanted drinks that sounded classy or faintly foreign: Harvey's Bristol Cream sherry or Dubonnet. They wanted cocktails that matched their outfits and coated their stomachs—Golden Cadillacs and Brandy Alexanders—cocktails that needed shaking. And they came to see me shake.

They tipped—a five- or ten-dollar bill slid slowly over the bar for a two-dollar club soda, the offer of change waved away, sometimes without even bothering to make eye contact. The wave said, *I don't need to look at you to know you're waiting there, girl. You're insignificant; you need to work harder if you want my attention.*

Pimps think topless dancing can be a gateway drug to a life of prostitution. The ones sitting at my bar were betting on it.

❊ ❊ ❊

Every choice grows out of something: I would eventually dance topless when I got bored working behind the bar. I worked slinging drinks in a go-go bar because I was fired from a law firm. I was fired from the law firm because I wouldn't pay attention to the penis on my desk, because I wanted some choice in the matter of who I fucked. Because

I had fucked too many people already, because I couldn't imagine anyone would want me if I didn't. Because I couldn't stand to be with myself. Because it was too loud in my head. Because my parents had a bad marriage. Because in the late fifties, divorce was not a thing a woman took lightly. Because my mother's mother was divorced, and it was the Depression, and it wasn't easy—you can't even imagine; she worked all the time. All the time. That kind of if/then logic is like that Passover song: "Then came an ox and drank the water that quenched the fire that burned the stick that beat the dog that bit the cat that ate the kid my father bought for two *zuzim, Chad gadya, chad gadya.*" It goes on and on. With that kind of thinking, it follows that the stock market crash of 1929, a year before my mother was born, was responsible for my desire to be a prostitute.

Years and years after all this, when I am ten or twelve years sober, a friend's cancer will come barreling back after eight years of remission, at the same time as I find myself also extremely ill. Someone will invariably say how it isn't fair that his cancer is back, or that we've both gotten clean and sober just to wind up sick and frail. And he'll say, "Life isn't fair. You don't get what you deserve, you get what you get. What you do with it is the measure of your character."

It would take me a long time to get enough character to measure.

<p style="text-align: center">✳ ✳ ✳</p>

But I was telling you about pimps. Like a grifter setting up a mark, or a gypsy reading tea leaves, a good pimp is always reading signs, spotting weaknesses, and subtly manipulating those weaknesses and fears. When someone discovers your weakness, sooner or later they'll use it against you. I knew

that like I knew the world was round, like I knew I was safe in the dark, like I knew I'd die if I stopped breathing.

The arguments between my mother and father always ended with her crying into her hands while he stood silently. Years passed like that. Like a scratched record *skipping skipping skipping*, playing the same short piece over and over. Once, when I was five or six or seven, I found her in their bedroom crying, ripping clothes out of the drawers and throwing them into a suitcase. She was leaving; she couldn't do it anymore. I don't know the particulars of the fight they'd had that day. What I remember is being sent upstairs by my father to "look in" on my mother. I was his secret weapon; he knew I was her weakness. She knew if she didn't get out then, she never would. She never did.

Romantic love is a trap, the soft underbelly that sooner or later gets ripped open. In 1975, I was still operating on the axiom that women give sex to get love. I gave a lot of sex to get love; what I got was a lot of sex. I was available to one-night stands, married men, possibly gay men, definitely gay men, men on their way to prison. Having learned to subsist on emotional leftovers and scraps, when faced with a full hot meal, I couldn't breathe. I was always hungry, I was afraid to eat, and I would settle for crumbs. I was the only one who couldn't see what was plainly written on the sandwich board I wore. Pimps saw it from a block away.

Enter: Jasus J. Huntsberry. Everyone who knew him called him JJ, and everyone on the Deuce knew him. It seemed like he'd been leaning on that bar just waiting for me to arrive. Skin as smooth as pecan shells, sleepy gray eyes behind delicate gold wire-rimmed glasses, and a voice soft as an inhalation. His suits were tailored and dark blue with a subtle pinstripe; his shoes, handmade of soft leather. There was a stillness to Jasus J. Huntsberry, a bit of quiet in

the middle of the Mardi Gras chaos. In the thrum of Times Square, amid the garish flap and display of other pimps like chattering parrots, he had the coo and quiet of a mourning dove.

At eighteen, I was loud, rebellious, and I got louder with every drink. Like a magpie, I was attracted to anything that glittered or sparkled, snatching it up to eat it, wear it, or have sex with it. I could certainly see the charm of a rainbow gator shoe or a pistachio green three-piece polyester suit. I knew these men wanted to turn me out, put me to work. You can't fault a predator when he goes after prey; it's his nature. It is in the nature of a pimp to think of all women as a potential source of income. He starts by knowing that he is better than, smarter than, in charge of, and that he deserves money from every woman he meets—and that he is doing her a favor by making her decisions for her, because without him, she'd be lost.

JJ waited quietly while the others strutted, and while he waited, I began to see that he was different from the pimps who were trying to play me, trying to run a hustle. JJ was a pimp, and a pimp has a singular goal, but how that's achieved, *well*, it's the difference between being an egg-laying hen raised in a factory farm—drugged, held in a space too small to stretch your wings, forced to produce around the clock, and when you're no longer profitable, being left to die—or being hand-raised on a small farm. Either way, you end up as chicken soup, but one way, it's a much sweeter journey to the stewpot.

For two years, every night since my father tossed Snake out of the house, I'd been having the same dream: It's 4:04 p.m. on July 27, 1980, four days after what will be my twenty-third birthday. The train cuts me into pieces every time. I'd dreamed that dream over seven hundred times by the

time I got to Robbie's Mardi Gras, dreamed it so long I believe it's telling the truth: I have no future. What I have is a little less than five years left to do whatever I want, and what I want is to be one of Jasus J. Huntsberry's hand-raised chickens.

JJ tried sanding down my rough edges and pointing out the fine line that separates sexy from sleazy. At diner dinners, I watched him treat waiters with respect and receive respect and good service in return. I learned the value of silence, to defer and demure, that men liked it when you let them choose. When we were together, I felt charmed and charming. At after-hours bars or other strip clubs, he liked me to mingle, and I did, safe in the knowledge that we'd leave together. I felt like I had choices that wouldn't leave me crying into my hands. I felt a sense of control.

JJ taught me about men: what they thought they wanted, what they really wanted, and how to read them. I'd already picked up a lot of those skills from Fred. My father never really read tea leaves, or palms, or crystal balls; he read people. A good grifter can't afford to miss or forget details. I watched people all the time, studied the way they dressed, walked, spoke, even the way they sat. Did his shoes need resoling? Was there a missing button? Were his shirts frayed at the collar or cuffs? Are his nails manicured or ragged and bitten? Is there a ring of pale skin where a wedding band should be? Does he order top shelf or cut rate? Compile enough data, and a portrait begins to emerge. Toss out the bait and wait for the tell. Let them taste it, run with it until they're hooked, really hooked. And then reel them in, subtly shifting your story as needed. Con games are based in story—knowing which one to tell, whom to tell it to, and how to tell it. The best storyteller always wins.

If I wanted to make any money working in the Mardi

Gras, or anywhere else on the Deuce, those were the kinds of observation skills that were essential. I was the Artful Dodger to JJ's Fagin, although he saw himself more as a Henry Higgins to my Eliza Jewlittle. He saw something in me I couldn't, that potential my schoolteachers said I was never living up to. If I really applied myself, I could be JJ's girl: his top moneymaker, his bottom bitch.

Some days, at the end of my shift at Robbie's Mardi Gras, I found my way down to his Gramercy Park apartment. Some nights, we had dinner, or drinks, but every night ended with JJ hailing a cab and pointing it toward Penn Station. Every night ended with me sitting on the Long Island Railroad, heading back to my parents' house, untouched. Years later, a sweet-hearted pimp would explain that pimps don't fuck for free. I hadn't been earning anything for JJ. I wanted to work, to get paid for what I'd been giving away for free. I couldn't imagine it would be much of a transition, but everything had to be done in his time. I was like a kid on a long car trip: "Are we there yet? Are we there yet?" He'd let me know when I was ready, he said. Maybe it was part of his strategy, that cliché about treating a tramp like a lady and a lady like a tramp. He treated me a like a lady. Always.

I settled for part of him. I needed a new name, a work name, for Robbie's. I took his. Like a branded cow, carrying his name let everyone know JJ was looking out for me. I wasn't the baddest ass in the bar, but I carried the name of the coolest cat on the street. In doing so, I felt safe from the reach of gorilla pimps who relied on violence and intimidation to turn out new fish like me. So, we were Little JJ and Big JJ.

* * *

I was coming home with five times more than what I had made at the law firm, and it wasn't enough. JJ wouldn't let me start turning tricks, but I was ready for something. The dancers at Robbie's were the cheese in the go-go bar mousetrap, and I wanted cheese money. I wanted to be the main attraction, the show everyone came to see.

If I wanted to be onstage, I needed an audition. Ralphie let me borrow a G-string from the office, a worn blue number with a stiff glittery fringe that itched. It was a small triangle of shiny, coarse material, the lining soiled with the bodily fluids of the anonymous girls who'd been there before me. The milky stain on the lining taunted me, daring me to be the next to give it a try.

The girls, dancers and barmaids, smiled and nodded at me as I walked to center stage wearing nothing but borrowed shoes, a borrowed G-string, and chutzpah that was all my own. I couldn't exactly do a striptease, and I had forgotten to put something on that I could tease off.

And then I started to dance. I heard music, inhaled it. Dancing, high above everyone, machine guns exploded out from my nerve endings. My nipples were hard; my skin taut, electric; my mouth dry. The world spun. Faster, and faster than that. My shattered reflection danced with pieces of me wherever I looked: two of me, three of me, dozens of me. Dancing, spinning, twirling. Dancers watched me. Men were watching me. Everyone was watching *me*.

Suddenly, with no warning, I was beautiful. I mattered. Suddenly, I was something more than just available.

Then Ralphie barked, "Hey, let's see some floor work!"

The bubble of glorious angels singing my praises in strobe lights and mirrored walls burst and shattered at my feet. Floor work? I'd never heard that phrase, didn't know what I was expected to do. I stopped.

"Pretend you're on top, c'mon," he said.

I'd just turned eighteen. I'd never been on top, and no one with any style had been on top of me yet, either, though thirty-four boys had climbed on top of me at some time. I'd already had more men than most women have in a lifetime, but still, I didn't have a repertoire. I was a one-trick pony: I was easy, and I kept secrets. Okay, I was a two-trick pony.

Ralphie brought back reality and expectations I couldn't live up to. I wouldn't admit that to him, though. I'm my father's daughter, and we are fake-it-till-you-make-it kind of people. We are lie-with-a-straight-face kind of people. We are never admit-you-are-wrong-or-ignorant-even-when-the-undeniable-proof-is-right-there-in-front-of-everyone people. Although her intention was elegance, even my mother's advice—"When you don't know which fork to use, watch the person next to you"—was just a nicer way of saying, "Don't ask, fake it." In other words, look around for someone else doing floor work and do what they do.

I looked around. No one was on the floor; everyone was looking at me.

I tried to imagine being on top, what it must be like to be a man with a woman beneath him. Lying facedown onstage, I began doing push-ups. Humiliating girl push-ups, the ones we do from our knees. When I looked at the mirrored column in front of me, I saw a chubby, naked girl with coarse, unruly dyed hair and swamp-green eyes doing sissy push-ups in borrowed high heels on a wooden stage in front of strangers.

Ralphie didn't ask me to dance again after that day. But there'd been a minute of complete abandon. A minute when I was *in*—inside my own skin, inside the invisible bubble, inside a secret society. A minute or two, no more. But in that moment, I'd been beautiful and free and lovable.

* * *

Back behind the bar, I danced in my head and hustled champagne. The champagne hustle was the lifeblood of go-go bars. Offstage, a girl's time was measured in bottles; the bigger the bottle you bought, the more time she'd spend with you. A small screw-top bottle (a "nip") cost twenty dollars. At the end of the shift, champagne sales were tallied up, and if you'd sold two hundred dollars or more in champagne, you took home 10 percent of your sales. Anything less, and the house kept it all.

Whether a screw top or a magnum, the champagne was the equivalent of a box of wine: bottom shelf, a sloppy drunk, and a mean hangover. Spit or swallow wasn't a question: girls were served an empty frosted "chaser" glass (a spit glass) with every bottle of champagne. I've never been one to spit out perfectly good alcohol, and I've always considered any alcohol I don't have to pay for to be perfectly good. With nothing but pimps at my bar, I rarely had champagne bought for me, but when I did, I didn't bother with the frosted spit glass.

Ralph and the other bosses didn't like JJ more or less than any other pimp, and if it was just him, they might have let me slide. But as far as the bosses were concerned, I was attracting the wrong kind of man. As the pimp procession settled in, they left less and less room for the middle-class white guys—those scotch-and-soda, gin-and-tonic boys; the respectable married guys who are always paying someone: the ones who buy the champagne. Every time even just one of them complained to a boss, I'd get marched into the back office in the middle of my shift. Ralphie's jowls shook when he yelled at me. "I don't pay ya ta talk ta niggers! Jus' give 'em their drinks, take their money, move on ta the next guy.

JODI SH. DOFF

Why's this so fuckin' hard ta unnerstand?" He ran a meaty hand through his thick hair.

Pimps didn't buy champagne. I knew that. Hustling champagne was how the bar made its money. I knew that, too. But I also knew where *my* money came from. The tips I pulled in from the pimp parade provided me with five times my shift pay. I wasn't about to bite the manicured hands that were feeding me.

"You barely pay anything at all. My shift pay is fifteen bucks, and I make a hundred a shift in tips, easy. I'm here to make money, same's you."

There was a sign on my bedroom wall at home, a gift from my father, that read, "ENGAGE BRAIN BEFORE OPENING MOUTH." I needed a lot of reminding. Things tended to just fly out of my mouth with no consideration of the consequences. Chubby white girls from the suburbs? We were a dime a dozen. The Mardi Gras would not feel the loss of me, I knew it, and yet, still, my mouth kept on running. "Why is that so fucking hard for *you* to understand? Do the math, Ralph, just do the math."

Ralphie got up, hand in his hair again, and stared me down. I sensed I might have overplayed my hand.

"Ya got a smart mouth. Ya like spending time wit'cha jungle bunny muthafuckas? Ya can spend every g'ddamn day'n night wit'em. Getcha crap'n get outta here."

I pushed past Ralph, out of the office, and back to my station behind the bar.

"Little J?" JJ's whisper slipped through the blaring dance music. The music felt louder, pounding the inside of my head, battering down everything except my anger. I grabbed my clothes and my tip jar from behind the bar. I turned to leave and bumped into Ralphie; he was cashing out my register.

JJ reached across the bar for my hand; I handed him my bag, my clothes, my tip jar. "I've been fired"—I cut my eyes at Ralph—"for talkin' to NIGGERS." I was loud. I wanted everyone to hear.

"Get the fuck outta here!" Ralphie shoved me down the bar. The other barmaids watched. The dancers continued dancing. The Two-Dollar Ties continued drinking.

"Shift pay, Ralph?" I held out my hand, cocked a hip, and smiled.

"You don't work a full shift, you don't get paid. How'dya like it when I do the math?" He smiled back and puffed his chest out.

"Fuck you, Ralph, just fuck you. I don't need your god-damned fifteen bucks."

JJ walked out the door with me as I pulled my jeans on over my leotard. With JJ at my side, nothing really bad could happen. We'd find me another place to work, he said. I was meant for better things, he said, than Robbie's Mardi Gras. It would be years before I could figure out what those things were.

INTERVIEW WITH JODI SH. DOFF

LIZZIE BORDEN: You're a prolific writer. To start, how much education did you have?

JODI SH. DOFF: I have three useless degrees: an associate's in theater arts, which means I can be a waitress; a bachelor's in English language, which almost everyone here already speaks; and an MFA in creative nonfiction, which nobody even knows what the fuck it means. None of these will get me a job or a raise in pay.

LB: What kind of student were you in high school?

JSD: I graduated high school at sixteen. I was using drugs and drinking, but I was still a good student. I combined my junior and senior year and graduated a year early.

LB: You grew up in a middle-class household in Long Island. When did you start drinking?

JSD: I started around eleven, twelve, thirteen. By the time I was in junior high school, I was drinking before class and drinking during my lunch break. By fourteen, fifteen, I was drinking in bars. Levittown was about as middle class and clichéd as it gets. It was designed for returning vets, a cookie-cutter community with "ticky-tacky houses," filled with retired cops and firemen and working-class people from Brooklyn, Queens, and the Bronx. We didn't fit in. My father was a photographer, so, the only guy running a business out of the house, the only one with the goatee, and certainly the only one who played the bongos. He wasn't any good, but he liked the attention. And my mother worked as well, back when mothers didn't do that. She was also involved with civil rights. There was a Rainbow Coalition coming in and out of our house in the middle of lily-white Levittown. There was a codicil in the original Levittown lease that you could not sell to a person of color—Black or Asian.

LB: Do you think that prohibition led you to Times Square and Black pimps?

JSD: My mother has blamed my father for that all my life, and there's some truth to it. I grew up on his stories. He was a storyteller—mostly lies, but it was all fabulous. He told

me about the burlesque shows where he was a bouncer, and I grew up knowing about all the old-school strippers and pinup queens, like Tempest Storm and Bettie Page, and I knew what split beaver was by first grade. I was drunk on all his stories, and we had a complicated relationship. I'm still trying to define that relationship. I wanted to be him, I wanted to impress him, I wanted to be better than him, I wanted to win—but I never really could get his attention. That was what led to Times Square.

LB: Did you have boyfriends?

JSD: I had sex with a lot of people, but boyfriends are a whole other thing. I had sex the first time a few days before I turned fifteen, because I was curious, and the second time because I thought it was a badge of honor . . . I didn't really understand how to be a girl. I was a big, bumbling bull in a china shop. I've never had an internal editor; I said the wrong things, didn't know how to play the game. I just wasn't very good at it. I grew up with all this sexual knowledge, because my parents subscribed to this Montessori train of thought about not hiding things, everything is fine, so you don't have that repressed "you're a bad girl if you have sex" thing, but they didn't count on the way I was going to take it. Like my dad used to say, "Men give love to get sex, and women give sex to get love." There was a lot of that with me. I didn't think I had much else to offer, so with nothing to barter for love, I learned to be very good at sex. It was a survival tool.

LB: Pleasing your father?

JSD: No, I wanted to be better. My dad was a bouncer in

the burlesque shows; I got onstage as a stripper. He rode a motorcycle; I rode with the Hells Angels. It was a one-up competition. When I would run these little cons, I felt like, if he knew, he'd be proud of me, because he raised me on con men and con games. We used to take family drives into the city, and he'd point out all the hookers on Delancey Street and wherever—because there used to be hookers on Delancey Street and the West Side Highway—and I would think, *Oh, it's the sexy women that have his attention.* So, when I started getting high in Washington Square Park, I just sort of migrated north to Times Square after I graduated high school. Stripping, at that point, was the perfect job for a drunk girl like me. I had all this access to booze, no boundaries, and no restrictions. At the time, it felt like bravado, but really, looking back as an adult, I see that sex was the only language I had. I didn't know how to have a real conversation for a really long time.

LB: But your father was a great storyteller. Why did you have no conversation?

JSD: Telling stories is not making conversation. I felt unattractive, I was awkward as fuck, I'd do anything for attention. I was working with nothing as far as belief in myself.

LB: Do you think your mother was competitive with you?

JSD: Absolutely not. She was fine-boned, tall, a hundred eighteen pounds her whole life at five feet nine, gorgeous red hair, and very patrician-looking, elegant. She couldn't be anything but beautiful. My father was focused on her, and my mother was always focused on me. So, my *father*

was competing with me for my mother's attention. It was horrible. Nobody won. We all lost.

LB: It's interesting that this was the dynamic when you got up onstage.

JSD: When I got everybody's attention, it was amazing.

LB: Where did you go after Robbie's Mardi Gras?

JSD: I went to school for two years, got a degree in theater, and became a bartender. Robbie's Mardi Gras closed and, a block away, Paul's Mardi Gras opened. It was just as big, just as glamorous and glitzy, the biggest club in the city at that time. I'd been bartending at various topless bars and then drinking at Paul's Mardi Gras afterward, and I started going up onstage once in a while. I had no act, but I had fabulous nipples. I could take my clothes off and hang them from my nipples. That was it. That was the whole act. I had to hope that impressed you, because I really didn't have any-thing else. I was dancing in cowboy boots, which nobody was thrilled with, but I couldn't dance in heels. I was lousy at chatting men up and hustling for drinks, which is how the bar made its money. So, I'd dance for a couple of weeks, and when the novelty of "Oh, look, the barmaid is dancing" wore off, I would go back to bartending, and it'd be, "Oh, look, the stripper is tending bar!"

The thing was, I'd found my tribe, and the great thing about being in Times Square at that time was that no matter how fucked up I was, I was fine. I was sitting next to murderers and jewel thieves. I was a little bit of an outsider, because I had a college education, but I've never felt so much a part of anything as I felt there then. The guys who

did the live sex shows at Show World would come drink at our bar, and then we'd go watch them perform. Then we'd all hang out at Bernard's, where all the porn stars were from the Melody and the Harmony. It was just a small town of the same hundred girls who were circulating, trading bars. You work at the Golden Dollar this week, then you're at the Mardi Gras, Billy's Topless . . . or Diamond Lil's! That was a bottomless place downtown where men could pay to eat a girl out. I'd hang out there while one of my girlfriends sat onstage, smoking a cigarette, with some guy going down on her, and we'd be having a conversation. She'd have her cocktail, and I'd have my cocktail, and we'd be having a conversation.

LB: When did you leave Paul's Mardi Gras?

JSD: Around 1985. I fell in love with this male prostitute, and I didn't want him to work anymore, and he didn't want me to work, either, and we tried to build a life together. We were together for two stormy, madly-in-love years. I'd throw him out or he'd storm out, but we'd always get back together. The last time we split up, he moved to Florida, and we kind of lost each other. I got sober in July 1990, and he died six months later, from complication from AIDS, in February 1991.

LB: At what point did your rape happen?

JSD: Nineteen eighty-two. By a pimp. I call him Sammy in a story I wrote about it, but, really, I've blocked his name out of my head. He was big; he looked like Sinbad, the comedian; and he had a burn mark in the center of his chest where he used to grind cigarettes out on himself. Sammy

and I would hang out, hit the after-hours clubs. I wasn't interested in him; it was just fun.

We'd been at a friend's doing coke all night. It was late, or really early in morning, and I suggested he stay at my house because he lived in Jersey and had to be in the city early the next morning, so I suggested he sleep on my couch, which was actually a double bed in the living room. I fell asleep up on my loft bed, and he was going to bed on my "couch," and next thing I knew, he was coming up the ladder wearing my fuzzy red Christmas robe and crawling into bed with me. I kept a knife in my bed, and when he was on top of me, I remember thinking the blade wasn't long enough, because he was such a thick guy, that all I would do was anger him, and how, in a loft bed, there is no way out. I remember thinking, *I'm just going to let him do this, and then he'll leave.* And he did, and I thought he was leaving, but he wasn't.

He came raging back into my room, saying I had stolen this ring of his and how this girl had worked so hard for it and who did I think I was. I hadn't stolen anything. He had me dress up in this long negligee I had. And I had all these ties around my house. If I fucked a guy who wore a tie, I kept the tie. It was my thing, like a scalp for fucking a straight guy, a "regular citizen." So, I had all these ties hanging off my ladder. He tied me up with the ties, tied my arms and gagged me. He fisted me in the ass looking for this ring, and then he dragged me over to the toilet and ordered me to pee and shit in front of him to show that the ring wasn't hidden in there. He was out of his mind. I was crawling around on the floor looking for a way out, for the missing ring. This went on four or five hours, him throwing lit cigarettes and matches at me.

The ring was in his pack of cigarettes the whole time. It was a turnout. After he "found" the ring, he untied me and

said, "I'd never do anything to hurt you; I love you, and I'll see you later," and he left.

I called my job, said I'd be a little bit late, that I had had an accident. I cleaned myself up, went to work with my face all fucked up, bruised and burned, and I wouldn't tell anybody what had happened. He showed up that night, tapping that same little pinkie ring on the bar, asking for a drink. The bosses put two and two together when they saw how I reacted to him being there and eighty-sixed him. These were Mob guys who were supposed to be taking care of me, but they only banned him for *two weeks*. I went downstairs and curled up with my bottle of vodka. That was the reason I left that bar.

LB: What effect did the rape have on you? PTSD?

JSD: I broke out in hives from head to toe. The skin on my face cracked. The skin on my scalp cracked. The doctor told me I was allergic to soap, but of course I hadn't mentioned the rape. So, I haven't used soap on my face since 1982. When I wrote about the rape years later, I broke out in hives again from head to toe. It took years to not blame myself. I'd always felt that when you walk into a snake pit, you'd better expect to be bit.

LB: At what point did you start to write?

JSD: I didn't start to write seriously until I had a class with Louise DeSalvo, a Virginia Woolf scholar, who really supported my writing about this time in my life. Then my best friend started *BUST Magazine* as a 'zine, and she asked me to write for it. I wrote under the name "Scarlet Fever," because we all had clever noms de plume like "Selena Hex"

and "Tabula Rasa." It was an incredible opportunity to grow as a writer and get feedback as the magazine was growing. Susie Bright was editor at *Penthouse* at that time and bought one of my stories, so I started writing a little soft-core porn, still under the name "Scarlet Fever." I think my first check was two hundred dollars. I blew the check up and hung it on the wall. What I'd like to do is write the best sentence in the world.

THE GOOD PASSENGER

Terese Pampellonne

My first driver, Charley, was a balding, overweight, middle-aged sales rep for some kind of plastics company. For fifteen dollars plus toll he drove me back and forth from my Manhattan apartment to the clubs in New Jersey for two years, spending hours with his over-size frame wedged into his meticulously clean subcompact. He didn't so much steer as hover over the wheel, gripping it tight enough for the knuckles of his hands to glow white. He didn't see too well, either, and his bottle-thick eyeglasses gave his eyes an almost maniacal bulge. The constant qua-vering in his voice hinted that a nervous breakdown was not too far off. When he claimed he was a doomed man, there was no reason not to believe him.

His problem was that he was crazy in love with this go-go dancer named Diane. Like Charley, she also didn't belong in the go-go scene. Diane was beautiful but very overweight by go-go standards—a difficult thing to accomplish while addicted to cocaine. Because of this, the only places that would hire her were the clubs in the Portuguese section of Newark. These clubs were small and dark, lit only by the neon beer signs hanging on the wall or by Christmas lights strewn around the stage. The better establishments might throw in a mirrored disco ball. The effect always cast

a ghastly light upon the unshaven, dull faces staring up at the high stages; high enough so the men could avoid the dancers' eyes and gaze up into their crotches instead. The alleyways and side streets of Newark were lined with these clubs. No one there spoke English, and they liked big-bottomed, wild-haired girls like Diane.

I wasn't very good at my job, but at least I didn't have to work the Portuguese clubs. When Charley picked up Diane, I was usually with him, having finished my shift earlier in the night. He wouldn't allow me to stay in the car by myself because the neighborhood was so dangerous, but I hated going inside those bars. It was always the same scenario: blaring Latin disco would greet us, along with the suspicious glares of the half-drunk, angry men. At least, I thought they were angry. Maybe they were just bored.

Charley hated these bars more than I did because we'd always find Diane in a precarious state, but every night he drove her home safely, he was her hero. At least that was how I felt about him: as soon as I saw Charley waiting for me by the door of wherever I was working, I knew everything was going to be okay; the nightmare of these places was over, if only until the next shift.

Charley would do anything for Diane—even put up with her sidekick, Janet, whom she insisted he drive, too. He was usually very particular about the dancers he drove, but Janet was the exception. She was a coked-out British Joan Collins look-alike, and around Joan's age, too, which is why she danced in the same clubs as Diane. Charley used to tell me he knew Janet was feeding Diane the drugs, that he put up with her for Diane's sake, but Janet flirted with him in a menacing way, and that might have been the real reason. Either way, at the end of each shift, they'd both climb into Charley's immaculate, pine-scented car, reeking of cig-

arettes and beer. Then Diane would drunkenly dig into the food Charley always had waiting for her, while Janet chopped up a line of coke.

I actually preferred this to the rides I'd take with Charley alone. Our route always followed the New Jersey Turnpike, and as it snaked endlessly through the industrial fields of Elizabeth, Linden, and Newark, Charley would cry. Tears streamed down from under his thick glasses as we passed by lakes of sewage and sludge on either side of the highway. While towering infernos belched out black cinder and foul fumes weaved their way through the car's vents, Charley would quietly tell me how he often thought of killing himself. He just couldn't understand why Diane was throwing herself away on a life of drugs and losers. He couldn't see why she couldn't just love him the way he loved her.

"Charley," I said once, "I don't think you're ever going to find what you need in these go-go bars." From what I'd seen, the whole scene was one big, miserable tease, a lie. I didn't want to come right out and say anything against Diane, but he knew what I meant. I could tell by the way his hands tightened around the steering wheel as he stared off into the Dantean Jersey night, repeating how lonely he was and how all he wanted was someone to love.

I tried to understand, but secretly, I was thinking that Diane was never around for the tears and how I sometimes hated them both. None of it mattered, though. Charley was too wrapped up in his desire and loneliness to listen to me, and to tell the truth, I was just as much to blame as Diane. It was our need that kept pulling him out into the wastelands of the New Jersey go-go circuit. Diane, Janet, and I were a trio of sick Sirens calling him to his end, which came after Diane's family finally gathered her up and took her back to Chicago. Around this same time, I stopped driving with

Charley: he'd had a few accidents, and then I heard through friends that he had tried gassing himself. Not long after that, I received a Christmas card that read: "Thank you for being a good passenger and a good friend." But I never wrote back. I didn't know what to say.

My new driver, Louie, couldn't have been more different from Charley. He was an ex-con who worked as a construction worker by day and drove go-go dancers by night. I knew that he had had a hard life; he'd done time for manslaughter and statutory rape, but the way he described it, it had all happened *to* him, not because of him. He didn't like to smile, because he had a few missing teeth, but you never got the sense that life got him down. If anything, he seemed to thrive in spite of it.

Driving with Louie was much different from driving with Charley. Louie cracked jokes and would travel anywhere in Jersey to pick up a girl, whereas Charley never wandered far beyond Diane's prescribed route. The first time I rode with Louie was during the worst blizzard the East Coast had seen in years. I was dancing at the Caboose in Bloomfield, and at closing, the manager was ready to turn me out onto the snow-layered streets, ride or no ride.

I had taken the subway from Newark to get there, but because of the weather, all public transport had stopped, and as I stood in the parking lot in a snow drift up to my knees, I cursed Louie. I was sure he would leave me stranded—but it was just at that moment that his beat-up Impala with the missing door handles and mysterious grumble came swerving down the empty street at five miles an hour. The car was full of other stranded dancers, and even though I had to sit on their laps for a two-hour trip back to Manhattan, I knew then that, with Louie, I would never have to worry about getting home.

Sometimes he could hit eighty driving down the Jersey Turnpike in that old Impala, steering one-handed while snorting lines of coke with the other. I refused to sit up in the front with him, because all he had for a seat belt was a frayed rope entwined somewhere underneath the seat legs. Still, whenever he picked me up, he would open the front door almost hopefully, even though I always climbed into the back. Any conversation we had was held via the rear-view mirror.

The Impala was a far cry from Charley's ever-green-scented Ford, but I was no longer so sweet-smelling myself. Now I was doing lines of coke on Louie's backseat after long nights of dancing for men who would just as soon spit at me as look at me. I'd cry on Louie's shoulder, and he would always listen. If he couldn't pick my spirits up with a kind word, then he would with a line of coke. I came to understand why Diane behaved the way she did with Charlie. Every once in a while, Louie would say to me, "You know how I feel about you, don't you?" More usually, he would just laugh and say something like "Well, I'll always drive you wherever you want to go." Louie protected me, and not only because he stood six foot two and weighed two hundred pounds. He protected me from foul weather, depression and, in a way, loneliness, as much as I hated to admit it.

This all changed once the Mad Russian came on the scene. That's what Louie called her, because she would get knee-drop drunk while working—so drunk, he said, that he sometimes had to carry her out of the bars. Her real name was Mia, and she was Israeli, not Russian, but since her accent was foreign, Louie just arbitrarily dubbed her a Slav. Mia always seemed to need help getting up, and of course, Louie was always there to oblige.

At first, he used to try to make me jealous about her. After late-night shifts, he'd prattle on about what the Mad Russian was up to now. He liked to recount how she would sit in his car, drinking out of a bottle of vodka long after they arrived at her home, and tell him she wished she would just fall off the stage one night and break her neck. Once, in slurred confidence, Mia told me why she did the things she did: "Oh Terese, I have to drink while I'm on the stage. If I didn't get drunk, I'd cry instead, and you know how bad that is for tips."

Louie's tactics, however, didn't make me jealous; they only made me feel for Mia more, since we seemed to have a lot in common. She was a singer, I was a professional dancer, and then there was our relationship with Louie. Was he our friend or just a driver? Was he enabling us, or were we just taking advantage of him? Like when he would tell me how the Mad Russian would beg for lines of coke during and after her troubled nights.

"I give it to her," he reasoned, "'cause if I didn't, someone else would. Just like I tell you. But don't think I don't tell her she shouldn't be doin' it. Besides, that girl ain't going to fall off no edge of a stage if I can help it." A less cynical person would think these gestures were merely that of a valiant friend, but his retelling of them always made me uneasy. Sometimes, in evil moments, I used to think Louie might be working a little too hard to keep us where we were.

One night, Louie picked me up at the end of my shift at the Riviera, in Hackensack. I knew something was wrong the moment I saw him. He didn't come in to the club to get me, as he usually did. When I stepped out into the empty street, all I could see was a shape, slouched down, almost hidden in the front seat of the Impala. I had to knock on the window to get his attention, and it took him a second to

rouse. He opened the front passenger door, and I reached in and unlocked the back, as usual. I told him he looked like crap, and he snorted under a sheepish grin.

"I ain't ever felt worse," he said. "Me and the Mad Russian? Hung out last night. In fact, I blacked out." He was craning his neck, looking at me through his rearview mirror.

"You blacked out?"

"Yep," he said and then started the car. "I don't remember a thing."

I went home that night and didn't give it another thought until the next day, when I ran into Mia at a bus stop. It was late afternoon, and I was on my way to an evening shift. Mia was on her way home, which was odd, because Louie always drove her. But there she was, sitting on a curb, wearing dark sunglasses, her head on her forearms. I walked over.

When she saw it was me, she covered her face with her hands and began to cry. Then she took off her sunglasses and began pressing the heels of her palms deep into her eye sockets. She begged me never to let Louie drive me again and said she had thought of Louie as a friend until last night. They had been hanging out in her apartment, drinking and listening to music while she was trying on some costumes. At one point, she changed her top in front of him. The next thing she knew, he had thrown her down on her bed and was on top of her.

"He raped me," she said, holding up three fingers. "Three times he raped me. At the end of it all, I told him I wanted to die. He dragged me over to my balcony and held me over the railing. 'You want to die? Then let me help you, because I ain't going to jail for no stupid bitch.'"

No one believed Mia except for me. She quit dancing not long after it happened.

I never spoke to Louie again. It was easier that way, to

pretend that Louie was never really my hero and that Charlie was never really a friend. I got through those Jersey nights all right, but it was only because I'd taught myself not to look too closely at what I was seeing, or hear what was being said.

INTERVIEW WITH TERESE PAMPELLONNE

LIZZIE BORDEN: You used to be a professional dancer. Did you perform with a company?

TERESE PAMPELLONNE: I was classically trained in ballet but was drawn to modern dance in my late teens, when I first saw the Alvin Ailey dance company perform in Detroit. Later, I moved to New York with the hope of dancing with them, oblivious to the fact that it wasn't likely that this primarily African American company was going to hire a white midwestern girl like myself. But I did receive a scholarship to their school, and the training I received there took my dancing to another level. While performing with dancer/choreographer Bebe Miller, I was spotted by Elisa Monte, the founder and director of one of the premier dance companies at that time. I was asked to audition, was accepted, and from then on traveled extensively with them.

LB: How did you first learn about go-go?

TP: I needed to supplement my income when the company was on break. One of my jobs was dancing at the Cat Club in New York. It was basically a nightclub, but at midnight they put on a little show, like in the movie *Flashdance*. One of the Cat Club dancers told me about clubs in New

Jersey where you were paid a lot of money just to dance around in a bikini. I was a little self-conscious because I was so flat-chested.

LB: How did it feel to have small breasts in the world of go-go?

TP: There's a practical reason why go-go dancers get breast enhancement surgery. One of the ways dancers collected their tips was by pushing their breasts together so the guy could tuck the dollar into their cleavage, or they pulled their breasts out and wrapped them around the dollar. Either way, the guy usually copped a feel, but just looking at me, they could see that wasn't going to happen.

LB: Is that why you danced in New Jersey instead of New York?

TP: New York meant dancing topless, and that was a line I wasn't about to cross. A go-go club implies there's actual dancing involved, while going topless basically means you're nothing more than a pair of boobs. I was cocktail waitressing at Billy's, a topless bar in New York, for a short time, and sometimes I would watch the girls "perform." Basically, they stood there and played with their breasts—juggling them, bouncing them up and down, playing with their nipples. It looked humiliating.

New Jersey was a different story. The bars in New Jersey had rules, a go-go "etiquette," so to speak, that by law had to be posted in every dressing room. Your nipples had to be covered; no touching or contact with the customers was permitted; you were not allowed to touch yourself in a lewd or lascivious manner; tips must be placed in your hand;

flashing was grounds for immediate expulsion. Dancers were even required to wear pantyhose (though rarely any did). And if the owners didn't enforce these rules, the State of New Jersey had undercover agents that would. A bar could be fined or even closed down for any of these infractions. Working in a place with these guidelines made me feel better about what I was doing. If any guy gave me a hard time about wanting to put a tip anywhere but my hand, I had the rules to back me up. "Sorry. That's not allowed." I was so strict, some of them called me Mother Teresa.

Sometimes I was the only dancer onstage, because all the other women were working the bar. I didn't feel comfortable doing that. It felt like coercion. If you liked what I was doing, call me over and tip me! There were many times when no one did, and that didn't feel great. Fortunately, clubs paid dancers twenty-five dollars an hour back then, so I could still earn a good chunk of change without having to cross any lines I was not comfortable crossing.

LB: What did you use the money for?

TP: I started going to college near the end of my go-go days, about six years after I started. I was also trying to be financially independent from my parents. It didn't feel right to have them still supporting me when I was in my early twenties. But even with go-go dancing, I needed their help from time to time.

LB: You must have been okay with go-go, since you're the one who first introduced Jill [Morley] to it.

TP: I was actually ashamed of it. No one knew except for my closest friends. But as a writer, I figured that Jill would

see that the bars were fertile ground for material. One of my first attempts at writing was with another dancer. We wrote a play called *Go Go Go Go*. The premise was a struggle between two types of dancer, one who doesn't have any boundaries while the other has too many. We performed it only one time. It wasn't very good.

LB: Did go-go give you any sense of empowerment?

TP: Yes—but in a bad way. I was very angry when I was young and had no impulse control. If someone insulted me on the subway or street, I didn't think twice of giving it right back. It only got worse in the go-go bars. If someone insulted my body, my looks, I felt safe in insulting them back because there was an enforced barrier—the stage, the bouncers, the regulations. There were dark times during my time in the bars. It could be unbelievably depressing, and I used to imagine what I would do if I were middle-aged and still go-go dancing. I was sure that I would end up killing myself.

LB: But there were positive aspects as well. You met your husband, Bob, in a go-go club. How did that happen?

TP: By time that time, I had started acting, and I was writing a letter to my manager asking to get out of my acting contract. Because Bob was an accountant, I figured he wrote business letters all the time, so I asked him to take a look at it. He said it was one of the best letters he'd ever read. He wasn't like the other guys. He understood this was a job, never snubbed anyone, and most of all, appreciated my dancing. I think the first thing he ever said to me was, "You didn't learn how to dance like that in a go-go bar, did you?"

I think some of my best dancing was done on a go-go bar stage.

Although I used to think go-go dancing was a mistake, it actually expanded my creative life. I'm not sure I would have ever become a writer if it hadn't been for my experiences in New Jersey. Ironically, it was go-go dancing that gave me my voice, as well as a husband who, twenty years later, still likes to watch me dance.

SOME KIND OF ARTIST

Jill Morley

t was a long haul from Brooklyn to Nyack, a lot of time to think. I hadn't danced for over a year. I was an artist in the civilian world and had written and acted in a performance piece about go-go. Now I was broke. Real go-go—in bars, not on stages—was the only way I knew how to make a pile of money at once. Going back to go-go in New Jersey would be taking a step back. Topless in New York was a step forward.

That's what went through my head as Angela drove us to Lace, "Rockland County's Premier Gentlemen's Club." We were on the schedule for Friday's day shift. Driving upstate through the countryside that morning, we stared at the huge houses on hills with relief. Upscale men have upscale money.

Angela was working another double, the third that week. Still new to topless, she had danced the straight clubs in Jersey for twelve years. The drop in pay and years creeping up—her "ticking clock"—had sent her on a mission to try dancing topless for bigger bucks. At thirty-eight, she still had all the right go-go equipment: surgically enhanced breasts, fabulous costumes, and snakelike charm. She strategized as she drove, sun shining on her bleached hair and reflecting off alabaster skin that never saw the outside of a go-go club in daylight.

"Table dances. That's how you make the money in these clubs. My friend Beatrice told me she made twelve hundred dollars in a night! One night! Then it struck me. Of course, do it that way. Work them ten dollars a time. Ten dollars a song. Do a few in a row in between sets. Ya have it made! Me, I'm a mule. Doing those Jersey sets, half hour on, half hour off, waiting in the dressing room for the next one. . . . This is much more economical. No sitting around on your butt waiting."

Angela's eyes lit up and hit the jackpot in her brain when she talked about money. I wasn't as worried about making tons of it that day, although maybe I should have been. I'd eaten a potato for breakfast every day that week. Garbage bags had become a luxury item. But I was more concerned about taking off my top in front of those men. The closest I came to anything like that was working a bikini bar in Jersey with a neon sign outside that read, "sTOPLESS GO-GO." I still don't know if it fooled anyone into thinking they would see tits inside.

I'd been practicing by looking at myself from all angles when I got out of the shower. Were these "topless" tits? Would they stand up pertly when I danced? I always thought I looked like a boy with breasts. Craving hips since puberty, I'd pull the sides of my G-string up to give that illusion. I liked how my breasts looked strapped in, pushed up, and protected. I didn't want the men to see too much of me. I wrapped a towel around my hips and gyrated in front of the steamed bathroom mirror, hair slicked back, no makeup. My boyfriends had always loved my breasts, but they saw them only in the dark, in the heat of passion, attached to me.

"Beatrice said this place is slow until four," Angela told me. "We have to go to Diamond's. She said there are no pretty girls there. Rich guys come down from Connecticut,

and these out-of-shape Spanish girls dance for them. She made tons of money."

We went by a driving range, and I imagined the golfers coming in, having a few beers, and tipping us well, a true gentlemen's club. Golfers. We passed a monstrous, mirrored office building a half mile away, and I knew we'd be golden at lunch time. Angela saw it, too, and smiled.

A huge billboard heralded "LACE—1/4 MILE!" over a cartooned bottom half of a woman wearing stilettos and a lace G-string. She had a bottleneck waist and round hips that ballooned out like an umbrella. The club soon appeared on the side of the road, a huge wooden structure surrounded by a field. It looked like a farm or a warehouse, but, thankfully, there was a Mercedes car dealership across the street. "Lace" was written on a wooden billboard in cursive lettering.

"Good. We're the first ones here," Angela said excitedly. "We'll be the first ones up and out of here early enough to make my next shift at the Navel Base."

Angela made a beeline for the door, her bag of costumes bouncing at her side. I looked around at Nyack. It reminded me of where I grew up. I wondered if my dad's friends ever went to places like this. Or even my dad. Angela was talking to a man—a manager, bouncer, or deejay. Without introducing me, she motioned me to follow her inside. I took my long-unopened bag of costumes from the trunk. I hoped they didn't smell. I hadn't washed them in a year.

We walked on plush blue carpeting to the dressing room, passing enormous, tacky images of Amazonian women etched in glass. They looked like topless superheroes strapped in leather, ready for battle. One of them looked like Angela. When I pointed out the resemblance, she agreed matter-of-factly.

The dressing room had lockers, walls of makeup mirrors, and dozens of signs with house rules about putting a latex covering on nipples, styling hair and nails, and not touching the customers or letting them touch you during a table dance. One sign warned us to be careful: a few dancers had been arrested for prostitution.

"Did you see the Champagne Room? That's where the table dances are."

"Angela, I don't know what that is."

"What?"

"A table dance, how to do one."

"Sit down."

I sat in the dressing room chair, the kind we had in Sunday school, and Angela demo'd a table dance for me. She took off her shirt and did it in bra, jeans, and sneakers.

"You've got to get right in on them like this," she said, stepping in, straddling my leg, and leaning into me with her enhanced breasts. She shook them millimeters away from my face and brushed my leg with hers. Then she nuzzled my shoulder and blew into my ear.

"You do that?" I asked.

"Yes, it's very sexy. Men respond."

Men respond. It sounded so Pavlovian. One of Angela's degrees was in psychology. She tended to discuss behavior without emotion.

"And then, when you have them all worked up, you can get them to want more." She breathed heavily into my ear. I could smell her rose-scented perfume. She whispered, "Do you want to go again?" I did. She was good.

"Usually, they can't control themselves after the first, so you can get two or three in a row," she explained. "Especially, if you do it like that. Recently I've discovered that a little moan toward the end helps, because then they think

they're pleasing you. Also, when you ask for a table dance, don't just ask. Word it like this, 'I would love to dance for you. Would you like that?' The semantics are more pleasing to the ear."

She was brilliant. No wonder she made more than twice I did most nights we danced together. I spent too much time dancing, not enough time collecting.

A blonde with chubby cheeks and bangs came in carrying a cup of coffee, a gold necklace with big diamond letters spelling "SHANNON" around her neck. She took off her denim jacket, revealing a bad boob job and a chunky, tattooed figure. She didn't look the type gentlemen would prefer.

"Leslie, that you?" The barmaid stuck her head in.

"Yeah," the blonde drawled.

"I'll tell Sean you're here."

Her given name was Leslie? I couldn't imagine spending my money on a necklace with my go-go name, "Dylan," on it. Or worse, letting a guy pay for it. This must be her main gig. She eyed Angela up and down the way a dog sniffs another dog. Angela, blithely unaware, lined her lips the way her mother taught her, the way she taught me. Shannon put a quarter in the pay phone.

"Honey? The sitter got there just fine. Yeah. We'll see. The weather's real nice, it could be slow."

A doe-eyed Black girl in big jeans and an average girl with mousy hair sticking out of a red bandanna walked in, both regulars. They smiled at Shannon, chatting with her as they checked us out.

Shannon threw us a hostile look. "Sean booked too many girls."

Angela's head shot up. She challenged Shannon with a confident stare. The other girls drank their coffee and went through costumes, deciding what to wear first. The doe-

eyed Black girl smiled at me. I smiled back, hoping for some connection.

"Your first time here?" she asked.

"Uh, yeah. My first time topless, too." My lower lip quivered. "What's your name?"

"Bambi. You'll love it. I've only been at it two months. It's fun." She reminded me of a stewardess, sweet but not completely sincere.

Shannon hung up the pay phone in a huff. She looked at Angela and me, told us she was a porn star, flipped her hair, and walked out.

"She's a little deluded." Average Girl rolled her eyes.

"I'll say," Angela said as she rubbed rose oil on her legs. There was a knock on the door, a man's knock.

"You decent?" he called.

"Yeah," we all chimed.

Eric, our deejay, popped his head in. "Angela, Dylan, you're up first. The guys here mostly like rock, but I'll play whatever you want."

"Rock," Angela said.

"I like dance, rock, and funk," I said. "Mostly dance. Seventies stuff would be great. But good seventies. You know?"

"Yeah." He nodded, looking at his clipboard. "Bambi and Dinah, you'll be up next."

"I want to be called Thumper today," retorted Dinah—Average Girl. Bambi laughed.

"Whatever blows your hair back," said Eric. "He turned to Angela and me. "Who wants to dance the first set?"

"I'll go up first," Angela said. She turned to me. "You watch."

Angela wore a gold bra and G-string under a transparent gold evening gown and gold bangles all the way up her arms. I remembered her telling me to always make a good first

impression. She grabbed her purse like a briefcase and hit the stage. There were three guys sitting together, wearing white shirts and ties, and two men by themselves wearing blue jumpsuits, collars up. Eric cranked up Pearl Jam, and Angela began her set.

She immediately went for the poles on the vast stage and swung around them, head dipped back. Then she slid the evening gown up over her head and did the floor work she was famous for. She flung her arms down to her sides, her bracelets clanging together loudly. She'd told me that noise was an "auditory conditioning device" that made her feel like a warrior getting ready to "bring home the bacon."

On all fours, she pulled her G-string to the crack of her ass, humped the floor, and did this somersault, landing with her legs spread, her ass in the air, her head tucked underneath. It was not sensual at all, but quite a sight. Then she reached behind her back, popped her bra, swung it over her head, and threw it to a corner of the stage. Her breasts popped out, obviously fake, but so theatrical I wanted to applaud. This was better than the Ice Capades.

I looked at her audience of five, who watched in awe. They knew it was spectacular but didn't know how to react. She helped by getting off the stage, coaxing dollars from them with her prom queen smile and breasts clutched together in a bouquet. The white shirts inserted the dollars in between her cleavage, one at a time. She approached the blue jumpsuits, who did the same and left. I could tell this pissed her off, but it didn't register on her face. Angela was a master of illusion, a mistress of money. I recalled her telling me how she felt she was harvesting, plucking green leaves from men's hands, human ATMs. I wondered how she could feel that way and still work six days a week, three doubles at that.

"Gentlemen, straight from New York City, get ready for sexy Dylan!" Eric introduced me over the microphone.

Sexy? I was sort of glad I was dancing for only the three white shirts. It would be like a rehearsal.

I walked up the stairs to the stage in my two-year-old raggedy high heels and sequined thong bikini concealed by a black leather bustier. I wondered if the men would find me sexy. I did a catlike walk as if I were a drag queen. It was easier for me to perform that way. Acting. Embodying a character who wasn't afraid of her female sexuality, a man playing a woman. It was working. I had their attention. The white shirts and ties smiled lasciviously. Unsnapping the bustier from the bottom up, I took my time, teasing them. I was confident in this move because it was in the performance piece I had choreographed.

But when I saw the white shirts lustfully staring—men in a go-go club, not the art types at my performance—my cheeks became flushed, and I started to breathe heavier. It had been so long since I had danced or had real sex, I felt like an alcoholic who had been on the wagon taking her first sip of her favorite drink after a year. I ripped the last snap to the throbbing seventies beat, swung the bustier over my head zestfully, then dragged it on the floor in a sultry walk. I suddenly realized it was the middle of the second song. We only get three, and I hadn't popped my top or collected. The men started looking at their watches and talking to one another.

I'd lost them. I was losing my heat. I was losing. It was time. Both scared and excited, I imagined myself in my bathroom, gyrating in front of the steamed-up mirror. I imagined I wasn't in my body.

I pulled the string that released the top of my black sequined bikini.

Suddenly, my breasts were exposed. I don't even truly remember the moment. I was lost in the music, somewhere else. The white shirts held up their dollars impatiently—they needed to get back to the office. That woke me up: the green. My mouth was dry. I could hear the blood pulsing through my head as I stepped down from the stage into the pit, the moat between me and them.

Looking right in their eyes, I trapped each dollar between my breasts and transferred them to the garter on my left thigh. The garter was a new accessory for me, and I made the mistake of putting the dollars on the inside, where my legs came together. I could hear the dollars brushing against my skin, marking red scratches on the inside of my thighs, making the noise my corduroy jeans made in the second grade when I shuffled shyly down school corridors. I looked up and realized there were more men whom I hadn't seen come in; they were ordering beers and looking at me. But I had accomplished enough for my first topless set. I decided not to hustle the new guys. My heart needed a rest. Passing out wouldn't be sexy. Then I spotted an older man with a soft stare; he was wearing glasses. He smiled sweetly at me as Eric leaned into the mic.

"Let's welcome Bambi and Thumper to the stage. Thank you, Dylan. Dylan is now available for table dances."

I was? *Okay*, I thought, *I can do this. I'll set up my first table dance.* I walked up to the older man.

"I would love to dance for you. Would you like that?"

"Sure, stop by," he said.

Like a charm, that had worked. Angela ruled.

Bambi, transformed into ebony vixen, strutted onstage. Thumper followed, mimicking her stride. Exhilarated and shaky, I picked up my belongings, covered my deflowered breasts, and walked to the dressing room with feigned con-

fidence. On my way, I saw Angela's silhouette through the tinted glass of the Champagne Room giving a table dance to one of the white shirts. She was rubbing up against him, blowing in his ear. He was sure to go again. His colleagues waited impatiently by the front door.

Inside the dressing room, I felt a rush, the way I did after a good show. I realized I couldn't wait to go out and do it again. Shannon entered, dressed, put another quarter in the pay phone.

"Sweetheart, I'm just gonna go home. No sense in payin' a sitter when I'm not even makin' her wage . . . Yes, I'm tryin' to hustle the table dances, but these guys are duds. Some new blond girl is whorin' herself out there, gettin' all the dances anyway. Not worth it. I'll work tomorrow night. Bye, Pumpkin." She hung up the phone, slowly turned to me, and said in her trailer park drawl, "Your friend better be careful, or she'll get herself arrested."

"She's not doing anything wrong. I was watching her."

"Well, she must be, to be getting that many dances from the same guy."

"She's just . . ." I wanted to say "smart" but thought better of it. "A hard worker."

Shannon clicked at me from the back of her mouth and waddle-walked out the door, car keys in hand. Angela rushed in moments later, shaking, out of breath.

"Did you see that guy?" she asked.

"The white shirt?"

"Yes. Three table dances. He's so attractive. Feel this." She put my hand on her pounding cartoon heart, which was pulsing out of her chest.

"Wow! Angela, you all right?"

"Get me a paper bag. I need to breathe into it."

"Okay."

"But don't tell them what it's for."

I went up to the bouncer and got him to get a paper bag from the kitchen.

"What's it for?" he asked.

"Uh, my friend needs it for something. She's not feeling well."

"Oh," he said knowingly, but not knowing really.

He gave it to me, and I brought it into the room. Angela breathed into it.

"This has never happened to me before," she said, alternately breathing into the bag and talking. "Most the men I dance for are not handsome. I never get emotionally involved." Breathe. "Or hormonally." Breathe. "But he was also classy . . . had money." Breathe. "An intellectual, I think." Breathe. "Table dancing is another animal," she said. "Did you try one yet? There are a few more guys out there."

"I set one up like you said." I was proud. Approaching people was not something I did.

Angela knew this and looked surprised. "Good girl," she said. "Don't even change costumes. Get him while he's hot."

I wouldn't have described this man as "hot." I checked myself in the mirror quickly. I didn't like looking in the mirrors at the club. I didn't like seeing the lines that had crept around my eyes that weren't there when I first started dancing.

I grabbed my cover-up and left, passing a man who was looking at me that way, that table dance way. I raced by him, eyes lowered, and approached the older man. He was wearing green corduroy shorts and a banana-colored golf shirt.

"Hi, I'm Bob," he said jovially. "Have a seat. I saw you run off after your first set. That was your first, right?"

"Yeah," I said as I sat down next to him. He looked like one of my dad's golfing partners from the club.

"I thought so. You look like you don't quite have the hang of it yet. Don't get me wrong, you do look good up there." His hair was parted way to the side. He had a shot and a beer next to his hand. "Do you want a drink?" he asked. His words echoed in my mind. I hadn't heard them in this context for some time—from more than a year ago, in Jersey, when I used to sit with the guys and drink scotch to blur the tedium of the night.

"No, thanks, Bob," I said, remembering my renewed promise not to drink at work.

"This is my last one," he said. "I have to pick my wife up from work soon. She's a nurse."

"Oh."

I liked that he told me about his wife. I liked that she was a nurse.

"She comes to these places with me sometimes. I enjoy talking to women in a sexually charged atmosphere. Where are you from?"

"Manhattan."

"I work there. What brings you all the way out here?"

"Money, anonymity." I sighed.

"Are you some kind of artist?" he asked. "You must be."

"Yeah. Some kind. So, do you want that dance?" I smiled lamely. I didn't want to repeat Angela's words. He'd know it was technique.

"I'd rather talk," he said, handing me a ten. "You seem like an interesting woman. We'll dance later, if that's okay."

"Sure," I said, although I thought the dance would have been better. Dancing millimeters away from him in a G-string was somehow less intimate. Still, he seemed harmless, and I wasn't ready to approach anyone else.

Our conversation went from where to get the best burritos in New York to human sexuality, love, and marriage.

The Great Wall of Dancer/Customer was chiseled down. I found out he slept with his socks on, even in the summer. He was afraid to check off the donor box on his driver's license, and every time he renewed it, he felt guilty. He liked to go for long walks barefoot late at night and listen to the crickets when he couldn't sleep, and it made his neighbors nervous. He listened to self-help tapes on his drive to and from work and thought they were working. He enjoyed washing his wife's nursing whites.

"Dylan and Angela coming up after this next song. Get ready, gentlemen," Eric warned our customers.

"You know, I still want that dance," he said.

This was going to be uncomfortable. It was one thing to dance for a man I didn't know. The illusion was the turn-on for both of us. But I thought this encounter might have some sort of deeper meaning. This was never something I wanted at work. It was easier when faceless bodies danced for disembodied dollars.

I stood up and saw Angela make another trip to the now-bustling Champagne Room with a different guy. She glanced back at me and gave me a look to hurry up and make the ten bucks before my next set. I took Bob's hand and led him to the infamous room encased in tinted glass. We could see silhouettes of Bambi and Thumper grinding in between the laps of men they had just met. Other girls I hadn't seen come in were doing the same.

I closed my eyes and remembered Angela's huge breasts shaking in front of my face. "Men respond. Men respond." I turned and smiled nervously at Bob.

"Dylan, I don't want you to dance for me," he said. "I'd rather dance with you. Do you think that's weird?"

I looked at the women writhing over the seated men. I saw Bambi rub her ass against a fat man's leg. I saw the

now-above-average Thumper pop her bra a hair away from an eager bearded face. I saw Angela blow in another suit's ear and wondered if this one would make her hyperventilate. The next song came on, a house mix.

"We could waltz," he said. Still dressed in my cover-up, I looked him in the eyes, took his hand, and let him lead. *One, two, three; one, two, three.* We started a waltz to the pounding house beat, unnoticed by the other inhabitants of the room. *One, two, three; one, two, three.* Glancing at fragments of ass and cuff links and long hair and cigars and implanted breasts. *One, two, three; one, two, three.* White collars and bare legs and bald heads and sparkly G-strings and glazed-over eyes. *One, two, three; one, two, three.* I waltzed with Bob in my first table dance, wondering how his wife looked in her nurse uniform that afternoon.

INTERVIEW WITH JILL MORLEY

LIZZIE BORDEN: You introduced friends to go-go; you've written a play and made a documentary about go-go. How did you first start?

JILL MORLEY: I was twenty-six, doing a catering job with Terese [Pampellonne]. It was getting slow after the holidays. I asked her what we should do for money, and she told me she go-go danced in New Jersey. I was shocked. Terese wore glasses, had a pageboy haircut, was really smart, and wasn't at all the kind of person I imagined doing that. At that time, I was writing and performing my material in a one-woman show called *Hail Mary*. Madonna was huge in pop culture then. I remember looking up to the Big M and thinking, *Look, she's exploiting her sexuality. I'm doing that in*

my show! I identified with the idea of dancing as "empowering"—and went for it.

LB: Did you take to it right away?

JM: No, I was nervous. I didn't even have the right costumes. I cut jean shorts down until they showed my butt. I didn't even own high heels, so I wore cowboy boots onstage. I was kind of uncomfortable in my body, because I was never used to being looked at in a sexual way. I was a tomboy, the girl next door. I was afraid guys were going to make fun of me because I wasn't pretty. And then I thought, *I'm an actress! I'll act like I'm sexy and see what they do.* So, I got on the go-go stage, and it worked. So, in the beginning, it was actually a good thing for me. It boosted my confidence.

LB: What was your go-go "persona?"

JM: I named myself Dylan—after Dylan Thomas, not Bob. My go-go persona was about being cute and funny, getting men to laugh. I was best at it in blue-collar Jersey bars. Having been a tomboy gave me a rapport with the guys. I didn't hate them yet. That happened after a couple of years on the job. Later, when I developed a more sexual persona, I'd be sexy onstage, come down, look them in the eye, take the money, then leave without talking to them. Even so, I thought, *This is interesting. Who are these guys, why are they here?* I was also fascinated by the girls who danced. I made a documentary about them and wrote a play called *True Confessions of a Go-Go Girl.* The final version was published in *Women Playwrights: Best Plays of 1998.*

LB: Did you continue to dance while you were performing your play?

JM: Not at first. My play was supposed to go Off-Broadway. I stopped dancing and was rehearsing in an Off-Broadway theater. A week before opening night, the producer didn't come up with the money, so they pulled the plug. That was also the week before my thirtieth birthday. Shortly after that, Susan [Walsh] disappeared. Angela, another woman in my documentary, died during routine plastic surgery. I was turning thirty and felt like a failure. So, I went back to dancing. This time, I danced topless in New York. It was self-punishing. I was depressed because my play didn't go, so I thought I should delve deeper into this world by going topless.

LB: How was topless dancing different?

JM: The guys look at you differently, and I felt differently about myself. Maybe it was the stigma I put on it, but it wasn't just bikini dancing in New Jersey. I'd avoided the real sexual stuff by trying to be cute and funny, but that didn't work in New York. I only did it for three months, because I couldn't take it emotionally. I'd been on various talk shows like *A Current Affair*, *Donohue*, and *Entertainment Tonight*. I was always talking about my play to the press, so I'd raised my own consciousness about go-go. It wasn't an anthropological experiment anymore. It was just me making money stripping, which disturbed me. I started drinking every time I had to dance. That was when I knew the honeymoon was way over.

LB: You have used your body as your "instrument" in performance art, theater, as a go-go dancer. Since then, you've been boxing competitively. How did that happen?

JM: At first, I was just taking classes at a gym. Then, in 1995, I discovered that women were allowed to compete in the Golden Gloves. At the time, I was still an actress and didn't want to mess up my face. But when I turned forty, I decided to give it a try before I got too old. I had to lie about my age in order to qualify, because the age limit for the Gloves was thirty-four. I lost some, I won some, but I loved it—the training and the fights. Since then, I've made a documentary about female boxers, won the National Golden Gloves for women over forty, and have been teaching girls and women how to box through Fight Like a Girl Boxing [https://www.flagboxingla.com]. Now I work with women and give them something that will make a difference in their lives. It's really fulfilling.

HONEY ON A RAZOR

Susan Walsh

Most evenings at six, I throw my G-strings and shimmy tops, spike heels, and makeup into my bag, get on the subway, go uptown. On Fifty-Fourth Street, I enter the dark dive, sign in, troop upstairs to the small ladies' room, where seven or eight women dress, undress, comb hair, put on makeup, chat. We talk about the day. The theater people talk about auditions, scripts, dance class. The pros talk about shopping, clothes, the guy last night, other dancers, other clubs, places getting busted.

Dressed in my blue satin G-string, the one with the fringe, and high blue heels, I wobble down the hallway, street clothes heaped across my arm. I tread the torn carpet and frayed stairs cautiously, traipse past the shabby bar and decaying crimson main room to the back room, where they store cases of beer, packs of napkins, and clothes for the outside world. I put on finishing touches of lipstick and eye shadow, pick up my small change purse with a lipstick and a comb, go out onto the floor.

It's seven p.m., still early. One or two hangers-on from the daytime sip beer. The day girls stand on the stage barely moving, wondering if they can squeeze one last drink out of one last guy before their shift ends, score one more appointment for the night.

Sal, the dark-haired manager, growls, "Up first, Lila." I drag my bones up onto the chair, then onto the stage. Check out my belly in the mirror, suck it in. Dance a little, watch myself as I take off my blouse, look at my tits and waist, back and arms, like what I see. I like my body. I like to watch myself dance. It pleases me.

It pleases the men, too. They watch. I'm bored. Every night here starts the same. Bored. The litany: *Why am I here? 'Cause I like dancing. But it's degrading. No, it's not.* Naked boobs are no sin. They're fine soft globes, curving mountains. The degrading part are the silent requests, the lonely hunger that pervades men's eyes. That's what burns me out up here, what robs me. When I watch myself mirror-dance, shut out the eyes nibbling at my flesh like small fish, I fly. If the beat is right and I'm feeling easy, I'm gone in liquid ecstasy, licked with fire. I'm mine, and I'm dancing. They want me then, but I'm not there. I'm soaring over the buildings, leaping on the sunset. The world is mine, and I know it.

One night, Jim, the playwright writer, jumps up on the long table and dances with me. The men hate it. It robs them of their fantasy. The bouncer storms in, yelling, but not before Jim spins me around and rubs me soft against the hard buttons of his jeans, his thigh between my legs, letting me ride. Men buy me drinks. We talk. They're either curious or horny or both. And all the sad young men who really want to fall in love don't realize it's a hoax. We aren't really here. We're an illusion.

Alan is a corporate lawyer. He handles millions in mergers and acquisitions. He buys me drinks every week, every Wednesday. Asks my advice. He's good with numbers, bad with people, tells me the binds he's in with conflicted egos. I unknot the tangles, explain human psychology. We

drink some more. He asks me to lunch. We meet at fancy restaurants near Wall Street. No sex. No innuendos. There are larger issues looming in his life. We unravel them.

It happens every week. I'm his psyche prostitute. He pays me to lay his mind at ease. Too proud for therapy. Too isolated for sex. We fornicate in public, his cock-eyed fears in my yielding fold. Consummated over consommé.

The club is getting crowded now. Alone or with their buddies, they sit up close or far away. The Japanese men come clustered in fives or sixes, sit close, don't yield a thing, just blank masks of repression. Sometimes I test their empty faces, shimmy close, bend low, spread myself wide-legged before them. But they don't flinch. Their arms stay glued across their chests, face muscles taut, eyes impassive. It's truly amazing, come to think of it. A subtle art, perplexing.

The bachelor boys come in to party, loud, rowdy, raucous. More to give their friend a royal send-off into matrimony. Pathetic. Do they really think this is something they'll miss in married life—vague topless dancers in a nameless bar? The boys guzzle beer, belch, and yell. They have no idea what sex is all about. bold young men afraid to feel. Sad sex. Divide and conquer. Spread her knees and plunge on in. What about circling tongues on subtle flesh, sucking her hard to moist surrender? Nipples and flicks, thick hot juices. They don't know this. They don't care. Maybe, someday, some woman will show them how she gets full pleasure. Let a man ride her, riptides gushing, pulse him mad to beyond his mind. Till then, it's all mechanics of the crudest kind: place tab A into slot B and rub.

They're rubbing me the wrong way, loud and ludicrous. I move on. I remember this: Sad sex keeps this place in business. If they had exquisite sex, they wouldn't be here.

The videos play pointless porno. Scene one, clothes on;

SUSAN WALSH

scene two, clothes off; scene three, close-up details of two naked women and one man; scene four, fake ecstasy; scene five, fake credits. Distracted, I watch in a stupor. The night is endless, the music loud. I notice a magazine on a customer's chair. *American Cinematographer*. A kindred spirit.

He shoots film. Comes here often. Never buys the ladies drinks.

Sweet, shy, gentle. We become friends. I can sit until the bouncer bounces me, because the film guy buys no drinks. Why do you come here? I want to know. It's more interesting than a regular bar, he says. Thanks, I tell him. He gives me publicity sheets for his new film, a modest success. He's happy. But why do you come here? I ask. I don't know, he says. I don't really know.

<p style="text-align:center">✳ ✳ ✳</p>

There was Artie once, five years ago. He came to see another dancer, Charlene. She was mean to him, cut him out. He was hurt. I consoled him. He bought me drinks, was tender and quiet. A handsome young man of twenty-three, an auto mechanic. I was older. He was blond and blue-eyed, wide-eyed, an innocent. He drove me home one night, made delicate love. Next week, we had dinner in the village, walked, ate brownies with milk like kids. We made love that night. But something happened. He lay his head between my legs, gone for no apparent reason. I asked what was wrong. He was silent. Then we hugged, sang old songs. He left happy. I went to sleep.

At nine a.m. the phone rang. His father, frantic. What happened last night? he demanded. Were you drinking? No, I tell I him, groggy. But Artie's dead, his father yells. He killed himself. Car fumes in the garage. It was a customer's

car he drove, sideswiped it, the second time this month. His partner found him at the shop right now. Dead on the front seat. There was a note: Sorry, Bob. I fucked up again. Artie.

Oh god no, I breathe into the phone, smash the pillow against my face. This isn't true. You're lying. It's my son, he says. He's dead. The funeral's tomorrow and the wake. He liked you. He told us. Please come. You're the last one who saw him alive.

I go. I swoon. It can't be true; he was so young. I had no idea; he said nothing. Why didn't I see? Damn my perception. But it was his secret hidden in silence.

And I remember that last night, when his head lay still between my legs and I roused him, saying lightly, "It feels like you're dead."

I'll never speak again. All speech is treason.

His family reassures me it was written on the wind, but for me, it's an airless season.

At his grave, his mother says, This job was his last chance. He dropped out of college, out of technical school, too, quit job after job. Never could make his father happy, never could do enough to please him. So, he gave up.

His father cries and clutches me to him, desperate for a last touch of his son. Desperate for an answer. His grief smothers me. Dry despair and gaping agony. The graveyard, the hole in the ground, the box. How can it dare be so sunny this day? I'm alone in the crowd. I know no one but the dead man, and I didn't know him, either.

His aunt says, nasty: Well, you certainly have an appetite, when I eat the mournful lunch with them. Her suggestion chokes my screams: *But I'm alive. I'm alive. I'm still alive, that's why I'm eating, goddamn you.* Instead, I cast my eyes into the plate and swallow one last time.

I return to his grave when they all leave and ask him why.

Ask the raw earth, and he tells me: There is no hope. All is horror.

I turn my back, but he never leaves me, his blond, pale face a breath away, a heartbeat missed. I knew him oh so little, the last two weeks of a too-short life. He needed to be saved, but who can we save but ourselves?

Daughter of death, temptress whom men expect to save them. But life's a ploy for deeper secrets: The dance of life is our salvation. Death wins when we stop dancing. I dance oblivion in naked sorrow, touch the horror of a wasted life. His face smiles back beside me. We are one.

The blond man at the bar winks at me. I never date blonds anymore. It's a superstition. I never date men under twenty-four. I never accept silence as an answer.

<p style="text-align:center">✳ ✳ ✳</p>

I am loose now. I am floating. Janine dances close to me, and we giggle. We do hip dances and shimmies to see who slows down first. My heel slips on the threadbare rug. She wins. I take off my shoes and dance fast and furious. Why not? It's night, and there's music and mirrors and men, and I like that they want me. I like that I'm alive and ticking. I feel my power, and I know it's mine. I swallow life like a banquet. Give me more.

INTERVIEW WITH JILL MORLEY ABOUT SUSAN WALSH

LIZZIE BORDEN: How did you first meet Susan Walsh?

JILL MORLEY: She came to my play, *True Confessions of a Go-Go Girl*, which I had written and was performing in

the East Village in '94. It had been reviewed in the *New York Times*, and other stripper-writers were coming. I had read an article Susan wrote with the late James Ridgeway for the *Village Voice* about the Mob trafficking Russian women into go-go clubs—"*Girlskis! Girlskis! Girlskis! Russians Bare in Jersey Bars*"—although no link with the Mob was ever found. I was really excited to meet her, so when she came up to me and said she really loved the show, it felt like having a sister in the world, someone who was a writer who also danced.

LB: So, was she still dancing at this point?

JM: Yes, at some of the racier, darker places, more dangerous than I would ever set foot in.

LB: Did she really have dealings with the Mob?

JM: Susan was bipolar, so sometimes I wasn't sure what she was saying was true, although I do think she had some interactions with the Mob, as well as with the Russian Mafia, because of the article she wrote. She really got off on that kind of stuff. She would get herself into situations with people that could be dangerous. It was the dark journalist in her.

LB: Did she always want to be a writer?

JM: Yeah. She grew up in Nutley, New Jersey, and went to William Paterson University in Wayne, New Jersey, where she majored in writing and worked on the newspaper. She wrote poetry, short stories, an autobiography and was really interested in doing investigative journalism. She also wrote for Al Goldstein's *Screw* magazine because she liked his attitude about freedom of the press.

LB: How did she first get into dancing?

JM: She saw an ad in the paper. It wasn't even dancing—she went in and did a live sex show at Show World in Times Square, a live nude peep show. She said she was naïve, but she did live sex onstage. She started with that and later went into dancing.

LB: It's interesting because Kathy Acker did live sex shows, too. She knew her partners. Did Susan?

JM: Not in the beginning.

LB: But she was always okay with being looked at naked?

JM: She was kind of an exhibitionist. Actually, when she was doing her live sex show, she sent a flyer out to some of the guys she went to school with, to encourage them to come. The show was called "Sweet Sue and the Blues Brothers"—Susan getting fucked onstage at Show World. She invited one of her teachers. I think she saw herself as a female Charles Bukowski. A little Annie Sprinkle. Kind of Andy Kaufman, a little absurd, in on the jokes. She thought it was cool.

LB: But many of her stories about stripping are so dark. By the time she disappeared, was stripping her only option?

JM: Yes. Her estranged husband, Mark Walsh, wasn't supporting her and their child, even though they continued to live in the same house in Nutley. He lived in the basement. When Susan went to work, he could look after their son. Then Susan had a boyfriend, Christian Pepo, also living with her at the time, who claimed to be a vampire.

LB: Is that how she got into investigating East Village vampires?

JM: No. She got into the East Village vampires through James Ridgeway, who had heard reports of blood being stolen from hospitals, which some people were blaming on these New York vampires. That story wound up not being true, but Susan started exploring the goth scene. That's where she met Christian, whom she started dating. He moved in to help take care of the son.

LB: When did you find out Susan was bipolar?

JM: She was diagnosed and told me years later, but I always knew there was something there. When I went to the book signing at Sally's Hideaway for James Ridgeway and Sylvia Plachy's book, *Red Light*: *Inside the Sex Industry*, which Susan researched and helped write, she was very giddy, talking about the Mafia, dancing in a totally manic way. I have a video of her on *Midnight Blue*, Al Goldstein's cable show, where she's dancing sexually to the camera, saying, "I hate you, fuck you; you're pathetic droplets of insect mucus." It sums up her attitude—she kept dancing and hated it, but got off on hating it. It feels like she was bifurcated from herself in some ways, and one way was by going back to those clubs. She kept doing it and making herself vulnerable physically. I don't think she had any boundaries. I know she had been sexually abused, and it didn't seem like she felt she had ownership of her body. She let it be used.

LB: Was she abused as a child?

JM: Yes, by one of her mother's boyfriends. It's in her autobiography. And her mother was extremely sexual, inappropriate a lot of the time.

LB: Was her father around?

JM: No. He left when she was a young girl. He was an alcoholic. But she had a stepbrother, whom she loved and supported when he came out as gay. Working on *Red Light* really helped with her confidence, but she fell off the wagon around the time it was published. She'd been sober for about twelve years.

LB: What kind of drugs did she do?

JM: She drank alcohol, she did coke, and she was doing Xanax. A lot of Xanax.

LB: Do you know what triggered her relapse?

JM: The way she was wired, she was set up to fail. She happened to be an attractive, blond white woman who could make money stripping and was made to think that was the most valuable thing about her. She thought she could never get out. We shot a scene for my go-go documentary, *Stripped*, and in it she says dancing destroyed her. It just became too painful. After *Red Light*, she had hoped to get her own byline, but there was so much resistance at the *Voice*, because she was a stripper. She was also depressed because she was thirty-six. In the beginning, like it was for a lot of people, including me, stripping for her was like, "Oh my God, men are looking at me like that. Men are actually attracted to me; that's insane." But for her, being thirty-six

and pursuing writing for so long, the hardest thing for her was that what set her apart was her knowledge of the sex industry, so she went into it further. But then, because of that, the people at the *Voice*, except for Jim, didn't like her. It was whorephobia—that she was a stripper. They had that stigma against her. They were prejudiced. Just knowing how she was, so sweet, so easygoing and smart, walking around in jeans and a T-shirt—she wasn't walking around in a bikini, so you wouldn't think, *Oh, she's a stripper*. You'd think, *Oh, she's a writer*.

It still haunts me that she disappeared two days after she shot that scene for my documentary. That was the last time I saw her.

LB: The tabloids blamed the Russian Mob, or the East Village vampires. Do you think it was them, or could the perpetrator be someone closer to home?

JM: I think it's a good story that it could have been the Mob or vampires, and it goes along with her being a stripper. It's a great, sensationalized story. That it could've been someone closer to home would be too pedestrian to make news.

The police didn't really start looking for her until five days after she went missing. This is a woman who left her beeper and her keys at home when she disappeared and had filed three reports of domestic abuse by an ex-boyfriend. She also had a restraining order on a guy named Billy Walker. He's the one who her vampire boyfriend, Christian, says he thinks killed her. Billy Walker also had claims to have some Mob affiliation. He had attacked Susan and Christian in their home a few months earlier. But the police still dragged their feet finding out what happened to her. If a missing person has a restraining order against somebody,

and you know that person came into the victim's house and tried to kill them, and then they went missing, wouldn't you look for that person the first day? Wouldn't you find it suspicious that her estranged husband has never permitted you to examine his apartment? The police let all that go, because she was a stripper.

LB: It sounds like there are two men close to her who could be suspects. But at this point, any forensic evidence would be gone, unless they find a body. I know James Ridgeway hired a private detective to look into it, because the police weren't—he said that, as a reporter, when you have a colleague in danger in the field, you don't cut and run. And you've been continuing to search for answers, too.

JM: For me, it isn't like I left a colleague in the field. I don't feel responsible for Susan in that way. I feel she was failed by everybody else around her and needed someone to stand up for her and at least tell her side of the story. I've been working on a documentary about Susan for years, but it isn't a movie people want to fund, so I keep filming, following her case, talking to lawyers, petitioning for police evidence. I won't stop.

LB: After all these decades, a woman's voice, especially a sex worker's voice, still means so little in the world. If a sex worker or an Indigenous woman goes missing, or anyone who doesn't have stature, no one looks for them. Or it's that thing about an "ordinary" white woman—if a white woman is attacked or killed, everybody is frantic.

JM: Right—that "missing white woman syndrome." Susan was one of those missing white women, and her case has

been covered internationally, by newspapers and TV shows. But because she was a stripper, no one has ever really tried to find out what happened to her.

SOMETHING GOING ON

Debi Kelly Van Cleave

The neighbor across the street talks on a cordless phone and nods like something important is happening. I try not to look; I try not to look interested. The neighbor in the yellow house comes home, and her kids spill from her car and crawl all over the lawns. I'm afraid that they will come across the street and run around my car and drop Popsicle sticks. I look down at my newspaper and pretend to read. The cordless phone neighbor and the yellow house neighbor sit together on one of the front porches with cups of coffee. Their voices drift over and get my attention, but I don't look up.

In the middle of the night, they are sitting out there with the men. Bamboo torches are burning like this is some tropical island and there is a night-light on in one of the rooms upstairs in the cordless phone neighbor's house. I see the orange heads of cigarettes get bright and then dull. My husband is asleep, so he doesn't hear the yellow house husband start to tell a story. The yellow housewife says, "No, no, lemme tell it; you don't tell it right," and she swats him on the arm. She tells a story that makes them all laugh. Then, as if she hears my own silent laughter intruding, she suddenly turns to my house, and I jerk away from the window.

At night I used to move in my bed as if I were fucking. My back arched, and then I woke up all tangled in the covers, all alone. But it was work, not sex, that I dreamed about. I was always surprised when I found myself moving. I could still smell the cigarettes all over me, because I chain-smoked at work, but I lit up another one anyway and blew it through the screened window. I couldn't go back to sleep. The crickets made a lot of noise at night. I don't know if I made noise as well.

* * *

The neighborhood is deserted during the day. The street is empty except for my car, and there is a wet mark from the street cleaner going right around it. I keep thinking I should move it into the driveway, but I don't do it. I like looking at the driveway all wide and empty, like driveways in suburbia on TV. My husband is careful about oil stains, so the cement is still the color of Bisquick. I get out there and pull weeds from all the cracks. Some have tiny purple flowers, and I arrange them in an old milk bottle I got at a garage sale. Then I think of something else to do.

The cordless phone neighbor comes back from places during the day. If I stand in my kitchen at the back of the house, I can see her, but she can't see me. I see her carrying a striped umbrella and beach blankets that are the same colors as my old costumes. She shakes the blankets out over her chain-link fence, and sand hits the sidewalk. Then she hangs them on the fence like bright flags from a country south of the border. She also hangs her bathing suit, and I wonder why she is not embarrassed, because it is faded and

it has a ruffled skirt attached to it like a fat lady's suit. Her children stay in their damp suits and bare feet until she calls them for supper.

You can smell supper around here. Cooking smells float in and out of windows and stain screens with grease. I cook things from cookbooks. My husband bought me a whole set from a man who was selling them door-to-door, and I keep them in alphabetical order with their spines facing out so I can see them at a glance. It takes me some time to make dinner because I buy dried beans that soak all day, and I always make a salad using something from the yard. But the yellow house neighbor comes home with food. I see pizza boxes and buckets of chicken and white cartons with little metal handles. I don't know how she can do that. It's no wonder she's back out on that porch so fast.

Once, I let a strange man put his mouth on my breast. I didn't know any better then. It was happy hour, and the men were making nose cones or holding the dollars in their mouths. The other girls were scooping them up, wrapping their breasts around the customers' faces like it was normal. There were no crumpled-up dollar bills next to my discarded robe on the end of the stage. I felt my movements get choppy. My set was almost over.

I got down in front of a man who was watching me but hadn't offered a tip. He had thick white eyebrows and pale eyes like distant rain. I stubbornly stood in front of him, pulled my bra down, and squeezed my breasts together. The man slowly placed a folded dollar bill between his lips. Then he bent forward, inserted the bill in my cleavage, and quickly veered to the side before I had a chance to jump

<div style="text-align: right">DEBI KELLY VAN CLEAVE</div>

back and say thank you. I felt his whiskers scratch across my skin and then his mouth was clamped onto my nipple. It was surprisingly soft and cold, like how a wet slug would feel. I stood there for a second, attached to him like that, and he sucked on my nipple, one or two sucks. I felt like his mother, connected to him, smelling Old Spice. I looked down and saw that his head was hairless and speckled. When I pulled away, I heard a hollow popping sound as his mouth came off me. My nipple was all moist and out-of-shape.

<center>* * *</center>

The cordless phone neighbor waves and asks if they picked up my garbage today. I look and see that my cans are empty. She shakes her head and tells me that they left her garbage again. She suspects it is because she put an old lamp in the can, and maybe they consider that bulk. "You have to pay extra for bulk, you know," she tells me. Trying to be helpful, I tell her to put it in my garbage. It cracks when she drops it in the can, and I think, *Oh no, what if the garbage men don't take it. It's broken in a million pieces.* I don't know what to say. I stand there in my own yard not knowing what to do with my hands.

The cordless phone neighbor is busy, and so she doesn't stay to chat. I see her on the phone over there five minutes later. Her head is tilted to the side so she can hold the phone and look at pictures in a magazine. I don't think she ever actually reads anything, even when she is off the phone, because she flips the pages too fast. I watch her licking her fingers and flipping.

When my husband comes home for dinner, I am ready with cold gazpacho soup I made with my own tomatoes,

homemade burritos, Spanish rice, and slices of avocado I drizzled with lemon juice like it says to do in one of my cookbooks. He says, "Mmm, looks good," and then he tells me about his day. Someone got fired at work. I perk up: that sounds like something going on. I try to get him to give me some details, but he insists he doesn't know any. Disappointed, I plead, "Well, what did he do?" But my husband shrugs and says, "I don't know. I guess he went home." I tell him about someone I know who got fired from someplace a long time ago, but it doesn't seem important now. It is not dramatic anymore, so I say, "Well, I guess you had to be there."

<p style="text-align:center">❋ ❋ ❋</p>

When I was working, I got home at four in the morning. I drove barefoot because my feet hurt so bad, even after all those years, and one time I tried driving with only one eye open. One of my regulars told me about that. He himself had only one eye, from an accident he had when he was framing houses, and now he was always the designated driver because he stopped seeing double. To get me to flash, he'd threaten to take his glass eye out and leave it on the bar for my tip, and once, he gave me a twenty for sticking my tongue out and licking my lips. I think he got money from the accident.

A cop pulled me over when I was driving with the one eye. He looked in the back of my car and saw my bags. "You a dancer?" he said right away. They don't miss a trick, cops. "This license suspended?" he asked.

It was a three-thousand-dollar blow job; that's what I told myself. That's what it would have cost me in fines and surcharges. The cop wasn't such a bad-looking guy, and we

started kissing, so it was almost like a date. But I threw up into a paper cup as soon as he pulled away. I ripped off the plastic top with the straw sticking out of it as fast as I could, and then I poured it out the window when I was finished, nonchalantly, like I was pouring out cold coffee.

* * *

After dinner I sit on the front porch and look through the classifieds, even though I know it is hopeless. I can't picture myself being half these things in here. I can't see myself wearing a frilly pink uniform, selling thirty-seven flavors of ice cream to rude people; or stocking shelves with washable fabric paints, fake ivy, and hot glue guns in a craft store. I can't picture myself as a girl Friday either. Girl Fridays are perky. They run for coffee and get the sugars right. They even smile in the morning and act happy when the boss asks them to do something. Real estate agent is out, too, because they are ladies who wear coordinated outfits with gold buttons and scarves around their throats. And they talk about flowering dogwood trees, wall-to-wall carpeting, and eat-in kitchens like those things really matter.

My husband is in the basement puttering with something while I sit with the newspaper, and the neighbors are already out. One of the neighbors, the yellow house husband, is watering his lawn. He mixes some chemical, I see him scooping and measuring to get it just right, and then he connects a container to his hose, and the water turns pink. He stands there spraying, with his hand on his hip and his big belly out, and the water comes out in an arc, reminding me of little boys who have contests to see who can pee the farthest.

The other husband, the cordless phone husband, has a

clipboard in his hand. He scratches his head, and then he sees me. He crosses the street clutching the clipboard like it's a shield. He tells me it's a petition for an ordinance to require work vans to park in driveways instead of on the street. He says it's an eyesore. I think, *Oh my God, that's earth-shattering*, and I ask for the pen. I say, "What about the people who don't have driveways?" The cordless phone husband scratches his head again and says, "I dunno. I guess they'll have to get one." Then he goes back across the street and sits on his porch, where I see him reading over all the names on the clipboard. No one I know.

* * *

I knew this girl who was missing. They had her picture plastered up all over the place, in all the dressing rooms and by the pay phones in the entranceways. Her stage name was "Jade," but her real name was "Carol." I didn't know that until I saw it on the posters.

Jade worked like crazy. She was never late for a set. None of the other girls liked her, because she hogged all the bookings and she was a real whore. If you worked with her, you had to flash, because Jade was doing everything else. If you didn't at least show a nipple or pull your G-string up your ass, you wouldn't make a dime, working with Jade.

I think she came from another country, because one time I saw her put a lit cigarette in her pussy and smoke it. She even blew smoke rings, and I can't even do that with my mouth. Another dancer told me that Jade's was a sad story. She said that Jade lived with her father and brothers, who smoked crack all day, and she supported them. They sent her out to work in a go-go bar as soon as she grew tits, and the father and brothers all slept with her. She even had a kid

by one of them. This dancer said that Jade didn't think anything of it. She said Jade didn't know any better. And then she turned up missing.

<p style="text-align:center">* * *</p>

My husband kisses my neck, moves down to my breasts, a quick lick on my belly and then down below until he thinks I am wet enough. He climbs on top of me, and I try to feel enthusiasm, but I can hear the neighbors. Soft music is playing, and the song reminds me of something. Something enough to distract me. But I know the routine, and so I am not caught off-guard. I catch right up, and then we are done, and I want to stay up and talk, but really there is nothing to talk about. I say, "I wonder if they ever found that girl." And my husband says, "What girl?" So, I tell him about Jade and how bad I feel and how she didn't know any better.

"You thinking about dancing again?" he asks me, worried.

"No, I was just wondering if they found that girl."

"She's probably dead."

"Yeah, I know."

"Don't worry about it," he says.

"I know. Go ahead, go to sleep," I tell him.

I shut off the light and press my nose against the screen and look at the houses across the street, where the music still comes softly from the cordless phone neighbor's house and a TV flickers blue shadows in the yellow neighbor's house. *Maybe we should have a baby*, I think. Maybe then I will talk on the phone and look at pictures in magazines. Maybe then I will think it is cute when children in wet bathing suits drop Popsicle sticks. Someday, I might even care where the neighbors park their work trucks. And then

I'll stop looking out the windows, listening to someone else's music.

INTERVIEW WITH DEBI KELLY VAN CLEAVE

LIZZIE BORDEN: Writing, from blogs to short stories, seems to be the way you process "foreign" worlds, from go-go dancing to living in right-wing states.

DEBI KELLY VAN CLEAVE: I've done so many different, crazy things in my life and lived in so many different, crazy places. I realized it's always about gathering material for my writing. Living in Oklahoma and Virginia, for example, was what I call my "redneck period." Not that I ever became a redneck, even though I'm a country girl, but I learned about them, the culture.

LB: What would they have thought about go-go dancing?

DKVC: There was no way I could tell anyone in Oklahoma or Virginia about it. I was shocked at how conservative the thinking was in both states. I thought most of America was as open-minded and nonjudgmental as we are in New Jersey. When I used to dance, I kept it a secret from my parents, but I could at least tell my girlfriends. Even if it wasn't something they would do, they didn't look down on me for it. I could never tell anyone in Virginia, even my friends. We'd be ostracized; my daughter would have been picked on. If I got a flat tire on the side of the road, no one would have helped me.

LB: How did you first get into go-go?

DKVC: I first became aware that such a thing existed when I was a kid and my aunt's husband left her for a go-go dancer. It was a terrible scandal. But I remember my cousins bragging that the dancer had skin the color of coffee, was double-jointed, and could put her arms around her back and clasp her hands in front of her belly. It was very exotic and mysterious. Then one of my cousins became a dancer when she grew up.

LB: So, you followed in her footsteps?

DKVC: I never considered go-go dancing until I got divorced from my first husband and was a single mom supporting myself by cleaning houses and working in a furniture store. One day, a guy who owned a local bar came into the store and told me that if I ever needed a job, I should come on down, because I could make good money as a bartender. I was about thirty, but I'd never even been inside a bar before, other than family shindigs like bridal showers in the back room. And I've never been a drinker. But I kept thinking about the money. And truthfully, being newly single, I thought it would be fun to do.

So, I went to bartending school, then went down and got the job. The first night, I wore corduroy pants, a turtleneck shirt, and a button-down sweater. It got busy and hot, but I didn't want to take off the sweater and make any moves that would call attention to myself. That's how shy I was. But the sweat was dripping off my face. Finally, one of the guys said, "Aren't you hot? Take off your sweater!" And that was the beginning of the end. I became comfortable with talking to anybody—plumber, lawyer, banker. I also learned how attractive I was. The corduroy pants and turtleneck shirts evolved into the latest styles, and I learned how to do

my hair and paint my nails. I experienced the blossoming that girls go through in high school.

LB: How did bartending lead to go-go dancing?

DKVC: I always loved dancing. My mother was the same way. She was always shaking her hips, especially to her favorite song, "Woolly Bully." When I was a little kid, I remember her pulling me out of bed when they had friends over and saying, "Show them how you can dance, Debi!" My cousin was go-go dancing at the time and told me I could make more money dancing than bartending, so I decided to give it a try. My quality of life improved immediately. I was able to quit the furniture store job, the housecleaning jobs, even the bartending job. I was home for my daughter. I could afford to buy whatever we needed. If she needed new clothes, I could get them. I could pay for gymnastics classes. We got a new car. On top of that, I felt more attractive. Go-go dancing taught me the power of my sexuality. I never slept around with any of the guys or even dated them—except the one I married.

LB: Terese [Pampellonne] also met her husband in a go-go bar. He's an accountant, and they're married to this day, but she says she hated the men in the bars.

DKVC: I never hated the men. I loved the men. They were nice. They gave me money. What's not to love? A lot of women also talk about how dancing is bad for a woman's self-esteem, but it was great for my self-esteem. Not only was I older than most dancers, but I had small breasts. I was always self-conscious about them and thought about getting implants. But when I started dancing, I learned that

I have beautiful breasts and they're perfect the way they are. You can be the most ordinary-looking woman in the world, but once you get up on that go-go stage, something happens. I don't know if it's the lighting or the atmosphere, but you look great no matter what you look like in real life. Dancing was so good for my self-esteem, even when I went about my daily routine—shopping and running errands in sweatpants and no makeup, my hair a mess—I thought I was gorgeous. And I had money. It was empowering.

LB: Were you ever tempted to dance in New York for more money, even if meant going topless?

DKVC: No. Covering your nipples was like you were saving something. But even in Jersey, the more you gave, the more money you made. I remember being annoyed when I'd see girls jerking off guys behind the bar. I didn't do that kind of stuff. Instead of flashing, I made money by using my personality and creating a fantasy. I was really into my costumes. I'd have a theme going: the beach girl in the neon orange, the dominant chick in the black motorcycle jacket and dog leash. Something for everyone.

LB: In one of your stories, you write about returning to go-go as if it's a slip, like falling off the wagon.

DKVC: It was hard to stop. It was probably one of the only jobs I ever really loved. But my husband wouldn't have liked me to do it, and I wouldn't want to do it while being in a committed relationship.

LB: Were you dancing while you dated him?

DKVC: For a short time, but I felt guilty about it. I met him in the same bar where I met Jill [Morley], a little neighborhood place called the Halfway Bar in Rutherford, New Jersey, near Giants Stadium. He came in a couple of times with a bunch of guys, and I was immediately attracted to him. But I was afraid to talk to him. He was too cute! In the dressing room, I asked one of the other dancers to go out there and ask him if he was married. But then I became worried that he'd think *she* was hitting on him, so I went out there myself. I tapped him on the shoulder. He turned around and was so surprised and excited, he almost fell off his bar stool. He said he wasn't married and didn't even have a girlfriend. Within weeks, we were serious. It took about that long for me to tell him my real name.

LB: What name were you using?

DKVC: "Kelly." It's my maiden name. I thought names like "Stormy" and "Venus" were too obvious. But I missed it when he stopped calling me by my dancing name. Later, we named our daughter Kelly.

LB: When did you start to write?

DKVC: I was a big reader from the time I was a kid. When we were living in Jersey City and the bookmobile came to the neighborhood, I was fascinated. I couldn't believe that I could actually borrow books for free. I scanned the shelves and decided on a book with a picture of a mouse on the cover, because I liked animals. It was *Stuart Little*. What luck to be introduced to reading by E.B. White! I was hooked. I was the first one in my family to finish high school, and I never went to college. But I always kept a journal and wrote

short stories. In fact, that's how I met Jill. I saw her writing in the dressing room between sets and asked her what she was doing. That's how we became friends.

LB: These days, Jill is boxing. You live on a farm.

DKVC: I'm also a barrel racer—it's a horse race at a rodeo. You race around three barrels set up in a cloverleaf pattern in an arena. One person goes at a time, and the fastest time wins. There's music playing, and if you're good, you win money. It reminds me a lot of go-go, right down to the elaborate costumes. I'm nervous, and the adrenaline is rushing. Then they call my name on the speakers, and I go into the mode. Boom, boom, boom—I feel the music, the crowd cheering, my heart pounding, and I go faster and faster. When I race back out of the arena—whew! *It's over! I did it!* It's a real high. It's addictive. Just like go-go.

NOTES FROM THE CATWALK

Elissa Wald

I have worked as a stripper off and on for the last four years, mostly off for the last two, but recently I've returned. This latest stint began in December, and I told myself it would end with 1997—four weeks, max; in and out. I would get that fast-flowing holiday cash and get out. New Year's came and New Year's went, and I'm still at it, an admission that brings me as much perverse pride as shame. Each return inspires a barnyard chorus of friends and family, people who care about me: *This is b-a-a-a-d.* I don't disagree with them, but it's not that simple. I believe that most of us have our "netherlands," subterranean places we visit to tap into our own pathology, resilience, and despair. The strip joint is an arena where I confront much of my own. I hope it will soon exhaust what it has to show me, but it hasn't yet.

I return during low points of my life, drawn like a child to what glitters instead of holding out for the warm and solid gold. I need the attention, the affection, the adulation. And the objectification and brutality just underneath? The strip joint is a sadomasochistic place, and sadomasochism is at the center of all my writing; it's the lens through which I

see the world. For this reason, the job is endlessly interesting to me. There is an immediate change in lifestyle. I spend money: on gourmet coffee, luxurious bath products, taxis, take-out deliveries, a new coat. Walking past storefront windows, I feel as if the world has opened back up to me. If I'm at the grocery store, I don't have to agonize over whether I can afford the imported tomatoes. If I'm going to a party, I bring a bottle of good liquor and a dozen roses for the hostess.

I sleep a good part of the day and stay up all night, often well beyond the end of the night's work. My shift ends at four in the morning, and why stop there? I'll go to the Hellfire Club, an after-hours S&M establishment, for a free and thorough foot massage, and then to breakfast with strangers. There is a heightened sense of adventure, abandon, unreality. Day turns into night turns into next day . . . I crash, and then it's time to do it again.

I work in a club I'll call the Catwalk. It's in Midtown, a few blocks northwest of Times Square. Sometimes on my way to work, I imagine I'm an actress, or maybe a real dancer who's gone too long between successful auditions. I walk past Forty-Second Street, under the bigtime billboards, past the Broadway shows, then the Off-Broadway shows, and finally into the strip club.

There is a bodily consolation in the entrance, that blast of heat as I come in from the cold—as poet Stephen Dunn put it, "What fools the body more than warmth?" Too, the music at the door is like a wave that flattens all thought, washes it away. I am never without gratitude for its mindless, insistent rhythm; I become part of its pulse almost

instantly. It pulls me out of myself and into "Jo-Jo," my stripping persona.

The strip joint has a carnival atmosphere: seedy, raucous, lusty. The deejay natters on like a barker all night long, calling girls to the stage, pushing the Champagne Lounge, casually insulting the customers. ("Hey guys, do you remember your first blow job? How did it taste? Har!") There is even a freak show element: the feature performers with their engorged silicone breasts, boasting measurements like 101-24-36; who dance with snakes, fellate foot-long sausages and the like.

A few words about how the place works:

The club does not pay the dancers to work there. The dancers pay the club: thirty dollars to the house, a ten-dollar minimum tip-out to the deejay (double that if you want to be on his good side, and believe me, you do), and at least seven dollars to the housemother. All in all, including the taxi home, girls drop an average of seventy-five dollars a night to work in a club like the Catwalk, relying solely on the customers to make that back and more.

Dancers rotate onstage as called by the deejay. Each stage set is three songs; girls strip down to a G-string and heels by the end of the first. Between stage sets, the dancers circulate on the floor and attempt to sell private dances to customers at ten dollars a song. The girls are topless during these private dances, which consist mostly of teasing a man into a frenzy. At the height of frustration, some men will elect to visit the Champagne Lounge, a room upstairs where a customer can take his favorite girl. The Champagne Lounge is the ultimate scam. The hourly rate starts at three hundred dollars. This entitles the patron to exclusive time with the dancer of his choice and a bottle of champagne. Nothing special happens in there, though many customers imagine

otherwise. I don't pretend to understand why anyone pays for it when they can open the Yellow Pages and find an escort for half the price. But dozens of men put their hundreds down every night, and it's not unusual for them to buy more hours when the first one is up.

The Champagne Lounge is the strangest aspect of a very strange place. Here is a man I don't know, and I'm climbing into his lap, and he's cradling me. Sometimes this is all they want, and once in a while, when I'm in the midst of such an encounter, everything falls away and I no longer remember how I got there. Only: he's hurting, and I'm hurting, and we're clinging to each other for this hour out of life. His arms are around me—strong, male arms. My cheek is resting against the starched whiteness of his shirt. He rocks me, croons to me. This happens. I close my eyes, and I am held. This is all I know; at this moment, all I need to know. All I need.

Each shift is something like an egg hunt. We're turned loose for the night at eight, and we convene in the dressing room again at four a.m., each girl with a different amount of money, bounty, depending on her calculations and effort and luck. The money is not discussed except in the vaguest of terms:

"How'd you do tonight?"

"Oh, I did all right. You?"

Strip joint managers run a tight ship. The dress code is non-negotiable. G-strings must be opaque, heels a minimum of

four inches high. The only agony to match dancing in those stilettos for eight hours is the moment they come off—the effort to readjust to being flat-footed. (In this respect, they resemble tit clamps: the hot, insistent bite while they're on; the excruciating rush of blood back into the nipple when they're removed.)

Tattoos must be covered; bodily piercings stripped of all jewelry; legs, armpits, and the bikini area kept clean-shaven or waxed. Garters are required, and each girl is expected to have several different costumes.

Dancers are not allowed to talk to one another while onstage. ("And I don't care what you're talkin' about. Just don't do it. Even if you're just tellin' another girl her tampon string's hangin' out. I don't know what you're talkin' about, and I'll make sure you get a five-song set.") Five-song sets are one way to torture a dancer. The stage is intended as a showcase, and the time spent up there is generally compensated with only single-dollar tips. The real money comes from working the floor, so extra time onstage is to be avoided at all costs.

More serious infractions are fined: twenty-five dollars if your stockings have a run, fifty dollars for lateness, one hundred for missing a night of work regardless of the reason, five hundred for missing work on a holiday, like Christmas Eve. Payment is exacted for absences without exception. Illnesses, a death in the family, emergencies of any kind cut no ice with the management. In this respect, the job is like the military. There is only one acceptable response after going AWOL: *No excuse, sir, there is no excuse.*

As a result, dancers drag themselves to work even when they're very sick. Recently, I worked with the flu. My throat was sore, my voice nearly gone. To be heard at the club, you have to shout above the music, and since I didn't want to

do that, I had an inspiration: I would pretend to be mute. All night, I indicated with hand signals, to men I hadn't met before, that I couldn't speak. Afterward, when I got home, I realized I'd made more money than ever before.

<p style="text-align:center">✳ ✳ ✳</p>

The Catwalk is a place where I can go up to a man I've never seen or spoken to, take his face in my hands, and say, "How beautiful you are." It's a place where one can touch and be touched. There is an easy physical intimacy between strangers, an immediacy to each encounter. I trace scars, asking, "What happened here?" I smooth hair back from foreheads and loosen ties. I knead

muscles, telling every single customer, "You work too hard."

"I know," they respond, to a man.

<p style="text-align:center">✳ ✳ ✳</p>

The strip joint is supposed to be about fantasy, but sometimes it seems to be about the bare bones of reality. The veil that hangs between the sexes on the outside—the guarded gaze, the pretended disinterest—is lifted; the men in their naked desire often seem more exposed than the women. Once, I was in conversation with a customer whose friends were impatient to leave. We were seated at a table, and his companions kept glancing pointedly at their watches. He ignored them. Finally, one of them tugged at his sleeve.

"Tom, come on. Look at the time. We gotta go, man."

He barely looked up. "Go ahead without me."

"What! You're not coming? You can't be serious."

Finally, he turned to his friend with an incredulous glare,

as if he couldn't believe he was being interrupted. "Come on, man, what's with you? *Can't you see I'm talking to a female?*"

<p style="text-align:center">✳ ✳ ✳</p>

The other night, I was on the side stage, a little caged-in platform by the bar, when a kid of about twenty-five came up to me.

"Do you remember me?" he asked. "It's Frank, from the Dollhouse."

The Dollhouse was the first place I ever danced. I hadn't seen him in years, since the beginning of my go-go career, and while he did look vaguely familiar, I wouldn't have been able to recall his name.

"Frank!" I said. "Great to see you. It's been a long time! What are you doing these days?"

Sometimes I am still overcome by the surreal nature of such a situation: I am nearly naked, in a cage, striking up casual conversation with a fully clothed boy just beyond the bars.

"I'm a cop now," he told me.

"A cop?"

"Yeah."

"In the NYPD?"

"Yeah."

"Really," I said. "Are you packing tonight?"

He nodded, then offered shyly, "Want to feel my gun?"

Of course I did. It was at the small of his back, and I reached around and stroked it. It was an arousing moment, seeming as primal, as quintessential a male-female exchange as the rest of what went on in there. We might have been a small boy and girl in that age-old transaction: "I'll show you mine if . . ."

Just minutes ago, I'd asked a guy in a cowboy hat, "Are you a cowboy?"

"No," he answered.

"An outlaw?"

He shook his head.

"What, then?"

"A photographer," he told me.

"Well, I was warm," I said. "Think about it: a cowboy, an outlaw, and a photographer. What do all of you have in common? You all shoot!"

He answered, "I think all men have that in common."

He was much cleverer than I was, and he wasn't even trying.

<p style="text-align:center">✳ ✳ ✳</p>

I'd rather strip than wait tables, or temp, or work as a receptionist. I've done all of the above and found them equally degrading, far less lucrative, and not nearly as interesting. Stripping brings me into contact with women and men from all walks of life. Some of the dancers are single mothers. Some are putting themselves through school or pursuing an artistic career. Others are just indulging expensive habits, and a few are hustlers and junkies. The men are equally diverse. Stockbrokers come in, and so do construction workers. There are the stereotypical dirty old men, and there are fresh-faced boys in for bachelor parties. I have dozens of conversations a night. It is unusual for an hour to go by in which I don't learn something new.

<p style="text-align:center">✳ ✳ ✳</p>

The stage names the girls choose for themselves have such fire and color, such a poignant and hopeful poetry: *Ambrosia. Blaze. Clementine. Delicia. Electra. Fantasia. Gypsy. Harlowe. Isis. Jade. Keiko. Lolita. Magdalene. Nikki. Odessa. Precious. Queenie. Ruby. Sapphire. Tabitha. Una. Vixen. Wanda. Xiola. Yasmine. Zora.*

<div align="center">✳ ✳ ✳</div>

The job allows me to wear costumes and accoutrements I would seldom have a chance to indulge in otherwise: elbow-length gloves, thigh-high boots, feather boas, sequins, long velvet gowns that lace up the front. It is the stuff of old-time movies, of vaudeville. I even went through a phase where I wore a pair of angel's wings.

I dress like a sanitation worker much of the time when I'm not at work. I go out in shapeless, oversize clothing, hair pulled back into a slovenly knot, little or no makeup. Part of it is exhaustion, the desire to be comfortable and warm after so many hours in spiked heels and a thong. Part of it is wanting a respite from male appraisal.

<div align="center">✳ ✳ ✳</div>

I like dancing for the customers most of the other girls are afraid to approach: little people, amputees, men in wheel-chairs. When they come into the club, I'm across the room like a shot. Once, I danced for a guy with a very unfortu-nate birthmark: a dark splotch, almost perfectly round, directly in the middle of his face like a bull's-eye. To me, he automatically had an edge on everyone else, the power that would come from walking around thus marked all his life. He had endured and, by now, I could only assume, had

the strength and stamina only such a person could possess. I wanted to rub up against him, in the hope that some of it would rub off on me.

* * *

The girls take care of one another. An outsider might imagine that the strip joint is an atmosphere that fosters competition, jealousy, backstabbing. But every dancer I've encountered seems to share the conviction that it's Us against Them. It's a tight sisterhood, and all of us call the housemother—the woman who oversees the dressing room, who provides aspirin and tampons, and who will fix a torn piece of clothing in a pinch—"Mom."

The other night while I was onstage, I had some words with a customer. He took a deep drag on his cigarette and blew the smoke directly in my face. I countered by spitting into his. The roar that went up from the sidelines was like the sound in a stadium when the home team scores. All the girls in the house, it seemed, had erupted in savage joy: "Yeah, Jo-Jo! You go, girl!" My immediate rush of pleasure was soon replaced by fear as I waited for him to report me to the management. He left instead, slunk out the door, and I realized it was the reaction of the girls that had most likely saved me. He must have perceived the atmosphere as too hostile to stay another minute.

Another illustration: one recent night after work, there were no cabs outside the club. I began trudging toward the nearest avenue, Ninth, but when I got there, no cars were in sight. It was four fifteen in the morning, sleet was coming down hard, and I was alone in the middle of Midtown with all that money. Somewhat anxious now, I began straining for a lit storefront, an open bodega to wait

by, when a cab came around the corner and stopped. The back door opened, and a female voice summoned me from the interior.

"Jo-Jo! What are you doing out here alone? Get in!"

I approached the car and saw Serena, one of the other dancers, in the backseat. "Oh, Serena, hi," I said. I was slightly bewildered. "I live down on Avenue D. Do we . . . do we live in the same direction?"

"It doesn't matter," she said. "Just get in."

<p style="text-align:center">* * *</p>

One night, I was dancing for a guy right next to the stage, and the girl who was on it leaned toward me. We kissed wordlessly above the man's head, as if by some prearranged choreography. I'd never seen her before, didn't know even her stage name; in fact, I still don't.

<p style="text-align:center">* * *</p>

When you're out in the daytime and you see another dancer on the street, you don't always acknowledge each other. Your eyes will meet, and often there will be an almost imperceptible shake of the head, an indication that you shouldn't approach. Maybe she's with family, or a guy who doesn't know what she does. And even if she can think fast enough to invent another context for knowing you, the two of you probably don't know each other's real names. You don't want to unthinkingly say, "Hey, Bambi," or "Amber," or "Gemini," or "Venus." So, it's best to not even speak to each other; you'll see her later, maybe even tonight. Still, there's an excitement in this silent communiqué, a sense of two spies exchanging signals in enemy territory.

A variation on this theme takes place when the Gaiety boys come into the club. The Gaiety is a gay male strip bar just a block and a half away, and a lot of the male dancers there are straight. They come to the Catwalk between their own stage sets as an antidote to the predatory male energy directed at them all night. The Gaiety boys are as good as it gets, as far as Catwalk clientele: they're clean, smooth, gorgeous, muscle-bound, and loaded. The condescension so prevalent in most of the customers is wholly absent in them. Their attitude is *We know exactly what you're dealing with in here; you are our sisters in slavery; let's help each other through it any way we can.* They pay twenty to fifty dollars for a dance. They come back at four a.m. to take you to breakfast. You compare notes over eggs and toast. They understand every single thing you say.

When I'm not having breakfast with a male counterpart, or any of the other girls, I often go alone. As a rule, I don't eat for several hours before work, and then I dance for eight hours straight. At four a.m. I'm wired and ravenous, and there's an all-night diner around the corner. At that time, it's nearly deserted, and arriving there is like walking into an Edward Hopper painting. There is something satisfying in the wan quiet. I have a sense of a lull in the action, of a space between the night's work and the average person's morning. It's an empty pocket, and I'm in it, bone-tired and anonymous and cozy. I feel all alone in the world, but right now it feels good instead of bad. I scribble notes on the napkins and paper placemats. I order comfort food: a baked potato, a cup of soup.

* * *

A customer—I'll call him Al—taught me one of the most important lessons of my life. I'd danced for him several times when he invited me to come to the restaurant he owned, an upscale grill in SoHo. Several weeks later, I did go in there, and while my friend and I waited to be seated, Al walked by several different times. He kept glancing at me with a puzzled expression, as if to say, "I know I've seen you before, but where?" I thought it better not to enlighten him, surrounded as he was by his staff, and the evening passed without a word exchanged between us.

About a week later, he was back in the Catwalk. I went over to him.

"Hey, Al," I said. "I took you up on your invitation and came into the restaurant last week. But I guess you didn't recognize me with clothes on."

"That was *you!*" he exclaimed. "That was driving me crazy. I *knew* I knew you, but for the life of me, I couldn't place you."

"Yeah, well, I could see that," I said. "But, of course, I didn't want to say anything in front of your employees."

"Why not?" he wanted to know.

"Oh," I said, startled. "You mean, it would have been okay?"

"Well, I'm here, right?" he said. "So, it has to be okay."

Said so simply, yet it struck like lightning, left me openmouthed in amazement. *I'm doing it, so it has to be all right.* I never lied about my job again.

* * *

The manager can walk into the girls' locker room at any time without knocking. The Champagne Lounge host, the deejay, and the janitor have to knock, and will wait outside until everyone is "decent." The half-nakedness outside in

the club—exhibited from the stage, revealed by degrees, washed in neon, and bared against music—acquires the Siren pull of eroticism; whereas our total nudity in the dressing room, under the cheap fluorescent tube lighting, is no more exciting than the bodies of livestock in a pen.

A scene from my second year in the business:

It was fifteen minutes before the night shift began, and there were perhaps two dozen girl in the locker room when Randall, the manager, strode in, dragging Maggie by the upper arm. Maggie worked the middle shift, from five p.m. till one in the morning. She was a rail-thin, statuesque blonde—on this evening, decidedly glazy-eyed. Randall was in a barely contained rage.

"Maggie, you're gone. Get dressed and get out."

"Randall!" she said wildly. "What did I do?!"

"If you're not out of here of your own accord in exactly ten minutes, I'm throwing your ass in the street, and I don't care if you're butt naked. If you don't believe that, keep trying to talk to me."

Maggie was crying now, her tears mascara-black. She moved, sniffling and unsteady, to her locker and began to get dressed.

Randall addressed the rest of us. "For the information of everyone else, Maggie has just been fired for doing cocaine in this club. You just have to look at her to see she's fucked up. She wasn't fucked up when she got here at five o'clock. But she's fucked up now. What does that mean? It means she's fucking up on my time. In my space!"

Maggie tried to cut in. "Randall, I'm—"

"Eight minutes and counting, Maggie." He paused. "You girls have tried my patience to the limit. Every night, I reiterate my warnings about the plainclothes pigs crawling all over this place. If you think I'm going to get closed down

because of your indiscretion, you'd better think again." He opened the door of the dressing room and called out to George, the janitor. "George! Come in here."

George entered.

"George, the girls are at the nose candy again," Randall told him. "They have to be sniffing their lines in the bathroom, because those are the only closed doors they have to hide behind. So, I want you to go get your crowbar and take the bathroom doors off their hinges."

"Yes, sir," George said. He went out again.

There was a stunned silence in the dressing room. Finally, Diamond broke it. "The bathroom doors are coming off? Permanently?"

"You heard right."

"Then I'm quitting," she said. "I'm sorry, I can't deal with that."

"Goodbye," Randall said. He looked around. "Anyone else who shares Diamond's point of view is free to check out of this job right now."

"I'm with her," Mercedes said. "This is supposed to be a club, not a prison."

"Nice knowing you," Randall said. "Anyone else?"

Silence.

"The rest of you, be ready to start at eight as usual."

The atmosphere in the dressing room had been altered. There was a general air of resignation and defeat. Above the lowered heads and averted eyes, I met Randall's gaze. I stared at him in a kind of daze, and as he stared straight back at me, I felt the heat rushing to my face. His recognition of my arousal intensified it, made it almost painful. The music from outside the door seemed to become more audible as we locked eyes.

* * *

There were a handful of such moments while Randall was the manager, unsettling moments: the slow burn, some unspeakable exchange that never even attempted to find words, a secret betrayal of my rightful allegiances. Another one came a few weeks later. I was working the room, circulating on the main floor, and as I walked by the leather sofas that line the back wall, a man touched my arm. "You. Are you available for a private dance?"

"Of course, I am." I smiled. "I'm Jo-Jo. And you are?"

"Jo-Jo, I'm John. And this"—he indicated the kid beside him, a boy of about eighteen—"is my young friend Ben. I'm kind of showing him the ropes." He winked at me as he took twenty dollars from his wallet and slid it into my garter. "So, I'd like you to dance for him."

"John, it would be my pleasure," I said. I moved to the boy, invaded the space between his knees, and began slowly stripping off my dress.

"Touch her," John said to him.

Ben shot his older friend a nervous glance. His hands stayed at his sides.

"Go on," John repeated. "Touch her."

"I thought the guys aren't allowed to touch the dancers," Ben said.

John reached out and ran a possessive hand up my flank. I closed my eyes.

"Look at her," I heard John say. "Is she all upset? Is she yelling for a bouncer?" He caressed me further, moving his hand to the inside of my thigh. I felt my breathing become rapid and shallow.

"See?" John went on. "She wants it. She wants you to touch her. She's a woman; she needs it. Go ahead. Put your hands on her."

Ben tentatively put his hand on my other leg. The two

men stroked me simultaneously: John as an owner would stroke a pet, Ben with tremulous disbelief. I shivered in a genuine response. Suddenly, Jimmy, the bouncer, materialized. He grabbed John's wrist in his formidable grip. Ben snatched his hand away.

"What the fuck do you think you're doing?" Jimmy growled. He squeezed the other man's wrist in his fist.

"Ah—don't—" John gasped.

"You picked the wrong girl, scumbag. Naw, scratch that. You ain't allowed to touch *any* of the girls. But especially not Randall's girl."

This was the first time I heard someone articulate what I thought was my own private knowledge, the most subtle understanding.

Jimmy gave the man's wrist a vicious twist before releasing it. "Now you got thirty seconds to get the fuck out of here."

John and Ben scrambled up and scurried out of the club. I pulled my dress back on, not looking at Jimmy. My face was burning, my body, too.

"Jo-Jo," Jimmy said. "Whaddaya doin'? Whaddaya fuckin' *thinkin'*?"

I couldn't look at him.

"Randall wants to talk to you," Jimmy said. "He said to send you to his office."

Randall's office was in the basement. He was behind his desk when I entered. He indicated that I should sit across from him, and he passed one hand wearily over his eyes before speaking.

"What are you trying to do, Jo-Jo?" he asked. "I don't believe what I just saw with my own eyes." He paused. "The middle of the floor! Two scumbags! Their paws all over you! And you panting and squirming like a bitch in heat."

"I'm sorry, Randall."

"You think this is a joke? Think I'm playing with you?"

"No . . ."

"You think I won't fire you?"

I was silent, staring at the cluttered surface of the desk. But I thought, *Yes. Yes, I do think you won't fire me.*

"This is my last warning to you," he said finally. "If you provoke me one more time, you're out of here."

"I won't," I said. "I'm sorry. Thank you."

* * *

Did I love Randall? I did love him a little. It pains me to admit this.

Randall was a long time ago. After he left, Richie became the manager; and after Richie, it was Johnny; and now it's Anthony. I never felt anything for any of the others. I don't know where Randall is now.

* * *

The terrible and redemptive aspects of the business will balance each other out for some time before the whole proposition begins to turn like milk. Sooner or later, for every dancer, the time comes when you can't swallow it anymore. Looking back on all the times I've left, I can't really pinpoint what in particular, if anything, finally made me walk. Maybe it was the sight of Angel, a feverish dancer trying to sleep between stage sets, curled by the locker room radiator in her pink bikini, lying on the bare linoleum. Maybe it was the man who threw his single dollar bills one by one onto the stage floor, so we would have to bend over to get them.

As for this time around, not long ago I went to work a

few hours after putting my cat to sleep. The cat was old and very sick, but I was heartbroken and unable to check my grief at the door.

"Whatsa matter, Jo-Jo?" the Champagne Lounge host wanted to know. "Why such a sad face?"

"My cat died this afternoon," I told him.

Incredibly, his doughy face creased into a grin. "Aw, look, honey, don't take it too hard," he guffawed. "As long as your other pussy's holding up."

* * *

Yes, the job can make you hate men.

"Laying and paying" is an expression you hear repeated like a mantra in the locker room. "That's all they're good for: laying and paying."

As if it were a point of pride that the exploitation is mutual.

* * *

Yes, the job can make you hate yourself. Because you're holding up the other half of that transaction, perpetuating it night after night after night of your life. There are telltale signs of when a dancer is on her way out: arriving at work five minutes prior to the beginning of a shift, instead of the half-hour needed to get ready; drinking too early; passing most of the night at the bar; crying onstage. For myself, I know the jig is almost up when I come out of the dressing room and, instead of trying to identify the man most likely to spend a lot of money, I look for someone I think I can stand to talk to. This is the wrong attitude.

Last night, the ache was upon me, and I kept searching for,

seizing upon, any man who might alleviate some small part of it. I walked around the club in several desperate circles, scanning the crowd for someone who seemed strong, smart, competent, gentle, kind. There was no one like that anywhere.

Once again, it's almost time to go.

INTERVIEW WITH ELISSA WALD

LIZZIE BORDEN: How did you start dancing?

ELISSA WALD: I was brought into it by a friend who was dancing in New Jersey. I started at a bikini bar off the New Jersey Turnpike during the afternoon. It was snowing, and Jenna and I took a bus to the bar. The manager was a middle-aged woman who warned me before I started, "This is not an easy thing that you're doing." She meant it in a sympathetic way: that it was possibly an emotionally loaded proposition for me. Of course, I was scared. There was fear in not knowing what I would do or whether I'd be able to pull it off.

The first song I ever danced to was "Bad to the Bone." The men were so kind. Nobody got too hot and bothered; they were there at their lunch hour, and they would be returning to work. Most of them just seemed like decent, good-natured blue-collar guys. They tipped me right away, which gave me confidence and put me at ease. It was a six-hour shift. I was on for fifteen minutes every hour, then able to study or read in the locker room in between. It went incredibly fast, and I made about two hundred dollars, which was such a fortune to me then, I could hardly believe it.

LB: When did you start dancing in New York?

EW: I danced in Jersey for a few weeks, but got tired of the long commute there and back. I realized that if I was willing to "graduate" to topless in New York, there was much better money to be made much closer to home. I danced at many different clubs intermittently for several years, and over time I called myself Ruby, and Jessie, and Joanna, and Jezebel, and finally Jo-Jo, which I thought was an upbeat, sassy, streetwise name. People referred to me as "Smoky Jo-Jo" because of my love for firemen and because of one fabulous, custom-made FDNY-centric costume, which featured a patch affixed to the back T of the G-string reading, "Keep Back 200 Feet." My nickname was "Jo-Jo the Go-Go."

LB: Your stories often include BDSM themes. Did this manifest itself in your dancing?

EW: I don't know whether dancing was any more or less an expression of S/M than anything else in my life. I really brought that dynamic very subtly into just about everything I did in my adult life: my relationships, my clothing, all my jobs. For instance, even as a waitress, I liked serving men and calling them "sir." I was "out" as an S/Mer long before dancing, but I was never a leather lifestyler. I'd wear chokers reminiscent of collars, or bracelets that suggested cuffs, but never anything truly overt.

LB: You were filmed in a harness, very exposed, in a documentary about bondage. Would you consider yourself an exhibitionist?

EW: I certainly was an exhibitionist back in the day—I loved flaunting my body in my youth and took just about

every opportunity to do so. I knew I was far from perfect, but I also felt hot as a firecracker—I think, in part, because NYC reinforces that feeling so consistently. A young woman walking down the street in New York City with any kind of sassy attitude or sexual energy is going to get relentless attention. I don't think I would have ever gotten a fraction of that kind of positive reinforcement in, say, LA, where the anorexic Barbie Doll aesthetic is considered the height of beauty. I felt special in New York in a way I didn't anywhere else. There's something ironic about that, because NYC is supposed to be the place that takes you down a peg and immerses you in cutthroat competition and makes you fight desperately to stay afloat and be noticed, but to me it has always seemed that New York honors and rewards all kinds of beauty—ethnic, eccentric, unsettling, unusual— and brazenness and invention and bravado, and I felt it was very, very kind to me in that way.

LB: There seems to be a constant tug-of-war in your essay between pity/compassion/attraction for the men and contempt for them.

EW: I didn't have any kind of uniform attitude toward the men. I loved some and hated some and got a kick out of some and took comfort from some. Dreaded seeing or dancing for some, agreed to see some outside the club. One customer, who was a composer, invited me to be his guest at Carnegie Hall the night his music was being premiered. Two other customers brought another dancer and me to the restaurant they owned for a private champagne breakfast. They let us pick anything we wanted on the menu, and they cooked for us. It was a customer who was responsible for getting my first book, *Meeting the Master*, a prestigious

agent and ultimately sold to Grove Press. Another customer helped me design its original cover. Dirty old men came in, but so did celebrities, even women. That's what made it so interesting.

PUSH AND PULL

Essence Revealed

Essence: the intrinsic nature of indispensable quality of something abstract that determines its character.

"Do you need encouragement to get out of the house or support to stay home?"

Chad was trying to decipher what I needed through my tears.

"I have to go to work," I sobbed. "I haven't been able to go, and bills are due."

Chad had been my confidant for years, ever since I'd met him at a regular bar where I'd once tried to get a job. I was told by an employee that the boss loved Black women and that they were looking for bartenders. Yet, when I went in, I was given what I've come to learn is the "we won't just say to you that we don't hire Black bartenders" runaround. The manager wouldn't even come out to speak to me. Apparently, his boss must love only to fuck Black women like me in private, not hire them in plain daylight. Sitting at the bar that third time, I realized no one behind the bar was a person of color. The "Currently Hiring Bartenders" sign was still in the window. I would have to stick with the stripping job.

At least I meet Chad.

"Okay," Chad was saying, "you know you're beautiful,

talented, and smart. You have a great body—especially those abs and that cute butt. You're kind and one of the most industrious people I know. Call me when you get to your car, and I will pump you up with more good karma."

Somehow, if anyone else had said these kinds of things to me when I was feeling down, my reaction would've been nothing but an eye roll. Knowing Chad was with me encouraged me to pick myself up off the kitchen floor and peel my back away from the cabinets. Someone earlier in the week had told me that they could see the sadness dripping off me. I felt like it had dropped off me abundantly enough to create a pool of sadness chin deep. That day, Chad was the flotation device I needed to swim out of it.

He spoke to me as I drove into work, cracking corny yet funny jokes. He was always so cheery. Sometimes it made me nauseated how chipper he always was. On days like this, I was deeply grateful for him.

Finally, I got to the club. "I'll be up until about eleven p.m., if you need another dose of good karma," he said right before hanging up.

All I could think was, *God bless you*. All I said was, "Thank you."

<p style="text-align:center">✳ ✳ ✳</p>

Point of view: the perspective from which a story is told. In acting, a term used to describe the cover given the true meaning behind the words. For example, the soap opera star may say, "I'm great" with a big smile. But, as the audience, we know the truth because we just saw he was weeping over his mother's grave.

I walk into the strip club to start my shift feeling like a wilted flower. I pass a group of dancers on my way to the

dressing room. One of them jokingly shouts, "Oh, great. She's here." I shoot a sarcastic smile. "Oh, please." While I get dressed, my face is blank. I turn me off and focus on turning my stripper persona on. What is my earning goal for the night? How close am I to my earning goal for the week? How many dances and/or VIP Room sales does that equate to? I have to leave my personal shit at the door. I have to remember the reason I'm here. I have to remember what the service I'm providing is all about. The customers want to feel appreciated and attractive.

Thongs, gown, heels, hair, makeup, last looks, and head out onto the floor with a HUGE SMILE. I walk the floor introducing myself to everyone I pass as I make my way to the deejay booth to check in and then to pay my house fee. I don't try to get any money from the men yet. I just say a friendly hello. On my way back, on the floor, I get stopped to do a few dances from someone I had introduced myself to. Afterward, I go sit at the bar so I can watch the room for any good customers, have a drink, and wait for my first set onstage.

While I'm sitting at the bar, another dancer, Arielle, approaches me. She is a honey-brown, light-skinned Black woman with big, curly hair.

"Can I ask you a question?" she says.

"Sure."

"How do you do what you do?" she asks me. "How do you always make money?"

"HA!" Well, A: I don't always make money, but I never show that I'm upset when I'm here. B: I focus on selling when I'm here; I talk to everyone that I can. C: I bring them the sunshine. They come in here to escape from the real world of being husband, boss, dad, whatever."

"Ugh, I can't stand even talking to them."

"Yeah, they probably can tell. You gotta make them think you sincerely find them fascinating and interesting."

My name is called, and I get up to go onstage. I dance and smile at every guy who makes eye contact with me like he is the only one in the room. While I'm up there, I feel out who I should go over to right when I get off the stage. Who seems to think that we have a "special" connection? That is who I will go and have a drink with. While he is ordering the drink, I excuse myself for a second, so I can go say thanks to any guys who tipped me onstage. If they want a dance, I promise that I'll come over after I finish my drink. I line them up. "Oh, sweetie, I have two guys ahead of you, but I'm coming right over after that."

All right. I'm the flirty life of the party. I smile, dance with wild abandon, crack naughty jokes, can cling to their every word. Once four a.m. arrives, I can turn it all off. I wipe off the makeup. I put on the baggy sweats I wore there. I stuff my money roll in my sock, and I drive home. I watch late-night/early morning TV silliness until I decompress enough to fall asleep.

*　*　*

PUSH

Before my eyes even open, I can feel my stomach churning as I wake up. It is that familiar dread of having to live through another day. I haven't gone to work in a week, and I don't care. I lie here in bed not seeing a reason to get up. I'm not hungry, so I don't eat. I don't have any auditions. I don't have to be anywhere. I can't come up with any reason to move from this very spot . . . ever. I may know a good number of people, but I have very few friends. No one will check up on me or know that I've been lying here for

a week. I won't even call Chad, because his chipper disposition just makes me feel worse sometimes. It's as if he has no clue what it feels like to go this deeply dark. He does his best, but empathy for this gloom is beyond the scope of his understanding.

I'm pissed off every time I have to go to the bathroom. It's the only action I begrudgingly take. I haven't bathed all week. Why bother? It's just me, myself, and I here, and I won't offend myself. When I do have to leave for an audition, I grab whatever clothing matches from a pile on the floor at the side of my bed. My apartment is dark, but my eyes have adjusted enough to pick through the pile when I have to leave the house for an audition. By my estimation, that's the only reason to go outside. No one in there will know what I'm going through. They don't care. Leave your shit at the door, show up on time, and be professional. I've perfected the public presentation.

There is a light-wood wardrobe to one side of my bed. Staring at the pattern takes up the bulk of my days. The other parts of the day are spent looking at the eggshell white wall on the other side. This wall has a framed black-and-white picture of a Black woman lying on her stomach with her round behind peeking out from under the sheets. Sometimes tears will stream down my cheeks. My facial muscles can't be bothered to participate in these crying games.

<p style="text-align:center">* * *</p>

PULL

I'm sitting in a waiting room at an audition, a group of Blacktresses are talking about how slow business has gotten.

"Remember when we used to go out three and four times a day?"

"Girl, yes! If I get out three times a week, that's good."

Three times a week!? This is my first appointment in three weeks.

Everyone *mmm-hmms* and *ahas* about the situation.

Eventually the conversation rolls round to what we are going to do to make a living now.

"I started working at TVI Studios. Hopefully meeting some of these TV/film casting directors will parlay itself into some work."

"Chile, I had to go back to the restaurant. Lawd knows I didn't want to, but I gotta pay rent."

"My husband just looks at anything I make as extra money. He said as far as him setting up the household budget is concerned, I'm unemployed."

We all start to laugh at that. I feel slightly jealous that she has a partner who supports her and her art. Only slightly, though, because she has three kids to raise, and I don't want to do that. This entire time, I've been quiet. I find that when I'm quiet, people tend not to notice. They are usually too busy talking about themselves to care that I'm not. I look at my roller bag. I know that inside it are seven-and-a-half-inch clear stilettos, several different-colored thongs, long gowns, baby wipes, and bags of makeup. I have finally escaped from the clutches of my bed enough to get to work.

It's Tuesday, so that means that Steve will be coming in to the strip club. He comes in between midnight and one a.m. He comes in that late hoping I'll be done with any other customers. He wants to get me to himself. He usually gets me all to himself. He's wearing khakis and a polo shirt. He's a middle-aged, balding white man. He's a truck driver. He's pretty fun to be around.

If I'm onstage when he comes in, he'll have my drink waiting for me. He usually sits near the waitress station at the bar. I'll sip on the Malibu and pineapple juice he ordered for me while we chitchat about everything and nothing. His daughter and his skills as an artist are his latest fodder for conversation. If I dare mention that he should buy a dance or go to the VIP Room, he'll protest. If I just sit with him for a bit, he'll eventually want to go into the VIP Room for an hour. Once we are up there, he takes off his polo shirt and khakis. He's still fully dressed. Underneath, he wears leggings, knee-high boots, a lady's shirt, and a bra stuffed with chicken cutlet–looking breast enhancers with a pearl-shaped earring stuck in each cup to create the nipple effect. Now I call him Stephanie.

"Man, I went to this cross-dress party, and all these gay guys were trying to hit on me. It was awful."

"I'm sorry, Stephanie."

"Where can a guy wearing a dress go to meet straight women?"

"I don't know, but this is New York, so it must happen somewhere around here."

Every time the VIP hostess comes up to let us know that our hour is over, Steve/Stephanie pays to stay another hour. We are having a great time. We make up stories about all the adventures we'd have walking hand-in-hand in Amsterdam. In between talking and laughing, I dance for him. Sadly, the club has to close, and he has to go home and be Steve.

PUSH

It's Thursday, which means Count Dracula is my regular customer tonight. He earned the name from the choc-

olate dancers he fancies. I suppose we could have named him Count Chocula. He has a thick German accent, greasy gray hair, and he smells like he hasn't bathed or brushed his teeth . . . ever. The smell of red wine and cigarettes permeates his breath. However, he will want to stay in the VIP Room for two, three, four hours, which means one thousand, fifteen hundred, two thousand dollars.

He whispers way too closely to my nose. "You have three lahverz, unt one of dem iz a vooman. You ahr such an ahrtizan, so soft, so tender."

I get up to escape the smell of his breath and start to dance for him, facing away from him. As I hover over his lap, he trips me up so that I land on his lap. He grabs my arms, "You run, but da chase, da chase, eet is all a parht of eet, izint it?" I try to get up, but I can't. "You need sumwan who will be dere for you . . . help you out financially from time to time . . . someone who will not restrict your movement." He has me pinned down by my arms. I sigh as I sit and listen. I regulate my breath so that I am breathing out in order to avoid breathing in that smell of his. Then his hand starts to make its way to my thong. I forcefully free one arm so that I can grab his hand before it reaches my pussy. "Don't move, leave it, leave it, I want you to enjoy it." *How* could he possibly think that this is enjoyable for me? I use jiujitsu-like moves to keep his prying hand away.

He is what we call in the industry "a lot of work." We tend to rotate him among us, because some weeks, ya just don't have the mental energy for the fight. I keep checking the time on my watch every so often behind his head. I close my eyes and picture twenty one-hundred-dollar bills to help ease the time on by. I think about how many people say stripping is easy money. I daydream about punching someone in the mouth the next time I hear those words escape from their lips.

PULL

It's Friday, and a group of high rollers have come in for a bachelor party. There are about ten of them. They have corralled about twenty strippers to party with them in the far back right corner of the club. It is one of Tommy's last nights of "freedom." They celebrate by popping bottle after bottle of champagne. There were making it "rain" on us with one-hundred-dollar stacks of singles at a time. We were given garbage bags to collect our money. What they were spending had long since gone over the limits of what we could fit into our purses. In the dressing room, there is a house mom. She keeps an eye on things there and sells to us, or provides us with, anything we could possibly need, from aspirin and tampons to dresses and shoes. Those of us who were close with her handed her our bags of money for her to organize while we headed back out to make more. She got big tips that night.

There is an electric energy in that corner of the room: the rush of the music, the pace, bottle after bottle of Cristal popping, the rush of extreme celebration. Tonight, I forget to remember that I'm supposed to be ashamed. I forget to remember how much I'm supposed to hate this game. I'm getting paid to hang out and play. This is a mutually beneficial fantasy. They get to be that player who knows how to keep the "dime pieces running his way." I get to be that "I deserve every bit of money in your pocket just cuz I look like me" kinda chick. This is an excellent night at the night job.

* * *

I'm sad. Not just "it'll pass in a little while" sad. I'm "spending all my free time alone for the last few months constantly on the brink of tears" sad. I'm "sit on the side of the building sobbing uncontrollably as New York ignores me and gets on with its day" sad. I'm "sit on the subway and let the tears freely flow down my apathetic face" sad. I'm "so numb that I can't even muster my usual doses of hope and positivity" sad.

I thought I did everything right. I stayed in school. I stayed out of trouble. I got amazing grades, which led to an overpriced education at a big-name school. I graduated cum laude. I followed my passion and did what I loved. I even ate my vegetables. So, I cannot comfortably grasp why I am not able to figure out another way to take care of myself besides stripping.

Stripping itself isn't the problem. It's a job with pros and cons like any other job. I love being able to work as little or as much as I choose. I love that how much I make is on me. The more I develop my sales skills by studying sales books, the better I become at selling VIP Rooms. The biggest thing that can stop me is me and my moods. The main thing that makes this seem like a sucky way to make a living is the negative outside perception. This stigmatized perception affects how I am treated by some customers at work. It definitely affects how I am treated by anyone outside work who is able to pin the "stripper" label on me.

My eyes pop open one morning, and I look up to see depression over me. It has me by the neck. I wish I would disappear, so I could finally be released from its clutches. My kind of depression, though, isn't the kind that is strong and willful enough to make me harm myself. It just buzzes annoyingly and incessantly like a fly. It is only strong enough to make me not see the point in . . . anything, everything.

PULL

I have to get out of New York for a while. Maybe a change of environment will put me in better spirits. I research what I will need to go work in Vegas. This is another benefit of this job. I can go to just about any major city in the world and find work. I have to get a business license to work in Vegas. I read online that women should get employment paperwork from a club they don't want to work for but where they'll be easily hired. I also have to get fingerprints done. It is suggested I get to the fingerprinting office early to avoid the long lines. For a reasonable rate, I find an extended-stay hotel that looks like a mini-apartment. It's near the club that is my first choice. I book a room for two weeks. I got most of this information by lurking around on stripperweb.com.

When I land in Vegas, it is too late to do fingerprints. I find a dinky club to audition for. Why is this club so dark? The manager might as well be a part of the anti-marketing campaign for this spot. "You'll make more money working someplace else. Oh, and you'll have to wear two thongs at all times when you're working." I have never heard this rule before or since. My imagination runs wild with reasons and scenarios that could have brought this rule to be. Do the customers have some kind of stealth thong-penetrating skills or something? Are two thongs like kryptonite to these thong-penetrating superpowers? Employment paperwork in hand, I've got what I needed—which is the paperwork to get my business license in the morning.

Business license in hand and fingerprints done. The first club I go to won't even let me audition. I look around, and I don't see any women of color working. It must be one of

those clubs that is a land of a million blondes. They probably have about three Black women on the entire roster. They claim it's because the clientele is not interested in women of color. Yet I make my money mainly and almost primarily from white men. It's annoying, insulting, and belittling. Next, I go to Spearmint Rhino. The manager leads me to the dressing room to change. It's about the size of an entire club in New York. There's tons of counter space, and mirrors with light bulbs across the top. There are so many dancers buzzing in and out. There is a whole section of bathroom stalls. I guess they don't have to use the club's bathrooms here.

It's intimidating. The club is huge, and there seem to be hundreds of women working. I dance on the stage for two songs and am asked to come down. I am sure that I am not going to get hired, given that they call me down so quickly. I am granted employment for the coveted shift of eight p.m. to four a.m. I wander around the club from room to room. I feel how tourists who come to New York from a small town for the first time must feel. I am overwhelmed and in awe of the size. There are not only several rooms, but several *stages*. This club is not open just until four a.m.; it's open twenty-four hours a day. I snap out of my shock and get to work. There are so many men that I just repeat the same thing over and over. There seems to be no need for long small-talk chat sessions here like in New York. "Hi, what's your name? Where are you from? Is this your first time in Vegas? It's mine. I should take my dress off and rub my body all over you; that sounds like a good idea, right? Should we do it here or get some more privacy in the back?" I make in one night what it would take me a month to make in a New York borough club. During the day, I am a tourist doing things like going to Madame Tussauds wax museum. I hit

up all-you-can-eat buffets when I want something different from the restaurant near my hotel home.

<p style="text-align:center">✳ ✳ ✳</p>

PUSH

I get back to New York and am alone all over again. I actually miss the familiar strangers I met in Vegas—like the waiter that served me every day at the restaurant near the hotel. One night he hooked me up with free dinner, so I treated him to a free dance the next time he came into the club. The thing I really miss about Vegas is that no one treated me badly when I said that I was a stripper. One cab driver asked if I was visiting. "Yes, from New York. I came to work for a few weeks. I'm a stripper."

"Oh, which club? My wife works at one of the ranches. I gotta go pick her up later. They stay for a week or two at a time to work."

"Oh, wow. I didn't know that. How much do I owe you? Have a nice day."

Now I'm back to this isolated little bubble. After two weeks of not having to self-edit, it sucks even more now. This morning, my head feels like it is going to explode from the force of all the really awful things I have to say to myself: *What are you so sad about? There are children starving in Africa. There are people living in war zones in some parts of the world. Poor you, you're a stripper, whaaa! You have a safe place to live, you can buy food, both your parents love you. What are you always crying about? GOD. Stop it.*

I can't stop the talking. I can't stop the tears. I go to the computer and research a suicide hotline. There will be someone I can talk to on the other end of the line at least. I find a number and call it. I get a recorded message. The

number is out of service. *Really*? If I were suicidal, that might be enough to convince me that killing myself was a good choice after all. Jeez, not even the suicide hotline cares enough to pick up my call.

I dial another number. I'm on hold, to be connected to someone in my area.

"Look, I'm not suicidal . . . I just . . ."

"But you just said the word *suicide*."

"I know I said the word *suicide*, but I'm not suicidal."

"How can I help you?"

"I just need someone to talk to . . . I'm a dancer."

"Oh! A dancer? That's nice."

"Yes, well, not a dancer proper. I'm a stripper and . . ."

"A stripper?"

"Yes, a stripper. Anyway, I feel *so* alone. I feel like I'm about to pop. I don't have anyone to talk to about it, and I'm so sad and stay in my apartment for days. It's like I'm in this little bubble, and my brain is gonna pop."

"Hold on . . . No, no, no paper no plastic . . ."

"Are you shopping?"

"Listen, sweetie. I'm going to give your information to the psychiatric ER near your house. There's a psychiatrist on call there all the time. What's your name?"

The next day is a bright, sunny Saturday. I'm lying in bed and can't even open my eyes. The voices in my head are going to cause it to pop off: *SHUT UP! Hello. I'm not suicidal. I just don't have anyone to talk to. I'm a dancer. Well, not a dancer proper, a stripper. Yes, STRIPPER. And . . . no, yeah, I know I said the word* suicide, *but I'm not suicidal. I just feel like I'm alone in this bubble and I'm gonna pop because . . . Are you shopping?*

Go to the psychiatric ER. It's walking distance from your house. Hold on . . . no, no, no paper bag . . . I ahhhhhhhm, I'm going to let them know you're coming. What's your name?

* * *

There are three other women in the waiting room. The first one is massive. I've never seen someone inhale and exhale so much air, ever. "Hey, y'all forgot to gimme my juice. And what y'all got for dessert today?" number two shouts. She is dressed like that ghetto aunt you have that is too big and old to be squeezing into the too-tight clothing she wears. The third one is walking around nonstop. I feel like I have to keep my eyes on all three. That's just hour one. Then, slowly, I inch my way to the office where the *one* nurse on duty is stationed. Inside a glass booth. Imagine a space like a phone booth just large enough to fit a desk.

* * *

Peaceful. Peace. Peace envelops me. In the storage-closet-size solitary confinement room in a Brooklyn psychiatric ER on a sunny Saturday afternoon. My brain turns off from its usual WISuck Ass radio station. I feel like I'm surrounded by magical molecules. The air and I feel like we are one, and we see only the beauty and wonder and possibility in everything.

LIZZIE BORDEN: From your stories, you seem funny and vulnerable.

ESSENCE REVEALED: In person, I present tougher than I am. That was actually an ongoing critique of my acting: that I was too tough, that I wasn't vulnerable enough.

LB: Are you from New York?

ER: No. I was born in Massachusetts, and I grew up in Dorchester during the height of the crack epidemic. I'm first-generation Caribbean, from Barbados and Guyana. My mom was born in Guyana but raised in Barbados. My dad was born and raised in Barbados. I'm the reason my parents were able to stay in America.

LB: Did you go college in Boston?

ER: No, in New York. NYU. I was in the acting program at Tisch. For grad school, I was in the Steinhardt School.

LB: At that point, were you in student films? Did you go on auditions?

ER: I'd been auditioning since I was sixteen, so I came to college already having an agent. I think that a lot of students I was going to school with thought I was weird because I had never taken acting classes or anything like that. I just had been doing pageants. The woman who was my first agent was one of the judges at a pageant. She invited me to come to New York to read for her agency and started

to rep me. I had the same agent as Tempestt Bledsoe and Emmanuel Lewis. When I got to Tisch, it was the first time I had taken class, but I had been auditioning for a few years.

LB: At that point, did you book anything that made a difference?

ER: It was toward the end of grad school that I booked my first national network commercial, for Wendy's. I did Wendy's spots for years. I ended up in the world of voice-overs and commercials—versus film and TV, which is what I really wanted.

LB: You must have been making decent money at that point.

ER: I was. And when I started dancing, I would sometimes see my commercials on TV when I was onstage.

LB: What was the impetus to dance?

ER: I graduated from school and found myself like, *Wait a minute. Now what? There's no employment office.* I auditioned, and when people say you hear no way more than yes, that's not a euphemism. When yes happened, it was great, but you don't know when you're going to get that next yes. I had reached this point where I was working four or five jobs—I was temping, teaching, an art model, a hostess at a restaurant—and could barely pay my bills.

LB: Where were you living then?

ER: I had an apartment in Brooklyn. I remember there was

one day I was on my bed crying because I was like, *Even if I get an audition, I don't have the money to get on the subway and get back home.* My girlfriend at the time paid for me to take a bartending course, and I attempted to try to get bartending work, which I failed miserably at, because I'm a horrible liar, even though I'm a good actress. Every bar in New York wants you to have two or three years of New York experience, and everyone's like, "You just lie about it, whatever. Make up a résumé." I made my little fake résumé, but apparently nobody would buy my story. After three months of looking for a bartending job, I walked into a strip club. The manager showed me around. I didn't know anything about it, but there was only juice, no alcohol, because it was a nude club. He's like, "You know, you'll make a lot more money dancing than you will bartending." I was like, "I just graduated from NYU." He's like, "I got a lot of NYU girls here, whatever." So, I became a stripper trying to find a bartending job.

LB: How did you then make the transition to nudity?

ER: I had already been an art model, so I always felt okay about nudity. About my body, yes and no. I would say that the years where I was really hard-core pursuing film and TV, I worked out like a maniac to maintain a smaller size. I was in the gym three to five days a week, and when I started dancing, I could do things like pay for trainers. I put in the work, because when I was pursuing acting, leading ladies were size four. I'm five feet four. I'm a tiny person. Then standards went down to a size two. That took work. That took freaking eating on a schedule. That took food journaling. That took me walking around with my food everywhere so I could eat every two to three hours. Then it

went down to a size zero. I was like, *I give up. There is no way my body is going to a size zero.*

LB: Did you have any relationships that were affected when you started dancing?

ER: I didn't tell anybody what I was doing except my girlfriend at the time. Her sister was a stripper, so she got it. She was like, "Go make the money." But I had dated a lot of women that had problems with it, too. She was kind of the only one. She and the guy I wrote about were the only two in ten years that didn't have a problem with me being a dancer.

LB: What did you tell other people you were doing?

ER: Bartending for private events, like in rich people's homes, because I once said I was bartending, and my godmother was like, "Oh! I want to come hang out at your bar and have a drink." I was like, "Um, well, about that, it's these private events. Yes, private events, and they're in rich people's houses, so you can't come inside."

LB: Is that when you decided to create your persona, "Essence Revealed"?

ER: I have a solo show called *Essence Revealed*, which is about exactly that: living a double life as an actress by day and a stripper by night. Right around the time when I was workshopping the play with my director, I discovered burlesque. I abandoned the play and started doing burlesque, and my play's name became my burlesque name, because I thought that I would circle back around and do the play, but it's been years, and I haven't done the play yet.

LB: So, it's still your ambition to do it?

ER: I actually have a crazy ambition to do two solo shows. One is that, the other is a lecture/demonstration about Paul Robeson, and I play Paul Robeson. I call them my yin-and-yang projects. Having a night where I do both of them back-to-back is my dream.

LB: When did you start to write and blog under another name?

ER: About the time Essence Revealed was born. I still keep things separate, because in the world of commercials and voice-overs, this would not exactly be welcomed. All my reps know what I'm up to, so I'm not hiding it from them, but I don't make it known widely.

LB: What do you do for money now?

ER: Burlesque and bartend. The way I was doing burlesque was very much to make it up in volume, because the pay is horrible. I'm currently on kind of a performing break. I still do commercials and voice-overs.

LB: Do you still go through periods where it's just really hard to meet the rent?

ER: Yeah, I've had that happen, because they're not making as many commercials as they used to. That means there's less chances at bat.

LB: Are you still going up for acting roles in film and TV?

ER: No. I pursued that hard for twenty-one years, and I just got to a point where it was like, *Annnnd release. I can't.* I can act until I die. It's not like I'm a dancer or an athlete where there's a time limit. So, I stayed in the commercial voice-over lane and stopped trying to do the other things, the things [for which] I would hear, "No, we can't represent you because we already have three pretty Black girls." "Really? How many pretty blondes do you have?"

LB: In acting and stripping there seem to be age limits, while in burlesque there seems to be none.

ER: The older you get, the more they love you. That's the wonderful thing. There are women who are eighty-something years old who are still performing, and we're like, "Yes! I love you! All hail the Queen! You are a legend!" The legends get so much love.

LB: Stripping involves some interaction with clients. Have you crossed boundaries you later regret?

ER: The dirtiest it got for me was, "Am I going to let this guy touch my thigh? Am I going to not say anything when he grazes my ass?" "Am I going to ignore that or am I going to say something about it?" was pretty much all I had to deal with. I remember in Vegas one night, there was this guy who seemed like he must have been high out of his mind on drugs, or maybe he got drunk. I don't know, but he was handing me hundred-dollar bills at a time. He was standing around, dancing, drinking, getting his white-boy woo on and then saying the craziest things, like, "You're my Black blah-blah-blah" and screaming at the top of his lungs. I was just like, *How much longer can I take this? He's handing me a*

hundred-dollar bill every few minutes. Will I take two? Will I take three? Will I take four? When will I leave? At some point, I was like, *Aaaand moving on,* but I stayed there and listened to that craziness. Afterward, I definitely didn't forget about it, and I felt all the things you feel when you're reminded that you're not really looked at as an equal.

LB: Yeah, it's humiliating. And have you experienced tokenism or quotas in terms of Black dancers in New York clubs?

ER: It's funny, because it shifted. Toward the beginning, when I started, around 1999, 2000, I was always only one of three if I was working in a white club. There were never more than three of us. Toward the end, when I was leaving—right around the financial crisis, 2008 or so—there would be about a dozen on the roster.

LB: More equality?

ER: I wouldn't say equality, but there were more than three of us because there were countless numbers of blondes, which the blondes would complain about. "Look how many of us there are, meh." Not all twelve were going to be working every night, so maybe you'd have four or five of us on any given night, out of forty, sixty, seventy white girls, depending on the club.

LB: In "Push and Pull," you write about depression. Do you think it comes on because of life circumstances, or was it always there in some way?

ER: Yes, because I had it from a very early age. In my own mind, I was always chastising myself. I can only chalk it up

to brain chemistry, because I'm a kid of Caribbean parents who were very strict, especially with girls. Then, later in life, it was usually financial. I was depressed because I couldn't take care of myself. I'm like, "Here I am, a smart woman, an educated woman, and I can't take care of myself," and it would get me so sad because I was going on dates with these white men who were very successful, and they'd be like, "Yeah, I have a degree in sociology, but somebody gave me a chance, and so now I'm this huge investment banker who makes a million dollars a year," or, "I didn't finish school but I own this company now that makes . . ." and it's like, *Wow, man. Must be nice.* So, that would get me down.

LB: Do you consider yourself a feminist?

ER: I don't identify myself as a feminist at all, because feminism has pretty much shown itself to me to mean white women. Really, if I need a word and a set of rules that people are going to be mad at if I break and other people are going to be mad at if I don't do and if I do . . . I am a Black, first-generation, immigrant, gay, working-class sex worker. I don't need a word to say that people should be equal.

LB: Do you still write?

ER: I wrote a self-help book, *S.T.R.I.P.: A Stripper's 20 Life Winning Lessons*, about the ways to successfully navigate life. It's about how you get out of your head and get into action, and it can be applied to anyone's real life. I use it in my coaching programs for female sexual abuse survivors.

LB: Do you use social media as a platform for social activism?

ER: I don't call myself an activist, because I don't work with an organization or go to Albany to talk to lawmakers. I don't demonstrate or go to marches. However, I am extremely outspoken when it comes to being a sex worker, because my life is such at this point that I can be an out former stripper without severely negative consequences. I think it's important for people to see that regular people they know are also strippers, dommes, escorts, sugar babies, porn stars, etc. People tell me I've helped change their perspectives about sex work, sexual violence, and race. If that counts as being an activist, then, yes, I am.

DANCING STEPS TO TINY FEET

Sassy Penny

t's strange when you are in your comfort zone but don't feel comfortable. Like so many other nights, here I was, a woman among women, watching the stage, catching up with old friends, nursing a chilled glass. But this time was different. My breasts were huge, beaten only by my swollen belly. A diamond ring, heavy and obvious, stood out on my left hand.

I wasn't going to be working tonight. I couldn't—I was pregnant.

I'd gone to the club to speak to the management about an art exhibition I was organizing with the East London Strippers Collective and ended up staying an extra few hours. It was a quiet midweek evening, and the heat outside was fierce, the air thick with pollution and pollen, the rush hour just beginning. I was glad to rest my swollen feet in the cool air-conditioned basement, recline on a thick velvet chair and watch the show.

We sat in an inconspicuous corner. I'd felt all eyes on me as I walked through the club and wondered if they were simply curious. The men looked surprised, followed by a judgmental shadow that flickered across their frowning faces. I didn't care. I knew my strength, and I had my reasons. I wasn't going to drink or do drugs—I was seeking

sanctuary, the same as the regulars who sat around the tipping rail nursing a happy hour beer. The city is too crowded, it's quiet here among the booming music and oscillating bikinis; there's no reason to go home yet.

But I did feel less comfortable. A changing body gives one a changing perspective, and as I explained to the tall blonde in front of me, a former stripper sidekick, my body's primary purpose wasn't turning men on anymore. It was creating life.

I felt envious even as she benignly complimented me on the wonders of my body, her words slipping out in between measured breaths. Pregnancy is a loss of control. I'd spent years shaping, toning, watching my curves and muscles develop. Every day had been a battle to control it. Watching my diet. Exercising regularly. Brushing shimmery powders and creams onto my skin, drawing in the lines and lashes to paint an idealized version of me. Now my makeup was light—I couldn't even dye my hair or paint my nails without fear of harming my baby. I had to embrace the natural look, but in a room full of unnatural women, that was hard. I'd spent years trying to stand out, be the unique stripper among the Barbie clones so I could widen my appeal to men. But now, almost by accident, I was doing just that. My pheromones and flushed pregnancy glow brought men and women to me like moths to a flame. I was the ultimate expression of femininity.

Suddenly, everyone in the club had a question, a story to tell, a picture to show. You forget that a strip club is full of women and what real women are sometimes. Dancers strolling past stopped to stroke my belly, expensive manicures tickling the taut skin. Carefully, they retrieved their mobiles and surreptitiously showed me photos of the children in their lives: sons, daughters, nieces, and nephews.

The manager, usually so quick to reprimand for bringing phones out on the club floor, had instead eagerly shown me photos of his baby. Even the girl behind the coat check had stepped out from behind her tall desk to show her own expanding waistline—I wasn't even the only pregnant woman in the club.

Enjoying myself now, I decided to treat my fiancé and myself to a lap dance. He'd had two beers and, while initially paralyzed by awkwardness, was now feeling jolly. It's funny, but picking a dancer when you are pregnant is different somehow. We were both drawn to a soft and squishy girl, a bubbly brunette from Essex. She had a big bottom that twerked and wobbled, so I didn't feel fat. As I explained to my partner after, I'd wanted to be turned on, not feel ashamed. It's all too easy to start comparing yourself to other girls, and who wants to pay for that?

I watched as he enjoyed the conventional girl-next-door charms of this other woman. He was getting excited by her lumpy bits—I could see his fingers twitching to squeeze the creamy expanse of flesh jiggling inches away. I wondered if he, too, was subconsciously choosing the more fertile look—if his tastes had changed in tune with my changing figure. As my tiny twenty-six-inch waistline had gradually expanded to forty inches, he'd still cuddled and kissed me. Never at any point had I not been sexy in his eyes. So, did that mean he was craving the cuddly type? In fact, were we both craving bosoms and bottoms and the traces of wobbly fat dappled along her thighs?

Pregnancy hadn't changed only my body and what it felt like to be a woman. It was changing my sexual feelings and ingrained stripper outlook of what was "acceptable," too.

* * *

Several months later, I found myself in hospital. My baby was barely five days old and was wilting away with severe jaundice. My body was tired, aching—the gradual change of pregnancy jarred by a morning of labor. My beautiful breasts now engorged to bruised and swollen basketballs. My vagina had been tiny—pink and tight as a rosebud. Now it was covered in scratchy stitches, raw and bleeding angrily.

It had been such a long day already, and now, with midnight approaching, I was being asked the impossible by yet another doctor.

Feed the baby every three hours?

Change his nappy on my bed?

It could take *how* long?

A harassed-looking nurse brought in a pistachio-green machine. It looked like a primitive dildo—a plunging mechanism on top and two tubes attached to strangely shaped plastic bottles.

"This is your breast pump," she explained, and we had a laugh as she showed me how to use and sterilize it. "Try and pump after every feed; you need about fifty milliliters, which you then feed to the baby to top him up after he's been at the breast."

"How long will all that take? Pumping and sterilizing and feeding—it sounds like a lot."

"It'll take a good hour or more, but we want the baby to take as much as he can to get rid of the jaundice. The more he eats, the faster it will go. Don't forget to set your alarm to feed him every three hours, okay?"

She left, and I stared at the green machine and the yellow baby in front of me. I put the pump to my breast, and my skin was sucked up against the plastic sides. I could see my nipples getting pulled in and out, in and out. I sat there like a cowboy, both hands up, holding my guns. With no

free hands and no Wi-Fi, all I could do was listen to the few songs on my phone: some annoying jogging anthems and the symphonies of *Swan Lake*. I watched the pump swell my nipples wider than my thumb. An eternity of drips to reach fifty milliliters—a double-vodka measure that could be knocked back in seconds, but now every drop counted.

I took the tiny baby in my arms and, as carefully as I could, put him to my bloated boobs and tried to get him to feed. He didn't know how. He'd be fine for ten seconds, a minute—two, three—then cough and splutter and turn his little head away.

I fed him the just-expressed milk from the bottle, patiently bringing it to his mouth again and again till it was all gone. I looked at my phone: the whole process had taken two and a half hours. Never-ending repeats of this inescapable scenario lay in front of me. I felt crushed, body and soul. All my careful birth preparation, the yoga courses, the expensive hospital bills—and yet, The Worst had happened anyway. My baby was dying in front of my eyes, and the only things that could save him were me and a silly fluorescent light.

I smiled. He looked so cute under these special fluorescent tubes, an eye mask across his face. It was exactly like a tanning bed. As I began to reminisce about the different tanning salons I'd visited across the world—ohhh, those glorious, carefree days when I was skinny and sexuality kept my life ticking—I had a revelation.

I can do this.

I used to do this all the time, week in, week out.

I can totally stay up all night and deal with a difficult and demanding customer.

Saving his life wasn't impossible—it was a challenge, sure, but one I'd been practicing half my life for.

I called upon all my stripper skills, that inner strength you nurture as a hustler when times are lean: When you are faced with a long night in an empty club and your rent is due that week. When you see other women making money and doing well, and yet you are struggling, alone, your questions and pleas answered by a brick wall again and again. When you ask for a dance, and they say no, turning away, you keep on nudging. Pleading. Conniving and luring them until they give in.

So, he was refusing my breast. No biggie. Keep at it, and he'll eventually come to Titty VIP.

So, I needed to express fifty milliliters every few hours. Well, pointless stage shows on rotation were a chore, too.

So, I'd be up all night. Whatever. I used to think working till five and six a.m. was normal.

So, I was stuck in a tiny, stuffy room with a fussy little man changing his mind and moaning in my ear. Who hasn't had a few nightmare lap dances like that?

My stripper goddess whispered in my ear not to get frustrated: *See not the tiny baby, don't feel unprepared or scared. See him as a man. You can handle a man, surely?*

Around me, the sounds of the ward drifted through, settling into a constant rhythm of beeps, voices, crying babies. Repetitive. I tuned the sounds out, not letting them annoy me further: the deejay was playing his same old songs again, speaking the same tired lines to work up the straggly crowd.

The baby suckled, and an inner peace descended on me. When he turned away, I simply asked, "What's the matter, little man? Do you know how many people have seen and loved these titties? These boobs have traveled the world, and now they are just for you." I'd breathe out my tiredness and pain, several long, deep exhalations, and then, taking

his tiny hand, tell him, "I think you are a very special little man. Let's go dance together in Titty VIP."

* * *

The following Sunday, I was seated with my breasts flopped out, surrounded by chocolates and fruit. I'd been in positions like these for four long days and sleepless nights, but this time was different. I was back home.

We. *We* were back home. The baby slept softly on my lap, his chest now rising confidently with each breath. He was alive, and while a new stage of my life was beginning, it was those dancing steps of yesteryear that had got us here.

INTERVIEW WITH SASSY PENNY BY ALLIE CARR

ALLIE CARR: When did you start working as a stripper?

SASSY PENNY: I went to Paris on an art trip for three days when I was around nineteen. I'd paid for the trip, then realized after doing my accounts that I would only have five pounds to spend for three days once I got there. I was already working a couple of jobs, one in a shop at a milliner's. There was lots of stuff in the newspapers about Spearmint Rhino and Stringfellows and how they had to go fully nude. I just thought, *Yeah, okay. I can do that.* Because I'd been at art college, I'd got used to being naked in front of people and parading around, so I thought, *Well, it can't be that hard.* So, I went. I didn't actually work in a strip bar. I was a hostess with strippers around where you got to drink champagne. I managed to cobble together enough money in a couple of weeks to go to Paris.

When I got back, I didn't really need to go back to the club, but there was something about the seedy glamour and the ready cash and the exoticness of the girls and the customers that really appealed to me. And I loved the fact that I was getting paid to get drunk. There were a couple of girls there who were dancing, and they used to come in and just do a couple of dance shows and then leave and go to another club and said that I should try stripping.

The [costume] stuff that I had was stuff I'd picked up from the market, from a high street. Normal high heels. I didn't have the Perspex heels; I had a long black dress that was still fairly revealing but actually kind of strippery. Nothing like the kind of custom-made dresses the girls had at the time, covered with sequins and cutouts. I remember my first time I had to get naked. I was on a little podium stage. I was dancing around for the first song, and then the second song came, where you have to get naked. I just closed my eyes, and I pulled my dress down and opened my eyes and realized that nobody was looking at me. Nobody gave a shit. I just stood there with my tits out in front of hundreds of people, and nobody was batting an eyelid, and that was such a freeing moment for me.

AC: Did anyone spot that you had the wrong shoes?

SP: I think I said to one or two of the girls, "I've never given a dance before." One of the dancers very kindly said, "You can come and do your first dance with me. We'll go and do a double dance." And so, she found some guys, and we went off and we did a dance together, and I copied what she did, and it was really sweet. It's actually something I've done myself with other new girls, and they're always very grateful.

AC: What was your dissertation about?

SP: It was called "The Encroachment of the Religious Right on UN Development Councils at Cairo and Beijing." Basically, the idea was that there'd been this crazy lobbying at these UN Millennium Development Goal meetings, which happened every couple of years. There'd been a big push in the nineties for better access to sex education and self-care, condoms, sexual health advice, sexual health clinics, abortion, even testing. The politicians were listening, and things were getting written, and it seemed that the world itself was going to become more aware of sexual health. Then the Vatican joined forces with Muslim religious groups, which started lobbying hard, and there was pushback. It was interesting, because I was writing about women who had had their choices and access to choices taken away from them. And in the evening, I was the purest embodiment of a woman who had free choice.

AC: You take on different aspects to your life education and various personas. How does stripping fit with all these identities?

SP: My dancer identity is very important. I have a stage name and a stage age, which has been twenty-eight for years. I've been twenty-eight, I think, before I was twenty-eight. And I have a stage place where I grew up in London. In the moment, I'm studying law, and before, I used to study politics. I never used to say that, because politics and strip clubs just don't work. So, I always used to say that I was studying art, which I had studied before, and that went down well; or art history, which went down well. The brilliant thing about saying you study art is that you can move the conver-

sation onto sex and women's bodies and then, "Would you like a dance?" so easily.

At the moment, I tell everyone at work I'm studying for law, and everyone just loves it. All the customers love the idea I'm stripping my way through law school. It's a massive sell they remember. I've been offered jobs, work experience.

AC: Do you have particular ambitions with the law degree?

SP: I started working a lot with the East London Strippers Collective—a lot of dancers, mostly from East London. It was about forming a community and a collective space where dancers could talk about their work, share their grievances, and produce stuff together rather than being isolated or vulnerable or feeling they were exploited by management or stigmatized by society. I realized that I could combine my activism trying to be an advocate for dancers' rights and workers' rights and be open about it rather than worrying about, *Oh god. If I got job as a lawyer, what if everybody found out about my secret or not-so-secret past as a dancer?*

And very quickly everybody wanted to know what we were doing, and that gave us the confidence to go, *Okay, we're not going to be hidden anymore. I'm going to be proud of what I do, but I'm going to shape that conversation in a way that suits me and my needs.* And I think that's what pushed me toward going down the law route, because I always sort of wanted to do it, and I've been thinking, *I've only got a couple of years dancing left in me. I want to do some education which will actually push me to an actual career.*

AC: So, what you're talking about is a kind of community where the girls can blossom. Is there any way girls can blossom within the strip club structure?

SP: It depends on the club where you work. You have to have a management and staff which relish the idea of a dancer having a bit of a personality and don't try and stamp it out, but where you can push your, say, performance side. So, you can be known for doing very good stage shows or as a very good pole dancer or doing lots of floor work or just having very good presence onstage. I'm not actually a very good pole dancer, but I have great stage presence, and I can really get everybody in the club looking at me, and I've got a good dancing style. But I think it's very hard to blossom in a strip club, because you don't always get to control your music, you don't always get to control your outfits or what customers you see or who's in there. You just have to take in what you've got. In a club, you've got to abide by the rules. You can blossom and have a sense of individuality, but only as far as the rules or the boss will let you.

AC: Body image is something that comes up in your story "Dancing Steps to Tiny Feet." How does that affect you as a dancer?

SP: When I'm having a fat day, my safe space is always onstage, because, conversely to what one might think, when I'm onstage, and the music comes on and the lights come up, I go into goddess mode. I try not to compare myself to anyone else. I purposefully trained my mind not to do it, as much as possible. Envy is a very bad feeling, and it can have horrible consequences, so I try not to compare myself to other women, because at the end of the day, there'll always be somebody that finds you hot and won't like the others. That's one thing that stripping has taught me. I can be with beauty queens and models and ballet dancers, and yet there'll still be guys who'll still think I'm the hottest girl in the room. You've

got to be very careful of the voice inside your head, because once you've nailed that, it's not holding you back anymore.

AC: Was that difficult for you?

SP: Oh my god, yeah, it was pretty difficult. Even now, it's a constant battle just to become more accepting, because people are judgmental, especially women. There are a lot of women who look at the way I live my life and the choices I've made and find it bizarre or think I've wasted my time or my life, especially career women who think I'm objectifying myself, that I'm only doing this to please men, that I'm being exploited, that I'm helping to fund sex trafficking and perpetuating vulnerable women being exploited in dark and seedy situations. I'm like, *Oh, for crying out loud. I'm really not!* I work in a massive club. I perform, and I make sure people have a good time. I know the management and the owners. You get seedy characters, but I'm pretty sure the girls I know don't have anything to do with trafficking. But some people don't see that.

AC: What are some of the best things about stripping?

SP: On a day when you're feeling good, you absolutely rock it. One of the best things about being a stripper is that, because you've got quite a high level of personal care, your body's on point; your hair is usually on point; your face will be, fairly; your nails will be all right. It's quite beauty- and looks-based, so you have got a high level of care; you can do some fancy stretches and yoga. So, that kind of thing is great. Especially if you walk down the road, and you've got a couple of your dancer mates, and you're out as a pack— then you'll just be so super hot. I love that kind of feeling,

of celebrating what gorgeous creatures you are and what gorgeous friends I've got. The travel that I've been able to do has been amazing. Also, the way that you can go to the club and it's an escape from everyday life. You put on a new personality and meet new people, and you've got music and a good time. That's a really nice way to be able to switch off. I guess that's why I keep on going back to it.

AC: Did you imagine you wouldn't go back to it after your birth, which you write about in "Dancing Steps to Tiny Feet?"

SP: I took about four years off. I didn't think I was going to go back at all, but I was short on money, so I had to. I'm really glad I did, because it rekindled a lot of friendships. This time, I've literally got a three-year plan. Then I'm going to start a whole new career, as a lawyer, and get a house, which is a monumental task, especially if you have a kid, but I'm going to do it somehow.

But I'm going to treat dancing professionally now as a hustle. I'm not going to use it to go off traveling or spend lots of money on clothes or buy a new car. I'm going to save; work hard; pay my taxes; invest money; live a fairly simple, normal life; study; get the marks—I'm a lot more focused this time—and obviously, along the way, do what I can for the cause and the sisterhood and my activism. And then, in three years, I'm going to hang up my high heels. I don't know how long I'm going to be able to say I look like I'm twenty-eight, but, yeah, I've got a few more years where I can do that. And I want to do more writing and document my journey a bit more.

AC: Did you have difficulties dating—or want to—at this point?

SP: On the few dates I've had, men's reactions have been worse about my having a child than that I exotic-dance at the weekends. One guy literally spat out his drink. I've resigned myself to the reality: with work, being a mum, life stuff, and studying law, I'm too busy to date. I've been very lucky that friends and family have looked after my son when I go to work. Also, I won't take any malicious comments about my life choices. If you're my friend or family, you have to respect there's a roof over our heads, food in the fridge, and all my tuition fees and books paid up from a career ten years in the making.

FLASHING MY GASH FOR CASH
(EXCERPT FROM THE BEAVER SHOW)

Jacq Frances

"Just stand there for a minute, will ya, love? I just wanna *lookatcha*."

I'm in a hot pink G-string. A black pleather push-up bra squishes my boobs together, while a red elastic garter grips my thigh. My "dress" is a two-paneled black tube of Lycra that hugs my ass while just barely clinging to my tits. This, I'm told by the salesgirl at High Heels, is a moneymaking outfit.

I feel cheap.

I'm standing on a black-tiled podium that's surrounded by mirrors. It is my stage. Jim sits across from me on a red vinyl couch. I told him my name is Iris.

I became Iris twenty minutes ago. Iris is my mask; Iris makes this all okay. Iris makes this not real. Iris is without doubt, hesitation, problems, cellulite, or a boyfriend. She is your dream girl for hire, at increments of ninety dollars every fifteen minutes.

I chose "Iris" because I thought it sounded sophisticated. This will turn out to be a huge mistake in terms of fantasy girl marketing: Apparently, granny names aren't sexy. And because I'm about to learn that "Iris" rhymes with virus. But I have nothing to lose and everything to gain in terms of

learning how to appeal to the Everyman, Ever Horny. Plus, I've already introduced myself as Iris to this sturdy, middle-aged man. So, let's just stick to the "Iris" alibi for the rest of this interaction, where I am expected to undress and exist in front a perfect stranger.

I grew up on Britney Spears and Christina Aguilera, so I feel like I have a pretty solid understanding of what is required of me as an entertainer. Hip undulations, panting rib isolations . . . hair flips. Lots of hair flips. Considering I have a pixie cut, I've planned to improvise by hiding my sultry eyes behind my wispy platinum bangs and then flipping the bangs away. You know, like Leonardo DiCaprio in his heyday. Or like the lesbian I try really hard to be when I go to my least-favorite place in the entire world: Ladies' Night at Sydney's local gay bar.

But all the planning I put into my stripper debut routine goes straight out the goddamn window when Jim asks me to *just stand here for a minute.*

So, I'm standing. I shift my weight to the left, casually pointing my right foot toward my audience of one. I pinch my shoulder blades together, raising my chin high. I try to look comfortable, natural and sexy . . . until it becomes clear that I am standing like my teen pageant queen self in a Sears catalogue.

In an effort to look less pageant-y and more fucky-fucky, I lower my chin. I don't know where to look. Scanning the couch, the maroon-shellacked walls, the transparent metallic curtain, I settle my gaze on his splotchy red face—because he's not looking at mine. His mouth is agape. I'm not sure whether to be flattered; perhaps he's just one of those open-mouthed breathers I used to dread sitting beside in the library.

I try to squash my trembling fears with superficial, aes-

thetic judgments about the stranger in front of me, but my efforts are subverted by the fact that I'm trying really hard not to shit my G-string before I get paid for this absurd interaction. When I'm nervous, my bowels tend to empty themselves with remarkable ease. Usually this is a great solution to constipation: just do some public speaking, or smuggle some narcotics past men in uniforms, and unplug that colon! Right now, though, standing half-naked in front of a man who has not confirmed himself a scat fetishist, is not a good time to shit myself.

Jim's eyes wander about my frame as though he were in an art gallery. A light-year passes before he asks me to take off my dress. I pull at the tie behind my neck, and the panels of Lycra fall to my ankles. Now I'm wearing the bra, in addition to a pair of bikini bottoms, beneath which lies a G-string. My rationale behind wearing all these layers was that the tease is the exciting part.

STRIPPER TIP #1: Less is always, *always* more.

"Just take all of it off in one go, will ya?" Jim asks, his voice a flat and steady trance.

I'm about to show my fun bags and vagina to a total stranger—an old, fat Australian stranger.

I turn to face away from him, because that's what you do when you undress in front of just about anyone. I unhook my bra and slip off both pairs of panties. While I'm bending over to slip them from around my ankles and over my brand-new plastic platforms, Jim stops me before I can straighten up again.

"Stay there."

STRIPPER TIP #2: Never turn your back on your audience.

I pause, folded in half, my bare ass a foot or two away from Jim's unblinking eyes.

"Here?" I ask, incredulous.

He's staring at my vagina. Oh my god, he's staring at my vagina. I hope he can't smell anything. Oh my god, it probably looks so weird from this angle.

"Just there, yeah, love." His tone is a firm whisper. His dungarees and dirty button-down have me pegging him as an agricultural engineer. You know, like a sheepherder or a horse whisperer. I settle on horse whisperer because I'm romantic, but only when it comes to stories of human-animal companionship.

I'm worried I'm going to tumble over in my platforms. I latch a firm grip on my ankles to stabilize my frame, which is in an impressive jackknife. In an effort to keep my balance and calm the fuck down, I entertain the idea of what a gorgeous privilege it might be to whisper to wild horses on the plains of Mongolia. Or on walkabout, since I'm in Australia now. I consider peeking through my knees at his face, but I'm too embarrassed. Instead, I look at his studious expression in the mirror.

"It's the most beautiful thing in the wooooooorld," Jim says with a sigh. He leans in closer. I contemplate snapping up from this precarious forward bend, shielding my bits from these predatory eyes, but I just can't. I need to get paid; I must tell this story, and I also admittedly wouldn't mind hearing more about why my vagina is the most beautiful thing in the entire world.

Breathe in, "Iris."

Breathe out.

I consider the possibility that my vag is the most beautiful thing in the world. I have personally found it rather funny looking, perpetually petrified that it smells "off." But Jim here says it's the most beautiful thing in the world, and my vanity likes to give people the benefit of the doubt.

"Will ya get on your knees? And stay bent over?"

I can see from my reflection that Jim is staring at my cunt with the concentration of a boat-in-a-bottle builder.

Oh god. Now I'm going to have to bend so he'll have a clear view of my asshole, too.

I've never been particularly asshole-confident. Is anyone? I may or may not have perused several online dating profiles, and no one has made clear that their most favorite feature (eyes? smile? collarbone? tramp stamp?) is their anus.

But now is not the time to weigh out who would be better suited for Jim's most recent request. I am here because he chose me, and he wants to see me on all fours. I must now serve up my asshole—and accompanying mole—with confidence, panache, and maybe a bit of passivity.

I get onto my knees and bend over, my forearms pressing onto the freezing tiles, which send goosebumps down my arms and probably over my ass, too. I am frozen.

Please don't fart. Please don't fart. Oh please god, don't let me fart in this guy's face.

In the months to come, I will become highly skilled at refraining from farting when putting my body into positions that are emotionally harrowing and also biologically conducive to relieving flatulence.

"Whoooooaaaaaaaa," he says, leaning in, six inches from my cornhole.

At this point, I am focusing on harnessing all the energy of the universe to keep myself from blowing gas in the face of a man who whispers to horses and has deemed my vagina the Eighth Wonder of World.

"I can see a little bit of moisture," he observes.

At this point, the WASP in me reaches to clutch her proverbial pearls. Blood rushes to my quickly reddening face,

confirming that I am most definitely embarrassed. I certainly don't have the composure to identify whether I am turned on—as Jim suggests—or just sweating bullets of vagina anxiety.

I look into the mirror in front of me to see if Jim has suddenly pulled a magnifying glass from his pocket. He hasn't. He is just very intent on looking very closely at every single one of my feminine folds.

I was blessed with a very sweet and very dumb First Boyfriend who was generous enough to go down on me twice in our two-year relationship. I, on the other hand, blew the shit out of his teenage dick. You could say I've always been an explorer. It's not that his reluctance to go downtown was mean-spirited; he was probably just scared and clueless. At first, second, and maybe even third glance, the vagina can seem like pretty daunting terrain for a boy who's been tugging on his junk for the past five years. Basically, what I'm saying is that no amount of money could ever make me jump into a time machine that would transport me back to my sixteenth year—a boy scared and a girl forever scarred. Perhaps this can help explain why one might think their vagina smells like a six-month-old Wonder Bread, mustard, and bologna sandwich, when someone with whom you're debilitatingly in love doesn't want to go near it. Little did I know eating pussy is a fucking TREAT compared with even the most loving and valiant efforts at deep-throating.

So, I don't really give blowjobs anymore.

But First Boyfriend liked snowboarding, never pressured me into anything, and his totally sweet and fashionable mom may or may not have gifted me my first and only pair of vintage Versace lace pants that I still wear every now and again. We take the good with the bad. And thank fuck my teenage years are over and that my new friend Jim thinks

my pussy is the neatest thing since sliced bread.

Years of pussy-shame conditioning are beginning to unravel as I kowtow on this cheesy podium, ass up, trying to understand if I'm actually enjoying myself. I may or may not be losing feeling in my feet, but the adrenaline of being "wrong," being sexy, making money, and just fucking existing makes it hard to connect whatever physical sensations I might actually be feeling in relation to my mind being blown to the goddamn Milky Way of pussy power.

I decide not to say anything regarding the alleged moisture down there, because, really, what the fuck does anyone say in a situation like this? I'm not seasoned enough yet to say, "Yeah, baby . . . I'm a goddamn Slip 'N Slide for your colossal wiener . . . How 'bout a little pre$ent for being such a wet girl?" This will happen later.

My gaze is still fixed on Jim's reflection. His nose is a few inches away from everything my grade-one teacher told me specifically not to show to strange old men. He closes his eyes, swaying his head to and fro as if he's smelling a pot of his mother's homemade secret recipe spaghetti sauce.

A sturdy woman with fake tits and business casual attire parts the curtain, poking her head into our booth.

"I'm sorry, sir, but your time with Iris is up. Would you care to extend?"

"No, thank you," he replies, standing up.

"Thank you so much, Iris," Jim says, nodding his head and leaving the room.

I slip onto my side, butt cheeks kissing the cold tile. My knees are white. My thighs tingle.

I just made fifty dollars for flashing my gash.

✳ ✳ ✳

I slip my kit back on in a hurry. Years of backstage quick changes at dance competitions and recitals have gifted me with a remarkable competency to put on tiny sequined costumes in a very short amount of time. Strutting through a maze of booths, gossamer curtains, and mystery girls, I tie the bow of my halter at the back of my neck. My stride is wide as I make for the main room. Is this what heroin addicts feel after their first high? Empowered? Hooked? Hungry?

Determined.

I'm ready for my next fifty bucks.

But the main room is practically empty. Jim is nowhere to be seen. Was he even real? The only people in the room are an old man and another dancer, sitting in the corner. They nibble at what appears to be a cheese plate. She smiles, carefully scraping a sliver of blue cheese onto a cracker. From across the room, I can see the precision with which she holds the knife and cracker using her flamingo-pink acrylic nails. Beautiful and effortless. As though dancing *Swan Lake* in slow motion, the dancer lifts the cracker to his open and smiling mouth. He looks like a baby—fat, happily coddled, and pink in the cheeks.

Though I was raised to understand that it is rude to stare, especially at an intimate moment between two strangers, it's impossible to look away. Everything anyone does in this space is performance art.

I look down at my watch. It's ten minutes before seven o'clock. It being my first day, I arrived forty-five minutes early for my "orientation and tour," which consisted of a very small man telling me, "Don't get too drunk; don't get too high. Got it?"

So, I hopped on the tail end of the day shift. I've already had the most insane experience of my life, and my shift hasn't even officially started yet.

Perhaps Jim was just my luck: my fairy godmother in a bogan's clothing, offering up a quiet and quick initiation into the world of vagina dollars in the calm before the storm. It's Saturday night, and I'm pumped to make more money. But this is show business: hurry up and wait.

I try to push through a door marked "Employees Only," only the door won't open all the way. I peek my head in to discover there is a bare ass in the way. The ass is in the process of being slathered with tinted moisturizer by a small pair of nimble hands with a French manicure. The ass moves just enough that I can slide myself through the jamb.

I whisper, "Sorry, excuse me," to no one in particular as I weave among semi-clothed bodies. Try as I might, my Canadian politeness and unrelenting apologies cannot be shaken.

The dressing room is a place to hide, to gossip, to dry-shave and apply concealer to your butt cheeks, face, and any other place on your person where you can develop a bruise, pimple, or ingrown hair. It is perpetually overcrowded with hair straighteners, designer handbags, and women in all phases of undress.

Showtime is in T minus ten minutes. If you're late, it will cost you. This is the dressing room's frenzied peak hour. A dozen women crowd in front of the mirror lining the longest wall in this room that I can only assume, by its size and narrowness, is a repurposed broom closet. No one is talking. Everyone is just staring at themselves in the mirror, brushing on war paint or wrapping their hair around a steaming curling iron. Quickly and calmly, they transform themselves into fantasy girls.

They all just seem so . . . normal. And young. Fresh-faced. Bored, but composed. I was anticipating a herd of Playboy bunnies, but in front of me are just a bunch of girls like me,

putting on costumes and getting into character. At first, I feel I should be disappointed, but instead, I just feel like I am more at home than I've ever been.

Never in my life have I ever known a stripper. Strippers are ubiquitous in pop culture, but only ever in this tragic, two-dimensional way. So, the act of becoming one is surreal. Growing up in the upper-middle class, going to university to become a journalist or some shit, you just don't ever imagine any of your peers doing anything but working for a forty-something boss with an "innovative business model" where there is a Nerf basketball hoop in the lunch room. Sex work wasn't an option outlined on my guidance counselor's office wall of career pamphlets.

It's a class thing. Middle-class girls with degrees don't become strippers. If anything, they take on a safety career as a dental hygienist and marry up to the dentist.

But I am here, doing something that I thought only less-fortunate, single moms with no college education were doing because it was all they could do to support their families without working eighty-hour weeks. I want to be here because I've always been a shameless exhibitionist, but also because I can't pay my rent or afford to eat anything but oatmeal in this new city I thought I'd try living in, on the other side of the goddamn world.

Where are the crack whores? Where are the cesarean scars? Where are the triple-D boob jobs? All these chicks are here to work. Unless you're a Middleton, everybody works.

"Are you American?"

I look up and see a poster woman for the curvy and impeccably toned brunette looking at me through an eyelash curler. She's wearing what appear to have once been a pair of Abercrombie jeans and a raggedy T-shirt.

"Canadian."

"Cool! I'm from Hawaii," she says as she slips out of her tattered jeans and into a pair of pink-and-black polka-dot panties and a black bustier. "You new?"

"First day ever."

"No shit!" She assesses her artistry: mascara on the top lashes and a hint of bronzer. (Not that she needs it: her tan is perfect and mystifyingly authentic.) She presses her lips together to even out a wine-tinted lip gloss. She, too, does not look at all like what I thought a stripper would. She looks like a pretty girl. A Real Girl. She pulls her hair out of its ponytail and gives it a flip. Perfect waves. "You'll be fine," she says as she drops her mascara into a pencil case.

She slips on a garter and into her heels. Walking past me, she's out the door. I hesitate and end up following her into the main room, where she takes a seat at one of the tables by the stage.

I want to ask her what she's doing here. I want to know what *everyone* is doing here. But I'm already realizing that asking that question makes you kind of an asshole, so instead, I ask, "How long have you been here?"

"A year?" She sounds unsure of her answer.

Her name is Tommie. Tommie loves to surf and thinks other jobs just don't pay enough for the amount of time they take away from her wave riding. She is the most beautiful, hilarious, and feminine tomboy I have ever met in my life.

"Ugh. I just hated college in Michigan. Everyone there wears Ugg boots, but for the wrong fucking reasons. Ugg boots are for surfers. They don't actually keep your feet warm when it's below freezing . . . Anyway, this is the good life."

Tommie's eyes fix upon something behind me. Immediately, they sparkle. She gets up quickly, walking over to an

old, yet strikingly handsome man in a custom-tailored suit. Her hips sway, her arms are outstretched. When a stripper sees gold, her eyes shine like diamonds, and nothing can get in her way of claiming it.

Gradually, the seats fill with customers. A good-looking thirty-something with a smug grin wants to go for a dance, but "not just yet." A white-haired man in a sweater vest is keen to tip the girls onstage, "but no private shows for me, love . . . A pensioner's gotta enjoy the simple pleasures." A team of accounting colleagues just wants to buy me a drink. Contrary to a common assumption about establishments like this, girls don't make any money off liquor sales at this club. There doesn't seem to be much else going on, so I oblige.

"So, where ya from, love?" the suit beside me asks. He smiles like a jerk: goofy and entitled.

"Canada," I say with a smile.

"Oh, it's cold there!" This is all anyone in Australia will ever have to say about Canada. They will follow up with an embarrassing misuse of "eh," and then they will ask how I like "'Straya."

But this is day one. These questions are lame, and I'm not yet rehearsed enough with quippy comebacks to entice them to open their wallets at every turn of phrase. I'm nervous but smiling through it.

My drink arrives, and I down the vodka soda with unprecedented ease.

"Slow, down, Sheila! We wanna hang out with ya for more than forty seconds!"

Before I can make up an excuse for why I'm "just so *parched*," there's a tap on my shoulder, followed by a firm whisper: "*Iris*, I've been calling you onstage."

"*Iris,*" right, *Iris. You're Iris.* I remind myself.

I excuse myself from the fraternizing suits and make for the stage. I bring my nearly empty drink with me. It feels rude, but I'd rather be rude than dumb enough to leave a drink unattended.

I've danced onstage before. Hundreds of times. Leisurely, competitively, and professionally. Throughout middle school and high school, I was an overachieving bunhead—the stage is where I've always felt comfortable. I figured out from an early age that an attention-seeking person is really fucking annoying unless she channels her insatiable need for love and accolades in creative, entertaining, and hilarious ways. If we were to forget the money part—but who can, really?—the performative aspect of stripping is why I considered shaking my tits for strangers in the first place. A few years ago, while I was a broke-ass university student, I was seriously considering this same job. Instead, I chickened out and opted to pursue the career of a penniless burlesque diva.

What's different now from my dance troupe days of flight suits and trophies is that I am wearing obscenely high platforms made of plastic. And—assuming I make it through the first two songs without toppling over, shitting my pants, dying of embarrassment, or all of the above—I'm supposed to flaunt my vagina for the entirety of my third three-minute song.

I climb the three steps to the stage and reach for the nearest pole. Clutching it for stability, I smile nervously at my hot-pink-manicured colleague, who has been waiting for me to relieve her of her nudity duty for nearly an entire song. The smile I saw earlier has vanished.

STRIPPER TIP #3: Never make a stripper wait. Her time is money.

Alas, the stage is mine. A techno remix of a shitty Top 40

pop song plays. Repressing my Mouseketeer training, I try to look seductive (read: no smiling, ever) as I sway back and forth. I'm at a loss for what to do with my upper extremities. If my hands can't be jazzy, what the hell am I supposed to do with them? I look to the stage opposite me for an answer, which is clearly illustrated by another colleague: fondle your tits.

So, I fondle them through my bra and dress. My sweaty palms rub the Lycra against the lace of my bra. I realize this move is better done topless. Clasping my only free hand to the same pole, I make an attempt at a spin. My knees clunk into the pole. Loosening my grip with the pulse of a very inexperienced driver, I slide down in a few jerky motions. But all these nerves and lack of rehearsed routine don't seem to matter. The men sitting at the tipping rail are waving five- and ten-dollar notes in my direction.

I slowly make my way toward the edge of the stage where a ten-dollar bill has "IRIS" stamped all over it. A guy happily slips it into my garter belt, nodding in appreciation. And then another one does the same thing!

The shitty song morphs into another shitty song by the volume of track A being lowered as the deejay announces, in a voice you might hear at a monster truck rally or at a Chuck E. Cheez, "And hello, everybody! This is song number two for the sexy Iris."

Song number two? Shit. I'd better start peeling off these six separate articles of "clothing" if I need to be completely naked for the next one.

I'm trying to shimmy my hips all the while pulling at the various strings, clips, hooks, and elastic bands that hold my hoochie ensemble together.

The alternating red and orange lights illuminating the stage and us dancers are hot. A drop of perspiration slides

from my temple, streaking across my rouged cheekbones. It leaves a dark, tearlike trail.

I look back across the room, where the other dancer is effortlessly grinding her pelvis a few inches from the pole phallus. A keen observer continually slips crisp bills into her garter belt. She isn't at all sweaty. Did she spray her entire body with deodorant?

She moves her hips in a figure eight at a glacier's pace. It looks like I'm watching a soft-core sex scene.

STRIPPER TIP #4: However slowly you think you're dancing, move SLOWER.

You don't have to do much to impress a man at a strip club. You've already done the hardest part: you showed up. A naked woman—in heels, no less—can really do no wrong. Knowing this and knowing that you have to dance for the next six or seven hours *and* that you have to look good doing it, do not waste one iota of energy trying to dance with reckless abandon. *Everyone* is watching. You can't look like a maniac— you have to look like an expensive and sanctimonious goddess. And dancing in a strip club is nothing like *actual* dancing, whether it's ballet, jazz, hip-hop, or that weird and amazing ravey shit you do when you're rolling on MDMA and listening to dubstep. "Dancing" from here on out is to be understood as moving your naked body from one flattering and slutty pose to the next. Like vogueing, only S L O W E R and less creative.

Once again, I remind myself to breathe. I stand still as my dress falls to my ankles. Gripping the pole for stability, I step out of the dress, bend over, and pick it up. This chore is in fact a signature "dance" move in the business. Bend like Reese Witherspoon in *Legally Blonde*, pick up that G-string or fifty-dollar bill, and snap back up.

By some grace of god, I am naked by the time the third song starts pumping and scratching over the speakers.

I take small steps, pressing my thighs and knees together for fear of my heart dropping out of my vagina.

A pinkish, snively man comes up to the edge of the stage. He waves a neon piece of laminated paper in my general direction. What he's holding is a "dancer dollar," or what strippers callously refer to as funny money. Each dancer dollar is about the size of a twenty-dollar note but worth only two dollars. They can be purchased using a credit card. The ones who use the funny money as a means of tipping are the men who go to the club on their company's expense account, or are too stingy to part with fives or tens. Rather than use their own cash, they can buy funny money and, on their monthly bill, it shows up as "ABC Restaurant," the registered business name of the club. "When did you spend five hundred dollars at ABC Restaurant, honey?" oblivious wives everywhere ask. "Oh, just took a few clients out for dinner." Meanwhile, accountants at large corporations are encouraged to use the company card to keep up client relations.

I wedge over toward the glowing slip of laminate, smiling, lifting my garter belt.

Pinky is about to slip it beneath the elastic before he snatches it back toward his chest, lifting his chin.

"Come on, now. I wanna see you do a trick!"

It's my first day. Isn't getting up here naked and bopping about enough of a "trick"? Especially for what amounts to two whole dollars?

I don't get it. I smile, because that's what you do when someone tells you a joke and you don't get it.

I'm embarrassed, because I don't know any tricks. I feel unprepared. I feel like I owe him a trick. I feel all of these things because I'm a rookie stripper, but it won't take long to learn that entitled assholes abound, and they are yearning to be put in their place.

But for now, I have to undergo this humiliating feeling of not being enough for a man; to feel like I have to go above and beyond the call of duty to earn his attention, approval, and laminated money. I haven't been with a man in a long time or felt this way for one, but it's kind of like riding a bike. It comes back, and it comes back strong.

Fortunately, Tommie walks up to Pinky, plucks the dollar out of his hand, and slips it into my garter as she leans her weight into his shoulder.

"Isn't she just *beautiful?*"

Pinky nods. Tommie rests a hand on the back of his neck, which brings Pinky's shoulders to an immediate drop. His shit-eating grin melts into a resplendently longing gaze.

Men are that easy. They just need some encouragement and direction.

"This is Iris. She's Canadian!" Tommie uses her other arm to reach for Pinky's forearm. She inches her glossy lips closer to his ear: "Would you like to watch us take a shower together?"

A shower show is a special show where a client sits on a couch and stares at a girl through plate glass. She gets sudsy and giggles and wastes water while taking the least effective rinse of her life. She will not get to wash her ass crack, exfoliate her face, scrub under her arms, or shave the tops of her feet. A double shower show is the same, only two girls will be rubbing their sudsy tits together.

I step down from my stage to see that Tommie and Pinky are waiting for me at the bar.

Tommie takes Pinky with one hand, me with the other, and guides us to the front desk.

The business-casual woman stands like an ox. She has total dominion over her funny money booth and security cameras. She doesn't seem to give a fuck about anything else.

"How long would you like to go with Tommie and Iris?"

Tommie inches between the Ox and Pinky: "It's two eighty per girl for a half hour," she says with the biggest salesman's smile I have ever seen.

Oh my god. She didn't even offer him the fifteen-minute option. This girl is a genius.

"And we're so *dirty* . . . I don't even know that half an hour will even be enough time for us to get clean, right, Canada?"

Tommie raises her eyebrows, glaring at me. *Play along, already. Don't be a dead weight.*

"Yeah, I'm just so dirty and sweaty and gr—"

Subtly, Tommie shakes her head in a panic.

You're not gross, Iris. You're SEXY. Horny. You're a nymphomaniac who will certainly die if she doesn't rub up against any and every body and/or surface in this establishment. Come on.

"I mean, I just really need to get wet already!"

Tommie smiles and nods encouragingly.

Thank fuck, yes. I am not a dead weight.

"Half an hour it is," Pinky says as he slides his American Express over to the Ox.

Pinky takes a seat on the couch while Tommie and I slip out of our shoes. A tiled wall separates the voyeurs from the exhibitionists. We hang our dresses up on the hooks. I am about to take a shower with a hot girl I just met a few hours ago, for which we will each be paid two hundred dollars.

Tommie reaches into a small bag, pulling out a loofah and a miniature shampoo bottle. "Don't worry about getting a yeast infection; it's unscented."

I don't really know what she's talking about, nor do I want to try to figure it out right now. I'm about to perform, and this girl is beautiful, smart, and Hawaiian, so, naturally, I trust her.

Tommie lifts the detachable showerhead from its cradle, cranking on the pressure. She waves for me to step in with her. On the opposite side of the glass, Pinky sits in the middle of a couch, knees apart, arms outstretched to his sides. Expectant.

Tommie gives me a wink and shouts through the glass, "Hey, Pinky! Oooh—it's chilly in here!" She sprays me with the showerhead. "Look how hard Canada's nipples are!"

All right. It's showtime. I can do this.

"Ohhhh . . . Hawaii . . . I'm just so filthy! It feels sooo good to be . . . wet!"

I feel like an idiot. But the lesson my dance teacher taught me when I was eight is ringing true: If you feel stupid, you're doing it right.

"Look at her *tits*, Pinky. Don't you just wish you could squeeze them?"

Tommie grabs my tit in her hand and gives it a jiggle. "Damn, girl. You have nice tits!" I think she just said that in earnest. It's been hard to tell what is sincere and what isn't since I walked into this place.

"Oh, it's all that maple syrup we drink in Canada that keeps us soooo perky and . . . sweet?"

Pinky has the stupidest grin on his face. I think I'm getting the hang of this.

"Bend over," Tommie whispers. "Face the wall and show him your ass."

I oblige.

"And would you *look* at this Canadian bacon, Pinky! I just want to take a bite out of it and have it with my eggs in the morning!"

I feel something cool dripping on the small of my back. I look over my shoulder to see that Tommie is drizzling white goo—the body wash—all over my booty. I can barely

see Pinky through the mist, but I can hear an encouraging "yeahhhh," so I'm assuming he is enjoying this trompe l'oeil of cumming all over a girl's ass.

Tommie slathers the loofah over the "cum" and gets the suds in the relevant places: tits and ass. We repeat the same act again, only now Tommie is the one bent over, and we replace the words *maple syrup* and *bacon* with *pineapple* and *coconut*.

"It looks like Iris is enjoying this more than I am," Pinky offers with a grin.

I blush.

Facing the wall, rump still in the appropriate position for Pinky's viewing pleasure, Tommie yells over her shoulder, "Oh, Canada and Hawaii have always been great allies, baby!"

There is not one comment for which Tommie does not have a clever retort. She is queen of improvisational comedy.

The Ox thrusts her head past the curtain. "Time's up." It appears the moderate politeness she displayed earlier in the evening has worn thin.

"Oh no! But we were just getting to the naughtier part of the show, Pinky!"

"Yeah," I chime in. "I'm still a dirty girl and need a sudsy spanking from Hawaii!"

Pinky pulls at his slacks, gets up, and lowers his head. "I really shouldn't, girls. But thank you."

Tommie shrugs. "The water was getting cold anyway."

The Ox leaves. Pinky follows.

"You did great," Tommie offers as we dry off and slip back into our G-strings for the umpteenth time this evening. "Always try to nab a shower show," she advises. "You get paid twice as much and you don't have to reprimand them for pawing at you. Everybody wins!"

Tommie is out the door before I am even halfway dressed. It's becoming apparent that, no matter how quick I am at getting dressed, the more pieces of clothing I wear are only costing me time, and therefore money: Less is more.

I walk, I chat, I accept a few more drinks, and before I know it, another man wants another moment of my time in private to stare at my bits. By the third private show, the I'm-naked-and-he's-a-stranger factor is completely underwhelming. It's a job. The exciting part is that I'm told it's high-paying and, well, it's naughty and secret.

By the time the deejay's worn-out vocal cords announce last call, I look down to my feet to notice the plastic strap has lacerated the top of my foot. Now that I see the bruising, chafing, and blood, I can finally sense the pain signals shooting to my brain.

The dressing room is once again chock-full of girls, only now they're moving with lethargy rather than grace. I slip into my Real Girl clothes and sling my backpack over my shoulder.

House lights up, we slink into the chairs and wait our turn to get paid. Tommie slumps into a chair beside me.

"How was your night?" she asks.

"It was all right. I did five rooms."

Tommie raises her eyebrows, tired but encouraging. "That's good!" As my career goes on, I will learn that, for a Saturday night, that is not good. Not good at all. But tonight, I feel like a champ.

"When are you working next?" I ask her.

"Oh, this is my last night. I start training to be a flight attendant back in the States next week."

The potential for a friend vanishes; she's gone before I can even get her real name. This is how it will almost always be in this business.

The Ox pays me. After a bunch of house fees that don't seem to make sense, including a towel rental and deejay tip-out, I end up with $324.

Slumping into a cab, I watch the drunk kids on the sidewalk flail for taxis, tripping over their own feet. *They probably just spent $324 tonight.*

I go home and recount my earnings. Then I count them again. Suddenly, I'm not at all tired anymore. I'm buzzing.

INTERVIEW WITH JACQ FRANCES BY JILL MORLEY

JILL MORLEY: Jacq, you became a stripper supernova with your books, your strip comedy tours, your Strippers Forever apparel line, your work on the movie *Hustlers*. When did you become a stripper? Did you go to college?

JACQ FRANCES: I have a bachelor's degree in Russian literature and cultural theory from McGill University, in Montreal. But as a middle-class girl in college, I didn't want to be a stripper. The shame and the stigma were too great for me to even consider it.

JM: What changed that?

JF: One day, I met a real-life stripper. She wasn't stripping at the time. She was a photographer and had paid off her student loans and had bought all this camera equipment by dancing. At the time, I was part of the strippers-aren't-people school of belief, where you just don't see "those people" as humans; you see them as downtrodden lepers or something. And this girl had a great head on her shoulders and was chasing after her dream and financing it herself. I

was so curious about that. I remember walking around my apartment naked in my only pair of heels, imagining what it would be like to be a stripper.

JM: How did you go about becoming one?

JF: I had no money. I was traveling poor, though—white-girl poor. I was out of money, on the other side of the world, tired of waiting for shitty jobs to come along. So, I just did some googling and looked up "gentlemen's club." The first club I went to was like, "Yeah, sure, okay. Here's the orientation. Come back, and then we'll get you sorted out." And they were very nice about instructing us how to do it. They actually had a three-hour seminar on how to be a stripper, taught by a veteran dancer. They paid her to sit and go through this very thick booklet about how to deflect customers asking inappropriate questions, what to bring to work, what to wear. No American club would ever do this. It was amazing. She was like, "This is a fantasy; make up a story." It prepared me so well, because nothing really prepares you for stripping. And when girls ask me, "How do I become a stripper?" I'm like, "Show up." If you don't show up, I'm not wasting a breath on you. Show up, see what happens, and see if you like it. If you don't like it, don't go back. There are other options. They might not pay as well, but if you don't like it, it's not worth it. I write about it in my first book, *The Beaver Show*.

JM: You retired from actively stripping a couple of years ago. How did you make that decision, and how does it feel?

JF: Not everything is forever. It was sad but so necessary, so I'm grateful for the time I spent doing it. It's been an interesting journey, finding all the ways that stripping hon-

ored parts of me and sending them on a new journey. When I first quit, I missed it a lot—not enough to be inspired to go back, but occasionally I have moments of "I really miss dancing," or "I really miss talking with strangers," or "I really miss cash." But you have to make sacrifices along the way to chase after what you want, and sometimes what has to be sacrificed is the thing that got you there. Stripping put me on the map as an artist. "Jacq the Stripper" is my moniker, and people still call me that, but I'm not introducing myself by that name anymore. It's part of the legacy, but it's just a character. I've distinguished between who's Jacq the Stripper and who's me, Jacq.

JM: Did you find that you can focus more on your other stuff now?

JF: For sure. For a couple of years, I was still dancing while my career as an internet influencer started taking off. Most stripping for me then was pretty covert. But I didn't realize how distracted I was. I was writing while I was stripping, and stripping is a job. A lot of energy and intention go into doing a full-time job and also trying to nurture yourself creatively and treating your body well enough so that you can continue doing it. All the work that goes into maintaining yourself as a stripper is like a second job on top of the actual job of stripping. Eventually, something had to give, and it was dancing, because I wasn't trying to be a dancer forever.

JM: Did you do more acting after being in *Hustlers*?

JF: I never stopped doing stand-up, although I'm taking a break from it for a while. I'm writing a new set. But I love acting. I love putting on a show. I'm kind of living my dream

creatively. I just shot my first pilot. I wrote it, directed it, starred in it, executive-produced it. And I got a bunch of my stripper friends to act in it. That was always my dream, from the second I became a stripper. I was like, *There needs to be a TV show about this, because this is hysterical.* A couple of shows have existed or come and gone, but nothing like the story that I want to tell. To me, stripping is so mundane and ridiculous and hilarious and heartfelt and so unglamorous, despite what we all may think. And I want to tell that story, but I want to tell it with extremely good jokes.

JM: Why do you think stripping is inherently funny?

JF: Because it's real. In spite of showing a fantasy, you're actually just interacting with people on a very real level. When you're honest, you're funny. Where there's truth, there's humor.

JM: How were you finally able to make your pilot?

JF: I reached a point where I felt I wasn't succeeding.

JM: Why? You've been killing it.

JF: I'm so proud of my career and grateful for it, and my career is kind of my driving force in life. But I was struggling with worthiness, and worthiness to me meant not asking for help. When I act really independent it's because I want to do it on my own. But at a point, you realize it's not that fun doing it alone. And I always wanted to make movies, but I didn't know that was me asking for help. And because it was my first pilot, I realized I had to finance it myself. But in so doing, another revelation was *Oh my God,*

I can't pay everyone. A lot of people donated their time and their talents for free. And as a sex worker, I'm always talking about the money. I'm always like, "Fuck you, pay me," or "Thank you, pay me." I feel like my time is extremely valuable, so why should I ask other people for their time for free? And then I realized I just had to ask anyway, and everyone said yes. And everyone had a great time. But I had a lot of internal battles about being exploitative of people's time by not being able to pay them.

JM: Were the women in your pilot women you'd danced with?

JF: I had started this art collective called Art Camp. I moved upstate, so everyone would come over and make art and cook and do witchcraft and hang out and go in nature and frolic. Most of these women are sex workers, or used to be. It's a common thread. All the Art Camp girls were involved in the pilot, so I call my production company Art Camp Productions.

JM: It's like Art Camp gives you the community you may feel you lost from stripping.

JF: Like that dressing room feeling—what's the good vibe, what's the fun, how do we all hang out and get creative and whatever and laugh and play? It's basically a quilting circle, but with plant medicine and, I don't know, body painting . . .

JM: . . . and acting?

JF: I cast my Art Camp friends as fictionalized versions of themselves. Every stripper in the show is portrayed by

an actual stripper. My show is not about actors who took a class and think they get it. We shot in a strip club in upstate New York, sandwiched between two freeways—two highways, two country road highways. And everyone just sat in lawn chairs in the parking lot between shots. It was like summer camp; everyone was laughing, having a great time—like doing community theater.

JM: Has stripping informed all your creative work?

JF: Yes. It was like, *This is what I'm going through. This is hilarious.* I knew it was marketable, right? *This is gold!* And I was doing it. I have to make art in order to process my feelings or develop my understanding of things, so I write and make jokes. I realized what I was experiencing as a stripper was literally nothing like anything I had ever imagined it would be, because pop culture told me it was just this horrendous, sad, exploitative shit-ass industry. Meanwhile, every fucking job under capitalism is that, but they don't tell you. They only tell you that being a whore is that. So, I had to figure it out for myself. And stripping was just such a hotbed of material. I was so afraid to stop, because I thought I wouldn't be interesting anymore. I really invested a lot of my identity in my job. And I had to deal with what it's like when your work is your identity and your work stops. And I had to make art about it.

JM: One of the things I admire about you is the way you celebrate women.

JF: I'm so proud of everyone making their own merch and putting it out there. No stripper ever wants to go and work for someone. My whole policy, though, with people I col-

laborate with or offer my content to, is, if you haven't done sex work, I will not work with you.

JM: Why is that?

JF: If you have not done the work, it's not your story to tell. If you haven't done the work, you're using this as an opportunity to make money. Even if you think you really care and want to tell these stories, show me a movie that has really depicted stripping honestly without using the women's stories themselves. That's why I wanted to make my pilot. I'm adamant about only working with people who have done sex work. Even if you only do webcam for a week, you still know that transaction, you still hold the stigma, you've still had the experience. If you've never done it and you just think it's interesting and you want to interview me so you can make money off me and not pay me adequately, I'm not doing it. It's a hard line, but I'm proud of that line.

SECRET LIFE OF AN AUTISTIC STRIPPER

Reese Piper

I walked past the stage and sat down at the bar, the neon lights illuminating my pink teddy, shadowed eyes, and crimson lips. I ordered my first drink of the night and took inventory of the club. There were a few listless customers scattered around, hunching over bar stools, and a dancer circling the pole.

I waved over a colleague, a transplant from Manchester with hair extensions that kissed her velvet garter belt. We grumbled about how slow business was—until I spotted a paunchy man at the bar. He was short, with a tuft of gray hair and a slight smile that crinkled his eyes. He was also more animated than the others.

"Do you want to try?" I asked her out of a sense of politeness.

"You go," she said, waving her hand.

I started off light, asking about his day and his job. His smile widened across his face as my eyes met his. I silently counted to ten and reminded myself to look away for a second—best not to terrify him. After three minutes, I transitioned to more personal questions, moving steadily through the formula I'd perfected to curate conversation with customers.

He started complaining about his recent breakup, but it didn't feel genuine, his eyes twinkling with eagerness. I switched my gaze to the top of his nose, to put a boundary between us.

I could tell he was interested in spending money but that he'd be hard work. It was time to either close the sale or walk away. He'd take advantage of my time otherwise.

"Ready for fun?" I whispered in his ear to avoid his eyes.

I didn't bother mentioning the private rooms. After two years in the industry, I knew which customers were worth investing in—not this guy. So, I led him into the corner, which opened up to the club like the bow of a ship, public and safe, for one quick dance.

Before working in strip clubs, I struggled to read people's emotions through cues like facial expressions, postures, and tone of voice in real time. I processed events after the fact with tenuous evaluation, like peeling off layers of old wallpaper. At the time, it was not something I had words to explain, so I turned the blame on myself. Whenever I struggled to understand if someone was angry or bored, I went home and berated myself for being lazy, ditzy, and dumb as I obsessively evaluated the night. *I just need to try harder to be more present*, I told myself.

One time, I went to a dinner party my sister hosted. A few of her colleagues and friends sat around her table while we snacked on hummus and bread, and someone asked about my recent trip to Europe. I rambled incessantly, illustrating the nightclubs, the hostels I stayed in, even how I bled through my powder-blue dress because I forgot to change my tampon. My voice was loud, a pitch you use at

a concert, not inside. I can see their faces now, wide-eyed and uncomfortable, but at the time, they coalesced into one indistinguishable figure, Dave Matthews playing in the background taking precedent. Their distaste didn't register until my sister pulled me aside and asked as kindly as possible to keep to "lighter" topics.

After dinner, we dispersed to the living room, and I attempted to talk to my sister's colleague, but I forgot to break eye contact, continuously staring wide-eyed while she spoke.

"You're certainly a character," she remarked, exiting the conversation. I didn't realize until later that I'd made her uncomfortable.

I didn't know what slow processing was then, but I was aware I felt embarrassed a lot, and lonely. Facial expressions, body language, and eye contact are the bones of communication, and it's quite difficult to build and maintain relationships without the ability to read them.

So, I meticulously designed a persona who nodded at the right time, rehearsed lines, smiled when appropriate, monitored personal space, spoke quietly. Before going out, I crafted notecards, scribbling how long to talk about acceptable topics and which to stay clear of altogether (like my period) in small talk. The persona was a mask that helped me appear to interact in the moment, but in reality, I crept by three paces behind everyone else.

I had just celebrated my twenty-fourth birthday in Australia when I started dancing. I settled temporarily in a bustling beach town at the edge of Melbourne and needed money to pay off my student debt. I considered a bar job, but I decided to try stripping simply because it meant fewer hours.

When I walked into a club to ask for a job, to my surprise, I realized it was just a bar with the usual roles reversed: women approaching men. I was intrigued but confused: How did they convince customers to spend money offstage?

The manager looked at my petite frame and nervous smile, pointed her manicured hand to the dressing room, and listed the rules: "Go get ready in there. You get one free drink. Don't be late for stage. No sex. No drugs on the floor." Simple enough, but nothing on how to monetize my time. I handed over my forty-dollar house fee and walked into the sea of hairspray and naked bodies.

Hundreds of customers came and went during the ten-hour shift, sitting on plush couches and crowding around the bar. I approached ten guys, mirroring my colleagues' coy smiles, suggestive body language, and light conversation starters, but I couldn't tease out who wanted to spend. All but one dismissed me.

I sat at the bar to observe, sipping my free champagne. One dancer particularly stood out, with her naturally frizzy curls and tattered black bra. She wasn't the most glamorous, but every guy she spent more than a few minutes with agreed to get a lap dance, like she had sprinkled them with fairy dust. A few times, she walked away from customers within seconds, once even waving her hand in a man's face to dismiss him.

From the bar, I saw her sitting alone on one of the upholstered couches that lined the back of the club. She was taking a moment's respite after a dance to count her money before securing it around her wrist with an elastic band. I took a deep breath and approached her, brushing aside the fringe curtain separating the lap dance room from the bar. It was getting late, two hours before closing, and I was exhausted and frustrated. So far, I'd brought in just

fifty dollars, meaning a ten-dollar profit after the house fee. I thought about packing up and never coming back, but I needed this to work out. My student loan wouldn't magically go away.

She took one look at me and asked, "Your first time?"

"Yes. I'm struggling," I said shyly.

She stared at me with a bored expression, so I got right to it.

"How do you know who wants to spend money?"

She turned around and outlined her lips with a beige pencil in the smudged mirror, advising in her Bulgarian accent, "I don't always know, but here are a few things I've learned after five years in the industry: Don't spend more than ten minutes with them if they haven't spent money. Five minutes if it's busy. You're not a free therapist. Make them pay big bucks if they want to dump their shit on you. Walk away from customers who want to get to know the 'real you' right away. They're usually creeps."

Before she left the lap dance area, she turned around and said, "And quit this nice-girl bullshit. You sound like a child. Don't try so hard to be someone you're not. Just be a hyped-up version of yourself."

As she sauntered off, she looked back once more, "I'm Claire, by the way."

Her words wounded me, but I was impressed. She saw right through my mask. The rambling girl at my sister's house was a distant memory, but strangely, Claire must have seen who I was before I tried so hard to appear normal.

After we spoke, I didn't reincarnate my older self, but I did carve another persona: Piper. I learned to showcase different parts of my persona based on the customer. It seemed practicing social skills paid off: I became a deft conversationalist, sometimes earning my night's wage just

from talking. I moved beyond the foundation I hid behind, laughing, smiling, and chatting more brazenly than before, enjoying eye contact with customers I trusted, dismissing ones I didn't. Performing felt strangely comfortable, even though the job was foreign and challenging.

That conversation lasted minutes, but the advice made for a successful career. Slowly, Claire's rules taught me how to read customers for signs of interest by attaching meaning to their words and actions, something most people learn unconsciously but that I'd always struggled with.

The club gave me a controlled space to decipher the crinkle around people's eyes for eagerness or a raised eyebrow for arrogance, as if I were reading a script from a teleprompter. And when I was unsure, I had her original rules to catch me. Are they asking for my real name? Are they relaying problems in their life without buying a dance first? On the floor of the club, I spent hours practicing each weekend, and for the first time in my life, I learned how to cut through layers of language in real time, just like Claire, until it became effortless.

Eventually, I moved back home to New York and started stripping full time. After two years of practicing by trial and error in the world's most social job, the tricks I learned in the club seeped into my social life outside work, and it got easier to notice social cues and use the same formula I used with customers to make small talk with anyone.

Most people I met outside work told me I was a great listener, unaware of how much time I spent in my room practicing the correct reactions. I didn't want anyone to know how much I struggled, so I let very few people get

close to me—better than anyone finding out that I couldn't really socialize, that I was a fake.

Nearly two years after I started dancing, my friend Sarah invited me to her birthday party. My least favorite social situation: a dinner party with unknown people. True, I was better at picking up more obvious cues like eagerness and anger, but group settings were strenuous—too many subtleties to keep track of. But I hadn't seen my friend in a while, and I missed her. I packed up my lace teddy and Red Bull into a discreet bag and headed over to the restaurant before work.

The hour and a half crawled by. There were six of us around a small table. I can't remember the other people's faces or even what anyone spoke about. I prayed no one would ask me personal questions.

"Sarah tells me you just got home from Amsterdam," my friend's brother said politely, turning in my direction. His words mixed in with the background conversation and sounded like another language. I broke out in sweat.

"I'm sorry, what?" I asked.

He repeated himself. A second later, the words clicked. I smiled and looked at his nose instead of his eyes while chewing over my words and length of speech, trying to offer the version of my trip he wanted to hear.

Sarah got up to go to the bathroom. I quickly walked over to her and asked, "Were people bored when I spoke?"

"Not at all. What's wrong?"

"Nothing, nothing. But I have to go. I'm sorry, I have work."

She looked confused as I hurried out the door. I didn't really have to go to the club. I'd made enough that week to warrant a night off with my friends, but work felt easier than this social performance. I let out a sigh of relief as the taxi plowed across the Williamsburg Bridge.

I walked under the familiar lights to the dressing room. I squirted a dollop of foundation on my hand and painted the dark circles under my eyes. For a brief second, I wondered, *Is something wrong?* Surely work shouldn't be more comfortable than a night out? But then I swallowed those thoughts and walked onto the floor to escape from myself.

I sat down at the bar and ordered a Hennessy on the rocks. The birthday was successfully buried, and I was buzzing from the bliss of escape.

I spotted a man at the bar—alone, tall, bald, with a kind smile and a glass of whiskey in his hand. I ran through the formula, and we connected right away.

"Hennessy is a strong choice," he commented.

"It's an underrated drink."

"I'll take your word for it. Can I get you another one?"

Ten minutes passed. I suggested the private room, and he agreed. The private rooms were where I connected with customers, sometimes in a way that was more intimate than my relationships outside the club.

There, I massaged their shoulders, let them touch me, expressed vulnerability. I bantered for hours—something I was never able to do before. With fewer stimuli around, it was easier to focus and converse back and forth in a way that felt less strenuous than at the restaurant hours before.

"You have a strange rhythm about you," he remarked, smiling as I cradled him. Customers who spent money like water didn't care if I was odd; they wanted an experience. My weirdness was worth their paycheck.

After two hours, I excused myself for a moment to go to a bathroom—where I got a message from Sarah: *Miss you. Wish you didn't have work. It's not the same without you.*

Below the message was a picture of the dinner crew, laughing with their arms wrapped around one another. I

felt such a pang of loneliness and regret that I broke down in the doorless toilet stall, my eyeliner smearing like watercolor on canvas.

Why am I alive only at work? Why can I give so much of myself to my customers and so little to my friends? Maybe I was just being stupid because I was drunk, but I wanted to be an active participant in my life instead of walking around confused all the time, experiencing my days after they'd happened, passive from the sidelines. I wanted connection.

Work was a temporary balm, but the interactions there were fleeting, not enough to sustain my longing for people. The force of my rotting loneliness hit like a tidal wave as the reality of how much I struggled to navigate social settings outside the club settled in.

I allowed myself just one sob before I fixed my face and performed for the last half hour. When I got home, I couldn't get out of bed for days, my sheets disheveled with my self-loathing.

Desperate for answers, I started scrolling through an online forum for women with ADHD, wondering if I might have an attention disorder, looking for an explanation. I started asking for advice, addressing some of my other issues first, like getting lost in obsessive thought.

Within minutes, responses flooded in that my symptoms resembled ASD.

"What is ASD?" I asked.

"Autism spectrum disorder."

I scoffed, but after I read articles on how autism manifests in women, there wasn't room for doubt—the evidence was clearly outlined in the bullet points on my laptop.

Central to autism is a difficulty experiencing life in real time. Many autistic people can't filter out information, which makes it difficult to zone in and focus. All those

years, I couldn't read people's cues because I struggled to cancel out the world around me. At my sister's house, the background music, the forks scraping on plates, the blue walls—all swam in front of people's facial expressions.

But in the private rooms at the club, there were no outside stimuli. The rules were clear, the distractions minimal, so I could focus and interact.

Women in the ADHD forum invited me to the group for autistic women, and there I saw myself a hundred times over. Scrolling through were women like me—sex workers, performers, artists, writers—all struggling to make sense of their invisible differences in their own socially awkward, wacky, and beautiful way.

I gradually pulled the blame away from myself and labeled the things about me that were naturally different, not defective. I stopped punishing myself when I got overwhelmed in conversations, stopped beating myself up when bright lights blanched out facial expressions and when background noise canceled out people's words. I took a deep breath and resisted pretending to listen and asked "Can you say that again?" without apology. I forgave myself when I slipped outside social norms and said something weird.

No more being sorry for things I can't help. People would love me or not. Frankly, I was okay with the risk.

＊ ＊ ＊

A few months later, I stood outside the club with a cigarette in my hand, looking over the busy highway at the deserted factories.

"Piper, you leaving?" my bouncer nudged in his Queens accent.

"Yes. I made enough tonight. I'm going out," I said, smiling back at him.

He waited outside with me until Sarah pulled up in a rideshare.

"This is where you work?" she asked incredulously, her mouth ajar in the window of the car.

I laughed. She knew I was a stripper, but she had never been to the club. From the outside, it looked grim: a tattered brown building on the edge of town. But it was home to me.

"I never said stripping was glamorous."

I kept the window open as the club disappeared, letting the cold air whip my face, feeling a mixture of relief and excitement. Forums for autistic women advised pulling off the masks that many develop to pass as non-autistic. The effects of camouflaging are toxic, they warned. I wasn't sure I could go back to who I was. The rambling autistic girl at my sister's house was dead, buried under years of performance.

"Did you have a good night?" Sarah asked.

"Yeah. I'm ready for a night off, though."

Who could I have been if I hadn't tried so hard to pass? I'll never know, but stripping provided a portal to who I might be without fear of rejection—a rare glimpse of the affectionate, brash, and funky edges of my personality. But I still had so much to learn. There was vast, dormant space to grow into beyond my work persona.

The twinkling lights opened the doors to Manhattan, my body still moving from the music of the club. The possibilities of the night unrolled in front of me, and I intended to savor them.

LIZZIE BORDEN: Reese, where did you go to school?

REESE PIPER: I went to a small liberal arts school in Eastern Pennsylvania, where I studied psychology, women's studies, and a little bit of queer studies. I got a good education, and I wouldn't be able to write as well if I didn't have it, but college is where my social problems started. And that's also where I accumulated a hundred grand worth of debt. I took out eighty thousand dollars, because when you're eighteen, you don't realize what that means, but it accumulated interest while I was in school. When I graduated, my payments were almost a thousand dollars a month. That's what got me into dancing.

LB: How did you start?

RP: I wanted to dance after college, once the reality of my student debt sunk in, but I didn't know how to get into it, and it felt overwhelming. I read Elisabeth Eaves's book *Bare*, about her experiences working at the Lusty Lady in the nineties. But she worked at Peep Show, and the idea of a full-contact club—it was daunting. Then I moved to Australia for a year, where I met my best friend, a dancer, who wanted to bring me to her club. I was always complaining about my debt to her, and she was like, "Don't worry about your debt. Just dance, and you won't have to worry anymore; you can make your payment in one night." After several months, I agreed, and she was really kind with her time and introduced me to all her friends, and I was welcomed into a community of dancers. I was drawn to the money and stability. I thrived under the social structure and network. I

never had that before; I'd never had that much support and fun in my life.

LB: In your story, you talk about how the rituals of dancing were easier to understand than the rituals of outside life, and how that made the club a safer space for you.

RP: Outside life is very challenging for me, but I feel a lot more confident at work. I'm able to communicate in ways I'm not able to in my regular life. Even today, it's nerve-wracking to talk on the phone and to interact with people. Communication is not something that comes naturally to me. I wasn't able to string together sentences until I was five. It's interesting, because I was born a few months apart from my cousin, who is also on the spectrum but has higher needs. We grew up together, and he was much more "classically" autistic, or in line with how we think of autism in a child. My family and teachers must have noticed a problem with my communication and social skills, but I was brushed aside because I can smile and make eye contact. There've been studies of therapists looking at the same symptoms in a boy and girl, and they will diagnose the boy—they'll think he's autistic, and they won't think the girl is. Without the diagnosis, I grew up thinking I was just a bad kid, that I was cruel or mean or lazy or inconsiderate or bitchy or just not able to cooperate. I was very lonely. I escaped heavily into imaginary worlds, which I later found out is common for autistic women. It wasn't until I started dancing that I found an outlet to help me communicate and interact.

LB: What makes the world of dancing easier for you?

RP: With dancing, I have the same conversation over and

over, even with the other dancers—we have a common interest: we talk about customers, the managers, different clubs. The first night, when I went home, my boyfriend at the time asked me how it went, and I said, "It was really hard. I can't believe how tired I am," but I added, "I feel really confident, and I feel happy doing it." I knew right away that there was something about stripping that would help me thrive.

LB: Was your boyfriend supportive the whole time?

RP: We had been dating for seven months when I started dancing. He was a practical person. He knew how much debt I was in. But he started having more of an issue with it as I started pulling away from him. I think dancing helped me need less attention from him because I was getting adulation from work, so it helped me distinguish desire from validation. I was able to question if I was interested in him, or any men. So, we broke up, and I've since realized that I'm gay. It was amicable, and we're still close friends now.

It's common for autistic women to rely on a close friend that explains the world and social settings to them. I, of course, was doing this unconsciously. I always had a really close friend—and, for a while, my ex, who would say things like, "Lower your tone of voice," or "You're not supposed to act that way in this setting," or "Try to be a bit more serious." Even though we didn't know I was autistic, we both understood that I couldn't read some social cues. When I started dancing, I learned how to pick up on nonverbal cues. Through all the hours of talking to customers, I learned how to communicate in the moment. Dancing gave me independence.

LB: Was nudity at all difficult for you?

RP: I was an art model, which was the highest joy I've ever experienced, being seen without having to be anyone. I think it's part of being on the spectrum. I didn't absorb the rules the same way other women have. And my body wasn't a source of concern for me.

LB: What about loving art modeling do you feel is on the spectrum?

RP: You can't let your mind wander, because you'll move. You have to focus on one thing on the wall. My brain is always going a thousand miles a minute. It doesn't stop. That ability to get out of my head and focus on one object was bliss for me. I enjoyed the idea of being seen and, pre-stripper days, that was the first time I felt like I was being seen for just me. I didn't have to be anyone. I didn't have to perform, I didn't have to talk to anyone. You can pose and be acknowledged for who you are and for your talents but not have to be anyone. In art modeling, everyone sees your beauty differently, and everyone draws you differently. That's why I love it and still do it if I can get work.

LB: Do you still need one person to navigate the world outside stripping?

RP: My sister, if it's a new setting. Through her, as a child, I was exposed to a lot of different social settings and became a little bit more social. That's probably why I didn't get diagnosed for so long, because I can present well. I'm less dependent now and lot more aware of cues. I have responses ingrained in my head, and that's come from

dancing. They're stored in the back of my mind, and I am able to converse in a way that feels natural for me and the person I'm talking to. It doesn't feel fake, but it's definitely a part of my memorizing brain, not so much of my spontaneity brain.

LB: Is dancing something you will continue to do?

RP: Absolutely. The world is so expensive now. Student loans and rent and just going out costs so much money. I really enjoy dancing as a side job. I don't enjoy relying on it as my main source of income. It's a lot of pressure, but I don't know how I would support myself without it. With my disability, regular work is hard. I don't think my autism will allow me to maintain a nine-to-five, forty-hour-a-week job.

LB: At what point did you decide you wanted to be a writer?

RP: Almost right after I started dancing. I danced in Australia for six months, and then I went home, and I wanted to write and took an internship. I worked at a magazine and was dancing on the side. But writing has always been really painful for me.

LB: In what way?

RP: "Secret Life of an Autistic Stripper" took me three months, and it was brutal. I got up in the middle of the night to write. I went to bed thinking about the piece, and memories would come back to me. I give a lot of myself in my writing, whereas in dancing, I'm just a character. It's

painful, the thought of people reading it, but I don't think I could not do it.

LB: What do you want to eventually accomplish with your writing?

RP: I want to write a book about how autism expresses in women—how autistic women tend to mask their autism, how we struggle with organization, why we're not diagnosed. I really think there's a big story there to tell, and people respond to my stories about autism.

LB: Will you write as "Reese Piper"?

RP: Yes. I like my pen name, but eventually I want to come out with my legal name. At the moment, with my three identities—autism, gay, sex worker—I would feel too exposed to have my name out there. But I think once I have a bigger body of work behind me, it will be easier.

LB: Has stripping made you more aware of these identities?

RP: It's made me more aware of how I feel. I'm a lot more aware of what's going on inside my head—like if I'm tired, or if I'm having fun, or if I'm just pretending to have fun. Before, everything just felt odd. I just had this big pit of always feeling uncomfortable. But with dancing, you have to be really aware of how you feel. Because if you're in a shitty mood, no one wants to buy a dance from you. So, I'm more aware of my energy. I enjoy life a lot more now that I'm a dancer. Stripping forces me to live in the moment, and it is an emotional escape from the world.

My ability to engage has a lifespan, though. I'm aware of

when that wall hits. I have days when I cannot engage with people, when I can't look someone in the eye, days when I can't have a conversation. It's starting to happen more, though, and I fear that I need to scale back on dancing and take what I've learned and grow from that, because it sucks all my energy. As the years go on, it's becoming more and more an issue.

LB: Will you be able to cut back financially?

RP: We'll see how it goes. Right now, I need to dance for six months a year and watch what I spend and try to see if I can make a little more money writing. I take it month by month.

LB: Have you ever had private clients?

RP: I'm a very practical person, especially with my disability. If the guy offers me a lot of money to have sex with him or to go home with him, and I'm tired that week and I don't want to be in the club, I will take it. I don't do it that often, because it's a higher risk, and I'm always weighing my options. But I don't necessarily see it as any different than dancing.

LB: How are you structuring your time for your book?

RP: I get a lot of help. My sister helps me structure my days, and my doctor does, too. And now I'm on an antidepressant. Before I found out I was autistic, I thought I had ADHD, and they put me on Adderall, but I couldn't write on it. I would obsess over one line, and then the paragraph would come, and then I'd reread the paragraph over and

over. The hardest part is accepting that I can't do too much in a day. I know how much I can handle. If I'm out socializing all day, I can't go home and write. My brain has limits.

LB: How are you handling this?

RP: I'm on Wellbutrin, which has a slight stimulant effect, so it helps a bit with my fatigue. Not too much, like the Adderall did. It's not a false sense of energy, but it gives me just a little kick. In terms of the memoir, I'm just starting to think about where I want to start my story, how much research I want to include, and the voice I want to use to talk about my life. I think it will happen naturally, but with support. So, I'm happy I have my sister, who goes through the calendar with me, and we talk about what I can do and what I can't—just kind of leaning into my autism instead of fighting it.

LB: Do you live with your sister now?

RP: Yes, because I'm taking care of her baby during the day. It's good, because literally every hour with the baby is structured: now he eats, and now he goes to bed. I do want to find my own place. I'm just worried if I move and I'm writing and coming here to take care of the baby, I won't be able to take care of my other things, like taking out the trash and feeding myself.

LB: What about dancing?

RP: It has to be really organized. I cannot go to work and have two different shoes. So, I pack my gig bag in a way where I know I'll have at least the right clothes. I have a

sticky note outside my bag, and it says, "Have you brought your six things? Have you brought your outfits? Have you brought your makeup? Have you brought your shoes? Have you brought your money to pay the house? Have you brought your hair supplies? Have you brought your makeup wipes?" I guess that's the approach I need to have with life. I always need to have that sort of checklist in my head. It's like what my doctor said to me: "If you can organize yourself to dance, you can organize yourself for life."

THE TRUTH ABOUT HOEING

Lindsay Byron

Everybody wants to know the truth about hoeing.
Who's doing what, for what money—and what, exactly, is going on in those dark closets, those VIP rooms in the back?

And nobody wants to tell the truth about hoeing, because most of us are operating behind the same façade: that all we're doing is following the rules and dancing sexy, and that *I would never let a customer touch me!*

I've done things for money so taboo that I won't admit them, not even here. I've done things for money that would make a mother claw her heart out, a lover gouge out his eyes, a child cry. I won't speak of myself, of the things I've done.

You always think it's easy to say no until you're alone in a room and half a grand is at stake, and then you realize— my god, you fool—it has *never* been easy to say no, not even when you weren't getting paid, not even when you were only thirteen and these men were boys with nothing to offer you, only empty promises, only hands reaching for the take.

It wasn't easy to say no when you were thirteen and your boyfriend's best friend pushed you into the pantry of his parents' vast mansion in the most coveted neighborhood of your shitty little hometown. *Forest Hills.* Where you come from, living in Forest Hills means something. He was pop-

ular even though he was ugly, your boyfriend's best friend, because he lived in Forest Hills and his family had a lot of money. And, also, it was possible to be popular and ugly as long as you were a boy. It wasn't easy to say no when he pushed his hand down your pants and clumsily shoved his fingers across your virginal vulva like he was grasping for a coin at the bottom of a well. It wasn't easy to say no: you certainly didn't want to embarrass anyone or hurt anyone's feelings. In fact, it was so difficult to say no that you didn't. You kept up that silence. For weeks afterward in school, that ugly rich boy would pass you in the hallway and sniff his fingers in extravagant meanness.

It wasn't easy to say no when you were fifteen and the only girl at the party. The sexy foreign exchange student was there—the soccer player, the one all the girls desired—along with a cadre of popular jocks from the senior class. That foreign boy with the accent like silk took your hand and led you into a dark bedroom. You felt like royalty: *he is choosing me.* There was always such value in that, right? In being chosen? It was hard to say no as he pulled you in by the small of your back and ran his breath up your throat with an expertise simply lacking in these American boys. It was hard to say no when, as they had apparently planned, one by one, the cadre of popular jocks entered the room and entered you, placing their hands on your body, in your body, taking off your clothes, sliding fingers and tongues in places without names, these boys without faces. A homosocial orgy, cum from different boys, a mess you have worn as shame for the rest of your life. The boys left, one by one, until you alone were in that room with that mess. All you had wanted was the popular boy to like you. And now he liked you even less. *Stupid.*

It wasn't easy to say no when you were eighteen and that goddamn beautiful skateboarder wanted to test his reli-

gion inside you, sacrificing his virginity to your welcoming body on a picnic table in the dark park as you comforted him, whispering, "It's okay." He came hard and immediately regretted ever knowing your name. "Let's leave," he said, and then dropped you off in the dark outside a gas station and sped away, repenting. In the weeks to come, he would deny you—"she means nothing"—after he had charmed you so sweetly, drawing a bouquet of flowers on a Post-it and passing it to you across the classroom, scribbling his phone number on the leaf of a tulip. What poetry. You had called him that very day, and he didn't answer. You became addicted to his scarceness, the way he acted like he loved you but promised you he didn't. It was hard to say no to this goddamned beautiful skateboarder who loved your blow-jobs but not you, because, honestly, you gotta admit it, you thought a good enough blowjob would earn love.

You wanted love from men, and you used your body to get it. But you never got it.

Men wanted sex from you, and they used their love to get it. And you—trained in politeness, acquiescence, deference—you gave, gave, gave, too afraid ever to present them with the bill.

Paradigm flip.

In these clubs, the men want *you.* Want you like they always have. But in this place, baby, there's one big difference:

You don't want them back.

They are no longer the popular boys. (Forest Hills means nothing here.) They hold no esteem that you wish to gain. You have everything you want in yourself now—you had to grow that garden long ago.

And so, in these clubs, these men are the objects—and you have no qualms about lying, pretending, and manipulating to get that thing you want.

Your body is so used to being used that it's almost like it hurts you none at all to do this shit again and again.

Everybody wants to know the truth about hoeing.

"Is it really just *dancing*?"

No, motherfucker. It is *not* "really just dancing."

There will be strippers who vow they never cross lines. There will be strippers who are lying, and there will be strippers who are telling the truth. But regardless of where they stand, strippers have one thing in common:

We love making money.

And so, for some of us—when half a grand is at stake, and all you have to spend is an hour with your soul clenched shut and your body laid open—it isn't easy to say no, especially for those of us for whom "no" has never been easy.

"I'm a gentleman," he promises, as he slides his arm around your waist, gliding you into VIP.

"Whatever you're comfortable with," he promises, as he runs his hand farther up the inside of your thigh.

"We won't get caught," he assures you as he tugs your thong to the side, thumb-wrestling for control of your underwear.

"Be nice, and I'll get another hour," he purrs as he pokes his dry finger at your dry pussy until, finally, you relinquish, weighing the price of this surrender against your goal earning for the night.

The truth about hoeing:

Fingering. Hand jobs. Blow jobs. Fucking. Cocaine. Molly. Choking. Abuse. Tickle fights. Nipple bites.

It isn't easy to say no when Jack, a middle-aged entrepreneur with a beautiful and empty home, wants to hold hands

in VIP. He tells you about his ex-wife, but he still calls her his wife; and he tells you about his ex-kids, but he still calls them his kids, even though none of these people speak to him anymore. "I'm learning to cook for myself," he says, and you're bored with his pain, but it is your job to pretend, so you hold him in your arms and you dredge from your guts an accurate facsimile of empathy—and you wonder, *How deep is this well, and does it ever run dry?* He wants to kiss you. You let him kiss you. You want his money to come back to you, riding along in his pocket like a hero hidden in an enemy ship. He has paid your rent tonight with his aching loneliness, which has entered your heart like black matter. He will pay your rent again next month if you let him. You find yourself yearning for a lighthearted comedy at six a.m. as you pass fitfully into sleep.

It isn't easy to say no when the friendly sports fan just wants to lick your pussy real quick and that's five hundred dollars for you. Really, it will take no time at all. You don't even have to dance. Just present your pussy to his face for the span of one half of one song and pretend to cum. Really, is that so hard?

It isn't easy to say no when Roger, a regular with a large expense account, asks to go VIP again, even though his visits are becoming more and more extreme. He has begun bringing towels in his pocket for clean-up afterward. You've been covered in cum before for zero compensation, so why not for cash? Even though he likes to hit you. Even though you've been beaten by a man, and when Roger the Regular hits you, you get this sickening simultaneous jolt of red-hot rage and a disgustingly wet pussy. Your body has been trained. *Hurt me, and I open for you.* He chokes you against the wall with one hand, pulls his dick out of his pants with another, shoots a load on your stomach. Shamefaced, he pays and leaves, but always, he returns. Shamefaced, you

accept payment and leave, but always you meet him again here, for more violence, more humiliation, more money.

"I'm a stripper, not a prostitute!" you hear another girl complain in the dressing room, and you think, *Well shit, I guess I am both.*

And, maybe, that protestor, that above-hoeing stripper, maybe she's not letting men touch her body. Maybe she is following all the rules that are made to be broken. But, if so, *What goods does she trade?* you wonder, wide-eyed, that precious unsullied stripper-not-prostitute. You wonder, *From what well does she draw, and how deep does it flow?*

You look around that dressing room full of women who are everything like you and nothing like you at all, and you marvel, *My darlings, my sisters: From what well do we draw, and when will it run dry?*

We'll never know, because a good stripper will never tell. But I haven't been a good stripper for a long time.

INTERVIEW WITH LINDSAY BYRON BY JILL MORLEY

JILL MORLEY: Lindsay, when did you stop dancing?

LINDSAY BYRON: In 2016. I won Best Stripper in Atlanta in 2015. It wasn't a competition; it's just this popular magazine, the "Best Of" edition in Atlanta, and it includes strippers. That was me, at the end, and one of the heights, of my career.

JM: Did you get burned out toward the end?

LB: Oh god, yeah. Abso-fucking-lutely. Anybody who doesn't, mad props. I have a friend in the industry who's

been at it longer than I ever was, and she's still rocking and rolling. I've got nothing but respect, but I couldn't do it.

JM: I'm with you. There's a line in "The Truth About Hoeing" that says, "Men wanted sex from you, and they used their love to get it. And you—trained in politeness, acquiescence, deference—you gave, gave, gave, too afraid ever to present them with the bill." Do you think that's a lot of strippers' origin stories?

LB: In today's world, to posit anything like a general stripper origin story would probably get me in deep shit with the Gestapo on the fucking internet. My dad died when I was a teenager—very traumatic. I was also cast as the high school slut—also very traumatic. Fucked a lot of dudes as a young woman because I was looking for love and validation. I lived in this very small—*very* small—southern town, Danville, Virginia. If you rearrange the letters, it spells "Evil Land," which would definitely be the title of one of my books. First chance I got, as soon as I got out of Danville, I went straight into the strip club.

The best I can understand it now is I wanted to vengefully turn what had been a scarlet letter, a thing of shame and pain, into an aggressive tool of power through which I could get the things that I wanted. I've gone through so many iterations—I stripped on and off for sixteen years, a very long time. But that was really my origin story. Some people actually get mad at my origin story because they think it's a narrative they don't want to be told about sex work at this juncture in history. But, yeah, I had daddy issues.

JM: There's a reason for these stereotypes, because sometimes these stories really happen.

LB: Absolutely, and I've seen it over and over, in a million iterations. I have a PhD, and my later stints in stripping weren't my only option. In today's world, it is hip and fashionable to frame sex work as this political, empowered choice that women with many other options are choosing to do as a political identity. That was not my experience with sex work twenty years ago.

JM: I had a similar experience with my documentary, *Stripped*. I was screamed at during a sex industry festival. Women were throwing popcorn at the screen because of some bad things that happened to stripper friends in my film, saying I was reinforcing the negative narrative. But it was a documentary: those things really happened.

LB: I feel you; I get a similar backlash by telling my life story, which doesn't fit what's currently hip. Today, dancers aren't outsiders. There's a real internet community of online sex worker activists. Jacq Frances just worked a retreat for me at the beach. It was awesome. She's a really good friend of mine; I fucking love her.

JM: That kind of community of like-minded women was missing before.

LB: Now there's this very active online sex worker community. I became "internet famous" in the pole dance community, teaching women who aren't strippers. They're housewives, lawyers—your average woman—and they're learning to pole-dance. So, I became famous in that world. That's where a lot of my stuff went viral. At that time, I was put on a huge pedestal in that online community of these twenty-something women, women who were much

younger than me. I had a podcast called *Stripcast*, which was a blast. It's an hour-long sermon, and people were paying for it. Now I run retreats all over the world. It's really more about finding your voice, naming your desires, being real about what you want, coming to understand what you're capable of, redefining yourself, reinventing yourself. My target demographic is women from all walks of life, not pole dancers or sex workers.

JM: Along the lines of Tony Robbins?

LB: Abso-fucking-lutely. I put people up in a beautiful mansion, and the number one thing I do is motivate and inspire them and sit around and cry with them.

JM: You're a super-entrepreneur. You created your brand.

LB: I spent my lifetime serving men. That's an unpopular way to phrase it now, but that's what the fuck I was doing. I spent my lifetime tap-dancing for dudes. I'm not going to do that anymore. I'm over it. I don't ever want to make another dollar from a man. I wanted to go from serving men to serving women, in a way I felt good about. I felt conflicted politically about my work in the strip club more times than I could count. Especially considering that my PhD was steeped in feminist theory, so there was a lot of cognitive dissonance going on. But you weren't there to get people politically straight. You were there to make four hundred dollars that night.

JM: I know one woman who said that stripping for her felt like it was a girl's job, and she's a woman now. Another unpopular thing to say, I'm sure.

LB: I can relate. And I also have to face the realities of who's really making money in this industry, who owns these clubs, and the unfair operating practices. The fact that we are handing over wads of money to these owners and everybody else every night. The fact that you've got to pay a hundred fifty bucks to work. What the fuck kind of shit is that? That was another thing I felt. On one hand, I wanted to be like, *Fuck yeah, I'm subverting the system. I'm capitalizing on something I'm not supposed to be capitalizing on.* But on the other hand, let's not pretend my titties aren't putting money in the pocket of another fucking gross man.

JM: How did you overcome abuse from your life before dancing and attain the perspective you did?

LB: I replicated it and slanted it for over a decade. I shudder to admit to some of the shit I've done for money. For example, I was brutalized in high school, beaten really badly, hospitalized. The dude went to jail, and it was a big thing. Yet, I've accepted money to get hit. I hate to admit this as a grown woman—not as a twenty-something, as an educated woman with multiple degrees. I'm like, *What the fuck is this?* I don't know, but the only way I can explain it is that I didn't overcome the trauma when I was working in the strip club. And I don't think I've overcome it yet. But in just the last couple of years, having a successful business, now I've got a little bit of money, now I'm able to put money into my self-care, I'm able to go to therapy. Having a life that wasn't so hard-pressed and hardscrabble was what enabled me to have the leisure to pursue my mental health. That's a harsh reality, but if you are busting ass for rent, paying for therapy is not really on the menu. Financial desperation overrides all other needs.

JM: When did you stop giving a fuck about what people think?

LB: I wish I could say. My image is based very heavily on that. People really associate me with this "I don't give a fuck" attitude. I often say that is absolutely a fucking brand and a façade. Because I do give a fuck, unfortunately. I wish I could turn it off. I work on my need for external validation, which is quite strong. I can pull away, and I can rationalize why other people's opinions don't matter, but it is a battle, a training of the mind comparable to the training of your body in the gym, like a muscle you work out.

JM: What kinds of bars did you work at?

LB: It has run the gamut. When I started in Richmond, Virginia, the place I worked at was about as upscale as it got in that city. But I've also worked in a trucker kind of sports bar that had the lowest surveillance of all. You could get away with anything in that place. I've also worked at the most upscale place possible, a famous club here in Atlanta called the Cheetah. That's all VIP money, that's all your hustle. I've worked at the Pink Pony, which is your real, quintessential Mötley Crüe "Girls, Girls, Girls"-type strip club: mirrors everywhere, pole dancing, money flying, because this is Atlanta and they throw money, which is awesome.

JM: Which are your favorite clubs to work in?

LB: The Pink Pony has been my favorite. I really enjoy myself there, because I love to put on a great stage show. They respect me, so they would give me and my work spouse—she's better than me onstage—a great time slot,

like one a.m. Man, we would make the club fucking explode every weekend. We'd sometimes make four hundred dollars on a stage set. They'd have to sweep our money up with a broom. That was the life.

JM: In my research, I found that Atlanta and New Jersey had the most strip clubs per block.

LB: There's got to be forty clubs in this town of all different levels and varieties. If you go to some of the low-down ones, it's a lot of fun, because you can just blatantly smoke weed. The shirking of the law is truly incredible. There's so much illegality going on in strip clubs.

JM: In New Jersey, clubs were often busted by the ATF [Bureau of Alcohol, Tobacco, Firearms and Explosives].

LB: The club I used to work at, the Pink Pony, just got into a shit ton of fucking trouble on some serious shit involving sex trafficking and pimping. We all knew that was going on. I even fucking wrote about it in a podcast. I wrote about it, but it's all gone to court and been dealt with. If you google "Pink Pony Atlanta sex trafficking," you'll find it.

JM: Why do you think we all accept the illegal stuff while we're working?

LB: Why do we accept it? Doesn't it always feel illegal as shit? We know so much is going on. All that under-the-table money, too. We're taking shit tons of fucking under-the-table money. It's practically money laundering. I felt like I was part of an underworld that somehow the real world turned a blind eye to. So, I felt like we could just do what-

ever we wanted. I kind of enjoyed it, because I've always been an outlaw.

JM: Do you consider yourself an activist these days?

LB: I've been an activist for a very long time. I was an activist when I was an academic. I did some great scholarly work on women who were wrongfully institutionalized in an infamous southern mental hospital called Bryce Mental Hospital, in Alabama. My thesis is called "Rewriting Elizabeth," in a journal called *Southern Cultures*. I wrote that article by researching archives in the bottom of libraries. I found diaries from the 1920s that hadn't been opened in a hundred years. I always considered that scholarship to be activism, publishing those women's voices, those women who had been purposely silenced from history in so many ways.

I've also been an activist online, big time, which is how I got my following, because I was always putting out all this feminist content that people were loving and eating up and sharing like crazy. I still do. Also, I traveled the world on tour preaching my sermon. I toured fifty thousand miles over the years. There are definitely women who have my quotes and shit tattooed on them, a good dozen women out there with "Lux ATL" tattoos; it's fucking crazy. So, I know for a fact that I've changed women's lives for the better. So, yeah, I consider myself an activist.

DIARY OF A BLACK HEAUX

THE INCREDIBLE, EDIBLE AKYNOS

1. MOMENTS OF LOVE, BUT NOTHING EVERLASTING

I am the poster girl for the girls who become heaux.

Grew up in poverty, woman of color, single-parent household, almost-absent father, and the list goes on. I'm also the epitome of the kind of girl who stalks or gets attached to men. The kind who has constantly been so hurt. We hang on with hope, thinking that every guy we meet next is the one. Or we give them chances they don't deserve, put them on pedestals they don't belong on, and give them the benefit of the doubt—all because we are so desperate for love. I haven't been truly loved by a man in well over a decade. Everyone that has come by has just been someone in for what he can get; then he's out. Moments of love, but nothing everlasting.

What was it about this nondescript man that made me so angry, so hurt, in so much pain that I felt suicidal? Here was this man I practically ignored for a year who popped up in a surprising way. Coming out to an event I was going to be at and we clicked, if even in the slightest of ways. And then he spoke well. If anyone knows me, they know I like a man who speaks well. He was tall, dark, and handsome. Had a job, a similar interest in the arts. He seemed to have good family values. We had good conversation. But that

shouldn't have been enough to make me think he was anything more than a piece of shit.

What else is there to call a man who leaves a woman at eight a.m. when he doesn't have to be at work until four p.m. the next day, then doesn't call her back fourteen days later? After she has left voice mails and text messages? I played the scenario out over and over in my head and realized this man left me to be with another woman. We slept together, not having sex. It wasn't because I didn't want to have sex with him; it was because he wasn't aggressive toward me, this sexually submissive woman.

What is it about men that make so many of them believe they are entitled to a woman's body? This one in particular is most comical, as he didn't even try hard. We never went out on a date, and as he lay naked next to me, he never pushed his hard cock onto my ass. He didn't grab me and rub himself all over me. He didn't kiss my neck. He did nothing. I guess he was lying there waiting for me to make the move.

Reasons like these is why I work. Things like this make me feel cheap. And worthless. I question my beauty, my actions, my thoughts, and everything I have done to make a man leave. It plagues my self-esteem. It fucks with me.

My clients respect me. We have a clear understanding of how our relationship works. Money goes in hand, he leaves, he never has to come back. Chances are he will, at least twice in my experience, but if he doesn't, I'm not hurt. Because I'm a whore and get paid to be one. I selectively allow clients to step into my chambers.

Here I was, singing this man's praises. Amazed that he slept with me and never tried to screw me. I wanted to have a mature, honest relationship with him. I asked him what he wanted and got no answer. I wanted to know what he was looking for. I wanted to know if he used condoms during sex,

if he liked to spit, if he liked anal, who else he may have been sleeping with. I wanted to tell him about my preferences and so on and so on. But we never got to that. He just assumed I had no intention of giving him the goods and left. Left me in the bed and ran off to be with someone else.

I have felt cheap for the last time. No other man, unless he has proven himself worthy or is a client, will set foot inside my door again. Here I am, such a good heaux, and I cause myself to get hurt by arbitrary men who are broken and so hurt and so weak they don't even know how to take the initiative.

The bills and landlord care not about my broken heart. It's time to get back to work and do what I do best.

2. THE THING ABOUT PRETTY GIRLS

I've never really considered myself a "pretty girl." There are days when I think I'm absolutely gorgeous, when compliments on my beauty are plentiful, but I'm still no stunner. In my opinion, I grew up an ugly duckling. My darker complexion probably had a lot to do with that. I was never the girl chosen by the boy if a friend and I liked the same guy. The other friend was usually taller and light-skinned, and I would always get passed up. I was the one boys dealt with only because I had a nice body. They'd fuck me, but they never wanted to be with me.

These are the makings of a Black heaux.

I've never been one to steer away from the blatant stereotypes of what makes a sex worker end up in sex work. I am the poster child for it all, and I'm okay with that. Everyone is the poster child for some way they ended up in life. Being a heaux is no different.

On occasions in my life, I've had to be victim to my "pretty girl-ism." You know, when a man tells you that because you're pretty, you think you can get what you want. You think someone is supposed to "sweat" you. Yeah, go ahead. Treat me like shit. I'm the spoiled, little pretty girl.

The inconsistencies I've had in love throughout my life break my heart. Recently, I tried to explain myself to a boy I like. I was being a little difficult toward him because I liked him, and he was displaying behaviors of many of the men I've met before. And I am totally tired of meeting the same men over and over again.

This one was younger than I am. He had been chasing me for approximately four years, trying to get my attention, but I wouldn't give him the time of day for many good reasons. Pants saggin', drug swindling, not the most articulate, the braids. But he got lucky one night. And being the romantic I am, I hoped he would be different, because already he was so different from anyone I would want to give the time of day.

My friends have said that men like him only want to make money and have sex, nothing more. To me, he was just a twenty-odd-year-old idiot. Overtexting. Real-world conversations are out the window. And him being on parole didn't help the cause, either. But I liked the kid. And I wanted to explain to him that I wasn't being difficult because I'm a miserable bitch or too pretty for my own good. I was being difficult because, too many times in my life, I've met men who never treated me like anything despite how pretty they said I was.

I am just a human being underneath all this flesh. Desperately wanting to connect with someone. To genuinely love them and have them genuinely love me. I desperately want someone to say they like me and mean it. It's not that

hard. If three a.m. is the only time you can find for a girl, it's fine. But get creative. Diners are open twenty-four hours. Bring flowers. Hug her, kiss her. Is that so much to ask?

It's not that I want to be a bitch. That we women or pretty girls want to be bitchy. It's that so many—far too many—of you men are either broken or out of touch with femininity that you treat everyone you come in contact with like shit, even if you don't realize it. If the number of men me and my friends have come in contact with is any indicator of the amount of shit out there, there's slim pickings on quality men.

And quality is not necessarily someone who speaks well or makes a lot of money. Quality comes in the way that person treats you and others. If making money is more important to you than connecting with someone who is interested in you and wants to talk to you, hold you and kiss you, then you are not a person of quality.

If making the effort to take someone out is too much, then your quality is null and void.

If calling, caring, talking, is a bit much, then you are not a person of quality.

I'm more than just a big butt and a smile. Don't reduce me to just that. In my work, I refuse any client who seems to be about only the sexual aspect of our time together. I'd rather someone who is looking for a more consistent and deeper connection. Why should I reduce myself to that in my personal life with lovers?

3. A LESSON IN INTIMACY

I was fully dressed with the exception of my shoes and socks, ready to head out the door to a kid's birthday party, simply because I wanted birthday cake. I love cake. I looked

at my phone to see a text from a client I'd been with twice, wanting to know if I was available. I asked what time he was thinking, in the hope I could go get my cake, return home, and have a good ole Sunday evening. To my disappointment, he wanted to meet within the hour. After telling him he had the worst timing in America and that I was really looking forward to cake, I decided to wait for him. The money was far more important. But he was reluctant to meet me. He wanted me to have my cake. I knew his resolve for us to meet another day could mean another week. I wanted and needed that money today. I urged him to come.

"I need a neck rub anyway."

It all went downhill from there.

"I'm not paying you to rub your neck."

He was right. But let's analyze this the way I had to break it down for him.

You are paying me for a service. The good thing about paying to play is that it teaches men how to deal with women. Not only did his statement hurt my damn feelings, but it made me feel a little less human. The experience I provide is not splash and dash. It's intimacy. I laugh with you, I massage you. I offer you something to drink, the option to take a shower. I am hospitable, I am kind. I suck your dick. If I were not a woman you were paying to spend time with, would you still feel that I didn't deserve to be touched? If the answer is no, you have to remember that those you pay for time are not just illusions.

A part of being intimate with someone is doing things that please them or give them relief. This could be talking, hugging, or other forms of mutual touching, from a simple neck rub to maybe even giving the other person, whom you've paid, a massage.

I told him he should come over for a lesson in intimacy.

"Come," I urged him, "I will suck your dick, and you won't even get to touch my hair."

He couldn't understand my logic.

"Because, you asshole," I explained. "You just told me that you were not paying me to touch me."

He rephrased it: "I am not paying you to give you a massage."

He still didn't get the point. So, I went on:

"Since I'm just an illusion, come and fuck me. Bend me over. Don't touch me. And while you are at it, don't do anything that will please me in any way. Don't go faster, don't even suck my tits. Just pretend I'm not really there and fuck me, because from where you stand, you are just fucking yourself."

In my mind, I was going to have a field day with this. It would be such a new emotion for him; he may not know what to do with himself. It would be like my domination clients whom I punished by not allowing them to touch me or even cum.

I assured him that I didn't exist for my own pleasure—just so he could use me as an empty vessel. Because if I am in the bedroom with someone, and they don't feel that they can do anything to bring me pleasure because they are paying *me*, then by all means, keep your hands to yourself and let me do all the work.

I was turned off and hurt, but still willing to ball up my feelings and see him.

"Just give me ten minutes to straighten up my room. And five minutes to go in robot mode. Are you coming?" I asked.

After a little silence, he replied, "No. Go enjoy your cake."

An epic waste of time after I had finally made up my mind to stay home. At that moment, I realized that most men are sensitive little bitches who have no backbone to

give you back some banter. They cannot take a challenge. It was too much for him, and he backed out.

"You know," I wrote in my final text to him. "This is exactly why, when I have someplace to go, I usually decline work. You take care," I added. And then I blocked him forever.

4. NEW YEAR'S FLASHBACK

I don't know what happened to me around holiday time, but I was in rare form. I don't recall being that horny in a long time. I was drinking, and I was ready. And, just my luck, one of my regulars called me. I was staying away from my usual location, and he came by to see me, but I was unprepared. Forgot all my protection. I had been seeing this client for a while, though, and my sex drive got the better of me. So, I began to give him a BJ without the rubber. I gave him the hottest skin-to-skin lap dance, teasing him every step of the way. And, to my surprise, he did something he'd never done before. He spread my cheeks and dove in for one of the best cunnilingus experiences from behind I've had in some time. Both of us knew we couldn't go *there*, so this was one hell of a tease session. It was hot. He had an erection like he'd never had before. I wanted to feel all his five inches in me like it was the biggest, most beautiful thing I'd ever seen.

We'd drunk a little coquito, and I was sipping on all kinds of Absolut before he arrived. I was lit. The thing about men with small penises is that it's so easy to fit them in my little mouth and tiny throat. I can do things with them orally that I have to work hard for with more well-endowed men. But I gave this man head like the champion I am. When he

ejaculated, it flew out like magic milk. His moans were epic. I almost wanted to swallow it. It was beautiful.

After he left, I remember wanting him to come back—or for anyone to come, so I could let loose on them. But no one did. I spent the night calling people, trying to get them to come visit me, to no avail. Instead, I had to masturbate, and I passed out, waking up the next morning angry that there was no dick available when I was in the mood to take ten of them at once.

5. STAMINA DADDY

This week, I broke up with my boyfriend. He lives in another country. I had to break it off because he slept with someone else, and although I understood, I wanted to be fair to him and let him live his life without feeling guilty about me. Besides, he could possibly not be telling me everything, and I am seriously not trying to be played. So, I cut him loose.

I have been desperately wanting to revenge-fuck for the past couple of days, so I wished for a copious number of clients, so I could fuck them in the name of rent while getting at least part of my rocks off. No go. Client one today was great, but I missed my so-called boyfriend, although four thousand miles away. And as I received my bout of cunnilingus—I've been seeing this client for years—I wondered if that little Black bitch ex-boyfriend of mine was living with the girl he was just with. So, the sex was fun, but no cigar.

Around midnight, I was awakened by a call from a guy I had just met the other night at a party, where he fought for my right to be paid and vowed to call me because he knew some others who might want to help me pay this month's

storage bills, 'cause lord knows I need a sugar daddy for the storage bills alone.

At first, I didn't know who it was. The call came in while I was sleeping, and I could barely hear WTF he was saying. He mumbled his code name. I was sure it was one of the three guys I gave my number to at the party. When I finally arrived at his place, it was none other than this guy fighting for me to get paid. Skinny AF, so not my type. And young— twenty-one young—but he was paying like he's weighing, so it was all good. I had to keep my eyes on the prize, because a little guilt came over me because his girlfriend was really nice at the party. But I'd taken a taxi there after about an hour of prep and had debt up the wazoo, so I was gonna have to put those good whore morals behind me and get this money.

He said it was his first time hiring a girl. Most clients are usually lying about this. It took about fifteen minutes or so for me to realize it *was* his first time. The conversation was a little awkward, the energy a little rough. I had to break the rules down for him: Pay first. We do our business. Then I leave. Easy enough.

No haggling on the payment. I loved him already.

He got undressed. His frame was about as big as a toothpick. His dick was hangin', and he said to me, "Don't go getting tired on me," and I laughed because he had to be kidding.

Prince wrote "Insatiable" for me! I'm grown and experienced. You are no match for me, Charlie Brown!

Thirty minutes later, and I was wondering if he was a machine. My walls felt like they were going to explode. The urge to pee was prominent. And my poor thighs were begging for mercy. It would take an hour before he finally reached climax, and that was very important to me as a professional.

So, I sort of got my revenge fuck, but it's not the same when I'm really not trying to connect emotionally to a person. Although he was sweet and gentle in spirit, the sex reminded me of my now out-of-town ex. It was machine sex, never-ending. They were both too slim, usually off my radar, and I was left with the memory of "damn" on my lips.

But it was good for the bills.

I anticipate his future calls. Until then, I do squats in preparation.

6. HOW WOMEN ARE NEVER ALLOWED TO LOVE

I'm currently listening to a lot of love songs.

And as I am listening to one of the greats, Rihanna, sing about "Same Ol' Mistakes," it's making me think about something. *Damn. I am never allowed to love. Not by the men who continue to reject my advances of giving them my heart, but by society.* My friends, my associates—everyone has a fuckin' opinion.

This new trend in dismissing my feelings has caused a hiatus between me and my sister wife. In response to a love affair with another faraway man, she expressed her disappointment by saying, "Can't you find someone that's closer to do this with?"

In my twenties, if I met him on the bus because he was driving it, I was told I didn't have any standard, that I'd date anyone.

If I met him while walking down the street, while doing laundry, at the club, 'round the way: I should have known better than to be meeting men like that. *There is a way to do this, and that ain't it.*

When he was closer to me, I was asked to get over it: *'Cause, you know, you are better than that.* I mean, I am.

If I fucked him too fast, I was a slut and needed to *Stop giving up your stuff!* Clearly, I had ruined potentially great relationships by thinking that having sex with a man was something we both wanted and could mutually share. Boy, was I wrong.

If I tried to keep it in my pants, he would get upset with me and leave, but not before insulting me. One guy, whom I knew for several years prior to our attempting to have sex, got so upset with me he started calling *me* the slut: "She is as easy as ABC, one, two, three." We never, ever had sex.

A doctor: I was out of my league.

Young: I should have known better.

Married: *The magic paper says you can't break through the barrier.*

Found out he was in a relationship, and it crushed me: *You have shitty taste in men. Why do you keep choosing these men* (who exist in astronomical numbers and are incredibly hard to avoid meeting)?

One-night stand I just didn't want to waste my time on, 'cause I know how these go: *Aw. You shoulda tried!* And get my fuckin' feelings hurt again? Nah. Then I'm accused of giving up rather than reading the fuckin' tea leaves.

And one of the great kickers was hearing I had issues because anytime I needed some healing and guidance, it was because of heartbreak. I mean, the nerve of me to love freely, openly, without judgment and to expect love and respect in return! And when I don't and it crushes me, I have salt rubbed in my wounds: *You should have known better than to love.*

And if he was a client: I crossed the line, passed the point of no return. 'Cause lord knows the men who walk into my room for love and sexual pleasure are completely off limits! There is no way my stone-cold robotic heart should even

look at these people as humans, even if I connect with them on a human level.

Too poor: *Why you keep picking these broke mofos?* I mean I thought love was an important factor. Struggle love isn't cute, and I am way over this one myself.

He got money: *Better have your own. And these money men are a force to be reckoned with. Play your cards right or get played. They got money. They don't have time for you.*

Too many abs: *I mean, girl. Look at how many abs he has. He is way too focused on that body to be concerned with you.*

One isn't a lonely number. I flourish in one! But it amazes me the different ways and types of men I have tried to love and how I was never able to get it right. But more important, I wasn't allowed to mourn the failure without some sort of judgment coming from one way or another. It's interesting, when you look back and think about it all. If you're not allowed to love anyone but the one person who is supposed to be the magic one, why did all these other mfkz come in the picture?

Sometimes I love good. Sometimes I love bad. I can't say I've never loved.

7. A PERSONAL HISTORY OF BEING A STRIPPER

My new lover is insisting I get back in the clubs because I look so good.

For one thing, from all my years of drop-splitting, my back has caught up with me. For another, those strippers work too damn hard. I'd rather suck dick all night.

Several years back, I was convinced by my light-skinned BFF to go to a Bronx club and audition, because money was slow and I needed it badly. But light-skinned privilege don't

allow bitches to see the reality. When I got to the club, not only would they not even let me in, but the womxn at the door claimed they weren't hiring. I said I would pay to come in and have a drink. After all, I had schlepped all the way there from Brooklyn. After I stepped inside, I saw that all the dancers were light-skinned.

By the way, yes, I had called first.

A couple of years later, I called Sapphire's in New York and straight up asked them if they hired Black girls. I didn't have the time to go all the way to the fuckin' East Side of Manhattan if I wasn't going to get in. I told them my complexion and height. After confirming they hired everyone and were indeed holding auditions daily, I put on a wig, a tight dress, and some makeup. I get to the door, and the doorman makes a fake inquiry only to tell me they have hired all the girls they need already. I left, humiliated.

Last year, a gal I met at a members-only club I dance at from time to time calls me to dance at a party. I strip in theater-type shows, so I usually come ready to do that type of shit. To my utter shock, it's some all-Black house party event with a young crowd of Black men. After trying my best to revert back to my booty-shaking stripping ways, the party ended, and I could take my shameful ass back home. So, I wait on my $150 pay, which was the agreement. The girl who ran the party didn't like me, so she wanted to pay me only $50. If it wasn't for another girl and her boyfriend that night, demanding I get paid what had been agreed, I would never have gotten my money.

We all think that, when it comes to sex and sexuality, any woman can "just" make money. It's not true. The darker, older, shorter, thicker you are, the more your rate and value are diminished. As a Black sex worker who is "dark"—I am actually of medium complexion—I am not afforded the

luxury of charging the same rates as white girls or even the womxn who are Black but light-skinned. Even those womxn who are visibly unattractive are allowed to charge substantially higher rates than my fine ass simply because they may be white. In case you're confused, by "unattractive," I mean just fuckin' ugly and stank-looking. You can GTFOH with your word policing, okay? I ain't got the time.

8. COULD YOU BE A STRIPPER?

If you've cackled at the idea of strippers (or any sex worker, for that matter) organizing for the right to take their clothes off, ask yourself: What is work? And after you've figured that out, ask yourself if you could stand up in six-inch heels all night, swing from a pole in them while donning a skimpy outfit; talk through an entire eight-hour shift to men with bad breath, fragile-ass egos, too much cologne, broke or cheap as fuck; deal with management up your ass about stupid random shit, with male entitlement, with other womxn who aren't designated to do your job stealing your money; and then battle stigma because we live in a suppressed-ass world whose entire population is rooted in sex but somehow always wants it hidden.

9. INFLUX

Like clockwork, whenever I am pretty darn sure I am leaving the world of self-employment, the surprise influx reels me back in. Today, for the first time in a long time, I saw multiple clients on the same day. It made me feel special that all my boyfriends and new potential partners in lovemaking

and intimacy would contact me, wanting to spend time. One of them even had no issue with massaging me for my pleasure. He is not the first overweight boyfriend I've been with who had stamina and a hard thrust. Open your mind, ladies! Big boys are giving it all to you for a multiple-orgasm effect!

After weeks of lonely nights and dry pockets, the boys are back. Is it something in the air? All I know is I like money and the ability to splurge on bills and other responsibilities. This will not, however, stop my quest to be less self-employed and to go back into conventional employment, where brown noses are donned and egos are out of control.

I doubt I will last anywhere. But I am looking forward to a pay stub, guaranteed income, and a spot on the basic-bitch train. Oh, to be ordinary is but a dream.

INTERVIEW WITH THE INCREDIBLE, EDIBLE AKYNOS, BY LIZZIE BORDEN

LIZZIE BORDEN: How were you introduced to stripping?

INCREDIBLE, EDIBLE AKYNOS: I grew up wanting to be in the adult industry. I grew up around the corner from the *Playboy* office. Back then, porn was a bit more free in New York, so it was a bit more grimy in the nineties growing up, before that fucker Giuliani cleaned New York up and destroyed its imagery. So, I grew up seeing a lot of the posters, like the trans women and the showgirl posters in New York and on *Hustler* magazine covers. And I grew up wanting to be one of them, because I just thought they were so beautiful and so admired and strong. They were pretty much white women, for the most part, but I was like, *Yeah,*

I want to pose. And I did end up posing in a nude maga-zine. Obviously, not *Playboy*—they put a fat Black woman in there only last week. But, yeah, I grew up wanting to be a dancer, and when I got to the strip club, I didn't know it was a strip club, because I was thinking it was more burlesque-y. But I stripped, and now I'm a burlesque dancer.

LB: Some strippers—not burlesque dancers—have very strict lines about what they will and won't do. Did you?

IEA: When I was a lot younger, before I realized that I really feel degraded by heterosexual relationships and het-erosexual sex, I had my standards, like, *Oh, I would never sleep with someone*, because sex was supposed to be about love. Sex is still about love for me. I still operate that way when I'm dealing with my clients. That's why I'm kind of picky about which clients I will see, because I need to be able to have a partially decent relationship with the client. And when I do have sex with men in my straight life, it really is about love for me. But before my thirties, when I became an escort, I would never do certain things. Now that I'm in the game, there's not much I wouldn't do. Why would I turn down money? There are certain things I'm not going to do sexually; I have my limits—but they're paying me to allow them to do what my limits are. So, it's not about *them*. I'll fuck almost anybody for the right price if they're paying and they're decent and they don't fucking stink and I know they're going to respect me.

LB: But you also like men.

IEA: I do; I really love men. I'm actually really boy crazy. But they're also disgusting, and I really can't fucking stand

them. And sometimes, when you actually like your clients, it makes it very hard to work. Every now and then, a client comes along and I'm like, *Oh, I like this guy, and I wish we could take it further.* But the moment you let them not pay or let them get extra time, it never ends well. So, when it comes to hetero men, you can't let them get away with anything, because they don't appreciate it. They think they deserve it.

LB: Has it ever worked out to date a guy who started out as a client?

IEA: It's never worked out. It's always been a fucking disaster. Having them as a client has a certain amount of protection. They know what the limits are, and they know not to cross certain lines. The moment you let that guard down, all of a sudden, they think they don't have to take care of you, they think the money should stop or the money should be less. The way men think they should treat women is appalling. I tried to date again this year, but no, it's got to all be work sex. It's unfortunate, because sometimes you want to have sex that's not work sex, because it's healing.

LB: Would you ever give up working if you could make enough money teaching?

IEA: I will never stop fucking for money. That would be absurd, unless I meet the most amazing man ever. I'm gonna want to have sex, and because men are so undeserving, they're always going to have to pay for it one way or another. I would love to just be an academic, be tenured, make my six figures, and live in my little cushy house or whatever. But I'd have to have the nerves pulled out of me

that make me turned on by heterosexual men. I'm not that person. If I'm going to continue to have sex, they're always going to have to pay. Even if it's one lone guy I screw who gives me an extra two thousand dollars a month, somebody has to be paying. Because I've messed with probably thousands of men in my forty-one years, and they're all horrible.

LB: So, it's about righting the balance of the patriarchy on some level?

IEA: Yeah, the patriarchy always has to pay, so I'm always going to be fucking for money.

LB: How did you feel about the balance of power in strip clubs?

IEA: It was hard. I hated it. That's another reason why I couldn't go back to the clubs—outside of no club hiring me—because you have to have a certain kind of hustler mentality. And having to do the one-on-one hustling wasn't my thing. Maybe now, if I were back, I'd be better at it. I feel like I could've been making more money. But then, the strip club was also really racist. Patrons discriminate, owners discriminate. So, unless I was a freak of nature—which I'm not—with a teeny, tiny waist, big fat ass, and light-skinned, I was discriminated against.

LB: I wonder if it's different now. First of all, you're not very dark.

IEA: I'm actually not dark, but in the world of racism, I am. I'm actually not even dark-skinned, but I might as well be Black, Black, Black. Maybe it would work better for me

if I were really, really Black, but I'm this weird in-between. Even my body type is in-between. I'm not quite fat.

LB: You're very petite.

IEA: But not petite enough.

LB: So, it hasn't changed.

IEA: It's really the same. Two Black girls cannot go into the strip club and try to audition. Only one at a time, because they have their Black girl quota. So, if you're going to be Black, you have to be fucking light-skinned. And I'm talking like really super-light-skinned, like as close to white as possible. Otherwise, you're just not getting in there.

LB: That part is horrible. But did you ever like the dancing?

IEA: I did like the dancing. Especially when I first came in, because I was really dancing like it was *Flashdance*, and I bought outfits every fucking night, because I really liked the clothes, liked dressing up. Waste of fucking money. I'm so bad at money. But eventually, I would start dancing like a stripper, which I hate. Because they all—we all—do the same fucking shit, and I like to be different, which is why I like burlesque. Burlesque has a certain striptease aesthetic to it, but I don't do that. I'm like, *I don't give a fuck, I'm just going to do this other shit, and y'all gonna take it.* And they take it. Whereas I'm not sure that me poppin' and lockin' would go over so well in a strip club.

LB: So, you bring a different dance style to burlesque?

IEA: I don't do "cutesy burlesque," which is what Penny Arcade calls it. I do a lot of West African dancing in my burlesque, and it's more about the dance than it is about stripping, you know, or teasing. Most of the time, my acts are improvised. But with some of the West African pieces, I have to practice, or I'm going to go out and be doing the same repeat-ass steps. For the most part, it's a combination of improv with a little bit of choreographed movement. I also lip-synch to everything.

LB: It's great you can be so specific in your burlesque act. You're right that, in strip clubs, a lot of women do the same moves.

IEA: In the strip club, white girls can get away with "Look at me! I'm so cute," and they can barely be moving, but the Black girls, we have to really work, and nothing has changed. We have to work twice as hard to get that dollar.

LB: What about strip clubs in other cities, such as Atlanta?

IEA: I've seen the girls in Atlanta work. I mean, they worked, they danced. It was amazing. They were like fucking goddesses, doing all of these pole tricks. I was in awe. I just love watching strippers. I wish I could be a stripper, but my stomach isn't flat enough anymore. And it's too much work. I've lap-danced until my back is out.

LB: You'd rather just be on your back and have the clients do the work?

IEA: Exactly. I'd just rather spread my legs. I am not going to that strip club. Y'all work too fuckin' hard. I remember,

several years ago, I tried to go back, and I was looking at the girls take the money with their tits. I'm not taking any money with my fucking tits. Not one of these assholes touching me. Not in this space. They can touch me in *my* space.

LB: They can put the money in your hand or put it on the countertop?

IEA: Right. It was so funny, because I spent five years doing that, and I never thought of it. Sometimes I do it for play at the burlesque shows, if I'm go-go dancing. But when I had to do it for real in the audition, and I'm looking at these girls doing it, I was horrified. I'm not built for this bullshit. But I can suck a dick, though. I will suck your dick.

LB: And I know you're proud of your abilities—you've written about it.

IEA: I've been told I'm actually a pretty good dick sucker. But I only want to suck a dick for about five minutes, because all I care about is sucking it just so it's enough to please me. And that's it. But those are the best five minutes of your life.

LB: You have written about, and have been a voice in, the strippers' strike in New York. Do you feel there is a lot of community among sex workers?

IEA: It's a lot better now than it was ten years ago. I have so many mentors. I have a mentor in California and one in New Jersey and a bunch of people I can call on now to look out for me emotionally that I didn't have a decade ago, which would have made a difference in my life.

LB: That's amazing. What about your connection with other burlesque performers?

IEA: The only time of the year a lot of the performers get to see each other is at the New York Burlesque Festival, so I try to always go. What's interesting is they have an awards ceremony, a very tongue-in-cheek kind of thing. None of the categories mean anything; it's all a joke. They have the stupidest categories. Two years in a row, I won an award. One for being a slut, one for being angry. The next year it was "Performer Most Likely to Kill You for a Gig." I won. But, first of all, I didn't even perform in New York City. Second, I'm actually not as angry as people think.

LB: Why do you think people think you're angry? Is it your online persona?

IEA: They don't know I'm acting. I'm just really passionate. That person that online will rip your head off is actually not really me. It has a lot to do with my fear of dying.

LB: In what sense?

IEA: I'm like, *I'm going to fucking drop dead, and who knows when, and what am I going to have to say for myself?* That's really all this is about. *I might be dead in five years, so I might as well just do it.* That's what it's all about, so I try to make an impact. So, if I drop dead tomorrow, what are people going to say about me? What did I do with my life?

YOUR LIFE AS A MIDDLE-AGED STRIPPER

Antonia Crane

The first time you quit stripping, in 2003, you shoved your pink Spandex bikinis and black booty shorts into a garbage bag and brought them to a lesbian bar in the Mission and gave them to a leggy blonde with phenomenal teeth. You moved from SF to LA, away from the strip clubs, where it was too easy to waltz in any hour you wanted and work until three a.m. and leave with a wad of twenties in your boot. You gave away three more garbage bags full of sleazy over the next ten years to baby strippers.

You moved. Like a crackhead hiding from his dealer. You waited tables, you cleaned houses. You wore scrubs and drew blood and siphoned porn star piss and stayed away from the nude clubs in the sticky valley. And then it occurred to you: You kept one pair of stripper shoes.

You only need one pair of stripper shoes.

You're 44—which is approximately 187 in stripper years. Okay, you're really 46, but you lie to everyone about your age, and have for years: to friends, coworkers, your dad, your bosses, your customers, CNN. You have been working in the sex industry for over twenty-five years. You wish there were someone you could talk to about it, but you don't know anyone who has clocked in for booty duty this

343

long. You look like hell. You have the shits. You're dehy-drated. The only thing multiplying in your cells are the dark circles under your eyes from zero sleep. Now, when you throw your neck out, it stays out. Your lower back screams. Your knees click.

After your boyfriend lied, cheated, broke up with you, and moved out, the same month your close friend died from breast cancer, your rent more than tripled. The last thing you want to do is flirt with dudes who neither care about you nor pretend to, allow them to hug you with their sweaty arms or squeeze your butt with both hands. The last thing you want to be is an emotional pit stop for sad golfers. The last thing you want to do is grind on cock for song after song, twenty bucks a pop. You feel more like a whimpering dog who was returned to the pound than a sexy stripper.

You're hungry. You're out of cat food again, and your car payment is ten days late. You can no longer put off work. You dash to the desert again—to the only titty bar in Coach-ella Valley.

At the strip club on a Tuesday afternoon, you feel like a hag on her death bed. Whispers can be heard from the stage. It's Kat, a thick redhead with blotchy black tattoos on both thighs. She talks to a short, stalky, bald customer you've seen before. He sips Coors Light and watches you strut toward the stage. You dance to "White Rabbit," by Jef-ferson Airplane.

"How old do you think she is?" he asks, pointing at you. From the pole, upside-down in a descending angel pose, you see the whole bar and everyone inside. Two girls give lap dances in VIP, the bartender scrolls through her phone, and the front door opens. A blast of aggressive sunlight and hot dust lands on Kat's naked stomach, which glows

creamy white in the red-black club. You remove your flimsy sequined bra and let it fall to the stage. Kat and her customer are a few feet away from you, in soft, low chairs.

They think you can't hear them.

"I'd say somewhere in the neighborhood of forty-five," she says. She's halfway in his lap now, drinking his beer, her knees between his legs. She makes a show of tossing her head back to shake free red ropey hair that smells like weed. Later, you will watch her count your dances, keeping score. She will smile at you angrily through freckled, pink-glossed lips. You are still one of the top earners in this club. You dance circles around most of your coworkers, and they know it. You smile back. Tell Kat you like her lacey top. She walks into the smoking area outside with one of your regulars. That month, your friend died and your boyfriend left. Kat asked you if you were all right, because you weren't. She told you it was going to be okay, and she meant it.

A couple of days later, you saw her pale fingers slide inside your small black purse when you were dancing onstage. You didn't say anything. Were you imagining things? You bought a brighter, pinker purse, so you could watch it more carefully from the top of the pole. She took only a couple of twenties. That day was horrendously slow, and all the girls were panicked, but you had a regular give you a couple hundred. Bored desperation followed all of you into an endless, deader night. Some girls cannot help where they find themselves: lost, grieving, broke, and panhandling in sparkly panties. Stripping at any age is an orgy of change: skin, bones, wrinkles, muscles, and hair. You didn't know you'd be surrounded by the newer, bouncier products that delight customers; that you'd stare middle age in the face and carry its soggy weight for everyone. And yet, you don't feel ugly or incapable. Your fingers and toes are an alarming

orange red—fucking immaculate. You still work the shit out of the pole. You've become more compassionate, wise and crafty at hustling. When you were younger, you thought you were so old, and youth is so fleeting it's as if you've never felt it. Stripping is physically demanding, mentally draining, deeply competitive, and ruled by envy, and you've spent your entire adult life dancing with naked women you envy. You wouldn't have it any other way.

The stealing doesn't bother you as much as the whispers.

Customers ask your age, and when you don't reply quick enough, they grab your chin and tilt it toward the ceiling light. They move your head left and right like you're a statue, a Barbie, a nameless fuck doll. They assume you lie about your life, your long-term sobriety, your teaching, writing—all of it. But you lie only about your age.

"Twenty-eight . . . thirty-six," they say.

You nod. Change the subject.

Clyde, a regular customer, sits at the bar working on a whiskey neat, probably his third or fourth. You sit next to him. You consider the many times Clyde offered you money to fuck him, the times he got plastered and asked you for a ride to Indio, and the time he Tasered your security guard. You'd never seen it happen up close until that night: the pow-pow of the Taser, which sounds like a gun shooting half a dozen fast bullets. Sam, your security guard, convulsed violently and then—boom!—face-planted on the floor with his chubby arms and legs in a starfish pose on the gum-stained yellow zigzag carpet.

"How much would you charge to murder me?" you ask Clyde.

He chuckles, his bloodshot eyes like sad gray stones. He stares at the men's watch you still wear. It's chunky, expensive, maybe worth more than anything you own. He shakes his head. Sips his Jack.

You take off your watch, drop it into his shirt pocket. "I'm serious," you say.

He tries it on, but it's too small. His wiry wrist hair gets tangled in the band. "I'll do it for free," he says.

You're called to the stage. You leave Clyde and your watch at the bar. During your second song, by the Black Angels, you wonder if Clyde is waiting for his ex-girlfriend to show up so he can taunt her by flirting with you. He's a guy with lots of dirty motives. Some say he preys on the weak. That day, you figure you qualify. This time, when you toss your bra, Clyde walks up to the stage and leans over, one leg perched on a chair. If anyone else did that, it would feel menacing, but it's more like he's being polite, paying his respects. He tosses wrinkled dollars on your stage—around fifteen bucks. No one else tips you.

You're rock candy, adept at sweetening the jagged edges of broken men. You're Little Orphan Annie in whore form. You sing, you dance, you make a mean lemon bar. You wash dishes like a motherfucker. Why won't anyone adopt you? Later, you agree to meet Clyde up the road after your shift. It's a warm, windy night with a negligible bullshit moon. When you get there, Clyde's sitting in a tacky brown booth with his son, cracking up. He buys you pancakes at Denny's and hands you your watch.

INTERVIEW WITH ANTONIA CRANE, BY DR. VANESSA CARLISLE

Vanessa Carlisle holds a PhD in creative writing, literature, and gender studies and is the author of the novel *Take Me with You* (Running Wild Press, 2021). She uses her twenty-three years of experience in sex work in her writing,

education, and advocacy to call for big change while celebrating the beauty and complexity of her queer, sex working, creative activist communities here and now.

ANTONIA CRANE: I don't know any stupid strippers. I only know brilliant strippers.

VANESSA CARLISLE: Even strippers who aren't traditionally educated are really smart, resilient survivalists.

AC: I would also say that there are no bad decisions, only decisions. When I put myself in risky or questionable circumstances, I learned the most about life and people and my job and survival. I may have felt stupid at the moment, but I learned a wealth of information afterward.

VC: So many people told me that getting a PhD in literature and creative writing was a stupid choice because it wasn't a lucrative one. The stigma around stripping is very much about it being a bad life choice that's going to hold you back. It's class descension, downward movement.

AC: The stigma includes words like *hoe* and *prostitute*, carceral words used to criminalize strippers and sex workers. Even as a sex worker, *hoe* has never been my word. And as an educator, words are important. And the way we see money and value—work—is important.

VC: You have a lot of experience, not just as a worker but as an organizer and activist. You've been out there for twenty-six years. I've been out there for twenty. When you think about so much time, do you think there's a mark you carry that new dancers coming up now don't have?

AC: As an elder dancer, I really don't understand how girls make money at these bikini bars. I've never made less money in my entire life dancing, and it's because there's no real lap-dance area. People don't want lap dances now, because there are cameras in the room. It feels humiliating, tiring, and annoying, and it's not what I'm used to at all.

While it's hard to be an elder dancer, it's also great in some ways, because I have wisdom, knowledge, and experience. I made more money a few years ago at forty-two than I ever did as a twenty-two-year-old stripper. The ageism in the sex industry goes largely unchecked. It also comes up in activism circles, because people assume stripping skews younger. It's what strip club owners want us to believe, because veterans have experience, wisdom, and knowledge of when stripping was better, when we made more money, when management took less of it. That's a value in the workforce. So, an important role is for me to show up at my age and talk to younger dancers and have good relationships with them.

I want to also interrogate how ageism goes unchecked in media. Men are allowed to age in their professions. There's the stigma about stripping where it's as if you're just supposed to enjoy it, you're supposed to be a "girl gone wild" for a weekend, take your top off, dance on a couple of laps, make a couple of bucks, and then move on to a better life for yourself. As a twenty-six-year veteran with a master's degree who's still stripping, I implore you to suck my stripper dick—because it *is* a viable career. It's a hustle you become more seasoned at, better at. It also has incredible transferable skills. I want to interrogate ageism and blast it apart and say, okay, if you want to talk about money, the top search engine search in porn is "MILF." The next one is "stepmom."

VC: It doesn't even match what's actually going on with our clients. I had a night-flirt client recently who said, "I really don't like to see a domme unless she's five to ten years older than me." That's beautiful, because it says something about the way the dynamic of sexual power in women is unrepresented. We literally have no representations in mainstream media of women in their forties and fifties doing powerful, beautiful, sexy things without the stigma being present. It's like, *She's a badass—even though. She is sexy—even at that age.* Even if it's celebratory, it's a special case. But, in general, it feels so much more conservative now than it did in my childhood, when I had [*The Golden Girls's*] Blanche Devereaux as an older woman who loved sex and talked about it all the time. Who is our Blanche Devereaux? I feel like we don't have representations of that kind of joyful-slut stuff now.

AC: Even though she's of a younger generation, Jacq Frances (aka Jacq the Stripper) has presented the image of a happy hooker; a happy, enterprising slut. I support her and love her artwork and her personality, but I worry about the idea of a "happy hooker," because that person has struggles and a deep emotional life, and they are probably not always cheerful—and why should they be? You don't know what their life really looks like. I find myself hungry for a less celebratory experience. Where's the melancholy stripper who's a woman of color, who's queer, who gets turned away from her strip club because they have too many Black girls? Show me the story of the melancholic Black stripper. Show me the human, sad issues. I talk to Akynos, the executive director of the Black Sex Worker Collective, a lot, and she wants to talk about boys. Her heart is broken. Her life is difficult. Where is that story?

VC: It's on social media but not getting support from media outlets that have money. Porn stars and dancers are creating large followings for themselves and exposing abuses, but those stories aren't getting transferred into larger media outlets where people who don't have contact with the sex industry might learn something and engage.

AC: I agree that these voices have large followings, but they're also being muzzled, censored, and seized by the FBI. Where's the world outside Instagram where sex workers get their stories and movies made? I'm concerned that a lot of my and other people's creativity gets transferred into platforms run by young, white tech bros behind closed doors. They created Instagram and other social media platforms, and now they're censoring women's bodies, pole dancers, women's fitness. Brava! That some people have great social media followings, and I hope that translates into some income and exposure for them. These are wonderful things. But the organizer in me is concerned that this makes people lazy and questions why they don't show up to meetings in person. It's not enough to change your icon on Instagram. That's not real activism.

VC: I think part of what's happening now is we're under so much pressure from FOSTA-SESTA [bills created to shut down sites that host sex workers and advertise their services] and the repression happening with shadow banning, erasing hashtags where profiles can be seen and shared, and people losing their income. It feels like we have to be super careful about everything we do and everything we put out—the infighting, the disagreements, our inability to coalesce around things like employment. There's a long tradition of sex workers taking care of our own, but nobody else comes

in to help when something serious is going on for us, even though we show up for all the other things.

AC: What do you think causes the infighting between sex workers and strippers? What's the impossible divide that we need to cross?

VC: I think criminalization and stigma have made all of us terrified of being arrested for being a certain kind of sex worker, this image of the "common whore." We're all trying not to be her, because she's the problem. She gets arrested. She embodies the stigmatized vision: the one who's high all the time, the one who can't manage her money, the one who doesn't care when she's victimized. Our internalized whorephobia makes it very difficult for us to organize with each other because we're all terrified of having people perceive us that way. Strippers won't organize with other sex workers because they want to just be strippers; they don't want to be seen as people who do other kinds of sex work. Sex workers who work one hundred percent indoors and make a lot of money at it won't organize with street-based sex workers easily, because they can't understand that their goals and needs are different.

AC: I was talking to Akynos about misogynoir (the hostility between white and Black women and between Black groups of women toward other Black women), and that segued into another conversation about what I call "the walking shamed." Organizing in the early nineties in ACT UP, with HIV and AIDS, we called ourselves "the walking wounded." Sex workers are the walking shamed, and it's based on layer upon layer of internalized stigma we've absorbed our whole lives, the terror that we're going to be associated with the

social pariah, the black sheep of the family, the survival sex worker. It's easier for me to judge you for doing survival sex work than it is for me to stand with you.

I have been arrested for prostitution. I know I'm unusual in this industry, privileged as a professor and writer, but I spent a night in jail at the Twin Towers in a room with survival, street-based sex workers. It was terrifying and humiliating. So, I have that experience. I did diversion, and I paid the fines. After that, for about six months, someone would walk behind me on the street, and I would run. I would get a panic attack walking into a hotel.

VC: How has all this affected your capacity to connect with men? Do you hate them? You're a queer sex worker, so your experience of men is different than that of a heterosexual sex worker who dates or marries men in their private life.

AC: I'm bisexual, so I've had long, long intimate relationships with men in a heterosexual dynamic, and I've also had long relationships with other genders, women and others; also long term, also very intimate, cohabitating. That does give me a different lens. I don't hate men. I do hate toxic masculinity. I hate that women have been asked to hold shame for men and hate how that translates into the emotional labor that we do. At least we get paid for it as sex workers, but I hate heteronormative hostility and misogyny. I hate the dynamics of whorephobia, but I don't hate people. I have complicated relationships with men, but I have relationships with them.

VC: Do you feel that your relationships with men have an element of transaction in them? Is that a lens through which you see your relationships because of the work?

AC: I think that everyone has transactional relationships. People are judgmental toward sex workers for being transactional, but I believe everyone is transactional all the time. I'm not talking about murky motives. I'm just saying we all need things from each other all the time. That's transactional.

VC: It's interesting how we don't allow that language. A marriage ends, and people talk about all kinds of reasons for it ending, but you're not allowed to say, "It ended up being a bad deal." Understanding relationships to have a balance and give-and-take was something I was resistant to before. I was raised Christian. I had a martyrdom thing about the way I related to people; I believed that sacrificing myself was the way I showed love. So, when you tell someone like that, "All your relationships are transactional," it's like, "Well, then I'm getting fucked all the time."

AC: I think Christianity is very much rooted in female socialization. When you're socialized as a female in this country, self-sacrifice is the party line. But clients come and go. There's an end. Two hours. Done. Maybe see you in a couple months. Long-term investment in friends build community. That's very inspiring to me.

VC: Sex work has definitely helped me have a clearer sense of standing up for myself, of looking for balance in relationships, understanding where I'm giving in order to get back, as opposed to just giving because it feels good.

AC: Do you feel like a better sex worker as you become more an elder person with all of these accomplishments?

VC: Actually, I have a lot of tension about whether I'm a better sex worker as I age, because I've internalized a lot of stigma about aging. Having my body change as I got older was something that triggered a lot of fear in me about whether I was going to be able to support myself or whether I was going to be desirable enough to clients.

Another thing I think that has come with age is trauma. I was doing sex work before and had really traumatic experiences with partners or clients. There was a time in my sex working life that was a more innocent, joyful time. I'm doing active healing around it, but it informs my capacity to be sexual with people and my perception of their being threatening or not. But there are things I'm so much better at now, such as holding boundaries, than I was as a sugar baby in my early thirties. I'd let clients stress me out all the time.

AC: Have you gone through phases of resenting men or hating them?

VC: I don't hate men. Like you, I hate toxic masculinity. I'm actually very interested in the way toxic masculinity harms men, too. I want them to get support for that. I wish men well on their paths of self-realization, but I simply don't tolerate their dominant habits when I'm not tolerant of them dominating me without my consent in social or professional scenarios. It's taught me about who gets to say and do what they want and who doesn't. So much of my life is organized around turning the tide on that.

AC: Yes on power dynamics, abusive power dynamics, and privilege and turning the tide. Let's do that together for the rest of our lives.

WE WERE STRIPPERS ONCE

Lily Burana

They came from a trashy store on Hollywood Boulevard, the shoes, but the first sight of them spun me back to an infamous strip club in San Francisco. Clear Lucite platform heels, a stripper wardrobe staple, they were comfortable and, in a sleazy way, quite practical. But it was the pink glitter accented with the sparkling white heart appliqué that sold me. They looked like something an O'Farrell girl would wear.

The Mitchell Brothers O'Farrell Theatre, in San Francisco's run-down Tenderloin district, was most widely known as a post–Flower Power bohemian hangout, where Hunter S. Thompson and other margin-dwelling luminaries would drop by to smoke pot and play cards with owners Jim and Artie Mitchell. I was never invited into the boss's office with Jim and Artie, though—by the time I signed on to dance there, Jim was in prison for killing Artie with a rifle blast.

Despite its old-school hippie associations, the O'Farrell Theatre was avant-garde in its elegance. It was the first strip club I saw that could authentically be described as beautiful, the crown jewel of the club's many rooms being New York Live, where dancers would perform two-song sets bathed in a body-caressing pink spotlight on a gorgeous, polished wooden stage. Watching dancer after dancer sweep across

that stage, her costume, mannerisms, and music perfectly coordinated, I knew that in order to fit in and pull down significant cash, I would have to make an effort; I would have to put together something resembling a show. Under the older dancers' tutelage, I learned how to kick off my thong and catch it in one hand, how to flip upside down on the brass poles, and how to cultivate a workable persona. I wasn't the sweet one, the popular one, the exotic one or—let's be frank—the gorgeous one. I was the aspirational, arty girl (still found today in clubs wearing glasses with her Catholic schoolgirl costume). For all the coaching, my costumes remained lame, hastily assembled affairs. Ambivalent about stripping, I was reluctant to commit to investing in decent gear. Why wear sparkling pink when scuffed, secondhand black would do? That final layer of professional polish evaded me.

So, a few years later, when I snuck back into the business to write about it and needed to costume myself again, I couldn't resist the shoes. By stripper standards, they were strictly utilitarian, but they felt like an homage. A shot at image rehab. A shot at stripper redemption.

If the New York Live stage was the elegant face of the club, the dressing room was the heart. Any businessman, Japanese tourist, curious married couple, or sex-positive feminist could sit in the New York Live audience and lay down singles and plaudits, thinking they were part of the scheme, but the dressing room was sacrosanct. Strippers only. Our job requirement was to be someone unreal, a hypersexualized girl who danced and deferred, but in the dressing room, we could be ourselves, neither distorted by fantasy nor brutalized by judgment. We could fix our makeup, wiggle our toes, count our money, goof around, and just talk.

When you came in at the turnover between the day and night shifts, you'd save your spot at the red melamine dressing room counter by scrawling your stage name on the mirror in lipstick. Girls could leave out their custom-ordered rhinestone gowns, their Borghese makeup cases, everything but tips and wallets, a remarkable contrast to dressing rooms at shadier clubs, where even dirty panties would get stolen and where the most you'd dare let lie around was a busted-up curling iron or your three-dollar Wet n Wild powder compact.

What made that dressing room so special was that it was infused with the sex industry's scarcest commodity: trust. That trust fortified us against the seamier aspects of the job: the cover stories quickly conjured to sustain a double life; the burnout; the dirtbag customers who thought it was okay to show up for a lap dance with reeking hair and wandering hands; the management favoritism; and the ever-changing, ever-more-demanding club standards. There was something reassuring about slumping onto a dressing room stool on a bad night; tossing a fistful of sweaty singles on the red counter; groaning, "Oh my God"; and having a girl inspecting her tan lines at the full-length mirror roll her eyes and say, "I know, right?"

Not every dancer could armor herself through camaraderie, however. I saw women positively implode—from drugs, from the weight of deadbeat lovers, or from death by a thousand surgical cuts—like one girl who, at twenty-three, had already had a phenol peel on her face and had shown up to work a week after having her breast implants swapped out for the third time with strange incisions below her nipples bound up with clear sutures like fishing line.

At twenty-six, I forced myself to move on from the O'Farrell, feeling ancient and emotionally exhausted by

an elemental sex work paradox: it's hard to feel like you're simultaneously above the job and trapped in it.

Starting with a single phone call a couple years ago, one reconnection led to another, and now dozens of us are back in touch. Turns out tragic endings have been few and far between—in fact, the most jarring loss was Jim Mitchell himself, who died of heart failure in 2007. Since our dancing days, we've gained husbands, partners, kids, careers, college degrees, spiritual practices, and homes, each wild child all grown up. I'm proud that our lives are so blessedly ordinary—because what we have now is more fulfilling; because after years of toiling in chaos, we deserve this peace; because we survived. I will never look back on stripping as the best days of my life, but these women and I share a unique crucible that is strangely glamorous yet impossible to glorify.

And our youth? We burned it at both ends, cowboy.

How funny that, of all my stripper memories, the club I most vividly remember is not the notorious establishment in which I worked, but the sisterhood that formed inside it. In a business built on fleeting fantasy and illusion, that kinship is the one thing that has lasted over time.

The shoes maintain permanent residence in my stripper trunk, now stowed in the basement. Once in a while, I take them out, put them on, and do a turn or two. The pink glitter sparkles in the light that shines through the windows of my suburban home, the click of Lucite heels on the hardwood floor an elegy. Like stripping, the shoes are horrible and brilliant, tacky and gorgeous, dangerous and common—and still, irrefutably part of who I am. I will never throw out these shoes, because they remind me of the women who inspired me to buy them. These shoes remind me that before they walked into history, they stood for something real.

ANTONIA CRANE: One thing that is super interesting to me is your legacy of dancing before the internet, when everything was more localized. What is your sense of the change in stripping then and now? In the nineties, it was very risky, but you were out and proud with your book *Strip City* [2001]. You were writing so directly about stripping and giving it a celebratory sheen.

LILY BURANA: When I started dancing, in the late eighties, I had some guarantee of anonymity—unlike now, when more women have pressure to self-market and be visible. That pressure is now considerable. The biggest thing that's changed is not having the option of anonymity. I feel really grateful; there are things that I would not be comfortable with hanging out there online. After all, you are judged harshly by your future employer. Relatively speaking, I am an out sex worker forever. I will always have that Google trail. I don't know how much visibility I would be comfortable with in today's market.

The decision to be out with *Strip City* was relatively easy because I lived in a very small, supportive bubble of queer gender activism, sympathetic allies and friends. I had a place to retreat when *Strip City* was written. I came out as a stripper in writing in the early nineties, and although it was scary, I was in San Francisco and New York, which had very established countercultures with sanctuaries. When you're talking about a punitive, misogynistic culture where you're going to be attacked, it's vulnerable and painful. Alienation and stigma kill people—that's real.

AC: Is stigma worse now than it was back then?

LB: No, but there is more opportunity for attacks on Twitter. Anywhere you go, you have this jack-in-the-box pop-up and someone is publicly telling you why you suck. On the other hand, there are so many more out sex workers writing about their lives in a way that is louder and more community based. I want to say this loud and clear: trauma from stigmatization is real. Being publicly ostracized and verbally abused and belittled can cause suicide. This is how shame functions—it casts you out from the herd, whether you're a teenage bisexual, recreational drug-using sex worker, an LGBTQ person, a person of color sex worker, a trans person, [or] any sex worker. The call to constantly settle civilian non-sex workers' anxiety about the fact that you are a sex worker or queer or trans—to be called into service in this way constantly is unreasonable and traumatic. A person's identity is not up for negotiation. Getting into someone's air space and demanding they justify their existence all the time is unreasonable, and it causes trauma. Stigma kills.

AC: Did you experience stigma in your writing career?

LB: In the literary world, "We don't see enough of your journey" meant "We want to see your tits." The answer was no. They wanted pictures of me that I didn't want to give them. In a way, that felt like a land grab—snatching at our resources. The truth is that our interiority as sex workers and women is so complicated that they covet it in order to use it and exploit it.

AC: What is it about stripping that makes it hard to get out of your system? Do you miss it?

LB: One thing that has helped me get out and stay out was the hustle and the onus of stage fees and fines. I knew I would go to work with zero dollars and that I was going to be minus two hundred dollars before I could make good money, so the stress I held was the thing I don't miss and never wish to have again—the exhaustion outweighed the exhilaration. You always miss the good nights because they make it seem easy. Do I still have Amateur Night trophies? Yes, it is a grim pride. I earned those. I went into an underworld and earned my own keep backward and in high heels. It was difficult. I don't miss it.

AC: Why are you writing about it now, since it's been a long time since you've stripped?

LB: We don't always choose the timing of this subject. I am far enough away from it, and there is a renewed interest in it. A San Francisco friend and I went to the New York Historical Society's exhibit about AIDS in New York, and it showed to us that the defining elements of the lives we lived then—so centered around Gen X queer club culture and the in-your-face activism that sprang from ACT UP and Queer Nation—are now considered significant in ways much larger than we could have foretold at the time. As kids who made our way in counterculture, through sex work, through activism, and through the theater of self that stems from all three strata, we are part of a lasting lineage that continues with us and beyond us. And my own perspective about it all is evolving right along with it.

AC: How has stripping shaped you as a person and informed your writing? Is there is a sense of tribe and pride to it now? Or is it about something else?

LB: I am still wondering how it shaped me as a person. I started at eighteen, when I was very depressed. It is clear in the sense there is a legacy now of sex workers who are connecting. People were hidden by both necessity and choice. Civilians put their rubber stamp on people by even a subtle disapproval of sex workers. But now, more than ever before, we are saying, "You are not telling us who we are. I did this. This is mine. The story belongs to me and connects me to the other women and men who do this work." So, *yes* to that feeling of tribe and pride.

AMPUTEE QUEEN

AM Davies

I hear everything in pieces. Each object has its own auditory vignette: the buzzing of the fan circling above my head, the birds outside the window, each car driving by on the street, the dog barking in the background. All humming along while I sit motionless on my bed, pulling at my lip with my long, pointy, red-glitter-coated index and thumb nails. The pain is creeping up again, in the foot that exists only in my psyche. The pain of knowing what's happened to the life I used to have—it can be debilitating.

Wake up, feed the cats, boil water for coffee, put the dishes away, work in front of the computer for hours. Every day, I know what I'll be doing that day. Every night, I go to bed alone. Every morning, I wake up at seven thirty a.m. naturally. I have the same conversation with my cats all day long. A once highly active and social life filled with lap dances, money rains, flowing champagne, and rubbing elbows with celebrities has turned into a stultifying existence.

Most of this is because Covid-19 is the new reality. Perhaps I would be more miserable about missing the glamour of sex work if I knew it still existed for everyone else. But, either way, Covid or not, prancing around in my eight-inch heels all night is no longer an option.

By 2018, I had an on-again, off-again relationship with stripping at Jumbo's Clown Room. One day, I hated it; the next, I loved it. It was a gaslighting experience, an abusive relationship. But now the stripping landscape was about to change, and I had to have a plan. Because of the new employment law in California, Assembly Bill 5, our boss planned to change our worker status from independent contractors to employees. She would have to let a third of the dancing staff go and wasn't giving any warning of who it would be. We were all nervous to be on the chopping block. Very few felt as if their job was safe. I thought for sure I'd get fired.

It was time to do what you do as a stripper: pivot, move on, adapt. Usually, that means going to a new club to be the new, shiny toy for regular customers. But I'd decided that this time something had to change. After seventeen-plus years of dancing, I was tired of all the bullshit. Being able to dance and watch other female bodies dance was something I wanted to do forever, but the way we were treated by employers and customers was tiresome. The same questions night after night: *Where are you from? What's your real name? What do you want to do with your life? What's your day job?* I had also started to gain a clear picture of the violations of our labor rights that dancers endured every day. It became infuriating knowing that the women I loved so much were being taken advantage of by every club owner in town. To me, it felt as if there were no safe places for strippers.

Transformation was on the horizon. It was so close I could touch it. I had just turned thirty-eight—perilously close to forty years old. I wanted to quit stripping so I could

be a strip club owner instead, one who would encourage unionizing, who would not perform wage theft against her workers, one who would classify workers properly, one who would listen to her workers and do what was best for them. During the last year in the club, I had felt like a spy, not a dancer. Every night, I would watch and learn what mistakes not to make, how to improve on pour costs, and how not to treat clientele from a bouncer's and bartender's perspective.

One night in December 2018, I met up with Elizabeth, a friend from the club, at the Grove, in the middle of Hollywood. Not for any reason in particular, just to be together. But I did have a lot on my mind. The night we first met, she was carrying a camera, and it turned out she was working on an art project photographing strippers. Over time, I became a muse for her; we talked about business, and I introduced her to other strippers. Her way of being was enticing to me. I was taken by her confidence: she was so sure of herself and what she wanted out of life, and when she spoke, I always pricked up my ears, ready to receive any life coaching she had to offer.

"It's time for me to step up in the world," I said to Elizabeth as we strolled past the splashing fountain that sat at the center of the outdoor mall. As folks bustled by us with their shopping bags, she told me about a self-development seminar that could help me. It was called Landmark, and it focused on personal transformation. I jumped on the idea. I trusted Elizabeth; I looked up to her and wanted to have the same business confidence she had. We made plans to meet at Landmark's Los Angeles headquarters, in Culver City, a few days later. As we walked to our vehicles, we could see the blood-orange sun hanging low in the sky, like an omen. We stared and marveled at its beauty and intensity.

The day before I was supposed to meet Elizabeth again,

I bought a car from a dancer friend who was moving out of state. With work changes on the horizon, I would need a car to drive farther. Living in Hollywood, I was able to walk to the club and needed only a motor scooter, a "Buddy," to get around. It was my favorite thing in the world. In the nine months I owned it, I'd learned how to drive in between cars, like all the kewl motorcyclists. On occasion, I would do daredevilish things like stand up while going forty-five miles per hour, or kick my legs behind me, sliding my body back so my stomach rested on the seat of the scooter. I felt like Superwoman flying close to the ground. So dangerous. But I was having the time of my life, living on the edge.

I gave my friend a few thousand dollars cash for her car, but she needed it for a few more days. My appointment in Culver City with Elizabeth was the next night. It was a longer drive, in the dark, which I had decided I didn't want to do anymore on my bike. But without another option, I strapped on my helmet, pulled on my leather gloves, and because it was cold, put on my thick leather jacket with a white vest over it, so I could be seen more easily. Even though I was running late, I did my five seconds of meditation and a "being present" exercise before driving off, determined to keep myself aware and safe as I rode. I was paying specific attention to navigation, because I'd never been to this address before.

There was a ton of traffic. #HolidaySeason. I kept changing course, because being late annoys the shit out of me. It was flowing pretty well going south on Crenshaw. I had a green light at Pico, so I sped through it.

And so did the Prius on the opposite side. She didn't see me and went left as I tried to go straight.

I tried to make a crescent-like swooping maneuver around the front of her car. I was close to clearing it, but she

hit me, her bumper slamming into the back of my scooter, right where I rested my foot.

I tumbled sideways off the scooter and onto the pavement. My hands and knees hit the ground as my body stayed in a seated position. I rolled a couple of times, then found myself on my back. My spine was intact—I could still feel my legs. So, I rolled onto my stomach and began an army crawl out of the street; I didn't know if I would be run over. Eventually, I felt hands on my back and heard people telling me, "Stay still. You're safe." I thought about the appointment I was about to miss and about the shift I would have to call in sick for the following night.

Later, in the ambulance, I raised my head for a brief moment and saw a spec of white and a ton of blood on my foot. That morning, I'd had a pedicure and went for the white nail polish. I wanted to know what was wrong with my foot, but at the same time, I wanted to shield myself from that information. I asked the handsome EMT, "Are they going to take my foot?" His response, breathed between clenched teeth, was "It doesn't look good, I'll tell you that." He asked if I wanted to look at it. I said, "No, I'd rather not," then asked him to dose me with the strongest stuff he had.

The pain was like nothing I'd ever felt before. I can remember squirming from it, writhing around as I lay on my back in the hospital. I wanted to curl up in a ball, but that was not an option. My right heel dug into the stretcher, my chin jutted up and out, my eyes rolled up into my head. I was trying not to scream, trying to stay still in the MRI chamber.

The question came out of my throat again and again: "Are you going to take my foot?"

Their response was always, "We can't tell you yes or no now. You have to wait for the doctor."

Why wouldn't they tell me? Each time, I would wait for a new person to enter the scene, thinking I was clever, and would ask them the same question—*This one will cave and tell me*—strategizing the whole way through. After all, I had spent close to eighteen years in the strip club strategizing, planning, reading situations and people.

I spent hours alone not knowing my fate, hours alone not knowing if anyone knew where I was. People were expecting me places. But it was all out of my hands.

My stripper survival skills were in full force. By the time the cops showed up to talk to me, I was heavily dosed, but I knew enough to remind myself, *Don't trust them. Say as little as possible.* Cops treat sex workers differently once they know your profession. Even though stripping is legal, and even though we may have done nothing wrong, police treat us like criminals. There have been times I've been terrified to be in their presence. That fear was wired into me at this point, and even in my vulnerable state, knowing I was the victim of an accident, I still feared them, and my guard was definitely up.

At Cedars Sinai, someone wheeled me upstairs and put me in a room on the seventh floor. In the ER, when I had asked, "Where am I?" they kept telling me, "The best hospital in the world." By the time I reached my hospital bed, I was slipping in and out of consciousness. They turned off all the lights and shut the door.

There I was: in pain, isolated, on drugs, in a dark hospital room. Just three hours earlier, my life was what it was. And then, just like that, I was lost.

Then, like an angel, Dr. Little came through the door. A tall, soft-spoken man with the kindest eyes and a soothing energy, he stood over me and told me that all five of my toes and the ball of my foot had been amputated. They were

completely gone. My skin had "degloved" down the rest of my foot, leaving only a third of my original foot skin. I had only half a foot left.

Dr. Little wanted to save as much of my foot as possible. We talked about the probability of saving what I had left and what that procedure would be like. The most important thing I wanted to know was "Doc, can I wear the stripper heels again?" Even though I wanted a career change, I still wanted to be in my stripper heels. When I understood there was a possibility of my not being able to wear them, I had realized they were a part of my identity. The shoes have always been a symbol to me. I recalled my early days of stripping, drawing the shoes in my journal and the dancers' feet inside them.

He said yes.

That lifted my spirits. I figured, *This isn't so bad*. It almost felt like a vacation on drugs.

During the next three days, I had two major operations. By day four, I was on the phone, making calls, trying to secure my position at the club, making sure my boss knew I was coming back. There was no stopping me. I spent eight days in the hospital, including Christmas. My mother came to take me home.

The day after I got home, some friends came over, and we all did a photo shoot. I wanted everyone to see I was okay and doing well. I wore stripper outfits and posed seductively, wore an eight-inch glitter heel on my right foot with a huge cast and brace on my left foot, and made sure it was all very glamorous. Perhaps, this early on, I was driven by a fear of losing all I had. If we did a photo shoot, I thought, if I stayed relevant, then it would all work out for me. So, I posted, I wrote, I worked, and I did a lot of drugs for four months. But I had to get back to dancing. I had to get back to wearing the heels. It was all I could think about.

Eventually, I realized that going back to Jumbo's Clown Room was not an option. For one thing, it felt like the owner was looking for a way to get rid of me. I had been there for over eleven years, and it was rumored she wanted the longer-term dancers gone. Also, with all the information I had on that place—how poorly it was run—it was eating me up inside to remain there. But, in reality, while I could dance in heels for five minutes at a time, walking around in them for hours on end like I used to? No way.

My identity was slipping away. There were moments, when I was alone, when I would cry to and kiss my foot. Saying things like, "It's okay, we'll figure it out." Wishing that we could dance together again.

Over the course of a couple of weeks, I could tell that the pain was traveling up my ankle. The five bones in my foot were digging into the muscle at the front and would eventually push through the skin. My ankle started to warp and pull my foot in sideways. I called the doctor, sent pictures. They said "You'll have to come in, and we will discuss muscle graft surgery." Several times since the original surgeries, I had experienced pain and breakdowns in the skin, and each time, I had a feeling that someday the whole thing would have to go, that another amputation was imminent.

I spent two weeks doing little other than reading Reddit forums and talking to experts and other amputees. One of my friends, Izzie, a below-the-knee amputee (BKA) on her right side, has a "stripper foot" prosthetic—a foot custom-made into the shape of a Barbie foot. The "stripper foot" prosthetic makes it so high heels can be worn in conjunction with the socket prosthetic part that hugs the leg. I spent time talking to her. I was in Facebook Groups. I was googling everything. My options were either a muscle graft or a Syme amputation, where they remove the foot

and ankle but keep a longer stump. The other was a BKA. With the Syme, I wouldn't need walking assistance in the middle of the night because I would still have some length on my leg—that is, it would still be usable enough to make it a short distance without a prosthetic. But when a Syme amputee is on her feet longer, she has to wear a prosthetic. Since a basic foot would be my only prosthetic option, I took it off the table. All I could think was *How do I get back into stripper heels? How do I continue to dress and express myself in a way that represents the community I stand for?*

I spent two weeks deciding—to cut off the leg or not cut off the leg? The muscle graft offered more uncertainty than the BKA. I had to keep asking myself *Is this real? Am I really considering this?* When I saw Dr. Little to go over my options, something he said was the clincher for me. He told me there was a chance the muscle would grow and get bigger, and then I might have a hard time fitting into certain types of shoes. At that moment, I made my decision.

I have not dated since my below-the-knee removal surgery. I have very little interest in adding new people, new curve balls, to my life. Instead, I have a deep drive and ambition to feel physically strong. My left leg is shorter and skinnier. The skin on it is looser. I exercise it, but not enough; it is not being used nearly as much as the right leg. I've lost twenty pounds of curves and muscle. My left butt cheek is so small and flat. I've never had a flat booty. I loved my curves.

I don't miss all that as much as I miss dancing with ease. I haven't been in the "flow zone" for so long—those moments that were like leaving my body, like being one with the universe. That zone was my greatest love, my deepest passion. Nothing in the world like it.

I'm crying now thinking about what that feeling was like.

A new group of men now find me fascinating. I meet most of them via Instagram. They ask me, "Can you make videos of you crutching around?"

"What does 'crutching around' mean?"

"You know, like, you on your crutches, just walking around on them. Like outside in public, or at the mall."

There is, it seems, a fetish where people want to see hot chicks on crutches. So, now I'm capitalizing off a niche I never knew existed.

These men have been much nicer to me than previous clients looking for sex work. They are kind, want to pay me for my time, and ask if and when they've gone too far. They're known as "devotees"—devoted to amputees. They want close-ups of my stump, to see me in stockings. They don't even care if I have clothes on or not. In most of my devotee videos, I'm wearing little outfits.

My least favorite questions from strangers online are "Hey, what happened to your leg?" and "Can you role-play and tell different stories of how you lost your leg?" As if I owe them an explanation, or the opportunity to jerk off to imagined scenarios of my trauma. To those people, I've become something to be examined, instead of someone to reach out to with compassion. But most people are thoughtful and tell me what an inspiration I am to them.

Recently, though, someone put my content on PornHub without my consent or knowledge and labeled me as a "sexy amputee" and "amputee stripper." That made me feel like I've become some sort of freak show, even though I am all those things—sexy, a stripper, and an amputee. Maybe what bothers me is my likeness being put on the internet, labeled in a way that isn't of my choosing.

It could also be my struggle with my new identity. These days, when I'm asked to perform with online shows, I'm

usually counted as part of the disabled community. I'm treated as part of a minority group in some ways, and I still don't fully identify with that; I still feel like an able-bodied, white, privileged person. While the former is not all that true, the latter is, and I don't feel good about taking space away from marginalized folx. In some ways, I'm even *more* privileged being an amputee than I was before, because now I'm considered special, "a fighter," "an inspiration." It's an uncomfortable feeling.

I'm in the home stretch of getting my first prosthetic leg. Once that happens, I will be thrusting myself into a rigorous routine of getting back in shape. I have "before" and "after" images of myself in my mind. I want my booty back in shape. I want to be dancing with ripped abs. I want to make music videos where I walk into the room in slow motion like a motherfucking badass, a phoenix rising from the ashes. All I keep thinking about is how kewl I will look back in my stripper heels and on the pole.

I can hear all the things again: the crows cawing, the birds chirping, two dogs in different parts of the neighborhood barking. The sun is high in the sky, the clouds are nonexistent, and the air smells fresh. And I can feel the tingle of nerves in the area that once was my foot as I sit here looking out my front window, sipping my coffee. I feel it all day, every day, reminding me that things are very different now.

SELENA: I met you not long after you had had your accident. I've been interested in understanding what the injury has meant to you over time. You're so resilient and act in a way that demonstrates high-mindedness as an example for the community. I also think there was a long time where you didn't fully let yourself address this major change. I remember, at first, you were talking about it as a "loss of carbon." It's a *major* loss of carbon, to say the least.

AM DAVIES: I'm still addressing it, even now. The original accident took all five of my toes and the ball of my foot. Getting the rest of my foot and leg cut off still hasn't resonated because of what happened this past May 2020, when the streets were on fire because of protests over George Floyd's murder. There's been no time to deal with my trauma because of what's been happening in the world. Just yesterday, I was standing looking down at myself, and I said out loud, "Where did that go? Where is that? Why is that gone?"

STS: Before everything happened, you were a dancer for a really long time. When did you begin? What was your first night like?

AMD: I began in January of 2002, at the Blue Zebra, in North Hollywood. I don't remember my first night so clearly, but I remember my first two weeks as a whole. It took a lot of getting accustomed to. I wasn't aware of how much contact I would be experiencing, and there was no setup, no conversation about what that would be like. I

would go home and cry every night while my boyfriend comforted me. I got caught crying more than once after a lap dance in the booth, and one of the bouncers walked up to me and said, "Maybe this isn't the job for you." My response was *Well, I'll show him*, and I just got over it. I figured out how to navigate and how to set boundaries. I had thought stripping was supposed to be super, super glamorous and didn't even fathom or think about all of the extra things that come along with being a sex worker. It only took two weeks to be like, *I get it*.

STS: How old were you when you walked into the club?

AMD: I had just turned twenty-one.

STS: What did you do before deciding this?

AMD: When I was sixteen, seventeen, eighteen, I did hostessing and waitressing. I had customer service under my belt—and in between, being a waitress and being a stripper, I was involved in a multilevel marketing company.

STS: A pyramid scheme?

AMD: Yeah.

STS: What were you selling?

AMD: Beauty products, like shampoos and conditioners, all-natural cleaning products, and water filters. I really believed in it. I was twenty years old when I got involved. I became really good at closing. That's one of the reasons why I just crushed it at the club—closing. At the time, I was

so convinced that the marketing company wasn't bad, that everyone had the wrong idea. Then it turned out it was bad. It got shut down.

STS: Then, walking into the club, you were with your partner, who was there to comfort you.

AMD: He was also there to take my money. He was also there to live off of my money. That only lasted for six months, when I was like, *Wait, wait a second*. Even six months is too long.

STS: How did he end up taking that role for you?

AMD: Our finances were connected. He was abusive and isolated me, which is a tactic. We used a lot of my money before I was a stripper. It got me into some pretty crazy debt. I got on ChexSystems, which meant I was banned from having a bank account for seven years. So, he and I were sharing a bank account, and he had more control over it. When I realized what I fell for, I schemed my way out of it.

STS: How did you get the courage to leave?

AMD: The courage to leave came from the sex workers I worked with that were an example to me of empowerment. Also hearing that this kind of abuse was common. I called some friends that supported me. I reconnected with my mother, who I'd become isolated from, and hatched a plan. My boyfriend decided to go to New York with some friends. I was like, *This is my chance*. He gave me blank checks to pay the bills while he was gone. When he left, I packed every-

thing up, and I went to the bank. I knew how much was in there and cashed out the check.

I didn't have a license at that time, because I got a DUI when I was twenty. I was a mess when I was younger. I took his car, packed with my stuff, and left the downtown LA Rhino one night with a thousand dollars on me at four o'clock in the morning. It was raining. I skated on the on-ramp and ping-ponged between the cement walls. Both of the axles of the car came off.

This van drives by to stop and help me. I'm like, "I need help. Please don't call the cops." I've got all this money. I've got this car that's not mine. It would have been a mess. Miraculously, a tow truck pulled up on the ramp and agreed to take the car. I took a cab. Then, a couple of days later, my ex gets home, and he calls me, like, "There's no money. You're gone. You took everything. Where's my car?" I was like, "Your car is in a yard somewhere because I crashed it, and I'm leaving you, and I have all the money. I'm gone. Goodbye." It was crazy.

STS: You've done a lot of crazy, interesting things. It's not every stripper that's promoted as a headliner or an opener for clubs. What was that experience like for you?

AMD: It was fancy. It was fun. I made so much money. If you go into Spearmint Rhino Vegas right now, there are huge photos of me on the walls. I think there's one of me in London, too. I basically signed my image away for life when I won Spearmint Rhino Entertainer of the Year. I reigned in 2006. It was a rock star life: drugs, sex, money, private jets, gifts, fancy hotel suites, celebrities.

STS: It had to have been so surreal and intoxicating.

AMD: And then you find yourself in situations where you're like, *What am I doing here? Still on cocaine twelve hours later at the owner of the Buffalo Bills's house with random trust fund kids?* It sounds cool, but it was also such a waste of time.

STS: I suppose it was a waste of time, but do you feel like you really deserved it? Like, *I'm the baddest bitch?*

AMD: I did feel like I deserved it, because I worked really hard for it. I treated that time of my life as a serious career and one I was striving to be the best at.

STS: When was the turning point in your thinking about it? What made you become so introspective?

AMD: When I went to New York. It's a very expensive place to live. The strip clubs in New York are different than they are here. I didn't fit in. Everything's a lot more expensive. The style of dancer they liked was very thin. I was very thick and wasn't allowed onstage for a while, which broke my heart, because I'm amazing onstage.

STS: That's wild to think about you not being allowed onstage at all, because pole dance and especially erotic floor work are truly your niche. You've been really integrated in the pole community for a really long time. How did you end up interacting with the pole community to begin with?

AMD: I was angry at stripping, but I wanted to continue performing.

STS: What were you angry about?

AMD: I was angry about feeling like I didn't have a place to dance, feeling like there was no option for me because when I would complain or talk about the issues we were dealing with in the workplace, I wasn't listened to; I was sent home to sleep it off. The managers and bouncers were just dismissive. I was always in with the managers, so I felt like I had some power and some sway. But that's not the case. I still had privilege, but not enough to make a difference. I quit stripping cold turkey and found a pole dance studio.

STS: What year was this?

AMD: Two thousand seven. I was twenty-six.

STS: So, it was five years after getting into stripping.

AMD: Right, in July of 2007. I became a pole dance instructor at a studio called X-Polesitions, owned by Leah Butler. It was a Black-owned studio with Black instructors. I was the first white instructor. I was so honored and excited to be there. I helped move with them from the smaller studio to the bigger one. Then we became partners and created the first pole dance competition outside of strip clubs, with rules and points and prize money. We gave away ten thousand dollars. Spyda, the legendary Black stripper from Atlanta and Florida, won that competition. From there, everything snowballed. That event was a half success and a half failure.

STS: What was the half success and half failure?

AMD: The success was it was a completely packed room. Coolio was there. Apollonia was there. Ray J was one of our

judges. TMZ showed up. It was a madhouse. It was also mis-managed. There wasn't a mixture of music. There weren't a lot of places to sit. The pole almost came crashing down at one point, and we had to stop the show and have it fixed. But for me, the biggest failure from that event was that I had a falling-out with these people I really cared about. Thankfully, we have since apologized to each other.

STS: Do you think that the names of pole tricks came from strippers or from the emergence of the pole dance movement?

AMD: Definitely the latter, because during the time when I was first dancing in the strip clubs, we weren't teaching each other things. We didn't say, "Hey, have you tried such-and-such trick?" If someone said, "She stole my move," it was like, "No, a lot of us do that." There was no name because there was no exchanging of information around the movement.

STS: I've definitely been in a club where someone's been like, "You stole my thing." But I feel like the whole pole dance movement has popularized the use of the move-ments. When I started in Baltimore, the biggest pole thing was just climbing to the top of the pole, if you had a two-story pole. It wasn't the flips and inverts and everything that it is now. Do you feel like these moves make sense in a strip club context?

AMD: I think some of them do. I like the moves I see that come out of Atlanta and the really big clubs with the super-tall poles, because they're doing Genea Sky style, where they're up at the top and holding on to the railings and

flipping upside down on the ceiling. That's exciting as shit. But I find that some pole tricks don't really make sense in a strip club, because they're really complicated to get into. Unless you're extremely amazing at them, they're not very flattering and don't showcase your sensual side, which is the main reason people go to the strip club. When I pole-dance, I'm not doing hard trick after hard trick. I do basic tricks, but I do cute things in between—play with my hair, touch my breasts while I'm upside down—because I'm still dancing. I don't do pole tricks. I pole *dance*.

STS: I think, especially now, pole dancing has almost entirely shifted the whole idea for civilians about what you need to do to be a stripper. I hear so many times, from people who want to become strippers, who are like, *Well, but I don't think I could do pole tricks. I don't think I could pole-dance*, or *I need to take a pole class first*. What would you say to that person?

AMD: Stripping isn't about pole dancing. The movies are lying to you. The media is lying to you. If you want to be a stripper, talk to other strippers and sex workers about what you're about to get into. Offer them consulting fees and treat it like any other line of career. Learn about what you're about to do. That was my biggest mistake: I went into it blind, thinking I knew what it was about because of TV and movies.

STS: There is that glamour factor to it, often like a cruci-fying sexiness.

AMD: So sexy that they have to be punished, or so sexy they can't have relationships with people.

STS: Right now, you have been involved with a lot of different organizing efforts, but particularly a campaign called EveryBODYVisible.

AMD: EveryBODYVisible was created in the summer of 2018, when sex workers and strippers were shadow-banned and deleted on social media. Then pole dancers were shadow-banned and deleted. That created more of an outcry. Of course, when civilians are affected, it becomes a bigger deal. We recognized very quickly that this wasn't just a pole dancer issue; it was a human-body issue. We reached out to other communities, like LGBTQ communities and Black artists and the fat community and the trans community. We created this campaign around raising awareness of discrimination. More recently, we have determined that the discrimination and the policies practiced by social media companies stem from the absurd laws that lawmakers are putting in place, to the point where porn will eventually be illegal online. Our privacy is at stake. I definitely see a *Handmaid's Tale* future if we do nothing. If people don't have a place where they can freely express themselves, then they don't have any way to thrive.

STS: What keeps you hopeful?

AMD: I think people are being shamed into paying attention. The types of conversations we're having now weren't happening ten years ago. I definitely see growth that way.

STS: Given what happened to you, are you able to take time for yourself?

AMD: Just lately, I've made a decision to leave LA for an

extended period of time and to go home, to be in a position where I can be taken care of. Where I live now, I take care of a lot, and not just with my work but with my home life. I live in a large house with other people, and I'm responsible for a lot. This is another reason why I haven't had any time to deal with my own personal things. I'm constantly taking care of everything. So, I'm excited to go home and have conversations with myself and my body and with the trees and with nature.

STS: Where's home?

AMD: What was my grandmother's house but is now my mother's house in the countryside in Pennsylvania, near the border of Maryland. It's really beautiful, open space. The house is surrounded by trees. The trees do a lot of talking. The last time I was there, I spent a lot of time with the trees. For the first time, I acknowledged that those same trees have always been present in my life. So, I honored the trees, and I spoke to them. I'm having fantasies now of speaking with the trees again and being with them.

STS: What has the transition been like for you from doing sex work? How are you living now?

AMD: The transition has been illuminating. It's allowed me to dive deeper into finding out who I really am. As a blond-haired, blue-eyed, big-breasted female, I've been complicit in and almost obligated to fit the role of the all-American woman and the desired archetype in a capitalist society. I had never really taken the time to ask myself questions about my own gender identity or sexuality, because filling that archetype role was expected of me and

was what I believed was the best way for me to make it in this world.

The hardest part about moving on to not practicing sex work has been cash flow. For the last twenty years of my life, I've known exactly how I was going to make my money. Now I'm unsure, looking for new avenues, but I have an overwhelming desire to not work for someone else. It's a time of discovery for me, and I'm grateful to have the privilege and opportunity to take this time. Because of my past and current privilege, I use my time to volunteer for organizations like Strippers United and the Black Sex Worker Collective, to support others, to create resources, and to give back to the community that has taught me so much about life.

A FOREST

Kayla Tange

'm standing—barely—slumped over the jukebox, back turned
to the stage, one arm perched on the glass supporting my
body. Shifting between one foot and the other. Legs like jelly,
hurting yet hovering. Back. Forth. My body, a pendulum. My
eyes fixated on the Jägermeister sign. There's the sound of salt
crunching on the rim of a glass, the shuffling of heels on a hard-
wood floor followed by "Thank you, thank you for your tips."

Flipping through the ninety-nine CDs feels like an
impossible chore. I try to reach deep within myself to pick a
song, any song that will move my body enough to exorcise
my despair and reel in the monetary love from strangers. I
choose a go-to: the Cure, from *Seventeen Seconds*. It's one of
my favorite albums, different from the others in its under-
stated, melancholic tones.

Ten p.m. Some regulars sit at the end of the bar. They tell
jokes. I laugh. Usually, I have the script of most evenings
down to a science, mustering connections out of thin air
like clockwork. But now, when I need that magic the most,
is not one of those times. I desperately want to vanish.

I am in such a daze that everything is on autopilot. Some-
times dancing is like that. When it's good, it's great. It feels
familiar yet new. But tonight, I am tired of the world and
the persona I've constructed to mentally survive.

"How was Korea?" I hear a faint voice say behind my back. Dread creeps in. I should have a generic response prepared for this, but I don't.

* * *

"Happy birthday to you," they sing. My second day in Seoul. It's my birthday. I'm surrounded by seventeen other adoptees whom I met the day before. We're in a restaurant that serves barbecue, but not the kind with the grills on the table. They've ordered me some dessert from the menu. Although strangers, we get right down to business: *How old were you when you were adopted? Were you in an orphanage or fostered? Did you come with hope of finding your birth parents?* The smell of *galbi* fills the air. Fast friendships are forged over food and displacement.

* * *

Normally, I am great at switching seamlessly between my internal monologue and my client-facing persona, but at this moment, I feel weak. I don't want to be at work in this condition, but I fear that if I don't put a schedule in, I'll be punished with fewer shifts next week. And after three weeks in Korea, I desperately need the money. I spent around six thousand dollars on one of the most eye-opening and disappointing trips of my entire life. The happiness and sadness of some days was nearly impossible to contain. Being back in the States is painful.

"Painful" is an understatement.

I turn around, long black hair flowing, as I paint a smirk on my face. Walking, wobbling toward the stage as I pass by a regular customer. I'm friends with his girlfriend; she

must have told him why I was abroad. "It was great," I say, as if the person speaking from inside me were someone else. "There's twenty-four/seven shopping, and the city feels so safe to walk around."

A look of disbelief crosses his face. But what exactly does he expect? For me to lay myself bare right there in the club, right before I walk onstage to dance my abandonment away? I don't trust anyone enough to hold my despair. It is too fresh, still bleeding, not refined.

Our hotel in Seoul is central to everything. We even have a tiny washing machine in our room. After unpacking, I go off on my own to explore. The smell of street vendors making fresh candies and fried foods on sticks fills the air. I feel proud to be from here. The pavement is different from Los Angeles. I feel smooth stones beneath my feet, and I want to walk forever.

Jet lag is uncanny but, in this case, symbolic. The show must go on, despite my crumbling sense of self and limbs weak enough to float away. My body aches from my eyes to my ankles. My black patent leather stripper heels feel like a custom pair of cement shoes, far from the hollowed-out plastic they are made of. On any other night, my shoes are my support; they make me feel strong and unshakable, sexy, limitless. This is not one of those nights.

I'm onstage in a daze, doing slow-motion hair flips, spinning, offering an intense gaze followed by a coy look, then a quick turn. *I hear her voice / calling my name / The sound*

is deep / in the dark. I dance like a ghost, hardly registering the floor under my feet. I manage to fool the audience into thinking I am desirable, confident, insatiable. In reality, my soul aches, and I am disoriented by my own thoughts.

How could I tell them how deeply lonely it felt to be among a sea of people who looked just like me?

I've never met my mother, but sometimes I feel her in my bones, in my blood. We are the same, despite the nineteen years between us in age. In her translated letters, written to me before I went to Korea, she hinted at being wild, at having made choices that shamed her family. I never set out to live my life to redeem her buried sexual freedom, but somehow it chose me.

Suddenly I stop / but I know it's too late.

Who am I, anyway? I almost grasped an answer before it slipped through my fingers. I almost faced who I was, but she slipped through my fingers.

My set ends, and I crawl around the stage sweeping my money from one side to the other, stopping and pausing to thank patrons, attempting to humanize myself in the process. I collect my tips from the customers with their prying eyes and mouths. I don't think anyone can tell I am slowly dying inside as they stare at me, their tongues hanging out of their mouths like cartoon animals. How could I tell them that my mother had an opportunity to meet me, but instead chose to abandon me for a second time?

In the cab back to my hotel, I sob uncontrollably. "She couldn't do it. It was too emotional for her," the social worker relayed as she steered me, implacably, out of the agency's offices. This statement plays in my head over and over. In the

seat next to me lie a bouquet of flowers and a photo album I made of the years of my life she missed. The time elapsed from receiving this news from the social worker to stepping into the cab must have been mere minutes, and yet my whole life flashed before my eyes. *Do I even exist?*

<p style="text-align: center;">✳ ✳ ✳</p>

At the jukebox, I'm setting up my second set. My boss comes by and places her hand on my back. "Did you meet her?" she inquires.

Why is she being so nice to me? I don't trust her.

"It didn't happen," I respond while staring into the light of the jukebox. "She couldn't do it." My skin crawls. Why this conversation? Why now? I cannot handle being in my physical and emotional body at once. The air is stagnant, and the music is so loud. The sound of distorted laughter and clapping feels thick as I swallow in discomfort.

How could I tell her it felt like when I lost my virginity? It's the second time I've felt this different—enough that when I look in the mirror, I think that others must notice as well. But it's not the same; it's a different kind of exposure. Very real, in the flesh—the kind that feels exploitative. The kind that can be bought. Here I am for your viewing pleasure, possessed by pleasure and pain.

In the dressing room, I count my money. It was a good set. I've missed the sound of sweeping up dollars, missed the way they felt in my hands. I've missed unfolding them and neatly facing them the same way. The security guy used to comment on this when I changed them at the bar: "You have respect for your money." I didn't know what he meant by that. It's satisfying to see them neatly folded, and easier to know if I've met my "quota" for the evening.

<p style="text-align:center">✳ ✳ ✳</p>

Back at the hotel in Seoul, I am met with open arms by the seventeen other adoptees waiting for my happy reunion. I have nothing. I can hardly face them. I bow out of group lunch and dinner that day and do what feels the most healing, exploring the city alone. For hours I walk, until my feet blister. Being in Seoul is surreal. I see my face in others, and yet I cannot communicate with words. When it's brought up by shop owners, I mumble, "I'm adopted." They throw their arms around me and cry.

My mother hid in an unwed mothers' home with me. She didn't tell my birth father I existed. I try to feel him in my bones, skin, and spirit, given that he's part of what made me, too. I'd like to understand his side of the story. My mother felt she was doing us a favor, so I could "have a better life," so he could "have a better life." She put herself in a state of loneliness I cannot even imagine. I wonder sometimes if she "has a better life."

<p style="text-align:center">✳ ✳ ✳</p>

Outside, between sets, I light a cigarette. The action of inhaling calms me down. The boss doesn't like when we take smoke breaks, but at this point, I don't care what the punishment is. I need the release, though it means I'm forced to make small talk with customers who are likewise out smoking. My face already hurts from fake-smiling, but at least the cigarette keeps me occupied.

Back inside, in the lap dance booth. I could use the extra cash, but I'd rather be anywhere but here. My body sways, and he thinks I'm being sexy for him. I'm barely standing, leaning on his shoulders for support, but I make it appear

as if I'm angled for closeness. Manufacturing intimacy is a defense mechanism for me; it's become second nature.

Steve is a regular. He smells like cigarettes, but so do I. I made the mistake of adding him on my personal Facebook page, and now every time I see him, he makes some comment that suggests he "knows me." I can tell he's high right now, because he can hardly talk, but predictably, he spits something out.

"I read your blog. You're so *dark*." The words sputter and slide sloppily from his mouth.

I feel kicked while already down.

I've danced through breakups, through the deaths of family and friends, through tears shrouded by my hair, and now through this. It's as if the movement is a sort of conjuring, a merging of my body and my mother's, as if I am dancing away her repression, her shame. I dance when I don't know what else to do, a somatic response to everything that I have no words for. No language is needed, no explanation. I can be in my body, and in that moment I feel safe. I am autonomous, haunted, consumed, reckless, and abandoned in this space, this underground, where feelings are sin and feeling is foreign. But it's also here where people pay to witness my pain, night after night.

I'm running towards nothing / Again and again and again and again.

INTERVIEW WITH KAYLA TANGE

LIZZIE BORDEN: Where were you born, and how did you come to this country?

KAYLA TANGE: I was born in Seoul, South Korea. When

I was six months old, I was adopted by a Japanese American family whose relatives were placed in internment camps during World War Two. My adoptive mom was diabetic, so the doctors told her she couldn't have children. They tried to adopt two Japanese boys, but that fell through, so they adopted me and my sister, also Korean. We lived in Lemoore, California.

LB: When did you become curious about discovering who your biological mother was?

KT: I was always curious. My adoptive mom had a lot of health problems. Growing up, that always scared me, even though we weren't biologically related. I wanted to know if I would have health problems. My adoptive mom passed away the summer between eighth grade and my freshman year of high school. There were a lot of things that came up around abandonment. I was going through so much; I almost didn't graduate. But I was always into writing and art, so I wrote a lot of poetry and short stories and played the piano. I would go to LA and San Francisco with friends that had cars. I was interested in learning about nightlife and city culture, underground cultures, by experiencing them. I was interested in figuring out who I was.

LB: What drew you to stripping?

KT: In high school, I was in so much pain that I was drawn to creating characters. Later, I realized it was a portal for me to temporarily escape. One of them was a hypersexualized version of myself, even though I was a virgin. It started with mimicking. I was into very stylized films and photographs of women being in charge, because that was opposite to

how I felt. Even before I got into stripping, I was already doing erotic photoshoots with friends. There was something really cool about inventing this carefree self that was sexually liberated, mentally free. A few years later, when I was twenty-two and living in LA, I was in a lot of credit card debt and working a minimum-wage job. I had been wanting to dance since I was in high school, so I tried it.

LB: Where did you go?

KT: My friend and I went to a place called Fantasy Island, in West LA. I had no idea what the rules of this particular club were. After I got off the stage, the manager said, "You have a guy here that wants to go to the VIP Room." It was a hundred thirty dollars for thirty minutes. *This is what I make in two days at work*, I thought. I was trying to conceal my excitement. When I went in there, he took his penis out while telling me he was an ex-cop. I felt trapped, so, in hindsight, I was probably fawning. I danced while he masturbated. He asked if I minded. I didn't know how to respond, so I said, "Only if I can keep dancing." That somehow set the tone for my boundaries. I thought, *Okay, so some people will try to do this in the club. And that is a space of negotiation.*

LB: What were your boundaries?

KT: That same guy attempted that a few times after that, offering only slightly more money, then moved on when I realized he was a joke. I learned he only did that with girls who had just started dancing, because it was easier for him to abuse his power. I fell for it also. I'm not saying it was great all the time, but doing this job helped me negotiate

the rest of the world. It was the most direct way of learning what people will try to get away with. Plus, I thought it was exciting. I made money, I got to travel, I paid off my debt, I could work anywhere. It opened up worlds I never thought I'd get a glimpse of.

LB: How did you feel as an Asian dancer in various clubs?

KT: I was generally one of a few. Sometimes I was the only one. It was really strange to have the realization that fetishization was tied to a monetary value. I knew I wasn't always the favorite, but then there was always that one guy that was like, "I'm looking for an Asian girl." At times, maybe it felt comforting because I always knew there would be someone. I felt like I'd been rehearsing for many years before I actually did the job. I went into it knowing I was going to be objectified for a certain reason, so I might as well make money off of it. And looking at it like that, I felt like I took my power back, although there were many nights that I felt diminished by things people said to me. There was always some stereotypical commentary about my ethnicity.

LB: Would you ever not specify that you were Korean?

KT: I would state it, but I'd still get told I looked Chinese or Japanese, so I would purposely dance to songs like "China Girl" or "Hong Kong Garden" wearing a kimono. Making money off of their lack of nuance and understanding made me feel like I had the upper hand. I still am not sure if this was the best way to deflect, but I needed to respond to customers' racism in a way that felt like I had some sort of control. When you're at work, the behavior that you will accept from people for a dollar is *No, you can't say that.* But

for *five hundred dollars*, maybe I can let it slide because I can pay my rent? It's such a blurry line. You're literally making these deals with people about what are acceptable or unacceptable ways for them to treat you. Nevertheless, I was not immune nor invincible; I still found myself in dangerous situations.

LB: How did you first get in touch with your birth mother?

KT: I decided to go to Korea before my twenty-ninth birthday. I went through Holt International, a nonprofit adoption agency founded to help Korean orphans fathered by American soldiers postwar. I'm told it was a very popular service in the eighties. Holt organizes a tour so adoptees can go and get a broad experience of what their birth country is like. Through that process, one of the things they offer as a possibility is help with finding your birth parents.

My mother and I exchanged some emails beforehand that were translated through the social worker, and it was like any pen pal situation: "Oh, hi, how are you? Where do you live? What are you interested in? What do you like to do in your free time?" Just very surface-level stuff. Then I traveled there, and that was a whole different situation.

LB: You write in your story about stripping because of what your mother went through.

KT: One day I thought, *Wow, there's no other reason that I would be drawn to this work and do it for so long*. Later, it made sense to me when I read some of the letters from my mom, where she was telling me she was wild and wore short skirts. Korea in the eighties might not have been the ideal place to be if you wanted to be experimental with sexual

freedom, because it was frowned upon. Her father died when she was young, so her mother raised her by herself. Her mother basically forced her to give me up for adoption because of the way that hierarchy and families work—even though she, I later found out, was very in love with my father. It was her mom that didn't want the shame brought on to the family. And my mom thought her life would be very bad if she kept me, because she would have struggled a lot, and there wasn't a lot of societal support for single mothers at that time.

My experience in Korea with my mother—or lack thereof—was really traumatic. I felt shame deeper than I'd ever felt. After I got back, I broke up with my partner of five years and went through a complete life change. I attempted community college for the third time, moved across town, and ended up in another physically and emotionally disturbing relationship.

Following this, I desperately needed to start over, so I changed my stage name and promised myself, *No matter what, I will make work that's true to myself and to my story*. I incorporated a lot of the things I was interested in, things that pained me but that I still didn't know how to talk about. I began to nonverbally express the death of my adoptive mother and the abandonment by my birth mother through a combination of stripping and performance pieces I did either as myself or "Coco Ono." During this time, I was still stripping under my old stage name, Akira, but now I had another persona to escape to.

LB: A Japanese name.

KT: So is "Coco Ono." I feel like I was interpreting the culture I came from through a different lens than the one I

grew up with. I was overlapping a lot of different cultural elements to tell my story.

LB: Did any clients see your performances?

KT: At my early shows, the audience was mostly customers. I feel like it created this bond between us, sometimes leading to conversations about their own pasts and childhoods. It created a dimension in our relationship, and I suppose I maybe wanted that at the time. I think I, maybe, needed it more than I thought I did.

LB: They would have, then, two names for you: "Coco Ono" and "Akira."

KT: They would also call me by my real name, the ones that I gave it to. Some of the work was very personal—sometimes it was about them, a commentary on how I felt about sex work, but in a different context. It was really awkward and vulnerable at first when they came to my shows, but I felt truly respected and seen by some of these people, with who I am still friends today.

LB: Have you ever felt any guilt or shame about stripping?

KT: I never had a problem. It wasn't until I dated people that had a problem, or I realized other people wouldn't introduce me, or wouldn't want to be known to be dating me seriously, that I started to think about it. So, maybe some of the shame that I carried wasn't even my own. I thought it was a really cool job to have at times. That's how I felt for a long time—until the end, when I started to get really tired. It was a consistent shoulder issue; the emotional labor; the

nonconsensual touching; the unreasonable scheduling by managers, whether it be too many shifts or not enough; the racist comments from club owners, which for many years I'd laugh along with in fear of losing my job. But for the first five, six, seven years—ten years, even—I thought, *This is the best job. I love my life.*

LB: Did racist abuse become worse for you after the murders in Atlanta?

KT: It's hard for me to personally say, since clubs in LA were closed during that time, but I do remember getting some rude comments on social media. I definitely remember the Trump "China virus" period. However, some of us had experienced that before Trump. Even though we see LA as a melting pot, I have received aggressive or micro-aggressive behavior directed at me many times. But I do think that the murders exacerbated things and made some more scared.

LB: Have you missed stripping since the pandemic, when a lot of strip clubs were closed?

KT: Yeah. There's something about dancing on a stage and having people throw money at you while cheering—there's no other experience like that. It's just surreal to have that effect on an audience. It's not always like that, but when it happens, it's just a magic moment in time. During the lockdown, I felt fortunate to coproduce two online shows that felt really fulfilling to be a part of, *Cyber Clown Girls* and *Sacred Wounds*. But since the pandemic, and after everything that has happened in the past two years, I have a very different idea of what kind of interaction I desire. I never could have predicted feeling this way before, but something

shifted in me. We still do online shows since clubs have opened back up, but not as much.

LB: Are you going to make another attempt to meet your mother?

KT: She wrote me after I got back and said she was very sorry; she hopes we can meet again; she just couldn't do it; she thinks about me every day. I was very disturbed by this. Another odd piece to this: she said, "I want to give you money, because I feel bad about what happened." And then she said, "Please send me your routing number and this and that." And I responded, "I don't really need your money, but if you insist and if it will make you feel better . . ." So, I sent it to her, and that was the last time I heard from her. It seemed as if it was another negotiating guilt thing. I didn't want to have anything to do with her indecisiveness anymore; it was making me feel unhinged. Years later, I made a film with my friend and collaborator Luka Fisher, called *Dear Mother*. It was yet another attempt, a hope to maybe find her. But after a few years of sharing this film, I began to feel too raw, too exposed. It became unbearable to talk about my adoption again.

In the last few years, I've begun to learn about Korean shamanism and ancestral trauma. I had a fateful meeting with a *mudang*, who told me almost right away, "The spirits are telling me you look like your father." I replied, "There's no way you could know that." I had sent my picture to my birth mom, and she told me, "You look like your father's sister." I hadn't told that to anybody. And then the *mudang* told me, "Your mom's mental health is failing, and it's affecting you. You shouldn't contact her anymore. It's making you sick." And it was, so that was it. I stopped. I feel

a lot better since then, but the longing is still there. Like with any loss, I'm still confused. But I feel like the energy around it has transformed.

SEEKING AND FINDING ARRANGEMENTS

Selena the Stripper

I gave up on What's Your Price after a series of dead ends. I had spoken to so many men who eventually balked at my price, or who rushed me and lost interest when I wasn't willing to meet up with them at a moment's notice. I know that's the name of the game with sugar shopping, but it was frustrating, and after a point, I kept seeing listings for the same handful of men, over and over again. There were no new faces. So, I decided to bury my more than half-decade-old hatchet and reexamine Seeking Arrangement. I figured it couldn't hurt, and at least with the site billing itself as a sugar dating service, the men on there should have some expectation that they would be taking on a financial burden. Plus, I imagined the website had changed plenty since I first ventured to create a profile back in 2013—as had I. I was a wizened whore now.

To me, there's nothing more exciting than piecing together a profile. It's like playing a game, picking the right pictures and crafting the "About Me" text boxes. Even so, the majority of men are simple and will most likely not make it past the women's pictures. However, I realized that this time I had to be particularly careful—not regarding men, but because Seeking Arrangement is vigilantly against solic-

itation and explicit sex work. My first version of the "About Me" section got flagged because I listed my Instagram and Patreon links. Apparently, that counts as promotion, and it's not allowed. (In other interesting news, if you create a sugar baby account in LA, the founder of Seeking Arrangement might show up as a potential daddy. He has a profile and is using the site, trying to add additional concubines to his collection.)

It's easy for me to wonder about the role of race on the site. I didn't put on my whole ★Selena★ look, with a long straight ponytail, for my pictures, because that sort of thing doesn't work well IRL. A clip-on pony will be detectable—if not immediately, then at some point. I figured I might as well be me. But I do think that it's apparent who the site is for. You can tell from the front page, where we see a white woman and an older white man featured as the faces of Seeking Arrangement. I long for the day when I see a non-white woman as the face of any adult web page. I long for the day when non cis/able/youthful/skinny beauty is the way we rope people in.

I took an aggressive approach to this round of daddy-shopping. I paid to promote my page for twenty-four hours and messaged a number of potentials. I took phone calls with a few of them, text chats with others, and I ran into a lot of the same issues: they like my look, but my price point is too high; they don't want someone too experienced; they want a monogamous relationship, etc. I also ran into a few scams.

I should have sniffed out the first one from the start. First, scammers write a lot. They go into detail about who they are, what they do, how they are so affluent. The first scam offered me a nine-hundred-dollar starting weekly allowance, which to some might have sounded too good to

be true, but I'm a spoiled babe. My first thought was, *Why not just round up to a thousand?* We exchanged emails, and then the hustle began.

"I'm an oil man in Arizona working on setting up a drilling operation for the next few months. I also invest in natural minerals, including gold. I don't have time to date, which is why I'm here. I won't be able to meet until Covid is contained, but I want to send you an allowance until then just to talk and keep me company."

They offer you a sizable amount of money, but the catch is that they only do bank-to-bank transfers, because they are "unable" to use Venmo/PayPal/Cash App. They may even try to cover and say something like "I didn't ask you for your account number; I just asked what bank you use," but it's all a ploy to gradually collect your data. They might ask if you have any credit card debt or some other bills you want paid and then gather your information that way over time, asking for a screenshot of the bill so that they can pay it for you. As soon as a man starts avoiding basic e-wallets, I know he is a scam.

More disappointingly, I ran into a lesbian scam, which was quite a letdown, because the woman whose picture they used was pretty cute. I wanted to have a sugar mama so badly, I considered lowering my rates for the sake of the experience. But in the end, the ma'am was a scam.

Evan, my secondary partner, joined What's Your Price out of curiosity and also found himself chatting with a number of scammers—although he was buying, not selling. On the client end, the common scam is that a woman schedules a date with you and then, on the day of, she reinforces that she is coming by for the date, but along the way she "gets a flat tire" and needs cash to fix the flat. Dealing with these sites was a drag, but eventually, we both found people to break the barrier from URL to IRL.

One night in fall 2020, I had a few minutes prior to the *Cyber Clown Girls* online strip club event I'd agreed to perform in, and I was very jittery. It was a combination of election stress, performance anxiety, body shame, and too much coffee. I was not mentally prepared for the show; I don't think many of the performers really were. There was too much at stake with the election, too much damage we were already living in the wake of.

To kill time, I began messaging people on Seeking, and one man open-endedly asked to schedule a time to chat on the phone. Because I had a moment, I offered to talk briefly before the show. That's how it began.

He was pushy. He wanted me to ditch on the show and see him instead; he was promising me eight hundred dollars for the evening. I told him that I couldn't—I'd made a commitment to my friends and intended to follow through. I offered to visit him after we finished. Eventually, we settled on something in between: I would perform both my sets and then leave shortly after. He CashApped me a hundred-dollar deposit, to demonstrate that he was serious, which was refreshing. I'd been dealing with so many flakes. He promised he would pay me the rest as soon as I arrived at his house. But when I tried to pull additional information from him, he was very cagey.

Eventually, I flatly laid it out for him: "I am a small woman doing the work I do. You are a strange man who could murder me. I need you to trust me a little, because I have to trust you a lot." (I call myself a "woman" for clients because cishet men are out here struggling to sort blocks, and non-cis pronouns are advanced calculus to them.)

He reluctantly agreed to a Zoom video chat. He sent me the link, and then suddenly we were seeing each other for the first time. I put on my best "I'm a baby angel, don't

murder me" smile. He was tall, kinda wiry. His eyes buried themselves under his ample eyebrows. He returned my smile with his own awkward one. It was reassuring to put a face to his online ID. He went from being alarmingly pushy to coming off as more of a nerd with slightly underdeveloped social skills.

I had to make a decision whether the risk might be worth it. I called Evan as he drove home from a What's Your Price date, and he reassured me: "Homeboy's already leaving a paper trail."

Observing our parallel paths was very touching. I was considering providing, and he had just finished purchasing. I sent Evan my location and the man's address, then gave Evan a detailed description of the gentleman. If I was going to die, it wouldn't be a secret. I also shared my location with Starr and Cherry, my two closest sex-working homies, for extra protection.

I finished both of my *Clown Girl* performances and zipped off to see the new guy. He lived in Hermosa, which was a bit of a trek, but since it was already eleven p.m., I knew there would hardly be any traffic. When I got there, I took a picture of the license plates of the cars parked in front of the building and of the front of the house—partially with the hope that one of those cars might be his, partially to upload a picture to the cloud with the date, time, and location of my last breath if I got merked.

Shortly after I texted him that I'd arrived, "Wes" (not his real name, I assumed, given how hypercautious he was about even chatting on Zoom) appeared. The lovely thing was that as he'd promised, as soon as he saw me, he pulled out his phone and sent me the other seven hundred dollars. I was at least secure in knowing I was getting paid. Then he complimented my appearance.

He'd run me through his ideal order of operations over the phone, so I was somewhat prepared. As soon as I stepped into the apartment, he'd said, he would start undressing me. He wanted to be in charge. We would have protected sex for anywhere from an hour to an hour and a half. He wanted condomless oral, but I got him to settle for oral with a rubber. He had wanted me to stay over, but I was not considering that option. I would not be haggled into an extended stay after he had pushed for a last-minute, late-night, private-residence outcall. I planned to stay for two hours and then leave.

I was a little terrified, which might sound paradoxical: How can one be just slightly terrified? But that was how I felt. In our video chat, he'd seemed polite and normal, if a little nerdy, but of course, true crime lover that I am, my mind went straight to BTK. Serial killers are able to blend in and have friends; it's a lot harder to murder people if you have no social skills. To further bolster my sense of calm, I decided to play a mind game I like to call "If I Was a Gay on Grindr." My gay male friends do anonymous meet-ups for sex all the time. There is hardly any exchange of information, no decorum, just straight (gay) fucking. After listening to years of bathhouse and cruising stories, I decided I would handle this moment like a gay man.

Anonymous sex is normal. I can handle this. I have a penis.

Sometimes I really wish I had a properly hermaphroditic body, but that wasn't in the cards.

Before Covid-19, I would never have consented to an intimate encounter with a stranger without first meeting him in a public space, or at the strip club where I had the security of bouncers, cameras, and my friends keeping watch. But with reduced access to public space, I've had to adapt. A Zoom call will do instead of a chat in a café. I share with my friends pictures of an ID, a personal address, and a

detailed description of the person I see on the other end of my Zoom interviews. I also have to ask questions about how many people a client has been in contact with recently and whether they're being diligently tested for Covid-19. There are so many different kinds of dangers to worry about, and yet the risk I assume is less than if I were working in the strip club now during the pandemic. That's an option—my club has reopened quietly; my friends are back at work. But the idea of being around such a large group of people in an environment where clients are encouraged to cut loose and relax their normal inhibitions is terrifying to me. I tried it and found that nobody was following social-distancing precautions, and mask usage was inconsistent. It was disturbing, and my partner was concerned about what he might be exposed to tangentially. In the end, seeing two clients a week was the lesser evil in this situation.

As soon as I stepped through the doorway of Wes's home, we began kissing. He led me upstairs to his room, which was nearly pitch black. A vague halo of blue light could barely be seen around the edges of his blackout curtains.

Me: Can we have at least a little light . . . as a treat?

Him: No, I prefer to have sex in the dark.

I worried he could have a weapon hidden or a friend somewhere who would ambush me—although, he wouldn't really have needed a second person to take me down. I worried he might have a camera recording everything, but the beauty of cameras is that, 99 percent of the time, their night vision is shit. After I ran through my worst-case scenarios, my fear began to dissipate. I realized the most likely reason he wanted the lights off was body shame. He probably didn't want to think about how I perceive his boney, ectomorphic body, and getting intimate under the cloak of darkness gave his insecurities a place to hide.

I hadn't given a condom blow job in ages. I don't see the appeal: the giver has to deal with the gross rubber taste, and the receiver gets a pretty wack version of an otherwise good thing. It's not terrible, but it is not ideal. I was very dehydrated after dancing and, well, life. I had hardly enough spit to give him anything other than a dry kitty tongue.

Wes: Spit on my dick.

I attempted. I imagined a puff of dust coming out instead.

Me: I'm pretty dehydrated.

Wes: Oh! I'm sorry, I should have offered you something. Do you want some Gatorade?

Me: Do you have any water?

Wes: You don't like Gatorade?

Me: Not really. I'm a water kind of gal.

Wes: Okay, I'll go get you water in a second. Let's just fuck for a bit longer.

Me: Okay.

I let him go at it for a bit longer. Then he went down to the kitchen. I grabbed my phone to check the time. We were about thirty minutes out from my hard departure time. He returned with a glass of water.

Me: Thanks.

I gulped the water, greedily. I hadn't had time between the show and driving to Hermosa to hydrate. I was still a little grody from dancing and had Gorilla Snot pole grip on my hands, which I forgot until . . .

Wes: Spit on your hand and stroke my dick.

I followed his directions, only to remember the Gorilla Snot as my gunky hands wrapped around his condom-clad penis.

Me: Oh, shit. I forgot I have pole grip on my hands, so now your dick is covered in Gorilla Snot.

He laughed. Sex is so funny, maybe even more so when it's anonymous.

INTERVIEW WITH SELENA THE STRIPPER, BY THE GODDESS CORI

Goddess Cori is a sex worker, writer, scientist, podcaster, and performance artist in LA. They have published several works, including "*Hamilton* Fails the Revolution," a critical analysis of the musical *Hamilton*; "Searching for Foxy," which appears in *We Too: Essays on Sex Work and Survival* (Feminist Press, 2021); and *My Old Friends*, a self-portrait photo series about healing the shame one feels about being a survivor and sex worker.

GODDESS CORI: Where did you grow up, and how did that environment inform your ideas about sex and sexuality?

SELENA THE STRIPPER: In Oklahoma and Louisiana—both deep-red, family values, Christian states. And my family is very churchgoing. My experience with sex and sexuality was "Don't do it," with the undercurrent of sex being dirty or limiting the value of women. The other side of it was that my mom was molested all through her childhood by her uncle. So, my first discussions with her about sex were all about rape and about touch. My mom was pretty vehement about telling me that if anybody touched me the wrong way, put me into a situation where I was uncomfortable, even if it was her brother, she would cut them out, because the opposite had happened to her.

GC: What about homosexuality?

STS: I remember as a kid asking my mom what "gay" meant, and then I looked it up in a dictionary. It just said

"happy." And my mom was like, "Sure." She didn't want to tell me, and it was ironic in a lot of ways, because her brother was gay.

GC: Did you ever masturbate?

STS: I went to Catholic school from kindergarten to my senior year in high school. The pleasures of sex were not part of the curriculum, so I had no sex education, really. No pleasure education. I watched British Sex Ed videos, but also real sex videos. Anything I could get my hands on.

GC: When did your gender journey start?

STS: My first thing was experimenting with other girls in my grade, because my parents were very strict about me not having any male friends as a kid. There was a no-kissing-on-the-lips policy, but it was really erotic the whole time. I had a lot of shame around not being straight, not really knowing what I was, and just having a lot of sexual energy going in all directions. I felt like my body wasn't feminine per se. Not that anything is necessarily masculine or feminine, but it was like I didn't feel like my body made any sense in the girl clothes. I put on a lot of muscle. And I was not curvy. Maybe that's why I feel somewhere in the middle. Gender is just such a nebulous thing to me. I think, for some people, it's a bigger dysmorphia, but for me it's also like, *You can't tell me what I am, especially if I don't even know what I am.* Me going by different pronouns has been relatively new, and it's been after years of trying a lot of different things, and also trying to understand what "nonbinary" means to me, because I don't think it's completely a rejection of gender. It's kind of like living in the gray.

GC: What has been the most difficult about it?

STS: Having to correct people about pronouns. It's like having to come out over and over again. Just similar to sex work.

GC: How did you decide to become a sex worker?

STS: I was working a really terrible job that was expecting me to use my hard-earned degree that I had spent a house's worth of money earning. And my boss was treating me shitty, not giving me the tools to do the job and yelling at me anytime I made a mistake. She had been promising to give me a raise. I was working for eleven dollars an hour as a seamstress. And she was like, "Well, I'm going to give you this raise, but your work doesn't deserve it, and you're on probation." And so, she raised my wage a dollar more and continued to be horrible. And I was like, *I can't do this,* so I quit. I hadn't quit before without having a job lined up.

I had a bunch of friends that were working as strippers at this one club in Baltimore called the Ritz. I love the Ritz, but it was a shitty little club with all kinds of health hazards—but still really pretty inside. I had an ex who was also working there, and they were just a fantastic stripper. So, they sat me down and took me through how to twerk and how to dance like a stripper—how to *move* like a stripper is the more apt thing. You can dance, and there is dancing, but it's a certain movement, a flow. They showed me [the online stripper community] Stripper Web, and they were like, "This will answer a bunch of your questions about how to ask for this and that."

GC: Was that your first time?

STS: Actually, before that, I had tried camming and sugar dating, and that was such a mess. I had just shaved my head and had also decided to grow out all of my body hair. I was a little nightmare to these men. But I had shoulder-length hair by the time I decided to try to be a stripper. So, it was enough to get in.

GC: How did your mom find out you were stripping?

STS: I told her before I started my first day at the club. My stepdad cut off my phone line in the middle of my shift, which was scary. I was stranded without the ability to call a car home, so I had to depend on a friend for a ride. My mom is very anti-sex work because she sees the work as exploitative. She still doesn't know how to engage with what I do, because of her own trauma, but she can see that I believe in what I'm doing. Now she accepts who I am but doesn't ask for details.

GC: How did your ethnic background inform your ideas about sex work?

STS: As far as around sex work, I think that being a Black and Latine person has really made me aware of exploitation. I've definitely been taken advantage of and assaulted and raped, but my experience has been pretty privileged overall. It's hard, because I'm such an activist for sex work, but I also have to acknowledge that the anti-sex work people who talk about exploitation and trafficking have some points. I don't like to feed any of their fire, because I think it's much more complicated than they often make it out to be. But a lot of the most vocal activists are Black and brown women who were trafficked, so I feel like I have to pay attention.

As the leader of Strippers United, I've had a lot of personal conflicts in running the organization, because a lot of the solutions integral to what we're working for (ending discrimination and decriminalizing sex work) depend upon increased governmental interaction and oversight. I wouldn't say I'm an anarchist entirely, but I lean more in the direction of a deep mistrust of the government.

GC: What about unionization?

STS: It's fantastic, but it's a massive risk for minorities and undocumented people, even though I know that it has worked for undocumented people before. There are just a lot of risks I'm aware of as a person of color.

GC: Because the first thing people see when you walk into a room is that you're Black. And then the second thing is that maybe you're a woman. They don't see that you're a sex worker first.

STS: And because I have the experience of having multiple marginalized identities, I know that, for a lot of people, those things are not things they experience. I need to be aware of things I don't necessarily experience.

GC: How have you dealt with exotification and with the romanticization of having a mixed identity in sex work?

STS: It's complicated, because I didn't start off styling myself the way that I do now. I've just learned over time that you get treated like the fucking discount rack if you're at all Black. Even my degree of exotic Black. Just having curly hair is this giveaway that there's Blackness in you.

People are just rude, or there's an invisibility in sex work as a Black person. If there's a Black dancer and a white dancer onstage, the audience tends to look at the white dancer or the non-Black Latina dancer. And I've had the privilege to be able to choose what experience I have.

GC: Did it take you a while to discover this?

STS: I started off dancing with my hair natural. Over time, I've tried a lot of different things, and I found that I get significantly more money whenever I am passing as not Black. So, I wear the straight hair and all of that. If you're exoticized, there are a lot of benefits. People are so interested in what you are. It just hurts a lot to know that half of my identity is not valued at all in the club. There's a really concrete way that sex work highlights discrimination, because it is literally people handing you the tip that says how much they think you're worth. I just know I get treated better because I can be "exotic."

GC: In addition to presenting as "exotic" in the club, how does it feel to present as female?

STS: It feels like I'm playing an idealized feminine character. Selena isn't me. Maybe Selena is me in another reality, where I am a girl, but I've never known how to be feminine or known what to do with femininity. When I see Selena in the mirror, I see the phantom of who I am online rather than myself. She is aspirational and hollow, and sometimes I worry that her femininity is destructive.

GC: Do you have any rituals to cleanse yourself after the club?

STS: I enjoy a hearty meal. And I spend a lot of time scrubbing out the gel from my hair and all of that. I just spend time being awake, and alone, and feeling my body: all of the aches and the creakiness and the spinal compression. And whenever I just am myself, sometimes I have to contend with my own sense that this me is less valuable, which is maybe not a cleansing thing. I'm not restoring myself.

GC: No. That's a ritual. Not necessarily cleansing.

STS: Yeah. It's funny, because when I look at myself in the mirror as "Selena," I'm like, *Some people do this every day of their life.* Some people wear wigs and clips and extensions and straighten and primp and gel every day of their life. And I could do that. And I would probably get certain rewards, certain societal benefits, treated differently. It's kind of like I just see this alternative world of me, but it feels really good to not have to deal with it.

GC: Have you always been a writer?

STS: I've been writing ever since I was a child. I kept an extensive journal for years, where I kept a lot of secrets, from gushing over crushes to chronicling abuse at home. I really got into creative writing in high school. I had a teacher who noticed my skill and encouraged me to dive in. He edited my first collection of poetry, and through his guidance, I was able to win a state poetry prize.

GC: What kind of abuse at home were you writing about?

STS: Both of my parents had major undiagnosed mental illnesses. I'm almost certain that my mom has borderline

personality disorder. I don't entirely blame her for how she was with me, but even so, she was abusive. She would rant at me, my sister, and our stepfather for hours, accusing us of things we hadn't done. She would leave and not tell us where she was going or when she would be back. She refused to speak to me for a whole week once, and I didn't even know if she was going to take me to school. I wanted to leave, but I was the buffer between my mom's rage and my younger sister. I keep minimal contact with her now.

GC: What inspired your podcast, *Heaux in the Kneaux*?

STS: I was tired of listening to so many bad interviews with sex workers that focused on the salacious details of the job rather than the bread-and-butter of the labor. I created the podcast to talk to sex workers, to get to know about their working conditions and the real obstacles they face, because I was curious. I wanted to put it out there for other sex workers so that they could get useful information and feel like they're part of a community rather than working in a void, dealing with the danger and stigma alone.

GC: Who are some hoes, either in your life or just hoes that you know of, that you looked up to? Or look up to? Or, who is one of the first ones that you can remember being like, *I want to be like you*? Or not even *I want to be like you*, but, like, *Wow. You're doing this and you're amazing.*

STS: Oh, man. It's embarrassing, because it was a lot of white women. I just didn't know a lot of Black sex workers at the time. I guess the first one that I was really exposed to would probably have to be Nina Hartley. And I'm trying to remember the other major white MILF . . .

GC: Lisa Ann?

STS: Yeah. It was more I thought that they were so cool. I loved that they were MILFs. I also loved that Nina Hartley was doing so much. I loved that she was directing, and doing Sex Ed, and she had been in porn. And then also Annie Sprinkle. I was like, *That's so cool. You're doing art and sex. And just merging it together, and you're super weird. And it's super weird that you're Miss Frizzle, but also a porn star.* I just loved how quirky and out of the box she was. And then there are just so many cool people. I love . . . was it Kisha Noir? She's so funny. I follow her on TikTok now.

I just think the more that I've learned about hoes—and I think especially through our segment with *Heaux in the Kneaux*, having our historical hoes and just getting to know the lives of different sex workers—I'm just endlessly amazed and inspired, and it makes me feel like I belong as part of this heritage. I'm not just a lone hoe, because when you're a lone hoe, it's easy to let society get to you and make you feel like you're not worth anything. And your occupation has a time limit, and people don't take you seriously, and what are you going to do next? And do you need to be saved? And you probably do need to be saved.

I really love that Sita Kaylin's memoirs are called *Anything but a Wasted Life*. Because I'm sure that she's heard that so many times, especially being an older whore. Whenever anybody finds out that you're a sex worker, it's like, "Well, what are you going to do after this?" or, like, "What's your plan for after? It's cool that you're doing this now, but what do you really want to do?" It's a very patronizing question. It just undermines all of the work and joy and experiences and the vitality that comes from the industry. And not to just put a happy smiley face on

it—there's a lot of difficulties, and it's pretty grueling, but that's work in general. Work is sometimes pleasurable and sometimes grueling. And it's just worth it to do something that just makes sense to you.

GC: And for my last question, speaking of what comes next, what are some of your longer-term goals in the industry, outside of the industry? Where do you see yourself in ten years?

STS: Where do I see myself in ten years? Alive.

GC: Oh. Yeah. That's good.

STS: Hopefully having fun. Hopefully doing the things that I enjoy. And I really hope to see a lot of progress in the next ten years. I think that I've seen a lot even within the past however many years I've been in the industry at this point. I've noticed a lot of change in the dialogue, and in people being out, and social media making visibility a lot more accessible to people, even though we do face shadow-banning and all-out account loss. That's such a major thing. But, simultaneously, I see news agencies talking about sex workers. I saw the coverage around OnlyFans planning to ban sex workers and then turning that around because all of the headlines said, "OnlyFans banned sex workers in the middle of a pandemic." There's this new empathy that's happening. So, I'd like to see that momentum continue, and I'd like to be part of it. I'd like to see decriminalization actually happen. I do think that legalization is a much more likely outcome. But, even so, I will take legalization over people being locked up for something that doesn't make sense. God, sometimes the bar is on the

ground, and you're like, *Wow. That bar certainly* . . . Then it raises an inch. You're like, *Oh. Look at the progress.*

GC: *Oh, wow. Yeah. Look at what we've done.*

STS: *Wow. We've done it.* I'd like to be published at that point. I would like to have less of my income dependent on sex work at that point, to be honest. I really love the occupation, but I also feel like I want to one day get out, and I want to just write and be creating other stuff. I'd love for PeepMe to get off the ground, and I could just work at a fucking tech co-op. Make that tech money.

GC: Yeah.

STS: I'd like to own a house, I think, in ten years. I'd like to have a compound, actually.

GC: Your polycule compound.

STS: My polycule compound. I actually could not imagine my partners wanting to live on the same compound. That would be truly chaotic. But, yeah, something like that. Something weird and wholesome.

ACKNOWLEDGMENTS

Thanks to Jill Morley for first showing me stories from the eighties that became the cornerstone of this anthology. Thank you, too, Jill, for your constant energy and support throughout the years.

Thank you to Susie Bright, mistress of anthologies, for advising me, early in the process, to fall in love with every piece in the collection. I have, deeply.

Immense thanks to my avatar Antonia Crane for introducing me to dancers still in the field and for your tough, yet gentle advice.

Thank you, Matias Viegener, for the honor of working with you on decoding the unpublished story by Kathy Acker and the privilege of publishing it here.

This anthology wouldn't exist without Rudy Langlais, whose brilliant intuition as an editor of the *Village Voice*, back in the day, never left him; thank you for introducing me to the incomparable Dan Simon. Thank you, Dan, for sensing there was a book to be found in the too-long manuscript and waiting until you found the right editor for the project, the inventive and precise Molly Lindley Pisani. Thank you, Molly.

Most of all, thank you to all the writers and interviewers for trusting your words and time to this anthology and for your unflagging patience as it slowly became a reality. This book exists in honor of you, because of you.

CONTRIBUTORS

COOKIE MUELLER (1949–1989), née Dorothy Karen Mueller, played leading roles in John Waters's *Multiple Maniacs, Pink Flamingos, Female Trouble,* and *Desperate Living.* She wrote for the *East Village Eye* and *Details* magazine, performed in a series of plays by Gary Indiana, and wrote numerous stories that were published posthumously. She died at age forty of AIDS-related complications in New York City.

KATHY ACKER (1947–1997) was an American experimental novelist, playwright, poet, and essayist known for her idiosyncratic and transgressive writing that dealt with themes such as childhood trauma, sexuality, capitalism, and rebellion. Her best-known novel is *Blood and Guts in High School*; her earliest work is collected in *Portrait of an Eye*; and her last work is *Pussy, King of the Pirates.*

JO WELDON is an international performer and instructor, the author of *The Burlesque Handbook* and *Fierce: The History of Leopard Print,* and the founder and operator of the New York School of Burlesque, as well as the founder of the blog Sex Worker Style. She has participated in anti-censorship activism since 1978, sex work since 1980, and sex worker activism and advocacy since 1995. Her current work investigates the intersections of sex work, fashion, and culture. www.joweldon.com

SUSAN MCMULLEN was born and raised in Canada but has lived most of her life in Los Angeles. She is attracted to the esoteric and to ancient things that are full of magic; she has studied many of these herself as well as several healing arts modalities along the way. She cooks for fun, eats for pleasure, and dances whenever she can.

MAGGIE ESTEP (1963–2014) attended the Jack Kerouac School of Disembodied Poetics in Boulder, Colorado, and the State University of New York. The author of numerous books, including *Alice Fantastic* and *Hex* (a 2003 *New York Times* Notable Book), she published work in many magazines and anthologies and per-

formed in venues ranging from Lincoln Center and Lollapalooza to *Charlie Rose* and HBO's *Def Poetry Jam*. She died in Hudson, New York, at the age of fifty.

CHRIS KRAUS is a writer and a critic. Her eight books include *Summer of Hate, Social Practices, I Love Dick*, and *After Kathy Acker: A Literary Biography*. Her work has been translated into more than a dozen languages.

JODI SH. DOFF is a New York City–based writer whose work frequently includes autobiographical elements of drug use, alcoholism, and the strip clubs and nightlife of New York City's Times Square. She studied with Spalding Gray, Virginia Woolf scholar Louise DeSalvo, playwright Gretchen Cryer, and author and founder of the literary journal *The Rumpus*, Stephen Elliott. Jodi has been a mentor with the PEN America's Prison Writing Mentor Program and was awarded an MFA in creative writing from Lesley University, where she occasionally advises a graduate seminar in the art of memoir. www.onlythejodi.com

In addition to being a professional dancer who has toured internationally with the Elisa Monte Dance Company, **TERESE PAMPELLONNE** has published numerous short stories, plays, and a novel, *The Unwelcome Child* (Kensington, 2005). She currently owns and operates her own boutique Pilates studio on the Upper West Side of Manhattan with her husband, Bob.

JILL MORLEY is a writer and filmmaker who became a National Golden Gloves champion later in life. She now coaches (mostly) women boxers. Jill's screenplay *See Jane Fight* won awards in several competitions and is in the process of being produced.

SUSAN WALSH was born in 1960 and raised in New Jersey. She was a freelance journalist and writer whose work was published in the *Village Voice* and *Popular Mechanics*, among other publications. She was last seen in July 1996 in Nutley, New Jersey. Her missing persons case is ongoing.

DEBI KELLY VAN CLEAVE lives on a farm with Kurt, her husband of twenty-eight years (and her big tipper), and her daughter,

Kelly. She spends her days running her vintage business, Mad Girl Retro, riding horses, decorating her old farmhouse, and writing fiction inspired by her work in the blue-collar bar industry and her stint as a go-go dancer. She still likes to dance.

ELISSA WALD is the author of several books, including *Meeting the Master, Holding Fire,* and *The Secret Lives of Married Women.* She also cowrote a memoir, *American Daughter.* She lives with her husband and children in Portland, Oregon.

ESSENCE REVEALED was crowned 2016 Queen of Classic Burlesque Milan Extraordinaire. An Amazon number one international bestselling author, speaker, and educator, she has been published in many anthologies. She travels the world, appearing at universities, conferences, and burlesque festivals as both a solo performer and a sensual dance instructor.

Originally known as "Sassy Lapdancer," author of London's first stripper blog, **SASSY PENNY** became heavily involved in activism. She helped set up the trade union United Sex Workers and the East London Strippers Collective. She is currently stripping through law school and writing a novel.

JACQ FRANCES is a multidisciplinary sex symbol and philosopher. Originally from Canada, she lives as glitter in the wind.

REESE PIPER is a writer and occasional stripper living in Brooklyn. Her writing about sex work and disability has appeared in *Vice* and on Narratively, Rewire, Autostraddle, and other online outlets. She is currently working on a memoir.

LINDSAY BYRON is an author, women's community leader, and lifelong wayward woman based in Atlanta, Georgia. Most people know her by her alias, "Lux ATL."

THE INCREDIBLE, EDIBLE AKYNOS is a stripper and performance artist, two times an immigrant, hater of the patriarchy and white supremacy; a world traveler, grad student, and retired hor, but forever on some heaux sh*t.

ANTONIA CRANE is the author of the memoir *Spent*, which was translated into French this year by Éditions Tusitala. Her essays have appeared in the *New York Times* and *n+1* and on Quartz, BuzzFeed, and other places. She is currently a PhD candidate at USC. She loves making films and advocating for the labor rights of sex workers.

LILY BURANA is the author of four books, most recently *Grace for Amateurs: Field Notes on a Journey Back to Faith*. Her first book, *Strip City: A Stripper's Farewell Journey Across America*, made several best-of-the-year lists, including on Salon and in New York *Newsday* and *Entertainment Weekly*. She lives in New York's Hudson Valley.

AM DAVIES is an activist for sex workers, a retired stripper, and a new amputee. AM is the secretary of Strippers United, a labor movement for strippers and sex workers. She lives in Pennsylvania with her partner and two amazing black cats.

KAYLA TANGE was born in South Korea and adopted by a Japanese American family. Through poetry, video, sculpture, and more directly with performance and cultural production, she addresses structures of spectatorship while redefining ancestral trauma through public and private ritual. She is interested in exploring the way memory and desire are both constructive and destructive, focusing on the social constructs of sexuality and culture, simultaneously creating tactile, visual, and aural experiences.

SELENA THE STRIPPER is a sex worker, writer, activist and, as of this writing, the acting president of Strippers United, a coalition of strippers, other sex workers, and allies advocating for the right to a safe and equitable work environment for strippers everywhere. She has been featured in *Bust* magazine's 2020 list of activists under thirty-five to watch ("Meet the Next Generation of Superstar Activists"), a *Flaunt* magazine spread ("Strippers United: The Future Is Armed with Rights," December 2021), and other publications.

ABOUT THE AUTHOR

LIZZIE BORDEN is a writer, director, editor, and script consultant. Her film *Born in Flames* was named one of "The Most Important 50 Independent Films" by *Filmmaker* magazine. In 2016, it was restored by the Anthology Film Archives and screened around the world, called by *New Yorker* critic Richard Brody "a feminist masterpiece."

Borden also wrote, directed, and produced a controversial independent fiction film, *Working Girls*, depicting the working lives of prostitutes, which premiered at the Cannes Film Festival in the Directors' Fortnight, won a U.S. Dramatic Special Jury Recognition at the Sundance Film Festival, and was restored by the Criterion Collection in 2021. The Anthology Film Archives has just restored Borden's long-unseen first film, *Regrouping*, an experimental documentary about women's groups, of which film theorist Laura Mulvey commented that she was "surprised by its beauty, by the images and their tactility."

Borden is currently working on several TV and film projects.

"We Were Strippers Once," by Lily Burana, used by permission of the contributing author.

"Amputee Queen," by AM Davies, used by permission of the contributing author.

"A Forest," by Kayla Tange, used by permission of Kayla Tange.

"Seeking and Finding Arrangements," by Selena the Stripper, used by permission of the contributing author.